Hard Times

Social realism in Victoria

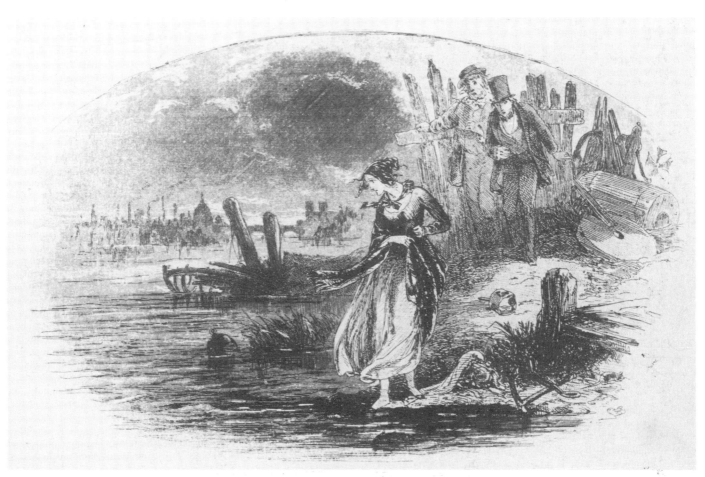

Hablot K. Browne ('Phiz'), *The River* (*David Copperfield*, 1849)

Julian Treuherz

Hard Times

Social realism in Victorian art

with contributions by
Susan P. Casteras
Lee M. Edwards
Peter Keating
Louis van Tilborgh

Lund Humphries, London
and Moyer Bell, Mt. Kisco, New York
in association with
Manchester City Art Galleries

Copyright © Manchester City Art Galleries
Texts copyright © Susan P. Casteras, Lee M. Edwards,
Peter Keating, Louis van Tilborgh, Julian Treuherz

First edition 1987
Published by
Lund Humphries Publishers Ltd, London
in association with
Manchester City Art Galleries

Distributed to the book trade worldwide (except in the USA)
by Lund Humphries Publishers Ltd
16 Pembridge Road, London W11 3HL

British Library Cataloguing in Publication Data available

ISBN 0 85331 527 2

Distributed to the book trade in the USA by
Moyer Bell Ltd
Colonial Hill / RFD 1, Mt. Kisco, NY 10549

Designed by Alan Bartram
Typeset by Nene Phototypesetters Ltd, Northampton
Printed and bound by Whitstable Litho Ltd

Front cover:
Hubert von Herkomer, *Hard Times 1885*
Manchester City Art Galleries
(detail of cat. 82)

Contents

This is the companion volume to the exhibition *Hard Times*

Manchester City Art Gallery, 14 November 1987 – 10 January 1988
Rijksmuseum Vincent van Gogh, Amsterdam, 24 January – 13 March 1988
Yale Center for British Art, New Haven, Connecticut, 6 April – 29 May 1988

Preface

This is the first exhibition of Victorian social realist painting to be held in this country. To explain why it has taken so long to stage would involve an account of changes in taste and in the social role of art during the last century. The fact that we can stage it now is partly due to the Post-Modernist Movement in art, which has freed us from some of the narrower dogmas of Modernism and is exploring once again figurative subject-matter and earthy tonalities. There is also the New Art History, which places greater emphasis on art in its social context than on the individual's aesthetic experience. Realist art, particularly when it has a political dimension, is everywhere being re-assessed. We have tried here to present the Victorian version as objectively as possible, showing what happened rather than adopting a critical stance based on a contemporary interpretation of history. We are aware that this whole school of painting, including Van Gogh's development from it, has recently been interpreted as an attempt by one class to impose its chosen image on another. We have left it to others to confront this complex issue in the knowledge that our attempt at objectivity will in time reveal unrecognised assumptions and motivations that many are now discovering in the work of the artists represented in this show.

Whether exploitative or not, we do know that these pictures were very popular in their day. One reason for this, we believe, was that they dealt with emotions. We tend now to dismiss all sentiment as sentimentality, but the feelings conveyed by these paintings do not ring false; they are concentrated, not exaggerated. The major figures, Holl, Herkomer and Fildes, made their mark as illustrators for the *Graphic*, and developed an intensely expressive language, using only black and white. Their paintings are, however, no mere coloured illustrations, nor is their power weakened by the vastly increased scale and change of medium. They proved remarkably bold and inventive handlers of oil paint, and earned their place in that distinct tradition within British art that began so brilliantly with Hogarth and is sustained today by artists like Auerbach and Kossoff. The key to the Victorians' contribution to this tradition lies in their ability to convey through a flow of brush-strokes, a sequence of changing feelings. What is more, they managed to do this on a large scale without resorting to the tricks of rhetoric.

Herkomer's *Hard Times* was bought, along with Ford Madox Brown's *Work*, in 1885, just three years after the City of Manchester took over the Art Gallery. It is fitting, therefore, that we should stage the first re-appraisal of this important aspect of British Art. We could not have done so by ourselves. I would like to thank the Director, Duncan Robinson, and staff of the Yale Center for British Art, and the Director, Ronald de Leeuw, and staff of the Van Gogh Museum, who have pooled their resources and expertise with ours to enable the project to proceed and reach a much wider public. I should like to thank the Fine Art Society who have done so much to promote art in this field and have generously sponsored the exhibition. The British Council in Amsterdam have kindly assisted with the showing at the Van Gogh Museum. John Taylor of Lund Humphries, the publishers, has collaborated with us on the publication of this book, which accompanies the exhibition and will extend, we hope, its impact into the future. Crucially, I would like to thank my colleague Julian Treuherz, who has written such a lucid history of the subject and selected such a high-quality exhibition. Our thanks go, first and last, to Her Majesty The Queen, the Tate Gallery, the Royal Holloway and Bedford New College, the Leipzig Museum, the Forbes Magazine Collection, and the many private and public owners who have lent their pictures so generously to the exhibition and made this whole project possible.

Julian Spalding
Director, Manchester City Art Galleries

Acknowledgements

Many people have helped with this exhibition. I would like to thank all private lenders, and the directors and staff of lending museums for their generosity in granting me access to their collections and answering my queries. I have had unfailing support from all my colleagues in Manchester, particularly Denise Eckersley, who typed the catalogue, David McNeff who looked after the transport arrangements and Imogen Lock who co-ordinated publicity. I wish to thank my colleagues at the Yale Center for British Art, particularly Susan P. Casteras and Timothy Goodhue, and at the Van Gogh Museum, Louis van Tilborgh and Aly Noordermeer for their help over the exhibition tour. Special thanks are due to my fellow-contributors to the catalogue. I am also grateful to the following: Jack Baer, Charlotte Burri, Simon Edsor, Judy Egerton, Jane Farrington, Peter de Figueiredo, Celina Fox, Cherry Gray, Andrew Greg, Richard Green, Gregory Hedberg, Richard Jeffries, Caroline Krzesinka, Sir Oliver Millar, John Millard, Edward Morris, Mrs P. M. New, Charles Noble, Julia Porter, Carla Rachman, Ian O'Riordan, Stephen Sartin, Barry Sheridan, Peyton Skipwith, Richard Thompson, Marie Valsamidi, Alexandra Walker, Alan Waterworth, Stephen Wildman, Christopher Wood.

Photographic acknowledgements are due to lenders and also to the following (by cat. no.):
Bridgeman Art Library 67, 74; Stuart Briggs 26; Geoffrey Clements 17; A. C. Cooper 22, 54, 56, 86; Prudence Cuming Associates 18, 20, 87, 95; P. J. Gates 68; Mellon Centre, London 35; David Messum 97; Catherine Moubray 66, 84; Otto E. Nelson 11, 30; Photo Studios Ltd 83; Tom Scott 91; Joseph Szaszfai 32; Rodney Todd-White 69; Witt Library, Courtauld Institute of Art 13, 14, fig. 1; Barry Wood 94.

Julian Treuherz
Senior Keeper of Fine Art, Manchester City Art Galleries

Introduction

The poor and dispossessed have been included in paintings from the Renaissance onwards. Mostly incidental figures, put in to give animation and charm to landscape backgrounds, they occasionally appeared in the foreground as characters in some religious or moral fable. Anonymous peasants, cottagers, beggars and field-workers became important characters for artists with the emergence of genre painting and the idea of the picturesque. But in the nineteenth century, painters sought to bring into their art the new social and political concerns of the age of industrialisation and democracy. Poor people were taken as subject-matter for a new kind of art, in which social conscience was combined with a documentary interest in accurate recording. Realism was an art which sought not just to represent things naturalistically, but to depict the lowly and commonplace, correcting the historical bias in art towards the grand and spectacular; and social realism sought to do both in relation to modern social problems. Thus throughout Europe, certain artists began to paint humble genre subjects not simply as diverting tales of ordinary life but as crusading pictures, intended to draw attention to the plight of the poor, their housing conditions, the exploitation of their labour and their tragically wasted lives. This was more than simply the adoption of a new type of subject-matter; and less than a coherent school; it was a new attitude of mind and it was one common to a number of painters in different countries. But everywhere these painters were in a minority compared to the many producers of more conventional, less challenging pictures.[1]

Victorian social realism is usually taken to refer to the group of British artists who in the 1870s provided documentary illustrations of scenes from the lives of the poor, especially in London, for the weekly news magazine the *Graphic*, and then used their illustrations as the basis for oil paintings shown at the Royal Academy. The chief of these were Frank Holl, Luke Fildes and Hubert von Herkomer, but there were others. Their illustrated work was given some kind of coherence by the technical demands of magazine illustration; each artist's personal style was to some extent distorted by the group style of the commercial engravers who took the original drawings and cut from them woodblocks suitable for printing in densely hatched black and white. But the paintings by these artists were more personal in style and less consistent in attitude than their illustrations: their work never amounted to a real movement or school.

The artists associated with the *Graphic* shared a common, though sporadic, concern with scenes of lower-class life and its difficulties. But the 1870s had no monopoly of social realism. There was throughout Victoria's reign a sub-stream of paintings not just depicting the poor, but depicting them in the light of social problems.[2] Emigration, charity, homelessness, poverty, unemployment and alcoholism were seen in fine art and indeed in illustration before the 1870s and continued in the work of late Victorian artists.

Yet Victorian art is not noted for its frank or disturbing qualities. The distinguished writer Richard Muther summed up Victorian painting as 'an art based on luxury, optimism and aristocracy . . . the ascendant view that a picture ought in the first place to be an attractive article of furniture for the sitting room . . . everything must be kept within the bounds of what is charming, temperate and prosperous, without in any degree suggesting the struggle for existence'.[3]

The pictures in this book, then, were in a minority and, surrounded as they were at the annual exhibitions by fancy subjects, historical scenes and portraits, made little impression on most visitors, whose attitude to poverty may have echoed that of Mr Podsnap in Dickens's *Our Mutual Friend* (1865), 'I don't want to know about it; I don't choose to discuss it; I don't admit it!'[4] Only on a few occasions did certain classic social realist pictures seize

the public imagination; they were much discussed and remembered long afterwards. Examples are Redgrave's *The Sempstress*, 1844 (cat. 11); Wallis's *The Stonebreaker*, 1858 (cat. 23) and Fildes' *Applicants for Admission to a Casual Ward* (cat. 74) which had to have a protective rail round it and a policeman to marshall the crowds at the 1874 Academy. But even in the 1870s the pictures which made such an impact were few in number and usually overshadowed by more conventional work. Besides Fildes' *Casuals* (cat. 74), the 1874 Academy included Holl's *Deserted – A Foundling* (cat. 66); Crowe's *The Dinner Hour, Wigan* (cat. 85) and *A Spoil Bank*, also by Crowe – just four paintings out of a total of 1,433 exhibited. Such subjects were outnumbered. The 'pictures of the year' were easier on the eye and less troublesome to the conscience.

Artists might try to tackle social issues, but their achievement in terms of realism varied. Almost unconsciously, artists evaded harshness and brutality. The subjects they did not paint were as significant as those they did. Emigration was shown by departures or the reading of letters, without picturing the slum conditions which caused the exodus; disease was typically portrayed as a pale convalescent, often a pretty child; death was painted in terms of funerals and mourners, with rarely a corpse in sight; workers were shown resting or as individual heroic or tragic figures, rather than as serried ranks of dehumanised factory operatives; field-workers outnumbered industrial workers; prisons were shown but not violent crime or rioting. For all the convincing surface detail of pictures of crowded city streets, the destitution and dirt familiar from written descriptions were usually absent. Hovels were spacious and well provided with furnishings; starving waifs with expressions of sweet pathos on their well-scrubbed faces showed no physical evidence of the malnutrition or the deformed limbs which are known to have been common among the poor. Often pictures supposed to show the lower classes were only too obviously painted from professional models posed in the studio wearing artfully torn rags. George Eliot, writing in 1858, noted 'the softening influence of the fine arts which makes other people's hardships picturesque', and later still, in 1874, William Bell Scott wrote: 'Whatever we would consider undesirable as a personal adjunct or condition, that is what the picturesque painter for the most part covets for his canvas . . . beggary is the most picturesque condition of social life.'[5]

The artists whose work is described below for the most part tried to avoid picturesque distortions or evasions, but critical opinion did much to discourage serious, hard-hitting social realism. The prevailing attitude was that such subjects were ugly and inherently inartistic. Most consistent in this view was the *Art Journal*: 'We protest against his continually dismal selection of themes apart from the highest and holiest purpose of art' (1858, of *The Stonebreaker* by Henry Wallis, cat. 23); 'a subject almost too painful for a picture: defects in nature should not be brought within the sphere of art' (1869, of the lost painting *Sisters of Charity teaching Blind Girls to sing* by James Collinson); 'there is little in a theme of such grovelling misery to recommend it to a painter whose purpose is beauty'[6] (1874, of the *Casuals*, by Fildes, cat. 74). This was a view which could also be found in many other journals: 'We think it was a pity Mr Crowe wasted his time on such unattractive materials' (the *Athenaeum*, 1874, of Eyre Crowe's *The Dinner Hour, Wigan*, cat. 85); 'Such old age as this has as little of pathos or beauty as comports with the decline of life . . . it is simply squalid, sordid, dreary in sentiment . . . At least we owe these idyllists gratitude for bringing pleasant country scenes and incidents to mind, instead of the dreary drama of the police-court and the prison, and the dreariness of the workhouse' (*The Times*, 1878, of Herkomer's *Eventide*, cat. 80, contrasted with pictures by Morgan, Boughton and Fahey).[7]

All the same, many of these critics were moved by such paintings: they looked for pathos and sentiment. 'It is fraught with feeling, truly expressed' (*The Times*, 1877, of *Gone* by Frank Holl, cat. 69); 'The sentiment of his work, peacefully felt and touchingly expressed, is one to reach all hearts' (the *Athenaeum*, 1878, of Herkomer's *Eventide* again).[8] But though they wanted to be touched, they did not want to be pained: it was a fine dividing line. 'The expression of the girl's face and attitude, notwithstanding her miserable surroundings, has wisely been rendered sad, but without that utter woefulness to which an inferior artist would have trusted for the effect of his picture' (the *Athenaeum*, 1866, of Shields' *One of our Breadwatchers*, cat. 25); 'the painful pathos of the story is kept on the whole within the limits of good taste . . . Mr Holl may be sincerely congratulated on a very decided success' (*The Times*, 1869, of Holl's *The Lord gave and the Lord hath taken away*, cat. 64).[9]

In such circumstances it was unavoidable that painters would, whether consciously or unconsciously, edit out of their work anything which might be found offensive. Some instances of deliberate changes are recorded. Holman Hunt altered the face of the woman in *The Awakened Conscience* (Tate Gallery) because its first owner found it

too painful, and Abraham Solomon removed some 'objectionable features' from his now lost *Drowned! Drowned!*[10] Herkomer, in translating the engraving *Old Age* to the oil painting *Eventide* (cat. 54, 80) cheered up the workhouse with a vase of flowers and happier facial expressions; what was acceptable on the page of a magazine was less so hanging on a wall. But, paradoxically, it was the successful introduction of 'difficult' subjects in a journalistic context which prepared public taste to accept them in works of art.

Herkomer's caution was endorsed by a view commonly held by art critics. 'A most sad and painful picture and one that few would covet as a possession to be looked upon often' (*Art Journal*, 1855, of H. W. Phillips' *The Modern Hagar*, unlocated). 'A picture cannot be shut up and put away like a book' (*Art Journal*, 1874), of Fildes' *Casuals*, cat. 74); 'It is a great pity that painters do not bear in mind the fact that their pictures are meant to adorn English living-rooms (*The Times*, 1876, of Fildes' *The Widower*, cat. 76).[11]

Despite the views of critics and the caution of artists, social realist pictures did not lack buyers. It is, however, true that Fildes, Holl and Herkomer all abandoned social realism in favour of portraiture in the latter part of their careers. This may not have been because social realism did not sell, but simply that painting portraits was quicker and less demanding. The search for novel subjects, models and locations was troublesome and time-consuming. Portraits were also more profitable. 'I should probably make more money by portraits, which I have to entirely give up, after making a success, to go on with his commission', wrote Fildes grudgingly after receiving Henry Tate's prestigious commission for *The Doctor* (cat. 78).[12]

In view of the strictures of the critics about the need to paint pictures suitable for private houses, it is unfortunate that so little is known about Victorian collectors: it is not easy to say why they did or did not buy social realist paintings, and in many cases not even the names of the original purchasers are known. In the 1840s, C. W. Cope's confidence in public taste was badly shaken when his *Poor Law Guardians: Board Day – Application for Bread* (fig. 1) failed to sell. 'I felt that I had done my best with a highly dramatic subject . . . why go on repeating such pictures?'[13] So he stopped painting them and went in for a different kind of picture altogether. Watts did not exhibit his social realist pictures until years after he had painted them, and it may be significant that Redgrave gave his most 'difficult' subject, *The Outcast* (cat. 12) to the Academy as his diploma work.

Later in the century the evidence is a little clearer. The collectors can be divided into several types. Firstly, there were the circles of family and discerning friends who often supported advanced artists. Frank Holl came from a family of engravers and artists. His wife Annie was the daughter of Charles Davidson, an amateur watercolourist. The Davidsons lived at Red Hill and nearby in Reigate was the home of a close friend of theirs Fred Pawle, a stockbroker, JP, and promoter of cultural and philanthropic societies.[14] Pawle was one of Holl's first patrons: it was he who having bought *The Lord gave and the Lord hath taken away* (cat. 64) refused to cede it to Queen Victoria when she wished to buy it. Pawle also owned the artist's *Hush!* and *Hushed* (cat. 71–2).

Another more significant patron who came from Holl's family circle was Captain Henry Hill of Brighton. Frank Holl's sister married Henry Hill's brother Edward Hill, who incidentally himself owned several of Holl's pictures. But Captain Henry Hill corresponds also to the second type of patron, the artistic collector of advanced, and in Hill's case, avant-garde taste. Other such collectors who bought social realism or works related to social realism included Clarence Fry, the photographer and patron of Rossetti, purchaser of Herkomer's *The Last Muster* (see cat. 79); Arthur Lewis, the wealthy giver of bohemian musical parties frequented by many artists, who bought Jozef Israel's *Fishermen carrying a Drowned Man* (cat. 33); and Burne-Jones's patron William Graham, MP, who bought *The Vagrants* by Fred Walker (cat. 36). But Henry Hill's collection, besides containing sixteen Holls, and pictures by English painters such as Prinsep, Walker and Mason, included works by Corot, Daubigny, Millet, Rousseau, Fantin-Latour, Israels, Whistler, Manet and Degas, by whom he owned at least six pictures. This was a remarkable collection for its date and suggests that Hill saw links between English and French realism which no-one else could appreciate.[15]

Such a patron was exceptional: but social realist pictures also entered more typical Victorian collections, those of Northern industrialists who adopted the style of country gentlemen, bought large houses and formed picture collections. Thomas Taylor, a Wigan cotton-spinner, had a large picture gallery at Aston Rowant in Oxfordshire. He bought two of Luke Fildes' principal works, the *Casuals* (cat. 74) and *The Widower* (see cat. 76), but their subjects were at odds with the general tone of the collection which included historical and orientalist works, landscapes and animal subjects, that is, a typical Victorian mixture: it would, therefore, be simplistic to attribute his taste for social realism to his Wigan origins.[16] Another

collector of prestige pictures was Edward Hermon of the Preston cotton-manufacturers, Horrocks Miller and Co. Hermon was MP for Preston and purchased Holl's *Newgate* (cat. 73) for his house, Wyfold Court, Henley.[17]

Finally, there were the newly-founded public galleries which had the money and confidence to buy straight from the Academy. Because these galleries were in industrial cities, social realist pictures appealed to their purchasing committees, who were aware of the need for their collections to speak a language familiar to the new mass public. Herkomer was particularly successful with these patrons: Liverpool bought *Eventide* (cat. 80) and Manchester *Hard Times 1885* (cat. 82). Fildes' *The Doctor* (cat. 78) was commissioned by Sir Henry Tate for his National Gallery of British Art. All these were acquired direct from the artists; a number of others were bought by public galleries from their first owners: *The Last Muster* (see cat. 79) by the Lady Lever; the *Casuals* (cat. 74) and *Newgate* (cat. 73) by Royal Holloway College and *The Widower* (see cat. 76) by the Art Gallery of New South Wales. The list of social realist paintings acquired early by galleries and museums in Australia is remarkably long. Besides *The Widower*, this includes *The Mitherless Bairn* (see cat. 27) in the National Gallery of Victoria; *Evicted*, 1887, by Blandford Fletcher in the Queensland Art Gallery; *Their Ever Shifting Home*, 1887, by Stanhope Forbes at the Art Gallery of New South Wales; and *The Pinch of Poverty* by T. H. Kennington (see cat. 98) at the Art Gallery of South Australia.[18]

One of the reasons for the tremendous popularity of these pictures among the Victorians was their 'Sentiment', a word often used by contemporary writers. Today the word has a perjorative meaning, given in the Oxford Dictionary as 'mawkish tenderness or the display of it, nursing of the emotions'. The word sentimental has come to mean self-indulgent and excessively emotional. 'Of course, *The Doctor* is not a work of art', wrote Clive Bell. '. . . what it suggests is not pity and admiration but a sense of complacency in our own pitifulness and generosity. It is sentimental.'[19] But to the Victorians Fildes succeeded in calling up deep feelings of pity for the boy and admiration for the heroism of the Doctor; in another context the artist wrote that 'Sentiment' was what the public considered his chief forte.[20] The Oxford Dictionary gives another definition of sentiment which is how the Victorians understood it: 'a moving quality resulting from [the] artist's sympathetic insight into what is described or depicted'.

The social problems of Victorian England which form the raw material of these paintings are too well known and too complex to be gone into here. Yet a few general points must be made. In the first place, there is no simple causal relationship between the urgency or intensity of social problems and their expression in art. Chartism, for example, found no immediate expression in painting. A few works of art were painted as a direct result of topical events, for example, G. F. Watts' *The Irish Famine* (cat. 13), Herkomer's *Hard Times 1885* (cat. 82) and Dudley Hardy's *The Dock Strike*, (fig. 9). But as a rule, violent occurrences, political events or reformist campaigns did not cause works of art to be painted. The greater emphasis on social realism in the 1870s and 1880s has more to do with developments in illustrated journalism (the commissioning of artists to provide illustrations) than with any intensification of social problems at that time. In a surprisingly high number of cases, literary sources provided the stimulus for an artist to represent a social subject: the frequent paintings of starving sempstresses came not from newspaper reports or direct observation, but from Hood's *Song of the Shirt*, and it was Mayhew's writings about the street folk which opened artists' eyes to material which they could have seen for themselves had they so wished.

Secondly, many of the paintings have to be seen in the context of Victorian philanthropy. The picture-buying classes, though they were protected from physical closeness to the poor, were on the other hand close to philanthropic activity. It was part of their daily lives: charitable subscriptions, benevolent societies and committees were both a Christian duty and a social imperative.[21] Thus, seeing social problems represented in art evoked in the wealthy classes similar reactions to those associated with charitable giving: a mixture of horror, guilt and sometimes ostentatious self-satisfaction at being able to help and being seen to help. In some cases, the link between philanthropy and individual pictures was particularly close. The rich philanthropist, Angela Burdett-Coutts, owned pictures of poor children by Thomas Faed and F. W. Lawson.[22] The painting by Macduff (cat. 20) was a direct tribute to Lord Shaftesbury. Pictures of the mourning wives of shipwrecked fishermen were associated with the promotion of life-boat charities.[23] *Graphic* engravings were frequently accompanied by appeals for funds on behalf of individual causes.

On the other hand, many people argued against the giving of charity as causing graver problems than those it solved in the short term: charity made the poor dependent, instead of encouraging them to fend for themselves. It was widely felt that poverty was caused not by defects inhe-

rent in society, but by individual inadequacy. The state did not take upon itself the role of ameliorating these defects and the main responsibility for charitable work was left to many overlapping voluntary bodies. The workhouse of the Poor Law was meant as the last resort of the destitute, hence the harshness of this and other official measures. From the 1880s, however, there was new awareness of the extent of distress, and there were calls for more official intervention leading eventually to the idea of the welfare state. But there was always a conflict between those who believed in individual charity as a remedy, rather than a short-term palliative, and those in favour of wholesale social reform as the only solution.[24]

Some modern writers complain that social realist pictures did not promote social reform. They merely aroused sympathy or pity for social problems; they tended to 'assuage concern while they incite[d] it' by creating an emotional reaction which 'would tend partially to satisfy the urge to reform these very problems'. They 're-inforced this sense of the ruling class as compassionate and charitable' thus making people feel they could solve problems merely by charity.[25] But how a work of art can specifically promote wholesale social reform is nowhere stated. These pictures were not intended to be acts of reform; they operated most effectively on the level of increasing public awareness of problems which had been hidden far too long. They were 'important' pictures, big pictures, intended to make an impression. Of the *Casuals*, one critic wrote, 'not a few of us will see the miseries of their fellow beings for the first time in these personations . . . Few men will turn away without long study of this mournful presentation of the *debris* of London Life; and many will not fail to say "What can I do to better this state of things?"'[26]

The paintings of the 1870s and 1880s were part of the new awareness of the extent and depths of distress. It entered art, it entered fiction and it entered the public consciousness through such polemical works as Charles Booth's *In Darkest England*. By the end of the century, art critics had ceased to be shocked at pictures of poverty, and concentrated on their alleged artistic defects or virtues rather than on breaches of taste or propriety. Poverty, dirt and distress were now part of the accepted language of art.

1 | The hungry forties

In the 1840s, the social problems caused by the industrial revolution and the growth of the towns came to the fore in the national consciousness. The decade opened with Chartist agitation; the poor winter of 1841–2 caused severe unemployment and hardship; the Irish famine began in 1846 and the cholera epidemic in 1848. Industry created wealth for the middle classes, but little of it passed lower down the social scale. Poverty, low wages, hard labour, unstable employment or unemployment, bad housing conditions and disease were the lot of the lower classes. Historians now believe that the 'hungry forties' were not particularly hungry in relation to other decades, nevertheless, they were a time when the full extent of social deprivation and inequality was realised and discussed by pamphleteers, journalists, politicians and novelists. The problems were summed up in the contemporary catchphrase, the 'condition of England'.[1]

In the fine arts, however, the 'condition of England' question hardly made an appearance. Painters rarely took up social themes, and when they did so, they often employed a tact amounting to distortion. Poverty was softened and distanced from the contemporary scene by the use of artistic conventions or literary sources, and a genteel sense of decorum ruled out anything too disturbing. Satirical draughtsmen could be more hard-hitting; working for books and magazines they were free of the necessity to produce pictures suitable to adorn drawing-room walls. Though in the fine arts the painting of scenes from everyday life flourished, their subjects tended to be limited and idealised.

Substance and Shadow

In 1843, *Punch* published a drawing by John Leech showing a group of wretched paupers shambling round an art exhibition, staring uncomprehendingly at the smug-looking portraits, pet animals and heaps of fruit or dead game pictured within the gilt frames (cat. 1). No better illustration can be found of the lack of social realism in early Victorian painting; there is a chilling contrast between the appearance of the visitors to the exhibition and the devastatingly trivial images painted by the artists. Here is a visual equivalent of the two nations of rich and poor described by Disraeli in his novel *Sybil* (1845).

Leech's drawing was a direct attack on the Government, for the caption which went with it said of its Ministers, 'as they cannot afford to give hungry nakedness the *substance* which it covets, at least it shall have the *shadow*. The poor ask for bread, and the philanthropy of the state accords an exhibition'. The occasion of the attack was the exhibition of entries in the competition to find mural painters to decorate the recently re-built Houses of Parliament. The Government had invited artists to send in scenes from British history or poetry to decorate the new building, seeking to encourage a more serious kind of art than was seen at the Royal Academy.[2] Serious this art may have been, but the High Art of lofty allegory and heroic legend bore as little relation to the urgent issues of the day as did the gentilities of the Royal Academy exhibitions. Incidentally, Leech's drawing marks the first use of the word 'cartoon' to mean a humorous drawing with political or social content. The exhibition organisers asked artists to submit cartoons, the technical term for preparatory drawings for large-scale paintings. In fun, Leech captioned his *Punch* drawing 'Cartoon no. 1'. The name stuck, thus originating the modern sense of the word.[3]

Punch cartoons at this time were not the drawing-room pleasantries or anodyne executive jokes of later periods. *Punch*, founded in 1841, often took up social causes in its early days. The jester's licence to say what no-one else dared can be seen in the directly observed cartoons of street life by Leech, Cuthbert Bede and Richard Doyle. Their work sometimes inspired Royal Academy artists to try more adventurous subjects. Leech was a friend of Frith

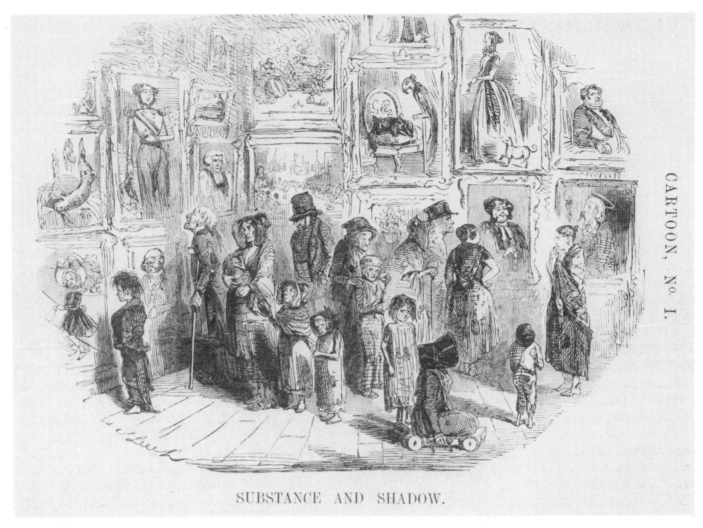

SUBSTANCE AND SHADOW.

1. John Leech, *Substance and Shadow* (*Punch* 1843), Manchester City Art Galleries

and Millais, both of whom took up his vignettes of pick-pockets, prostitutes and raffish Derby Day crowds in their own modern-life subjects of the 1850s.[4] A similar broadening of subject-matter in the fine arts was seen in the 1870s and 1880s, after the *Graphic* and other maga- zines had published vivid documentary illustrations of working-class life.

Charity and the Poor Law

In the 1840s, despite the publicity given to urban social problems, artists who painted poverty nearly always placed it in the comfortably traditional setting of a country cottage. The influence of Wilkie's cottage scenes was extremely strong on early Victorian genre painting.[5]

Charity, possibly painted by Frank Stone (cat. 2), is also dependent on even earlier models. In Renaissance art, charity was traditionally depicted as a female succouring two children; here there is also an echo of the iconography of the Adoration of the Magi, in the three figures, one kneeling, all bearing gifts; and another source may be religious paintings of the Acts of Mercy, showing the giving of alms to the poor. Similar cottage interiors and scenes of rustic charity were depicted by Gainsborough, Morland and Wheatley in the late eighteenth century.[6]

Charity shows two rich ladies with a servant bearing a basket of food. They are entering a cottage where a harassed mother raises her eyes in humble gratitude whilst her children look with anticipation at the loaf of bread emerging from the basket. Such domestic acts of

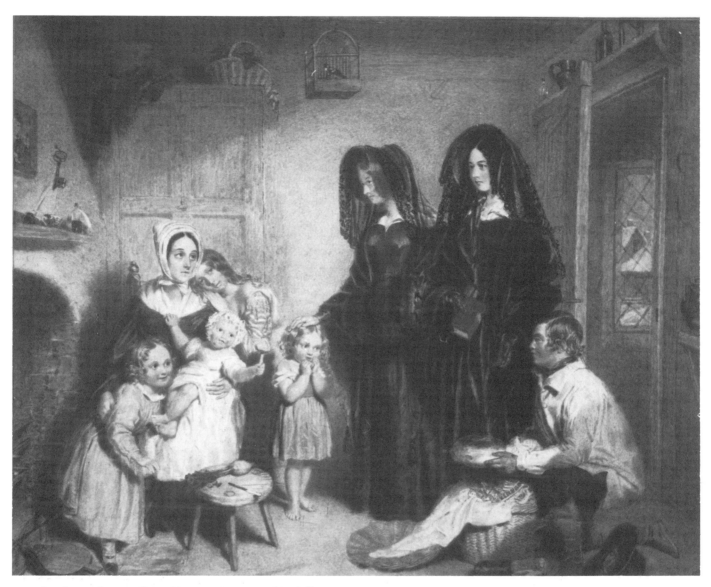

2. Attributed to Frank Stone, *Charity*, Warrington Museum and Art Gallery

charity were often enough recorded in the countryside, where gentry and farmers helped their needier tenants through difficult times with gifts of food or fuel. This watercolour, however, probably relates to the District Visiting movement which expanded in the 1820s and 1830s. Representatives of voluntary bodies visited the poor in their own homes to assess their needs and to bring practical help. This was in part a response to the inadequacy of the New Poor Law of 1834 which abolished 'outdoor relief', that is the relief of poverty outside the workhouse. No more did the state distribute charity to the able-bodied poor in their own homes. To receive it, they were compelled to enter the workhouse, with its strict regime, its separation of families and the loss of independence and dignity. Many refused and their only hope was unofficial, voluntary charity.[7]

The image of poverty presented in this watercolour is hard to square with the accounts of the poor in novels of the 1840s. These recipients of charity are happy, well-dressed and know their place. The cleanliness and neatness of the cottage owes more to the pictorial tradition descending from Dutch interiors via Wheatley and Wilkie than to observation of the living conditions of the 1840s. The focus of interest is on the ladies, fashionable 'keepsake' beauties whose opulently voluminous costume contrasts with their frugal surroundings.

Plate I
William Macduff, *Shaftesbury, or Lost and Found*, 1863,
Private Collection (cat. 20)

Plate II
Thomas Faed, *Worn Out*, 1868, Forbes Magazine Collection, New York (cat. 30)

Plate III
Frank Holl, *The Song of the Shirt*, 1875, Royal Albert Memorial Museum,
Exeter (cat. 67)

Plate IV
Frank Holl, *Doubtful Hope*, 1875, Forbes Magazine Collection, New York
(cat. 68)

Plate V
Luke Fildes, *Applicants for Admission to a Casual Ward*, 1874, Royal Holloway
and Bedford New College (cat. 74)

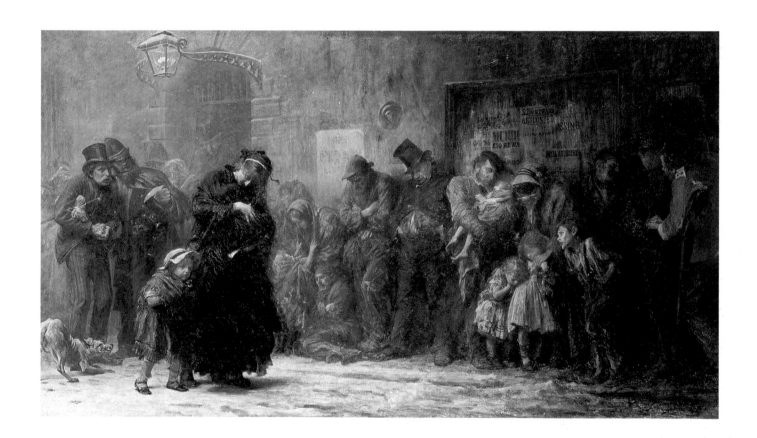

Plate VI
Hubert von Herkomer, *Pressing to the West: A Scene in Castle Garden, New York*, 1884, Leipzig Museum (cat. 81)

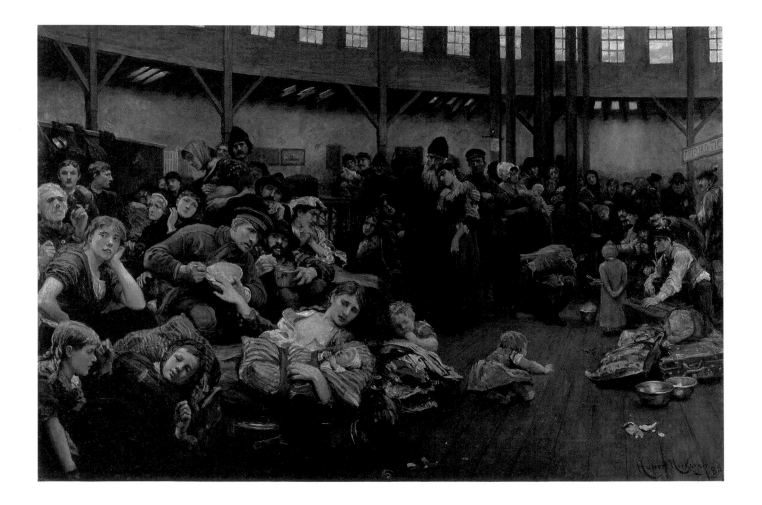

Plate VII
Eyre Crowe, *The Dinner Hour, Wigan*, 1874, Manchester City Art Galleries
(cat. 85)

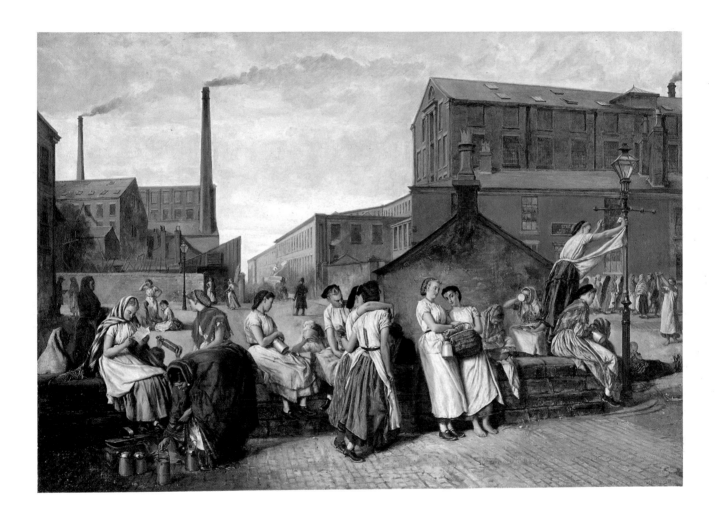

Plate VIII
John Henry Henshall, *Behind the Bar*, 1882, Private Collection (cat. 95)

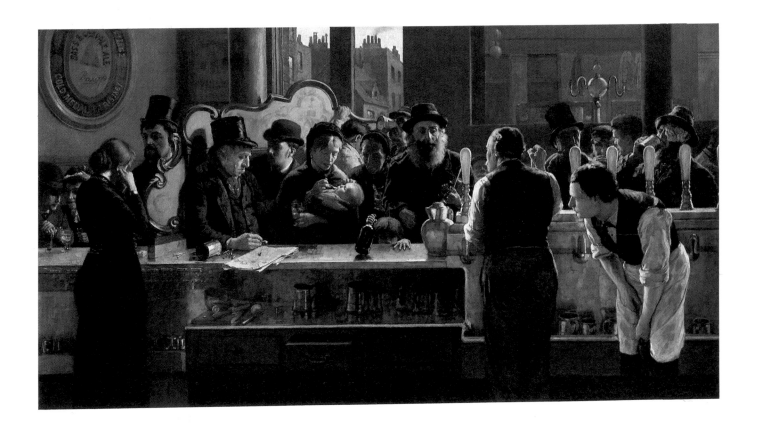

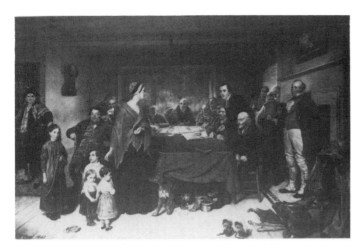

fig. 1. C. W. Cope, *Poor Law Guardians: Board Day – Application for Bread*, 1841 (unlocated)

That poverty existed could not be denied, but opinions varied as to how it should best be relieved. The subject of this watercolour seems to be the givers of alms rather than the receivers. It recalls Dickens's mocking of the ladies' visiting societies in *Sketches by Boz* (1835–6) and the fierce contemporary criticism of indiscriminate alms-giving.[8] In the more humanitarian climate of the twentieth century, opposition to charitable giving seems cruel, but it is true that it encouraged reliance on charity, it did nothing to solve the larger social problems which caused poverty, and it soothed the consciences of the rich. The water-colour of *Charity* may have been what *Blackwood's Magazine* had in mind when condemning popular subjects for pictures. 'Go where you will, you will see specimens of the style – mawkish sentimentality, Goody Families, Benevolent Visitors, Teaching children. There is nothing more detestable than these milk-and-water affectations of human kindness; all the personages are fools, and as far as their little senses will let them, hypocrites.'[9]

The number of paintings on the theme of charity in the early 1840s suggests social concern about it, but it was rarely expressed with directness. At the Royal Academy of 1840, the subject was seen as a classical allegory (*Almsgiving* by C. W. Cope, Victoria and Albert Museum) and in medieval dress (*The Monastery in the 14th century* by J. R. Herbert, Forbes Magazine Collection). In 1841, there were two modern-dress versions, Mulready's disturbing *Train up a child* (Private Collection), emblematic rather than realistic, and an ambitious character drama in the Wilkie manner, again by C. W. Cope, *Poor Law Guardians: Board Day – Application for Bread*.[10] This is now lost but it is known from photographs (fig. 1): it shows a largely unsym-

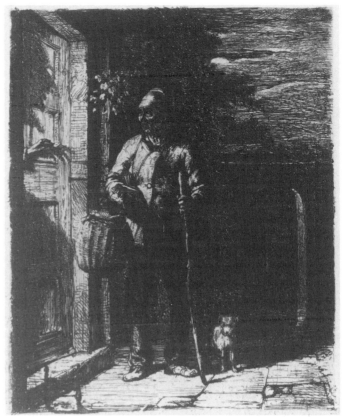

3. C. W. Cope, *The Wanderer* (*Etch'd Thoughts* 1844), Victoria & Albert Museum

pathetic board of guardians considering the case of a woman who demands to keep her child and receive charity, rather than enter the workhouse and be separated. Cope failed to sell the painting and gave up the idea for further work in this vein. After this, his social concern was seen only in minor works. Two of his etchings appeared in 1844 in *Etch'd Thoughts* by the Etching Club, a miscellany of poems and illustrations on all kinds of subjects by various artists (cat. 3). *The Wanderer* is a moving portrayal of a pedlar being turned away from the door of a house, the pathos emphasised by the effect of the candlelight emanating from the doorway. Accompanying the illustration is a poem by Mrs W. Hey:

Slow opes th'unwilling door; his glistening eyes
With eager wistfulness towards it turn'd;
Alas! a stern rejecting hand denies
The boon his age and suffering should have earned.
Truly he sighed – one look to heaven he cast
And from the rich man's door the houseless wander past.

Cope's second etching in this book also shows a beggar

outside a doorway, but this one is an impostor. *Rejected Addresses* illustrates not a fanciful poem but a Police Commissioner's Report about shady lawyers who sell begging letters to professional scroungers. The inclusion of both genuine and fake beggars in this book shows that for Cope, as for the critics of indiscriminate giving, charity was not a simple issue.

Emigration

The desperate poverty of the 1840s was one of the most important factors behind the great emigration movement which was at its height in this and the following decade. Thousands of people left Great Britain and Ireland to seek a better life in the USA, Canada, Australia and New Zealand. Emigration, the subject of intense public debate, was taken as a subject by artists throughout Victoria's

reign.[11] Most chose to depict it through leavetakings or scenes involving letters from abroad, images which could convey drama and pathos, but which glossed over the hardship and economic depression which lay behind the exodus.

The earliest Victorian emigration painting was P. F. Poole's *The Emigrant's Departure*, exhibited in 1838 (cat. 4), a scene of tearful farewells in a cottage setting. It was exhibited with two lines from Goldsmith's *The Deserted Village*:

Good Heaven! What sorrows gloom'd that parting day,
That called them from their native walks away;

The painting had a topical appeal, for it was sold to a buyer in Liverpool, where it had been exhibited after appearing at the Royal Academy.[12] Liverpool was the port from which a great many emigrants set sail for America.

4. P. F. Poole, *The Emigrant's Departure*, 1838, Forbes Magazine Collection, New York

Yet the generalised pathos of the picture suggests that the artist was more influenced by the poem, first published in 1770, than by any contemporary experience of the emigration question. The sad faces and nostalgic country setting recall the rest of the stanza:

When the poor exiles, every pleasure past,
Hung round the bowers, and fondly looked their last,
And took a long farewell, and wished in vain,
For seats like these beyond the western main;
and shuddering still to face the distant deep,
Returned and wept, and still returned to weep.

Answering the Emigrant's Letter by James Collinson, shown at the 1850 Royal Academy (cat. 5) carries more specific clues that emigration is the subject, and the cottage is furnished with more contemporary objects. A family is seated round a table. The children compose a letter whilst father and mother, who has a dishevelled child on her knee, exchange pregnant glances. Collinson was a member of the Pre-Raphaelite Brotherhood, founded only two years previously, and this is the first example of a Pre-Raphaelite modern-life subject. William Michael Rossetti, visiting Collinson in 1848, noted that he was finishing the details 'to a pitch of the extremest minuteness'.[13] But all was wasted as the painting was hung high at the Academy causing the *Art Journal* to complain that 'the question of correspondence is sufficiently evident, but it is impossible to determine that the family council is held on the subject of a letter to an emigrant'.[14] The picture does not reveal its subject until the words 'South Australia' are read on the map.

Twelve years separate these two emigration pictures, and this accounts for the difference in style. But over both hangs the shade of Wilkie's cottage interiors; and neither show the severe hardship which drove people to emigrate.

5. James Collinson, *Answering the Emigrant's Letter*, 1850,
Manchester City Art Galleries

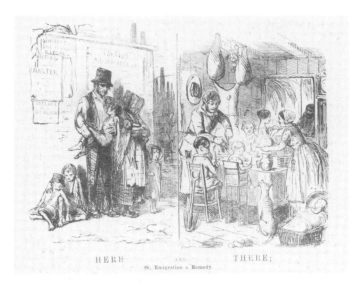

fig. 2. John Leech, *Here* and *There* (*Punch* 1848)

John Leech's *Punch* cartoon, *Here* and *There* (fig. 2) expresses simply the politicians' idea of emigration as a panacea: destitution and smoking chimneys at home are exchanged for prosperity and palm trees abroad.[15]

Temperance

Before the days of illustrated satirical magazines like *Punch*, Hogarth used the independent print to satirise or to preach on modern social questions to a mass audience, and he was followed by Gillray and others. George Cruikshank's two series of eight prints, *The Bottle* (1847), and *The Drunkard's Children* (1848) are in this tradition and like Hogarth's *Gin Lane* and *Beer Street*, Cruikshank's aim was to demonstrate the evils of drink. In *The Bottle*, a happy family is transformed by alcoholism. Starting with a casual, social drink, the husband and then his wife become drunkards, he loses his job and his possessions, neglects his family and eventually kills his wife. In *The Drunkard's Children* the son and daughter emulate their parents, the boy takes to crime and is transported, the girl turns to vice and eventually to suicide.

The prints employ a strip-cartoon technique showing the same characters in different situations, and in the first series, the same room is seen gradually transformed from a comfortably furnished home to a bleak and empty cell. Cruikshank's observation of this wretched hovel appears more authentic than in some fine-art versions of poor dwellings. In *Cold, Misery and Want destroy their youngest child. They console themselves with the Bottle* (cat. 6) the bare room has only a few sticks of furniture and a feebly smoking fire. The mother weeps, glass in hand, the father gazes at the bottle while the daughter, also weeping, peeps into the dead child's coffin. In *The Husband, in a state of furious drunkenness, kills his wife with the instrument of all their misery* (cat. 7) the room swarms with neighbours and policemen. The weeping girl points at the bottle while the father is arrested. The second series opens with a picture of a gin shop, *Neglected by their Parents, Educated only in the streets and falling into the hands of wretches who live upon the vices of others, they are led to the gin shop, to drink at that fountain which nourishes every species of crime* (cat. 8). Though the faces are drawn as caricatures, it was not an exaggeration to show babies and children drinking (see cat. 49, 95). A view of a low lodging house is seen in the plate showing the arrest of the son, *Urged on by his ruffian companions, and excited by drink, he commits a desperate robbery. He is taken by the police at a threepenny lodging house* (cat. 9). The dramatic motif of the policeman shining a torch at his victim was taken up by Gustave Doré (cat. 57). These plates have a documentary quality despite the satirical edge, but Goyaesque nightmare takes over in the final plate, *The maniac father and the convict brother are gone. The poor girl, homeless, friendless, deserted and gin-mad, commits self-murder* (cat. 10). Shocked onlookers watch as, in front of a moonlit sky, she throws herself from the massive arch of a bridge over the Thames; the girl's falling body, hands clapped over her eyes, and skirts streaming behind, is a horrifically compelling invention.

In the 1840s the temperance movement was still strong and over 100,000 copies of *The Bottle* are said to have been sold in a few days. The story was adapted as a play, a novel, waxworks and lantern slides, and Cruikshank made several watercolour versions (cat. 6 and 7). The faults of drawing in the prints are explained by the demands of the mass medium: like Hogarth, Cruikshank aimed at the widest possible circulation. 'My object was to bring these works of art out at a price that should be within the reach of the working classes, and [I] therefore sold these eight plates for a shilling and had them produced from my etchings by the only available cheap process at that period. It was a rough process and this accounts for the roughness of the style. When an artist is working for the millions cheapness is the first consideration – but although he may succeed in his object, in conveying a lesson, such productions cannot of course be considered as works of art.'[16]

6. George Cruikshank. *Cold, misery and want destroy their youngest child* (*The Bottle* 1847), Victoria & Albert Museum

7. George Cruikshank, *The husband, in a state of furious drunkenness, kills his wife with the instrument of all their misery* (*The Bottle* 1847), Victoria & Albert Museum

8. George Cruikshank, *Neglected by their parents ... they are led to the gin shop* (*The Drunkard's Children* 1848), Victoria & Albert Museum

9. (opposite) George Cruikshank, *He is taken by the police at a threepenny lodging house* (*The Drunkard's Children* 1848), Victoria & Albert Museum

Cruikshank produced *The Bottle* and its sequel because of his own experience. He himself had developed an alcohol problem in the 1840s from excessive indulgence; shortly after the appearance of *The Bottle* he took the pledge, and continued to campaign against drunkenness both through oratory and art. But though Cruikshank showed drunkenness leading to poverty, the real social problem was the other way round, and the only solution was the reform of the social conditions which encouraged the poor to resort to drink.

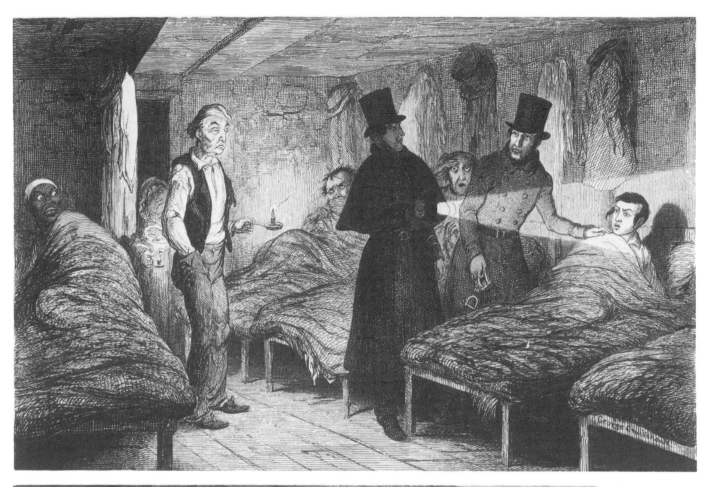

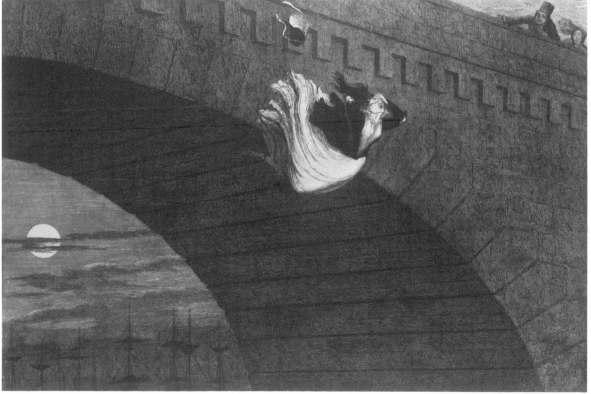

10. George Cruikshank, *The poor girl, homeless, friendless, deserted, and gin mad, commits self-murder* (*The Drunkard's Children* 1848), Victoria & Albert Museum

2 | Richard Redgrave and G. F. Watts: the first Victorian social realists

Only two artists of the 1840s depicted social problems with any degree of frankness. Both were men of humanitarian sympathies: Richard Redgrave wrote of his work of the 1840s that 'many of my best efforts in art have aimed at calling attention to the trials and struggles of the poor and oppressed'[1] and G. F. Watts' social subjects were, according to his wife, an attempt to externalise his own depression 'by going beyond self into the sufferings of others'.[2] Questions of labour, poverty and social deprivation were matters of inescapable public debate in the 1840s, but these two artists drew their inspiration only indirectly from the contemporary scene. The immediate sources for their subjects seem to have been literary, and their images owed more to traditional iconographic types than to observation of contemporary life. The pathetic female figures painted by Redgrave and Watts could be given greater pictorial appeal than say out-of-work cotton-mill operatives, or babies dying from cholera: their subjects were highly selective.

The social subjects of Redgrave and Watts were remarkable for their time, but neither artist painted many of them. Redgrave was later much occupied by teaching and took mostly to landscape (which he combined with a social subject in *The Emigrant's Last Sight of Home*, 1859, Tate Gallery). For Watts, modern-life subjects were something of an aberration; after 1850, he kept to timeless allegory, even when his work had a modern social message. Examples are his tribute to the prison reformer Thomas Wright in *The Good Samaritan* (1850, Manchester City Art Gallery) and his treatment of child prostitution in *The Minotaur* (1885, Tate Gallery).[3]

Richard Redgrave

Redgrave's *The Sempstress* of which cat. 11 is a replica of 1846, was shown at the Academy in 1844. It drew attention to the exploitation of sweated labour in the clothing trade, a notorious social abuse, which was the subject of Government Reports, Select Committees, and campaigning journalism throughout Victoria's reign. Six months before Redgrave's picture was exhibited, Thomas Hood's poem *Song of the Shirt* appeared in the Christmas 1843 issue of *Punch*:

With fingers weary and worn,
With eyelids heavy and red,
A woman sat in unwomanly rags,
Plying her needle and thread—
Stitch! Stitch! Stitch!
In poverty, hunger and dirt,
And still with a voice of dolorous pitch
She sang the 'Song of the Shirt'.

The poem caught the imagination of the public, and achieved instant success, trebling the circulation of the young magazine and becoming one of the best-known poems of the age. Its immediate result, however, was to bring home to public attention, as no newspaper reports could do, sordid facts about the disgraceful working conditions, the long hours, poor pay, unhealthy lives and frequent deaths of clothing workers.[4]

Oh men with sisters dear,
Oh men with mothers and wives,
It is not linen you're wearing out,
But human creatures' lives.

Redgrave's oil was inspired by Hood for he put this quotation from the *Song of the Shirt* in the catalogue. There is no evidence that Redgrave visited garrets or workshops; indeed most needlewomen were employed in overcrowded workrooms rather than alone, but Redgrave preferred the more poignant image of a single woman, her eyes raised to heaven, recalling the saints and martyrs of Baroque art and the melancholic females of Greuze.[5] Redgrave's painting is a piece of genre in the Wilkie tradition of cottage interiors, its story told through facial

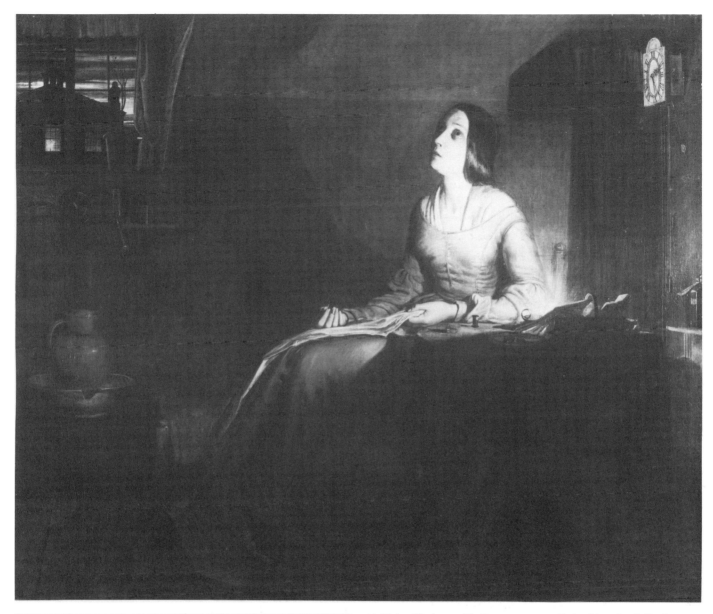

11. Richard Redgrave, *The Sempstress*, 1846, Forbes Magazine Collection, New York

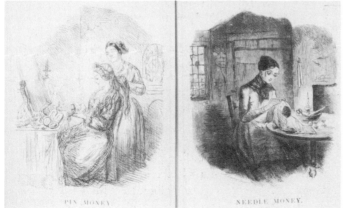

fig. 3. John Leech, *Pin Money* and *Needle Money* (*Punch* 1849)

expression, and telling detail, such as the dawn breaking, the clock showing 2.30, the bottle of medicine marked 'Middlesex Hospital', the cracked basin and the unhealthy plant by the window. Thackeray called it 'namby pamby' and the *Athenaeum* felt the 'real picture from the lyric would be too saddening if painted, and our artist has only reached a sort of theatrical and elegant sorrow'.[6] Contemporary cartoons on the theme were more harrowing, such as Leech's *Pin Money* and *Needle Money* (fig. 3). Nevertheless, many people must have shared P. F. Poole's

reaction to *The Sempstress*. Poole, then unknown to Redgrave, wrote to him, 'I think it is the most powerful for truth and touching from its pathos of any picture I have ever seen. Who can help exclaiming "Poor Soul! God help her"?'.[7] Together, Hood and Redgrave created a visual type which was to be frequently painted by others; they made the sempstress into the most commonly depicted social realist subject in Victorian painting (see cat. 18, 67).

Redgrave's social subjects all show defenceless females mistreated by society, such as *The Reduced Gentleman's Daughter*, (1840, unlocated) the country girl *Going to Service* (1843, Private Collection) and *The Poor Teacher* (1845, Shipley Art Gallery, Gateshead). The culmination is *The Outcast* of 1851 (cat. 12) showing a young woman clutching her illegitimate baby, cast out into the snowy night by her angry father. Another daughter begs for mercy, a son weeps and the mother looks on helplessly: a letter on the floor hints at the cruel revelations and on the wall is a print of Abraham banishing Hagar and her illegitimate son Ishmael, a biblical parallel to this scene of stern Victorian morality. But is it as Victorian as some would believe?[8]

Redgrave was led to this subject by George Crabbe's *The Borough*, a narrative poem written in 1810 but set in the eighteenth century. One of its episodes is about Ellen Orford, a village girl who had a baby by a man above her station and was cast out from home. Ellen Orford was depicted by Redgrave in a painting (RA 1838) and an etching in the book *Etch'd Thoughts* (see cat. 3). Here she was seen in eighteenth-century dress in a cottage with her baby, looking through a window at her former seducer and his new bride. *The Outcast* is a modern-dress version of an earlier stage in the story. A certain eighteenth-century flavour persists: Redgrave's tableau-like composition and frozen gestures recall Greuze's *La Malédiction Paternelle* (The Father's Curse) a similar scene in this case of a son being cast out of home; this also has English derivatives by Wheatley and Morland.[9]

G. F. Watts

The social subjects of Watts stand out of their time in style as well as content. Redgrave belongs to the genre tradition, telling his sad stories through prettily painted detail;

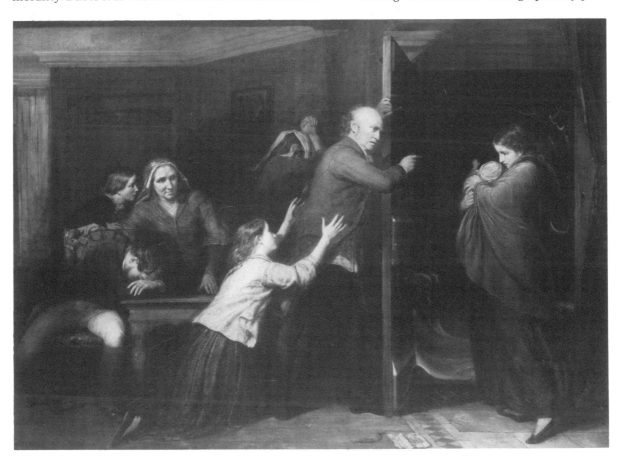

12. Richard Redgrave, *The Outcast*, 1851, Royal Academy of Arts

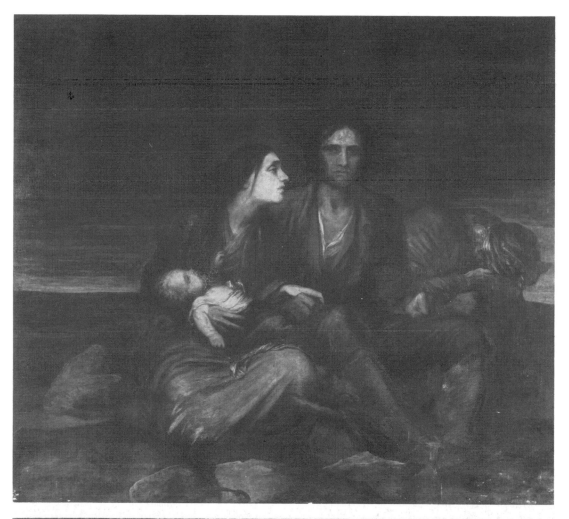

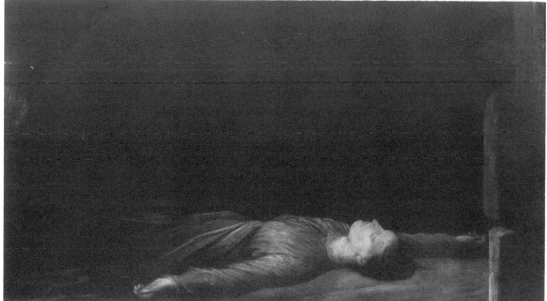

13. G. F. Watts, *The Irish Famine*, *c.*1849/50, Watts Gallery, Compton

14. G. F. Watts, *Found Drowned*, *c.*1849/50, Watts Gallery, Compton

Watts creates a sense of deep tragedy without detailed narrative by using broad handling and drab colour, anticipating the 1870s. Never regarded as among the artist's most successful works, these pictures, all of around 1850, remained unsold and are now in the Watts Gallery. They all show outcasts and include another haggard needlewoman in a garret (*The Sempstress*), *The Irish Famine* (cat. 13) showing a starving evicted family, *Found Drowned* (cat. 14) a female suicide washed up under Waterloo Bridge and *Under a Dry Arch*, a homeless woman sheltering under a bridge of the Thames.[10]

The Irish famine was the hungriest episode of the 'hungry forties'. The potato crop failed in 1846 and the famine lasted until 1849. Thousands died of disease or starvation, many were evicted and countless emigrated. Watts could not help but be aware of this, but his painting owes its direct inspiration to his friendship with the Irish poet Aubrey de Vere who frequented Watts' studio 1848–9. De Vere had devoted himself to relief work on his Irish family estates and wrote in his diary for September 1846: 'In the course of one month we saw nearly the whole food of the great mass of the country melt like snow before our eyes . . . In one day I have sat within nearly eighty mud hovels, without windows or chimneys – the roof is so low that you could not (in some cases) stand upright, and within and around a mass of squalidness and filth.'[11] His poem *The Year of Sorrow – Ireland – 1849* is close in mood to Watts' picture:

But thou O land of many woes!
What cheer is thine? Again the breath
Of proved Destruction o'er thee blows,
And sentenced fields grow black in death.
In horror of a new despair
His blood-shot eyes the peasant strains,
With hands clenched fast, and lifted hair,
Along the daily darkening plains.

Watts had not yet visited Ireland in 1849 when the picture was painted; he had only recently returned from Italy and High Art was very much on his mind. *The Irish Famine* was painted over an abandoned Greek subject, from Xenophon, and the grouping of the figures and their monumental style recall a *Holy Family* or *Rest on the Flight into Egypt*.[12] In 1850, de Vere invited the artist to stay in Ireland with him: 'You would find much to interest you deeply in Ireland . . . including not a little of which you must have had a second-sight vision before you painted your 'Irish Eviction.'[13] This makes it clear that Watts was depicting not just a starving but an evicted family, the theme of the outcast linking it with his other

social realist works. Herkomer saw *The Irish Famine* when it was exhibited in 1881 and it may have inspired his own outcast picture *Hard Times 1885* (cat. 82).

Found Drowned is said to have been based on an incident seen by Watts in London. But it is at least as likely to have been inspired by Thomas Hood's *The Bridge of Sighs* which pleads compassion for a girl who has drowned herself:

One more Unfortunate,
Weary of breath,
Rashly importunate,
Gone to her death!

Take her up tenderly,
Lift her with care;
Fashion'd so slenderly,
Young, and so fair!

Watts painted 'her fair auburn tresses' and alluded to her past life by having her hold a necklace with a medallion and a heart-shaped coral, perhaps suggested by Hood's lines:

Who was her father?
Who was her mother?
Had she a sister?
Had she a brother?
Or was there a dearer one
Still, and a nearer one
Yet, than all other?

Hood's poem was written in 1844 after reading about the attempted suicide of a shirt-maker called Mary Furley. Unable to feed herself and her children, she threw herself and her youngest child into the Regent Canal. The child died, but she survived and was convicted of murder, though her death sentence was commuted after a public outcry. Hood changed some of the details, leaving out the children, having the woman die and substituting Waterloo Bridge, a notorious place for suicides.[14]

Watts may also have known Cruikshank's engraving of the suicide of *The Drunkard's Daughter* (cat. 10) in which the arch of Waterloo Bridge is so prominent. The arch seen from below, in front of the lonely London skyline, is also the dominant motif in Watts' *Under a Dry Arch*, and was later taken up by artists as diverse as Augustus Egg and Gustave Doré.

In all the paintings of poor, outcast females, the suggestion of prostitution, though not explicit, is never far away: it was well known that poverty was the chief factor which drove women into prostitution, one of the most notorious problems of Victorian London.[15]

3 | The street folk: the urban poor in the 1850s and 1860s

The Victorian city, with its crowds of people of all classes indiscriminately thrown together, became an acceptable subject for painters towards the end of the 1850s. In the panoramic canvases of W. P. Frith, G. E. Hicks and Arthur Boyd Houghton the poor made their appearance, but the central concern of these artists was to paint the crowd and its contrasts of dress and social type, of rich and poor, rather than to draw attention to social problems. In 1849, Henry Mayhew had begun to publish *London Labour and the London Poor*, a survey based on interviews with his subjects, re-issued several times in the 1860s. It revealed, in great detail, a whole world of street characters: beggars, traders, scavengers, criminals and dwellers in low lodging houses or rookeries. Shocking and fascinating as these were to the Victorian public, it was some time before these characters were taken up as subjects for art. The Pre-Raphaelites, with their well-known keenness on subjects from modern life, were clearly interested in the immediacy and vividness such characters could give to their work. Nevertheless, the Pre-Raphaelites used them primarily in small-scale drawings. For most of their major modern-life oils, topical moral or religious questions were addressed rather than the social problems associated with poverty.

The Pre-Raphaelites and the city

'If a modern Poet or Artist . . . seeks a subject exemplifying charity, he rambles into Ancient Greece or Rome, awakening not one half the sympathy in the spectator, as do such incidents as may be seen in the streets every day', wrote F. G. Stephens in the Pre-Raphaelite journal *The Germ*. He described how a friend had helped a filthy old beggar woman to cross a crowded street 'as though she were a princess . . . Why should not this thing be as poetical as any in the life of St. Elizabeth of Hungary or anyone else?'[1]

This was written in 1850 and three years later a similar

15. J. E. Millais, *The Blind Man*, 1853, Yale Center for British Art

incident was drawn by Millais in *The Blind Man* (cat. 15). The blind man is led across the street by a young woman brandishing her umbrella at the rearing horses, which the man cannot see. On the right, a ragged urchin with a broom holds out his hand for money. He is a crossing-sweeper, a street type made extinct by the advent of metalled roads and drainage. In Victorian cities, sweepers were a common sight standing at street corners ready, in return for a few coins, to sweep the mud from the road, enabling people to cross without dirtying their clothes. Mayhew described them and Dickens immortalised Jo the Crossing Sweeper in *Bleak House* (1853). Millais may also have known a contemporary *Punch* cartoon by Cuthbert Bede of an urchin trying to catch the coins dropping into a blind beggar's hat; in both drawing and cartoon the beggars are led by little dogs holding tin cans in their mouths.[2] Millais did not make an oil painting of this subject but returned to the theme later in *The Blind Girl*

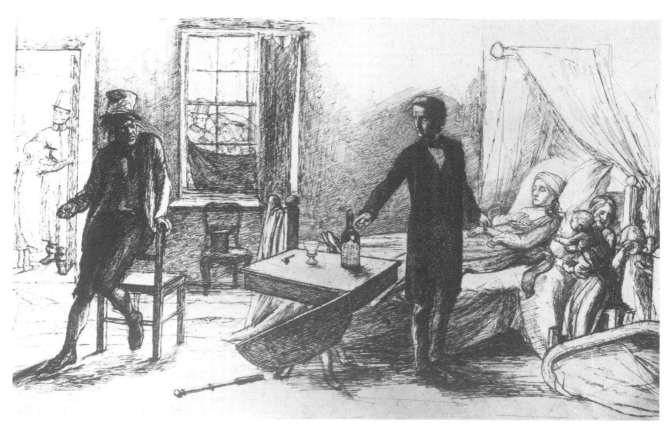

16. Charles Allston Collins, *Drink*, Dundee Art Galleries and Museums

(1856, Birmingham City Art Gallery). Like the man in the drawing, the girl wears a 'Pity the Blind' sign at her neck, and the substitution of an exquisitely painted landscape for a busy city street should not obscure the fact that she too is one of the wandering poor.

In the 1850s the minor Pre-Raphaelite artist Charles Allston Collins was very much influenced by his friend Millais and he also made drawings of modern-life subjects. *Drink* (cat. 16) was once thought to be by Millais but is more likely to be the work of Collins.[3] It shows a revoltingly drunken man who has beaten his wife to death with a poker; the doctor holding the wife's limp hand points to the instrument of her death. Policemen are at the door and in the centre of the composition, on a broken table, is a bottle of 'Fine Cordial Gin'. The drawing is very close to no. 7 of Cruikshank's *The Bottle* (cat. 7) which undoubtedly inspired it.

Another blind girl, pathetically holding out her hands for coins, is one of the figures in a curious drawing of 1857 by Simeon Solomon, a young man of seventeen, who was just beginning to mix in Pre-Raphaelite circles. '*I am starving*' (cat. 17) takes its name from the placard held by the little boy, presumably the girl's brother. He has a rat which he is said to be feeding to his pet owl, in return for money. The girl has fledgling birds and flowers for sale. The scene takes place by the river and a prostitute gazes at the city lights reflected in the water, perhaps seeking an escape from her well-dressed companion. Mayhew described how birds, birds' nests and wild flowers were gathered in the country and brought to the city for sale on the streets.[4] But the drawing is not simply a document recording street types; the birds are a metaphor for the plight of starving children neglected by civilisation.

Anna Blunden was a governess who, inspired by reading Ruskin's *Modern Painters*, threw up her position to study art.[5] Though she was not a member of the Pre-Raphaelite circle, her work was thought sufficiently similar in style for her picture of a sempstress (cat. 18) to be included in the exhibition of Pre-Raphaelite and other British art held in America in 1857–8. The full title is four lines from Hood's *Song of the Shirt*:

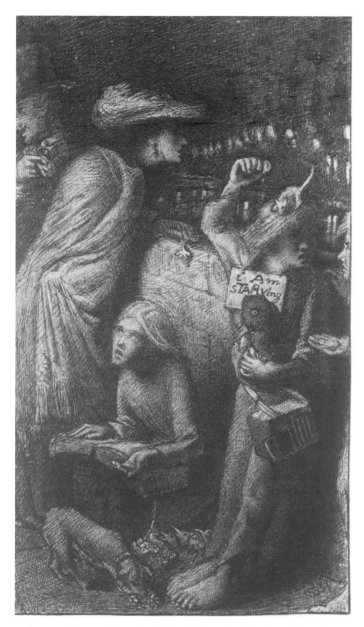

17. Simeon Solomon, *'I am starving'*, 1857, Roy and Cecily Langdale Davis

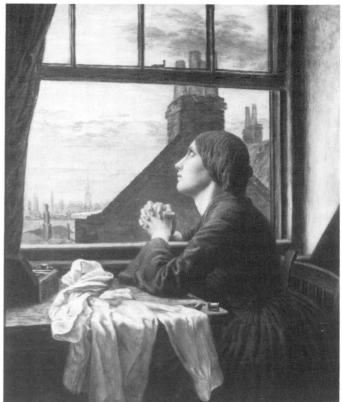

18. Anna Blunden, *For only one short hour . . .*, 1854, Christopher Wood

For only one short hour
To feel as I used to feel,
Before I knew the woes of want
And the walk that costs a meal.

Painted in 1854, it has more naturalism than Redgrave's *Sempstress* (cat. 11), with the figure in close-up rather than placed in a conventional stage-like room setting; the view of the London skyline may have been painted from the artist's lodgings at City Road, Finsbury, and the

carefully painted sewing is a full dress shirt with a pleated front, one of the most exacting forms of needlework. Yet the pathos and melancholic religiosity is unmistakably derived from Redgrave's prototype. Blunden's needle-woman sits at prayer, and a church spire is prominent in the background. The open window may have been suggested by Hood's lines:

Oh! but to breathe the breath
Of the cowslip and primrose sweet –
With the sky above my head,
And the grass beneath my feet.

Work

These works by the Pre-Raphaelites, are all on a small scale. The only major Pre-Raphaelite modern-life subject in which urban poverty plays a large part is *Work* by Ford Madox Brown (cat. 19), begun in 1852 and finished 1863. This is the classic Victorian painting of contemporary life. Inspired by seeing a band of navvies digging up the pavement in Heath Street, Hampstead, Brown created an

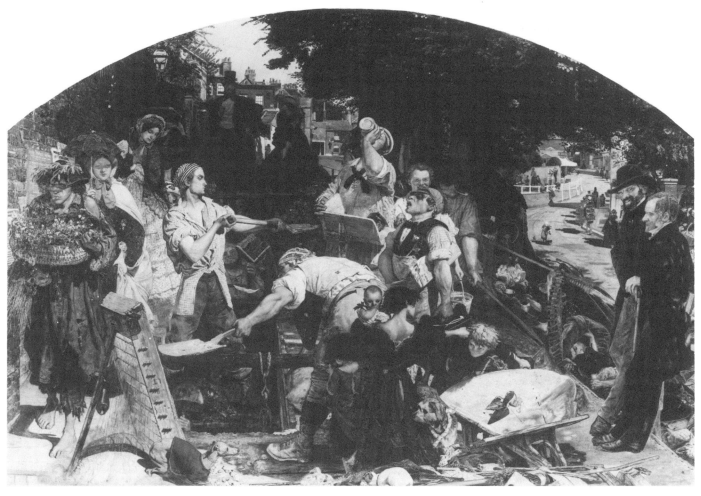

19. Ford Madox Brown, *Work*, 1852/65, Manchester City Art Galleries

assemblage of types representing not just the workers, but Victorian society as a whole. In heaped-up, sharply focused detail and brilliant out-of-doors colour, Brown depicted rich and poor, idle and industrious, working and unemployed.

The painting is a celebration of the value of work to society; this is underlined by the heroic appearance of the central figure, the young navvy 'in the pride of manly health and beauty', to quote from the artist's long description of his picture.[6] The underlying idea, much influenced by the sociological views of Thomas Carlyle, is summed up in the biblical quotations on the frame, glorifying work for its contribution to social and personal spiritual salvation: 'Seest thou a man diligent in his business, He shall stand before kings' and 'In the sweat of the face shalt thou eat bread'.

Nevertheless, the painting carries a strong element of social criticism, particularly of the relationship between the classes. 'Money!! Money!! Money!!', the words on a poster on the left wall, recall Thomas Carlyle's view that the exchange of cash for labour had replaced the ordered society of previous ages where the classes were bound by mutual obligation and respect. The ladies on the left represent the idle rich; one proffers an improving religious tract to the old navvy who in Brown's words, 'scorns it, but with good nature. This well-intentioned lady has, perhaps never reflected that excavators may have notions to the effect that ladies might be benefited by receiving tracts containing navvies' ideas!.' Lack of communication also besets the efforts of the two thinkers or 'brain workers' on the right, actually portraits of two men whose efforts on behalf of the underpriviledged were admired by Brown. The painting is a kind of homage to their ideas; they are Thomas Carlyle, author of *Past and Present*, a book highly influential on the artist, and Frederick D. Maurice, the Christian Socialist and pioneer of working-class education

at whose Working Men's College the artist taught. (A poster for the College is included on the left of the painting.) At the back is a rich MP; 'could he only be got to hear what the two sages in the corner have to say, I have no doubt he would be easily won over. But the road is blocked . . .'. Thus the gulfs between rich and poor and between intelligentsia and men of action are as wide as ever, even though on the pavement of a modern city all classes are thrown into close proximity.

The poor people in the painting are not stock characters and Brown described them in detail both in paint and in words. The strangest is the man with the basket of wild flowers and torn hat, left, a 'ragged wretch who has never been taught to work . . . before the dawn you may see him miles out in the country, collecting his wild weeds and singular plants to awaken interest, and perhaps find a purchaser in some sprouting botanist'. Equally prominent, though less grotesque, are the children in the foreground. 'Though at first they may appear just such a group of ragged dirty brats as anywhere get in the way and make a noise, yet, being considered attentively, they . . . develop qualities to form a most interesting study . . . The eldest girl, not more than ten, poor child! is very worn-looking and thin . . . fearfully untidy . . . and her way of wrenching her brother's hair looks vixenish and against her. But then a germ or rudiment of good housewifery seems to pierce through her disordered envelope, for the younger ones are taken care of, and nestle to her as to a mother'. On the left 'on the shaded bank, are different characters out of work, haymakers in quest of employment; a stoic from the Emerald Island, with hay stuffed in his hat to keep the draught out . . . a young shoeless Irishman, with his wife, feeding their first-born with cold pap – an old sailor turned haymaker, and two young peasants in search of harvest work, reduced in strength, perhaps by fever – possibly by famine'. Finally, on the extreme right-hand edge is the 'episode of a policeman who has caught an orange-girl in the heinous offence of resting her basket on a post, and who himself administers justice in the shape of a push, that sends her fruit all over the road'.

The contrasts between Brown's different types recall the subtitle of Mayhew's *London Labour and London Poor*, 'Those that will work, those that cannot work, and those that will not work'. Street sellers of oranges and wild flowers, Irish migrant workers and haymakers are all found in Mayhew. Brown may also have known a *Punch* cartoon of 1850 showing a policeman moving along an orange-seller; and characters from Dickens's *Bleak House* (1853) have been suggested as prototypes for other figures.[7] Nevertheless, whatever the sources, the result is a uniquely sympathetic portrayal of poor people. The social issues – poverty, unemployment, starvation, homelessness – are understood, but the figures are not simply vehicles for presenting social problems. They are well-rounded characters, in many cases painted not from professional models, but real people encountered by the artist in the street.[8] The importance of *Work* to the story of social realism is that though it glorifies the worker, it also represents the urban poor without forced pathos. They are part of the city scene and at the same time individual human beings.

Lost and Found

Just as *Work* arose from the social ideas of Thomas Carlyle and Frederick D. Maurice, and included their portraits, so *Shaftesbury, or Lost and Found* by William Macduff (cat. 20 and colour plate I after p. 12) was a tribute to the philanthropic work of the 7th Earl of Shaftesbury, whose portrait is seen in the shop window. The painting was shown at the Royal Academy in 1863 and Lord Shaftesbury was specially invited to the opening dinner.[9] Two causes associated with him were the chimney-sweeps and the shoe-blacks: the picture shows a shoe-black pointing out to a sweep the engraved portrait of their benefactor exhibited in a London print shop window. The 1860s were years of intense activity by Lord Shaftesbury on behalf of the abuse of child sweeps, culminating in the 1864 Act restricting their employment. The Shoe-Black Brigade was an off-shoot of the Ragged School Union of which Lord Shaftesbury was President for thirty-nine years (the paper on the pavement besides the shoe-black's stand is a notice of the meeting of the Union at Exeter Hall, London). The Brigade was started in 1851 to make use of the employment opportunities provided by the influx into London of visitors to the Great Exhibition. By early 1863, 373 boys were working in eight branches for different areas of London, besides a special Brigade for the 1862 International Exhibition. The boy in the painting wears the scarlet coat of the central London branch.[10]

Though an unusual subject, the shoe-black is not unique in Victorian art. H. R. Hine painted a shoe-black c. 1850 (Museum of London) and in the late 1850s, Frederick Smallfield exhibited a series of genre figures and street sellers, including a shoe-black, and this was etched in 1861 to illustrate a poem about an orphan who found new life by working as a shoe-black. In 1882 the French painter Bastien-Lepage painted a pair of London types, a flower-girl and a *London Boot-Boy* (Paris, Musée des Arts

Décoratifs).[11] Macduff, by including the chimney-sweep and the portrait of Shaftesbury, links his genre painting with very specific philanthropic work; he seems to have been much involved with Shaftesbury, for in 1860 his *The Shoe-Black's Lunch* was presented to the 7th Earl himself by the Ragged School teachers of London (Collection of the present Lord Shaftesbury)[12] and in 1873 he exhibited at the Royal Scottish Academy *A Plea for Ragged Schools* showing an orphan sheltering on a snowy doorstep.[13]

Shaftesbury, or Lost and Found was probably commissioned by Henry Graves, the art dealer, print seller and print publisher whose shop at 6 Pall Mall is depicted in the painting. It was engraved by Graves & Co. and quite apart from its social content, it was a tremendous advertisement for their engravings. Most of them can be identified[14] and many are relevant to the theme of charity and rebirth (hence 'Lost and Found'). Besides the portrait of the great philanthropist, the engravings include at the top left *The Blind Beggar* after the painting by Dyckmans (National Gallery, London); in the centre *The Alms Deeds of Dorcas* after Dobson (version in the Royal Collection); bottom right *Saved* after Landseer (unlocated) and two pictures of orphans by Thomas Faed (see cat. 27).

Two French-trained artists

Macduff used the bright colour and fine detail which the Pre-Raphaelites had pioneered: in contrast is the drab palette of another painting of city children, *A street scene in Manchester* (cat. 21) painted by Thomas Armstrong in 1861. Armstrong, born in Manchester, threw up a business career for art and studied in Paris, where he was a member of the set which included du Maurier, Poynter and Whistler: du Maurier's novel *Trilby* (1894) is a fictionalised account of their time in Paris. Armstrong's later work consists of decorative studies of draped females in the Albert Moore manner, and he later became Director of Art at the South Kensington Museum. But his early work is very different. Fresh from his French training, he visited Düsseldorf and Algiers, and then returned to Manchester: as a sensitive young man in a dirty industrial city, he must have been moved by the terrible poverty there, and is known to have painted several studies of slum life. In *A street scene in Manchester* (cat. 21) which he showed in that city in 1861, he may also have had in mind the Manchester artist Frederic Shields whose more colourful watercolour of street children *Playing Checkstones* (also known as '*Bobber and Kibs*'), was shown in Manchester in 1856 (Manchester City Art Gallery): Armstrong's children

are also seated on the pavement playing a game. The girl holds a hoop, beside her is a bucket of coal, and at the end of the alley-way is a slum courtyard with children and washing. The *Art Journal* criticised the colour as 'strangely dirty and monotonous'. The composition is rather awkward: Armstrong's friend, du Maurier, wrote of another picture of his of this period 'there is always something wanting, grace or charm or whatever you like to call it'.[15] Even so, the lack of anecdote or explicit message is unusual and must be due to the influence of French realism with its attempt at objective accuracy and its penchant for ordinary, normally neglected subject-matter.

Quite different is a contemporary painting of urban life by T. R. Lamont, a friend of Armstrong and another member of the 'Paris gang'. *Hard Times* (cat. 22) shows a tearful widow trying to pawn her husband's watch; she is contrasted with two blasé urchins, one pawning a bundle and the other trying to fish something out of a drawer. Like *A street scene in Manchester*, *Hard Times* was painted not long after the artist's return from Paris, but the pathos and fine handling of detail place this work firmly in the English genre tradition: the widow is similar in type to the melancholy heroines of Redgrave.

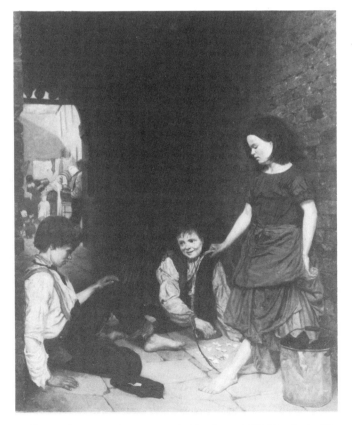

21. Thomas Armstrong, *A street scene in Manchester*, 1861, Manchester City Art Galleries

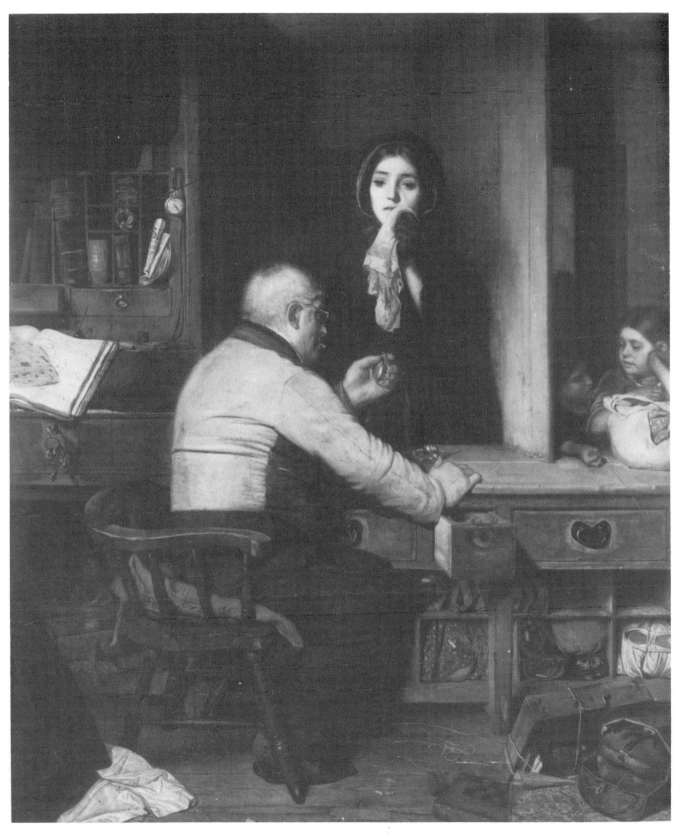

22. T. R. Lamont, *Hard Times*, 1861, Christopher Wood

4 | 'Thou wert our conscript': the rural poor in the 1850s and 1860s

Images of the city in Victorian art were relatively rare, and frank images of poverty even rarer; the city, as the seat of the most frightening problems of the age, was avoided by most artists. More landscapes were probably painted in Victoria's reign than any other kind of picture, and they included, as landscape paintings had always done, figures of the rural poor. Reapers, harvesters, ploughmen and woodcutters for example were painted by Linnell, Müller and Herring. Others, such as P. F. Poole or F. W. Topham, painted single figures showing rural types and occupations including gleaners, mushroom gatherers, gypsies, farm-girls and peasants going to market. These figures were not painted because they were poor, but because they were picturesque; 'who is not weary of simpering rusticity?' complained the *Art Journal* of 1856.[1] It was incidental to the artists' purposes that most agricultural workers were, at least until 1870, badly paid; that many peasants lived in squalid hovels from which they could be evicted virtually at their landlords' will; that child labour was exploited and that in some areas of the country there was frequent unrest and rioting at low pay and conditions.[2] The artists of Victorian rural scenes sought, for the most part, to create an idealised vision of pastoral tranquillity not to record or comment on contemporary life. Many rural subjects were even further removed from reality by the use of exotic foreign settings; Ford Madox Brown saw his choice of the English navvy for the hero of *Work* (cat. 19) as a riposte to the many pictures showing the peasants of the Campagna or the fishermen of the Adriatic.[3] Even when the Victorian countryside was painted in its modern aspect, with figures in contemporary dress, such images were used to convey an air of timelessness through the eternal round of the seasons and their traditional rural occupations, such as the harvest scene *Hullo Largess!* painted by W. M. Egley in 1860 (Tate Gallery). When considering pictures of children engaged in farm work, *The Times* asked of English artists 'Why do they so

constantly appeal to the mere pleasure of prettiness, so rarely to the sweet sentiments of sympathy and pity?',[4] and compared them unfavourably with French painters such as Jules Breton or Édouard Frère who were by no means the most realistic of French rustic figure painters. Few French artists, and even fewer British, succeeded in challenging these picturesque conventions.

The Stonebreaker

Henry Wallis exhibited *The Stonebreaker* (cat. 23) in 1858. For the first time, visitors to the Academy were confronted with the brutal fact of the death of a common pauper. Here was a labourer not happy at his job but one who had collapsed and died with exhaustion from the terrible hardship of his toil. It was, at once, recognised as a powerful general statement about the 'condition of England' and a criticism of the Poor Law. Crushing stones, an essential but back-breaking task preparatory to road mending, was one of the lowliest of occupations for the unskilled. It was commonly part of the workhouse regime, meted out by the Parish Poor Law guardians, a kind of forced labour for able-bodied paupers who were given board and lodging in the parish workhouse (the *Morning Star* suggested that Wallis's painting should be 'presented to one of our metropolitan workhouses and hung up in the boardroom').[5] Wallis had the frame inscribed 'Now is done thy long day's work', from Tennyson's *A Dirge* (1830) and for the catalogue chose a quotation from Carlyle's *Sartor Resartus* (1833–4), 'Hardly entreated Brother! For us was thy back so bent, for us were thy straight limbs and fingers so deformed; thou wert our conscript, on whom the lot fell, and fighting our battles wert so marred. For in thee too lay a god-created Form, but it was not to be unfolded; encrusted must it stand with thick adhesions and defacements of labour; and thy body, like thy soul, was not to know freedom.' Thus the common inspiration from Car-

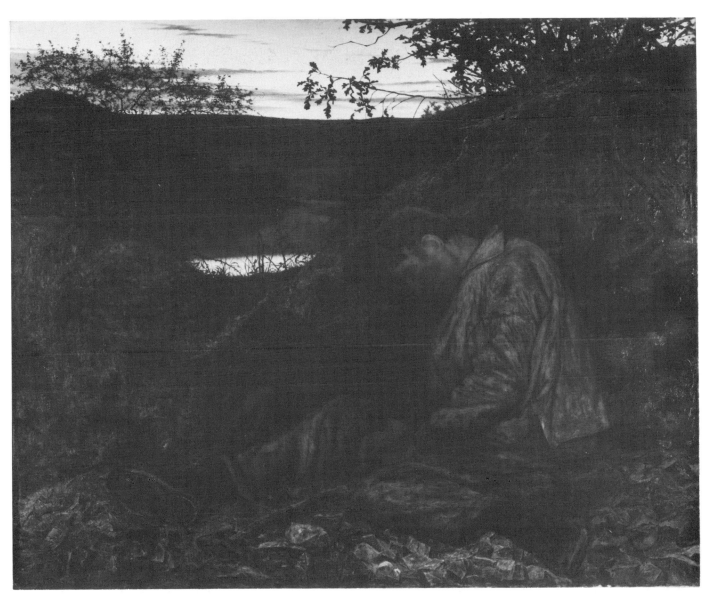

23. Henry Wallis, *The Stonebreaker*, 1857–8, Birmingham City Museum and Art Gallery

lyle's idea of the 'hero-worker' links Wallis's picture with *Work* (cat. 19) which Ford Madox Brown was painting at this time; only Wallis's worker is, pessimistically, heroic in death.

Wallis had studied at the RA Schools in London, but then attended the École des Beaux-Arts and the studio of Gleyre in Paris, and may well have known Courbet's monumental *The Stonebreakers* (1849, formerly Dresden Gallery), a powerful representation of oppressed labour, painted on an impressively grand scale. Wallis took the same, deliberately proletarian, subject but painted it much smaller and more delicately, drawing out a very English poignancy by placing the figure in an exquisite, almost miniaturistically, detailed Pre-Raphaelite landscape. Instead of Courbet's anonymous, matter-of-fact figures, their backs turned to the spectator as they work, Wallis's *Stonebreaker* is alone and motionless. The scene is suffused by the dim light of the setting sun so that the figure seems to be absorbed in nature; a stoat climbing his boot emphasises the stillness of death. The picture outraged many. 'It shocks the sight and offends the sense', wrote the *Illustrated London News*, whilst the *Athenaeum* wrote:

'This may be a protest against the Poor Law – against a social system that makes the workhouse or stonebreaking the end of the model peasant; but it may also be a mere attempt to excite and to startle by the poetically horrible.' But it certainly moved many viewers. 'It is a mournful subject; and has been treated with a mournful feeling; a birth in misery, it seems to give sadness to all who see it', wrote the *Art Journal*. For Ruskin, it was 'the picture of the year . . . It is entirely pathetic and beautiful in purpose and colour'.[6] Coincidentally, in the same Academy was another Pre-Raphaelite stonebreaker by John Brett (Walker Art Gallery, Liverpool) characterised by Ruskin as 'a boy hard at work on his heap in the morning' in contrast to Wallis's 'an old man dead on his heap at night'. But Brett's boy has none of the emotional or social resonance of Wallis's.

The later work of Wallis shows a falling-off in intensity, but a similar interest in the poor and downtrodden reappeared in his painting *A January Morning* (1869, unlocated). This was described as 'a painful bit of "realism" from the London streets, a wretched widow with her starving child on the step of a closed workhouse door, with a compassionate girl of the period stopping to put a warm knitted handkerchief from her own neck round that of the shivering baby, while her companions, shop girls, apparently, wait for her in the fog, a little further on'.[7]

At the next year's Academy a small picture by a young artist, Marcus Stone, drew praise from the *Art Journal* for its 'earnestness and simplicity'.[8] *Silent Pleading* (cat. 24) shows a tramp, a policeman and a country gentleman. The tramp, who has a child wrapped up in his cloak, has taken shelter from the snowy weather; the policeman is about to arrest him but the gentleman suggests mercy. The quotation from Shakespeare's *The Tempest*, 'Him and his innocent child' was printed in the catalogue. Stone was only seventeen at the time and this was his second painting shown at the Academy. Its subject can be explained from his friendship with Charles Dickens, an intimate companion and neighbour of his father, Frank Stone. In 1853, Dickens had congratulated the twelve-year-old Marcus Stone on a sketch of Jo the Crossing Sweeper, from *Bleak House*, and later Dickens commissioned him to provide illustrations for *Our Mutual Friend*.[9] *Silent Pleading* shows sympathy with the poor, but it conveys none of the passion or commitment of Wallis. Nevertheless, its narrative realism is very different from Stone's later productions, vapid pictures of lovelorn swains and their ladies in Regency costume set in pretty gardens.

Frederic Shields and Thomas Wade

Wallis's intensity is echoed in a highly finished watercolour by the Manchester painter Frederic Shields, *One of our Breadwatchers* (cat. 25). It shows the practice, observed by the artist at Porlock, Somersetshire, of leaving children out all day in the snow to scare the birds from the newly sown corn, using wooden rattles. The children sat in shelters rudely constructed of gorse and hurdles, and heated by tiny fires. On one occasion Shields 'worked for three days in a snow-covered ploughed field sharing the privations which his little model and many other boys and girls endured for the poorest wage'.[10] Shields had made his name in his native city with watercolours of pretty children in the manner of William Henry Hunt. He then came under the influence of the Pre-Raphaelites and this watercolour, his finest, is a *tour de force* of Pre-Raphaelite technique following Ruskin's precepts. It was shown at the Old Water Colour Society in 1866. Shields brought it to the gallery late, when the exhibition was nearly hung, but James Holland generously took down one of his own

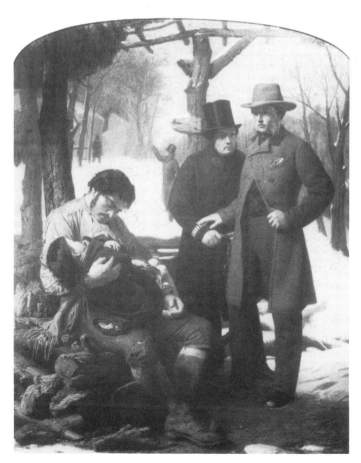

24. Marcus Stone, *Silent Pleading*, 1859, Calderdale Museums

works hung 'on the line' and replaced it with Shields' *Breadwatcher*. The little girl still has the big eyes and rosy cheeks of William Henry Hunt's urchins, but the composition of the watercolour and the pathos of its message about the exploitation of child labour recall Wallis's *Stonebreaker*. Just as the quotation from Carlyle made the Wallis into a general statement about the 'condition of England', Shields entitled his watercolour not 'The Breadwatcher' but *One of our Breadwatchers* thus implicating everyone who eats daily bread in the child's exploitation. It is not surprising that *The Times* objected to the title, as being 'of questionable taste'.[11] Nevertheless, the same reviewer responded to the appeal of the picture, praising it as 'not only a beautiful drawing in all technical respects, but a well-directed, unexaggerated appeal to our sympathies on behalf of the poor – all the more touching for its homeliness. There is a pathos in it that reaches the heart. It will be a good time for the art when our painters have learnt what a wealth of such subjects there is about us to be realised without falsehood, exaggeration or sickliness.'

Like Shields, Thomas Wade was a provincial follower of the Pre-Raphaelites. He was at first apprenticed to a house-painter (Shields began as a commercial lithographer), but then studied at the RA Schools in London. After that, he lived in the North of England for most of his life and did not, like Shields, become part of the Pre-Raphaelite circle. Wade's landscapes, with their precise feeling for colour and light, are indebted to the Liverpool followers of the Pre-Raphaelites. *Carting Turf from the Moss*, 1868, (cat. 26) is simply a genre painting of agricultural workers near the artist's native town of Wharton on the North Fylde, where peat-cutting had long been carried out. Yet Wade seems to have absorbed the message of Brett and Shields. Without trying to make a political point, he quietly conveys a deep feeling for the hardship of country life in the bowed head of the man tugging at the recalcitrant donkey, and in the poignant expressions of the wife and children. In the background, the bent bodies of the field-workers are perhaps an early echo in Britain of Millet's *Gleaners* (1856, Louvre).

25. Frederic J. Shields, *One of our Breadwatchers*, 1866, Manchester City Art Galleries

26. Thomas Wade, *Carting Turf from the Moss*, 1866–8,
Harris Museum and Art Gallery, Preston

5 | Thomas Faed:
the acceptable face of social realism

'It took a long time before I could admire Thomas Faed's work, but now I do not hesitate about it any more; for instance, "Sunday in the Backwoods of Canada", "Home and the Homeless", "Worn Out", "The Poor", "The Poor Man's Friend" – in short, you know the series published by Graves.'[1]

So wrote Vincent van Gogh, whose difficulty in coming to like Faed's art is understandable. For Faed's paintings derive from Dutch genre and interior painting via the Scottish narratives of Wilkie; but his characterisation lacks the edge of Wilkie's and is often spoiled by a fondness for humour and homely philosophy. Faed is not usually considered in the context of Victorian social realism. Yet poverty was his central concern; his pictures of orphans, beggars and poor Scottish families all drew attention to it. Faed's paintings, and engravings of them, were enormously popular and must have influenced the way many people visualised and thought of the poor. He held back from anything too starkly realistic in his settings, costume and figure types; as a result, he never drew from the critics the pained or shocked responses which sometimes greeted other artists. So though his work was more social than realist, he cannot be left out of a history of social realism. The way he made poverty and distress acceptable to public taste helps to provide insight into the nature of Victorian social realism.

Faed was born into a small rural community in Galloway, where his father was a prosperous mill-owner and farmer. His upbringing was civilised and well-ordered, not at all like the scenes which he was later to paint.[2] Several of his family also became artists. He studied art at the Trustee's Academy in Edinburgh and many of his early works were historical subjects from Burns and Scott, but his greatest successes were genre paintings of humble Scottish life which remained his staple throughout his life. In 1851 he first showed at the Royal Academy and he settled in London the following year.

The Mitherless Bairn

Faed's first big success in London was *The Mitherless Bairn*, shown at the Academy in 1855. (The original is in the National Gallery of Melbourne; cat. 27 is a reduced replica which still shows Faed's delicacy of touch.) It became his best-known picture: a copy of the engraving is displayed in the shop window in Macduff's *Shaftesbury, or Lost and Found* (cat. 20). The subject of a homeless orphan taken in by a kind family of cottagers, a 'charming little scene of rustic life'[3] was inspired by a poem, written by the Scottish weaver and self-taught writer, William Thom:

Her spirit that pass'd in yon hour of his birth,
Still watches his wearisome wand'rings on earth,
Recording in heaven the blessings they earn,
Wha couthilie deal wi' the mitherless bairn!

Oh! Speak him nae harshly – he trembles the while –
He bends to your bidding and blesses your smile!
In their dark hour o' anguish, the heartless shall learn
That God deals the blow for the mitherless bairn!

Ruskin criticised the technique as 'the most commonplace Wilkie-ism – white spots everywhere' and it must certainly have looked old-fashioned when seen from a Pre-Raphaelite standpoint. Yet Ruskin also found the story 'well told, and the figure of the orphan child very affecting'.[4] Faed's ability to capture nuances of expression is particularly evident in the pathetic bowed head of the bairn, trembling on the verge of tears. It was this which gave the picture such popular appeal.

The Mitherless Bairn was admired by the wealthy philanthropist, Angela Burdett-Coutts, and she proceeded to commission Faed's next picture *Home and the Homeless* (formerly Fine Art Society), a very similar scene of a family in a cottage giving shelter to a homeless woman and her child (an engraving of this is also seen in Macduff's shop window). Angela Burdett-Coutts was fully ac-

27. Thomas Faed, *The Mitherless Bairn*, 1855, Royal Pavilion, Art Gallery and Museums, Brighton

quainted with the problems of homelessness: among the causes she supported with great generosity were the Ragged Schools, the provision of housing for the poor and the training of destitute boys. She had certainly seen the worst conditions with her own eyes; Dickens had accompanied her on tours of London to see the squalid conditions of destitute waifs.[5] From a modern standpoint, it is hard to see how she could have related Faed's work to her experience of London poverty. For her, Faed's treatment of the theme must have been a kind of abstract representation or emblem of homelessness, for there is nothing realistic or up-to-date about it.

The 1860s

The Last of the Clan (cat. 28), exhibited in 1865, marks a big step forward in Faed's work towards greater realism

and immediacy in the treatment of social subjects. It is one of a number of pictures on the theme of emigration painted by Faed:[6] the subject had a particularly tragic meaning for the Scots because of the Highland Clearances. Faed showed his picture with a paragraph probably written by the artist himself to explain the scene:

When the steamer had slowly backed out, and John MacAlpine had thrown off the hawser, we began to feel that our once powerful clan was now represented by a feeble old man and his grand-daughter, who, together with some outlying kith-and-kin, myself among the number, owned not a single blade of grass in the glen that was once all our own.

The group on the harbour is dominated by the bent old man in a plaid shawl seated on a dejected-looking pony; half-hidden, the grand-daughter buries her face in her hands and on the right mournful faces and bowed heads watch the boat leave.

28. Thomas Faed, *The Last of the Clan*, 1865, Glasgow Art Gallery and Museum

The picture is much larger than Faed's previous work; the new grand scale and solemn mood are probably the result of seeing Jozef Israels' work at the 1862 International Exhibition in London (see cat. 33). Faed's handling is much more detailed and more brilliant in colour, showing belated Pre-Raphaelite influence. The modernity of the costume, after the more generalised country wear of the peasants in the cottage scenes, mark out the picture at once as a contemporary subject; and a vivid sense of actuality is given to the composition by the viewpoint, as though the spectator is present on the boat drawing away from the harbour and gazing at the women, children and aged left behind. Though as before, Faed glossed over the more sordid aspects of his theme, he brought to it an epic quality and a tragic emotional force which give it a powerful immediacy.

Two years later, Faed exhibited *The Poor, the Poor Man's Friend*, another large picture of which cat. 29 is a reduction. A less dramatic subject, though praised for its pathos and its brilliance of atmospheric effect, it shows a fisherman mending nets outside a cottage with his wife and children. He is giving a coin to a diffident barefoot girl, the companion of an old blind beggar. The title echoes that of a book *The Poor Man's Friend, or Useful Information*

and Advice for the Working Classes (1826–7) by the radical writer William Cobbett. Cobbett opposed the Poor Law which had the effect of dividing the poor into two classes; the labouring poor, who managed to fend for themselves; and the ragged or undeserving poor who, when forced by circumstances into hardship, were made dependent on the degrading life of the workhouse. Cobbett argued for a return to a paternalistic society where there was just one class of poor, all of whom had a right to a reasonable level of subsistence and freedom. Faed's picture presents the two classes of the poor. The fisherman and his family are respectable, but their lowly status is indicated by the turnip on the left, one of the staples of a poor diet. The beggar and his child, though ragged, are objects of pity rather than fear: Faed glosses over the threatening aspects of the undeserving poor. His picture should be compared with *The Beggar's Alms* by Courbet (Burrell Collection, Glasgow) of one year later, a more disturbing version of the theme. Here a revolting-looking beggar bestows a coin on a barefoot little boy. But in both pictures the inference is that charity is more likely to come from the poor than the middle classes, a change from the viewpoint of the 1840s (see cat. 2).[7]

In 1868, Faed exhibited *Worn Out* (cat. 30 and colour plate II after p. 12). He described it as follows: 'The picture represents a working man who has been watching his little boy through a *restless* night. The child, holding on by his father's shirt sleeve, has fallen asleep: daylight finds them both at rest – *worn out*.'[8] A poor carpenter is seen sleeping at the bedside of his sick child. The brilliant colour, minute handling and suggestive details – the bowl of food, the mat keeping the draught from under the door, the man's coat laid on the bed, the child's book and violin, the father's bag of tools – all, in the words of *The Times*, 'help to tell the story of the struggle of love and care and some refined tastes with poverty'. Even so, the same critic found no look of illness in the child's rosy cheeks: 'Perhaps Mr. Faed found it pleasanter to hint at recovery than sickness.'[9] The mouse is a detail recalling the stoat in Wallis's *Stonebreaker* (cat. 23), of a vaguely similar com-

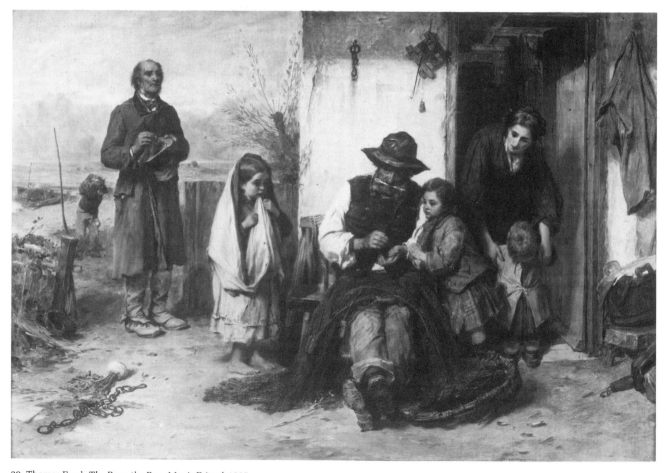

29. Thomas Faed, *The Poor, the Poor Man's Friend*, 1867, Victoria & Albert Museum

position, whilst the subject of a vigil over a sick child, combining lamplight with the natural light of dawn may well have suggested to Luke Fildes the idea for *The Doctor* (cat. 78).

Though Faed was best known for his cottage and Scottish subjects, he extended his repertoire to urban themes when the art dealer Gambart commissioned him to paint a series of London street characters. These seem to owe more to the picturesque tradition of Wheatley's *Cries of London* than to the low-life types of Mayhew. Faed began with *The Irish Flower Girl* of 1862 and also painted an orange-seller and a milk-girl.[10] *Homeless* (cat. 31) may be part of this series. Exhibited in 1869, it shows 'an over-worked street sweeper who has found a bed for a sound sleep under a portico, though the policeman coming up round the corner warns us that his rest will be rudely 'broken by a "Now then move on"'. Mayhew quoted a crossing-sweeper as saying that 'I have been to the station-house, because the police always takes us up if we are out at night; but we're only locked up till morning.'[11] Faed

prided himself on this type of subject, for at an art-school prize-giving he advised the students to paint the gutter children of London rather than Helen of Troy, Agamemnon, or Achilles on the grounds that they should only paint what they had seen with their own eyes. His motto was 'Observe', but whilst stressing the importance of nature he wrote also that 'things seen must pass through the alembic of the brain', acknowledging, half-consciously, his selective, edited vision of poverty.[12]

Late work

Faed continued to exhibit throughout the 1870s. Some of his pictures have an unfortunately coy sense of humour, but many of his interiors have an epic quality despite their homely setting. Most impressive is *From Hand to Mouth* (cat. 32), a large and very detailed picture of the interior of a grocer's shop which shows three contrasting levels of society, a poor man searching in his pocket for coins to buy a few meagre provisions; a middle-class shopkeeper who looks disapproving; and a rich lady whose ambiguous expression may be one of pity. The different characters and expressions make this, though old-fashioned in style for its date (1879), an absorbing dramatic situation. The old man, recalling the beggar in *The Poor, the Poor Man's Friend* (cat. 29) is in a soldier's uniform. Veteran soldiers were a familiar problem in Victorian society. Unemployment had caused them to enlist, but after discharge only a few were entitled to pensions and most were thrown onto the casual labour market. Unskilled, they became beggars or vagrants.[13] Faed paints the veteran as usual without disturbing qualities. He is presented as an unfortunate object of pity, not a scrounging professional beggar: the painting is subtitled, 'He is one of the few that would not beg'. He is shown with two appealing waifs, an exhausted girl (the pose repeated from the grand-daughter in *The Last of the Clan*, cat. 28) and a boy musician with a performing monkey. These are contrasted with the well-dressed rich girl turning away in fright, and the negro pageboy with the pet dog. The thrifty shop-keeper's daughters, hard-pressed and unhappy, reinforce the difference between the classes, pitiful poor, compassionate rich and suspicious tradespeople. Most of Faed's work and most social realist pictures of the 1870s show the poor alone, but Faed's painting introduces the contrast of rich and poor, which gave Ford Madox Brown's much earlier *Work* (cat. 19) a universal social message.

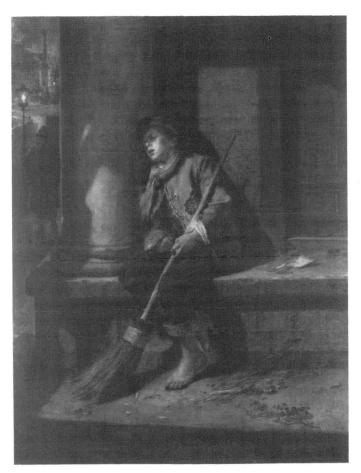

31. Thomas Faed, *Homeless*, 1869, Beaverbrook Art Gallery, Fredericton, New Brunswick, Canada

32. Thomas Faed, *From Hand to Mouth*, 1879, Wadsworth Atheneum

6 | Jozef Israels and Frederick Walker

The two artists in this section have little in common with each other besides an underlying humanity of vision. Neither of them can be fully classed as a social realist. Israels was Dutch and never worked in London. Walker founded the so-called 'idyllic' school, far removed in mood from the mournful tone of social realism. Yet each was deeply influential on the development of English social realism.

Jozef Israels

Israels was a Dutchman, born at Groningen in 1824. He studied in Amsterdam and Paris and returned to Amsterdam to paint subjects from Dutch history and literature in the approved manner of the French Salon painters. In 1855, he became ill and went to live at Zandfoort, a small fishing-village near Haarlem, where he lodged for seven weeks with a ship's carpenter. Here, and at nearby Katwijk, where he spent some time the following year, he was isolated from the world of art and shared in the life of the poor fishermen and their families. Like Millet at Barbizon, he came to see that the tragic and poetic qualities of humble village life could be more powerful and immediate a subject than the heroic but distant events of traditional history painting. Looking to his artistic patrimony, he set his fisherfolk in dimly-lit interiors and overcast shore landscapes, recreating in his own freely-handled technique the subtle light effects of Rembrandt and the seventeenth-century Dutch landscape painters. He became one of the greatest of nineteenth-century painters.[1]

Superficially, the work of Israels is not unlike the village scenes and cottage interiors popular throughout Europe and seen in Britain in the work of the followers of Wilkie. But this would be to misunderstand Israels, for he added to the genre tradition a new dimension. The differences are crucial. Israels preferred the general to the particular and the mood to the anecdote; his tone was usually sombre and tragic, not pathetic and never trivial; above all his work has an epic quality employing a grandeur of scale new to genre painting. He brought the large size of French history painting to his humble subjects, giving them a forceful emotional impact. At the International Exhibition held in London in 1862, Israels exhibited *Fishermen carrying a Drowned Man* (cat. 33) which became the success of the show. It was extensively praised in every review. William Michael Rossetti wrote that 'Israels's solemn and dirge-like painting of "The Shipwrecked" . . . is unsurpassed by any picture of domestic tragedy in the exhibition'[2] and *The Times* critic wrote that it 'stands by itself alike in the method of its execution, which is more French than Dutch, and in its imaginative power . . . The picture represents a dreary beach over which a party of fishermen bear the body of a drowned comrade up from the sea that still breaks in dirty surf all along the shoal coast, under a sky yet heavy with ragged, gray stormcloud and faint watery blue. Before the body walks the widow in dull, blank, tearless agony, leading two orphans, terror-stricken by their mother's mute misery. It is impossible to put more of the sentiment into a picture than the painter has done here. It is all in the right key. A sense of sorrow and sympathy goes out of it to the spectator, and none can look at it unmoved.'[3]

Also shown at this exhibition was the only slightly smaller *The Day Before Parting*; the later replica of it, *Grief* (cat. 34) is on a very much reduced scale. It shows a cottage interior with a corpse laid out lit by candles. The fisherman's widow sits burying her head in her hands with her daughter seated by her on the tiled floor. The mourning figures have the monumental grandeur of the Neo-classical history painting studied earlier by Israels.

The showing given to Israels at the 1862 exhibition made his reputation with English collectors: the *Fishermen carrying a Drowned Man* was bought by the London dealer Gambart who at once sold it to an English patron

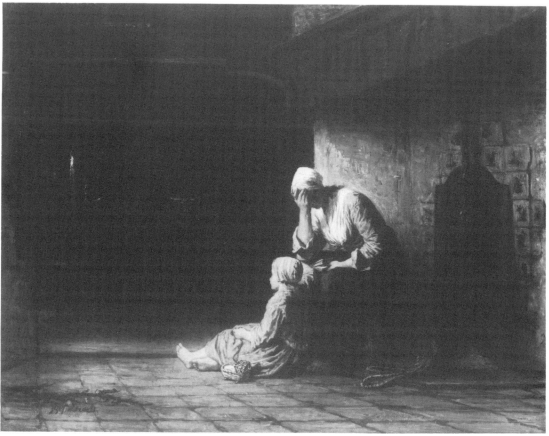

33. Jozef Israels, *Fishermen carrying a Drowned Man*, 1861,
National Gallery, London

34. Jozef Israels, *Grief*, Glasgow Art Gallery and Museum

and the picture eventually came by gift to the National Gallery. Both *The Day before Parting* and the replica of it, *Grief*, passed through English collections. The taste of English buyers for Israels has been studied,[4] but not so the effect of his work on English painters. The influence of Israels' style on Thomas Faed has already been noted (see cat. 28). Israels' work was also important for the painters of the Newlyn School, as seen for example in Frank Bramley's *A Hopeless Dawn* (1886, Tate Gallery) and the work of Walter Langley (cat. 92). It is recorded that Luke Fildes visited the 1862 exhibition, and it so fired his enthusiasm that he was given an allowance enabling him to attend the RA Schools[5]; he cannot have escaped the general admiration of the Israels pictures.

Above all, the cottage interiors, funeral processions and mourning women of Frank Holl show that he was deeply impressed by Israels (see Chapter 9). Holl's patron, Fred Pawle, purchased two paintings direct from Israels in 1869. One of them, *The Anxious Family*, showed a woman gazing out to sea through a cottage window, a subject often taken up by Holl.[6] Holl's daughter noted her father's love of Dutch art, 'Rembrandt in a great degree, but contempor-

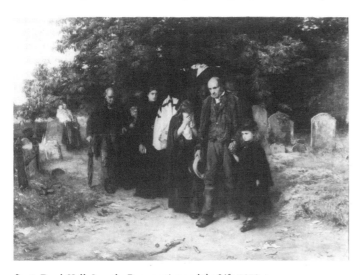

fig. 4. Frank Holl, *I am the Resurrection and the Life*, 1872, Leeds City Art Gallery

ary art like that of Israels most of all, showed him his artistic path'.[7] The influence is closest in *I am the Resurrection and the Life* (RA 1872, Leeds City Art Gallery; fig. 4). The country funeral procession, led by a man and his two daughters, is very similar to Israels' line of solemn and sad-faced fishermen led by the mourning widow and children.

Frederick Walker

Fred Walker was born in 1840 and died in 1875, his career tragically cut short by illness. Perhaps because of his early death he became something of a romantic legend in English art and his work attracted excessive praise. Yet he succeeded in creating a distinct style which was deeply influential. As a student in the late 1850s he drew intensively from the Elgin marbles, yet his early watercolours and illustrations show a lively interest in genre and in naturalistic detail, and a keen eye for the beauties of landscape. He came to maturity in the early 1860s, a time when the naturalism pioneered by the Pre-Raphaelites was giving way to a more poetic and idealised art. On a visit to Paris in 1863 it was not the realism of Courbet or Millet he admired, but the statuesque peasant girls of Jules Breton. From these diverse interests he made a personal synthesis, here summarised by Herkomer, one of his strongest admirers: 'it was he who saw the possibility of combining the grace of the antique with the realism of our everyday life in England. His navvies are Greek gods, and yet not a bit the less true to nature. True poet that he was, he felt all nature should be represented as a poem. The dirty nails of a peasant, such as I have seen painted by a modern realist, were invisible to him. Nor did he leave out the faces of the peasants, in order to produce grandeur as the French Millet did. He started with some definite poetic notion, and nature came to his aid as the handmaid of the poet, without assuming the shape of instantaneous photography.'[8]

In the 1860s Walker, in common with many artists, worked for *Good Words*, *Once a Week*, *The Cornhill* and other magazines which published black and white illustrations remarkable for their strength of design and forceful story-telling. Unlike the later *Graphic* illustrations, those in the magazines of the 1860s were accompaniments to fiction and poetry. Walker's first major oil painting began life as an illustration in *Good Words* in 1862 (cat. 35). It was printed with *Love and Death*, a poem by Dora Greenwell, inspired by a report of a woman who had 'perished in a snow-storm while passing over the Green Mountains in Vermont; she had an infant with her who was found alive and well in the morning, carefully wrapped in the mother's clothing':

On the death-darkened air,
Through the wild storm, amid the drifting snows,
A voice of murmured soothing blent with prayer,
Solemn in trustful tenderness, arose . . .
'Sleep! Oh, my baby, sleep! The night draws on.

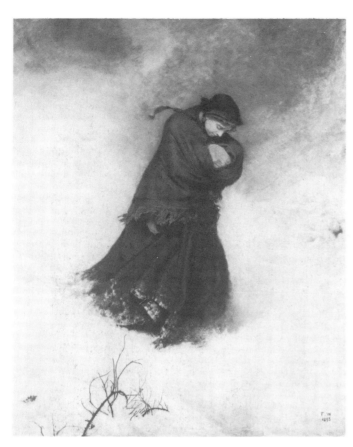

35. Frederick Walker, *The Lost Path*, 1863, Makins Collection

Sleep once again on thy poor mother's breast;
Ere yet the morning dawns I shall be gone,
And thou no more wilt know such place of rest . . .'[9]

Why the woman was wandering in the snow was not
explained, nor was there any suggestion that the baby was
illegitimate; but the image is strongly reminiscent of
Redgrave's *The Outcast* (cat. 12) which Walker could have
seen in the Diploma Gallery of the RA while he was a
student there. When, early in 1863, he turned the design
into an oil, he gave it the title *The Lost Path*, perhaps
implying that the woman had lost her way morally as well
as physically. *The Times* assumed she was a vagrant,
calling the picture 'an allegory all the more touching for its
triteness'.[10] Walker seems to have based the snow-storm
effect on study from nature, but also used photographs and
when he posed his sister, Mary, for the woman, he used
salt instead of snow, and a branch of bramble carefully
brought to his London studio after a country walk.

It was his first exhibited oil and was hung high at the
Academy, 'a cruel piece of bad hanging' (*The Times*
again). Though returned to the artist unsold after the

exhibition, it was sold very soon afterwards for £90.
Friends and critics found it touching and affecting and the
same critic later wrote: 'I still remember how deeply it
impressed me, hung as it was, in an undistinguished place
in the North Room. I still think it one of his most pathetic
pictures.'[11]

The Vagrants (cat. 36) also started as a black and white
illustration this time in *Once a Week*, 1866 (fig. 5). It was
treated very impressionistically, without fine detail, and
though this is in part due to the engraver, the result is an
apt equivalent of the poem which went with it, *The
Gypsies' Song*, a translation from the Russian, which calls
up an image of mysterious, fatal beauty of the kind created
by Rossetti or Sandys:

We are two maidens
With black eyes glowing;
We are two gypsies
With black locks flowing:
In the eye's blackness the fire sparkes gladly
In the heart's fountain the fire burneth madly,
Burneth, burneth, burneth, madly,
Burneth, burneth, burneth, madly.[12]

When making an oil painting of his illustration Walker
had to be more precise, and study all the details. He
painted the background at Beddington, near his sister
Sarah's home at Croydon, and included a robin which
perched on a bush while he was painting. Another sister,
Polly, posed for the standing woman and all the other
figures were painted from models after an attempt to find
real gypsies to sit had failed. 'The vile gypsies had "struck
camp" by the time I got there, so now I give them up, and
go at my own models here. The fools! to let money slip
through their fingers.'[13] This accounts for one of the chief
faults of the picture, that two of the children are not gypsy
types and look far too civilised. The painting gave Walker
much trouble, occupying him from January to September
1867. He rearranged the composition from the illustration,
added an extra figure, and was still retouching it even after
he had sold it. Walker ennobled the gypsies, investing
them with a wistfulness recalling Millais' *Autumn Leaves*
(1856, Manchester City Art Gallery). The standing woman
is like one of Jules Breton's statuesque gleaners. Neverthe-
less what had been in *Once a Week* essentially an imagina-
tive conception was given in the oil a note of social
realism. *The Times* critic found himself 'constructing a
story of those tramps, taking a human interest in them,
waifs and strays as they are', whilst the *Art Journal* wrote:
'There is a pathos, a melancholy about these poor outcasts
which awakens compassion. Hearts of a brave humanity

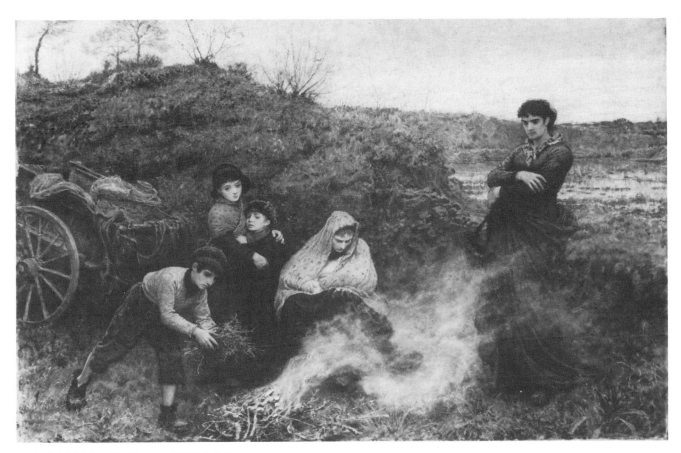

36. Frederick Walker, *The Vagrants*, 1867, Tate Gallery

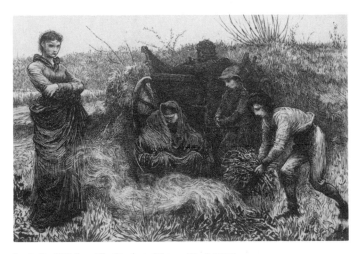

fig. 5. Fred Walker, *The Vagrants* (*Once a Week* 1866)

have these wanderers, though rude in person and ragged of attire. Specially noble is the bearing of the woman with arms folded and of countenance moodily meditative.'[14] The picture made a deep impression on Herkomer whose first engraving was of gypsies: his outcast family in *Hard*

Times 1885 has a similar combination of dejection and heroic gracefulness (cat. 40, 82).

The Harbour of Refuge (Tate Gallery; fig. 6), shown at the RA in 1872, is Walker's greatest painting. Its subject, a group of old people in the garden of an almshouse, is redolent with symbolism. A typical Victorian description of it runs as follows: 'It is not merely an almshouse with its few poor occupants. Youth and age, vigour and decrepitude, are placed in opposition one to the other. The health and bloom of the young girl, strong of frame, are fresh as the blooming may-tree opposite. She turns her eyes towards the vigorous young mower, and thinks, it may be, as she gives her support to the bowed and aged inmate who leans upon her arm, of that reaper whose name is Death. The swing of the scythe is heard, and the gentle murmur of engaging talk by the monument, where welcome news to cheer the monotony of the day has just arrived; and the sunset, against which the old roofs darken and the last lights play, means too the sunset of life for the peaceful souls who have found this harbour of refuge. To what higher teaching could painting be put?.'[15]

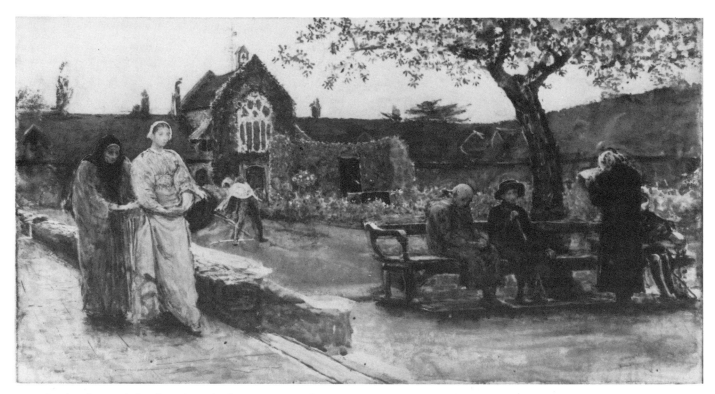

37. Frederick Walker, *Study for 'The Harbour of Refuge'*, 1872, Tate Gallery

The oil has great presence from its size and its radiant reddish glow which, when hung in the Tate, was sufficient to 'illuminate the whole gallery in which it hangs, even in the closing twilight of a December afternoon'.[16] But the watercolour version (cat. 37), though smaller, is handled with much greater freedom and delicacy. It gains additional interest in that it shows an earlier stage in the composition, before the artist's idealising process was complete. In the watercolour the old people are in the foreground; the detailed character studies give a greater degree of realism than in the oil, where the figures have been moved further back. In the watercolour, the mower is in the background, though there are pencil lines suggesting the artist was unhappy with his position; in the oil, the mower has been moved forward, giving greater emphasis to the symbolism of death. The oil is also less realistic in the treatment of the almshouses, taken from the Jesus Hospital at Bray. Instead of the founder's statue shown in the watercolour, Walker has shown a Baroque statue on a huge pedestal, taken from one originally in Soho Square.

The artist's friends Orchardson and Birket Foster had in 1870 seen 'one Sunday in church, a group of old, bent

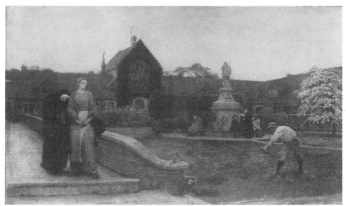

fig. 6. Fred Walker, *The Harbour of Refuge*, 1872, Tate Gallery

labourers on a long bench in front of the pulpit, reposing in the gleams of sunlight that lightened the gloom of the place'.[17] Walker was sent for and from this motif developed *The Harbour of Refuge*. The following year there appeared in the *Graphic* Herkomer's *Sunday at Chelsea Hospital* (cat. 52) which also used the idea of a row of old people in church. The starting point of both artists was nature; the finishing point sentiment and intimations of mortality.

7 | The Graphic

In June 1869, the young illustrator Luke Fildes was asked to make a drawing on a subject of his choice by William Luson Thomas, a wood-engraver and publisher, for whom Fildes had already provided book illustrations. Fildes chose a scene he had witnessed when he first came to London, a group of homeless people on a wintry night queuing for tickets to a night shelter. The result was *Houseless and Hungry* (cat. 38, 74). 'And now for the grand secret', wrote Thomas to Fildes, 'the drawing you have made, and others I have, is for a new weekly journal, to be a high-priced paper, the very best we can get together by the combination of the best writers, artists, engravers and printers.'[1] The drawing was engraved and published as a full-page illustration in the first issue of the new magazine, the *Graphic*, which appeared on 4 December 1869.

Illustrated journalism

The Victorian age saw the development of large-circulation illustrated magazines, which created new opportunities for artists and engravers. In the 1840s *Punch* employed them on humorous drawings (cat. 1) and other magazines followed. In the 1860s, magazines like *Good Words* and *Once a Week* illustrated poetry and fiction with forceful and imaginative designs by the Pre-Raphaelites and others in what became known as 'the sixties style' (see fig. 5). But the biggest and most sustained successes were the weekly news magazines. Chief of these was the *Illustrated London News* founded in 1842, which built up a large circulation (the Duke of Wellington's Funeral issue in 1852 sold 250,000 copies), and maintained its position in the face of a whole string of rivals, such as the *Pictorial Times*, the *Illustrated Times, Pen and Pencil*, and the *Penny Illustrated Paper*, some of which folded after only a few weeks.[2] The *Illustrated London News*, though it claimed to represent all aspects of the life of the times,

avoided all matter which might offend. Charles Knight, publisher of many works of popular education, wrote: 'The staple materials for the steady-going illustrator to work most attractively upon are Court and Fashion; Civic Processions and Banquets; Political and Religious Demonstrations in crowded halls; Theatrical Novelties; Musical Meetings; Races, Reviews; Ship Launches – every scene, in short, where a crowd of great people and respectable people can be got together, but never, if possible any exhibition of vulgar poverty.'[3] In the 1840s the *Pictorial Times* published engravings of poor living conditions more frank than anything in the *Illustrated London News*; the *Builder* in the 1850s featured illustrations of slum housing; and in 1867 the *Illustrated Times* anticipated *Houseless and Hungry* with an engraving of a queue for tickets to a workhouse casual ward.[4]

But the artistic standard of these papers was not high. Figure drawing was often poor, observation of character was stilted and compositions lacked immediacy or sophistication. There was no attempt to engage the sympathy of the viewer for the suffering of individuals. Though artists were employed, the main considerations were speed and topicality, to which artistic originality and often accuracy were sacrificed. The artist drew upon a wood-block (later his drawings were transferred to the wood by means of photography) and the blocks were cut by professional wood-engravers. Pictures were hastily drawn and even more hastily cut. Large illustrations were drawn on several pieces of wood which, for speed, were divided for cutting by different craftsmen. Sometimes they used different styles and often the joins showed. Stock designs were re-used for different events, with only a few details changed to give an impression of authenticity, and the same block was used by different papers to illustrate different events. 'Then, there comes the artist of a picture newspaper, with a foreground and figures ready drawn for anything, from a wreck on the Cornish coast to a review in

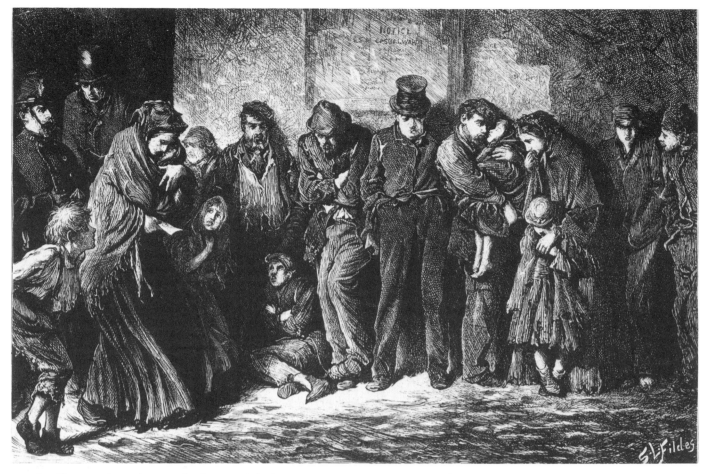

38. Luke Fildes, *Houseless and Hungry* (*Graphic* 1869), Rijksmuseum Vincent van Gogh, Amsterdam

Hyde Park, or a meeting in Manchester', wrote Dickens in *Bleak House* (1853).[5]

It was the poor reputation of such hack news illustration, and the contrasting achievement of the 'sixties style' illustrators of fiction and poetry magazines who cultivated high artistic standards and were given creative freedom by their editors, which gave W. L. Thomas the idea for a news magazine using artists. He recalled that 'the originality of the scheme consisted in establishing a weekly illustrated journal open to all artists, whatever their method, instead of confining my staff to draughtsmen on wood as had hitherto been the custom'.[6]

Thomas had considerable experience of engraving, publishing and journalism. He had formerly worked on the *Illustrated London News* from which he broke away to establish his rival paper. He raised money from his brother and friends, and brought in as first editor, Henry Sutherland Edwards, an experienced journalist from the *Illus-*trated Times, one of the papers which had published more daring subjects than the *Illustrated London News*. Edwards took with him to the *Graphic* his literary staff, though after a year, he was succeeded as editor by Arthur Locker. As founder and chief proprietor, Thomas remained actively involved with the visual side. He set standards, commissioned illustrations, paid well for good work and himself continued to engrave artists' work (*e.g.* cat. 42). He knew his way well round the art world for he was an accomplished watercolourist who regularly exhibited, and his wife was daughter of the marine painter J. W. Carmichael.[7]

Social realism was only one factor in the success of the *Graphic*. It was a general-interest magazine, and cheek by jowl with pictures of beggars and workmen were engravings of fancy balls, new town halls, royal visits and portraits of famous people. Social subjects were not regularly or consistently published. They grew less frequent in

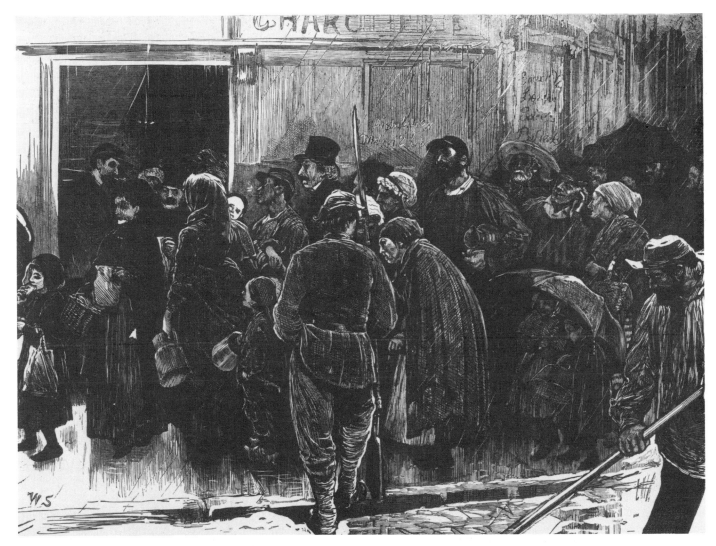

39. William Small, *A queue in Paris* (*Graphic* 1871), Rijksmuseum Vincent van Gogh, Amsterdam

the 1880s and one of the magazine's greatest and most typical later successes was a colour lithograph of Millais' sentimental portrait *Cherry Ripe*. The early success of the magazine was largely due to the outbreak of the Franco-Prussian War. A representative of the magazine in Paris sent over sketches, some conveyed by balloon, of civilian distress, which were engraved for the magazine, and devoured by an eager public throughout the war: a good example is *A queue in Paris* (cat. 39) by William Small. But the illustrations which became most famous were not, on the whole, related to news stories, though on one occasion Fildes worked all night drawing on the wood from a photograph of Napoleon III on his death bed.[8] Artists seem to have been allowed to choose their own

subjects: both Fildes and Holl wrote of wandering round the East End in search of material. But Thomas probably set general guidelines and even when artists were not treating immediately topical events, deadlines were important and according to Thomas, beneficial to the artists, who learned 'the qualities of speed, vigour and accuracy exacted by the circumstances of working for a publication like ours'.[9]

Subject-matter

The full-page engravings of which the *Graphic* made a feature showed a wide variety of subjects in which working-class life predominated. Only a selection can be

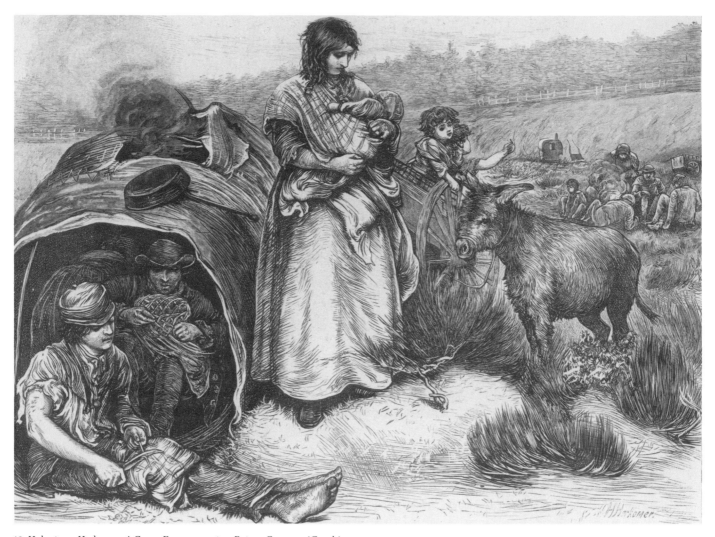

40. Hubert von Herkomer, *A Gypsy Encampment on Putney Common* (*Graphic* 1870), Manchester City Art Galleries

shown here. The dispossessed appeared in its pages from the beginning. Besides *Houseless and Hungry* (cat. 38), there was Herkomer's first engraving *A Gypsy Encampment on Putney Common* (cat. 40). This was a homage to Walker's *Vagrants* (cat. 36) and the text asked whether the gypsies were 'personified myths, endowed with nobility of character' or mere 'rogues and vagabonds'.[10] Herkomer, coming from an immigrant family, had a special interest in racial minorities otherwise neglected by artists and drew a touching *Sketch at a concert given to the poor Italians in London* (cat. 41). Criminals were also portrayed. The second number of the magazine included *Night Charges on their way to Court* by Arthur Boyd Houghton (cat. 42), a line of disreputable characters, drunks and pickpockets

escorted from their cells by policemen past a crowd of onlookers. A criminal was portrayed in *Heads of the People . . . – The British Rough* (cat. 43), an astonishingly frank and vivid character study, by William Small. The petty thief is not simply shown as a conventional portrait study, but his head is thrust into view by the hands of authority, firmly holding him still for the artist. This portrait is one of a series of 'Heads of the People', but the others are less unusual and show heroic and pious types, a miner, a coastguard and an agricultural worker reading the Bible.[11]

Several engravings feature not just working-class characters but types of shabby gentility, reduced to poverty. Holl's *At a Railway Station – a study* (cat. 44) shows

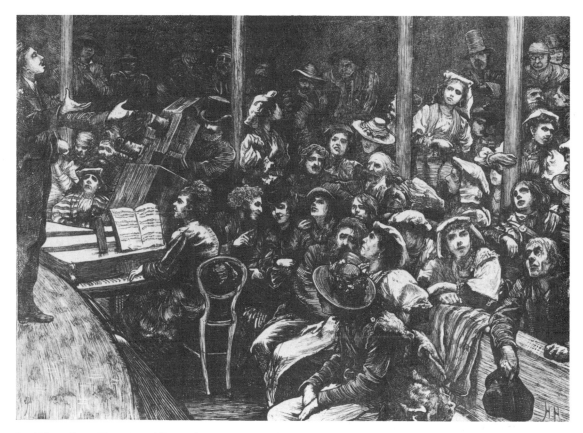

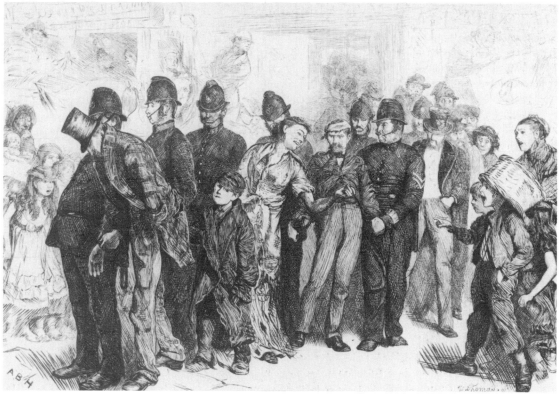

41. Hubert von Herkomer, *A sketch at a concert given to the poor Italians in London* (*Graphic* 1871), Rijksmuseum Vincent van Gogh, Amsterdam

42. Arthur Boyd Houghton, *Night Charges on their way to Court* (*Graphic* 1869), Manchester City Art Galleries

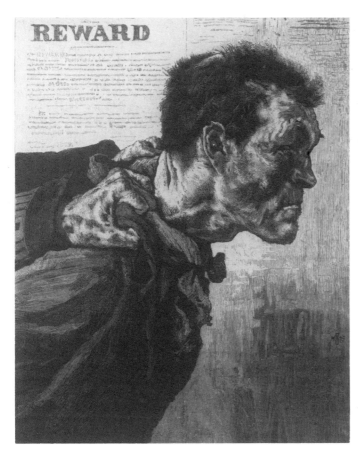

43. William Small, *Heads of the People drawn from life – 'The British Rough'* (*Graphic* 1875), Rijksmuseum Vincent van Gogh, Amsterdam

figures seated on a bench outside the third-class waiting room. A young soldier is saying goodbye to his parents, simple working people; next to them a governess is examining an empty purse. This was Holl's first work for the *Graphic* and he later turned it into a successful oil painting.[12] More pathetic still is *The Sisters* after a drawing by G. J. Pinwell (cat. 45) of a sombre room with two pinched-looking working girls. Van Gogh compared the sentiment of this engraving to 'the full warble of the nightingale on a spring night'. 'That drawing represents two women in black, in a dark room; one has just come home and is hanging her coat on the rack. The other is smelling a primrose on the table while picking up some white sewing . . . He was such a poet that he saw the sublime in the most ordinary commonplace things'.[13]

The magazine sometimes carried engravings of working men in industrial surroundings rarely depicted by artists. M. W. Ridley's *Pitmen hewing the Coal* (cat. 46) was one of a series about Durham miners.[14] Ridley's strong chiaro-scuro conveys the sweat and grime without false heroics. Ridley knew Whistler and Fantin-Latour and Van Gogh wrote of his 'Pits and Pitmen' series that they were 'done in a way that makes one think of the etchings of Whistler'.[15] Occasionally, instead of commissioning a drawing, the *Graphic* would engrave an existing oil painting, as in the case of Walker's *The Lost Path* (cat. 35) or R. W. Macbeth's, *A Lincolnshire Gang* (cat. 47) exhibited at the Royal Academy in 1876. This was inspired by newspaper accounts of the abuse of child labour in the Fens, and was therefore the kind of subject of interest to the magazine, which also published several engravings of strikes and workers' meetings.[16]

Working-class markets were another popular type of scene. Frederic Shields drew a well-known Manchester market, *The Old Clothes Market, Campfield, Manchester* which he later painted in watercolour as *Factory Girls at the Old Clothes Fair, Knott Mill* (cat. 48). (Knott Mill is the area of Manchester in which is situated Campfield, an open space which was the site of the Roman camp.) One of the chief features of this twice-weekly fair were the second-hand clothes stalls, all run traditionally by Irish women, where 'thread-bare garments, translated by the cunning hand of the cleaner and mender into a delusive freshness, are sold to the needy poor of the busy city'. Shields used to visit it to find costumes for use in some of his pictures.[17] Herkomer also painted a market scene in his picture of a Jewish East End market *Sunday trading, a sketch in Petticoat Lane*. This was prompted by the controversy over the question of trading on the Sabbath, also the subject of a Royal Academy picture by Fred Barnard, called *Saturday night in Seven Dials* (unlocated).[18]

Besides markets, the amusements of the poor were set before the readers of the *Graphic*: concerts, theatres and public houses. Charles Green's *A Sunday afternoon in a Gin Palace* (cat. 49) was printed with a companion picture *A Sunday afternoon in a Picture Gallery*, together subtitled 'Sunday as it is and as it might be'. Herkomer had previously shown the Bethnal Green Museum in *Art Connoisseurs at the East End*, but Green depicted the fashionable Grosvenor Gallery as an unlikely alternative to the attraction of drink.[19]

Perhaps the most commonly depicted subject was the charitable institution, usually a specific one as in Holl's *Shoemaking at the Philanthropic Society's Farm School at Redhill* (cat. 50). Reformed delinquents and vagrants are shown being trained at a trade. The text solicited contributions from readers; Holl's wife's family

44. Frank Holl, *At a Railway Station – a study* (*Graphic* 1872), Manchester City
Art Galleries

45. G. J. Pinwell, *The Sisters* (*Graphic* 1871), Rijksmuseum Vincent van Gogh,
Amsterdam

lived at Redhill, and this may have been why this particu-
lar reform school came to be featured. F. S. Walker's *'The
Young Ravens' – A Friday Dinner at Great Queen Street*
(cat. 51) shows a weekly dinner at a Ragged School which
was attended by pupils too poor to afford the School
Board fees. But it was the institutions for old people – the
Chelsea Hospital and the workhouse – which were chosen
by Herkomer (see cat. 79, 80). Some of his preparatory
work survives, so that an on-the-spot *Study of a Chelsea
Pensioner* (cat. 53) can be compared with the finished
engraving *Sunday at Chelsea Hospital* (cat. 52). Two
finished drawings *Old Age – A study in the Westminster
Union* (cat. 54) and *Christmas in a Workhouse* (cat. 55)
show how Herkomer's work looked before translated by
the engraver into print form; both these seem to represent
the final stage in the design before the transfer to the
wood-block.

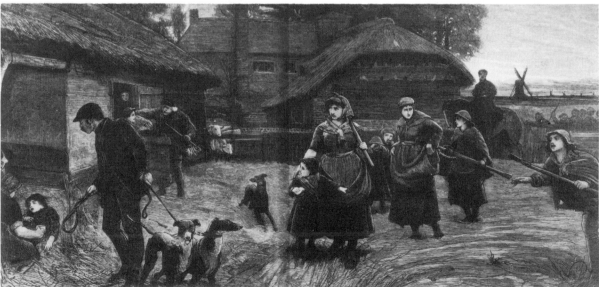

46. M. W. Ridley, *Pitmen heaving the Coal* (*Graphic* 1871), Rijksmuseum
Vincent van Gogh, Amsterdam

47. Robert Walker Macbeth, *A Lincolnshire Gang* (*Graphic* 1876), Manchester
City Art Galleries

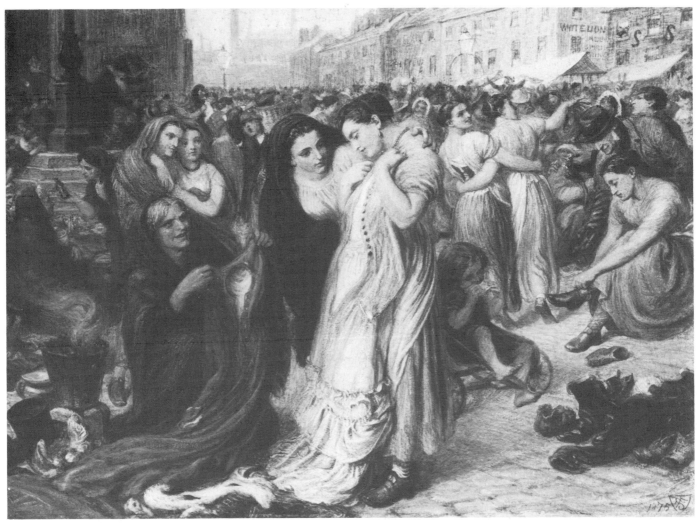

48. Frederic J. Shields, *Factory Girls at the Old Clothes Fair, Knott Mill, Manchester*, 1875, Manchester City Art Galleries

49. Charles Green, *A Sunday afternoon in a Gin Palace* (*Graphic* 1879), Rijksmuseum Vincent van Gogh, Amsterdam

Style

Though the *Graphic* made a feature of its illustrations showing working-class life, it was not the first to illustrate such subjects. Workhouses and hovels had appeared in the illustrations to Dickens, and in other magazines. But the *Graphic* gave these subjects firstly the large format of full-page or double-page illustrations, and secondly the human interest of the new style of art. Thomas shrewdly commissioned the younger generation of artists whose post Pre-Raphaelite training in realistic observation led them away from the melodrama and caricature of Cruikshank and Hablot K. Browne (cat. 6–10).

Working-class subjects in the *Graphic* were presented with a vivid sense of actuality. Because the subject-matter

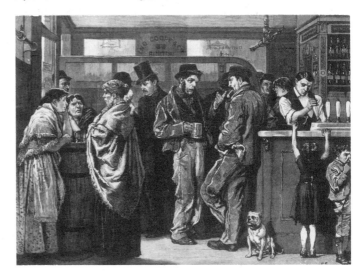

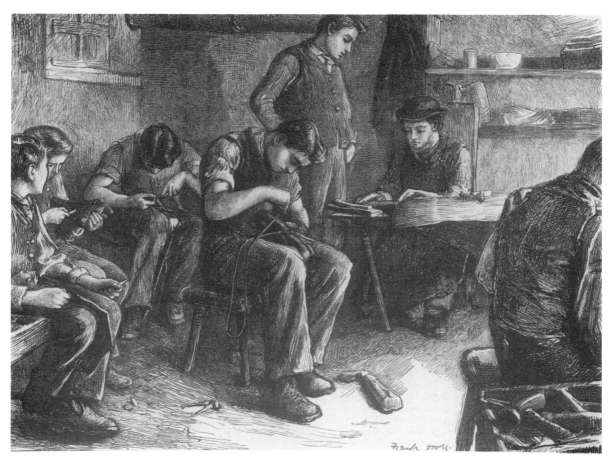

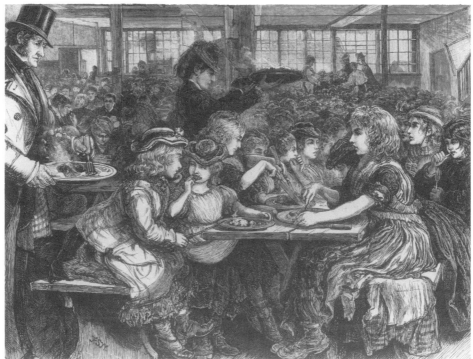

50. Frank Holl, *Shoemaking at the Philanthropic Society's Farm School at Redhill* (*Graphic* 1872), Rijksmuseum Vincent van Gogh, Amsterdam

51. Francis S. Walker, *'The Young Ravens' – A Friday Dinner at Great Queen Street* (*Graphic* 1872), Rijksmuseum Vincent van Gogh, Amsterdam

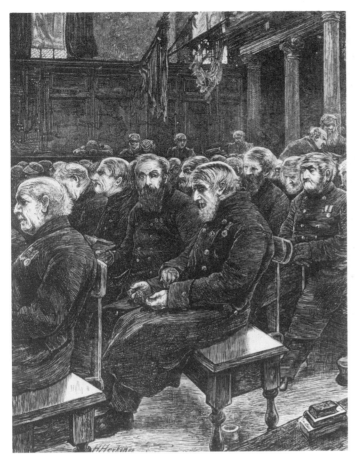

52. Hubert von Herkomer, *Sunday at Chelsea Hospital* (*Graphic* 1871), Rijksmuseum Vincent van Gogh, Amsterdam

53. Hubert von Herkomer, *Study of a Chelsea Pensioner for 'Sunday at Chelsea Hospital'*, 1877, Private Collection on loan to Watford Museum

was new, there were no patterns to follow, and first-hand observation was employed. The drawing of the figure was solid and well rounded, the compositions were often strongly designed with marked contrasts of light and shade, exploiting the densely hatched lines of the engravers, and dramatic effects of perspective were sometimes used. The observation of character was keen: portrait-like drawings of individuals, with attention given to nuances of facial expression, could elicit sympathy from spectators, investing a social problem with human interest. A favourite device to show a range of characters in a crowd was a queue or line of people, each a contrasting type. This was seen in Fildes' *Houseless and Hungry* (cat. 38) and was often repeated. Whether professional models or real street characters were employed, the impression given is of authenticity.

The *Graphic* engravings were quickly imitated, not least by the *Illustrated London News*, which published illustrations of social subjects of a high standard in the wake of its rival's example. Van Gogh admired and collected such engravings and most of those in this section come from his own collection. The success of the *Graphic* is further attested by the fact that it reprinted the best of its illustrations in book form. Its success was relatively short-lived; standards changed, techniques developed and artists moved on. As early as 1888 one writer was already mourning for a vanished freshness of vision. Of Herkomer, Fildes and others, Harry Quilter wrote: 'The best art which they have given us is not that which they produce today for two or three hundred guineas, but those early designs which they laboured wearily out upon the woodblocks, for a sum that would not now pay for the frame of their smallest picture'.[20]

By the late 1890s, photography had come into general use for news reporting, and already in the 1870s it had been used for social documentation (and sometimes social

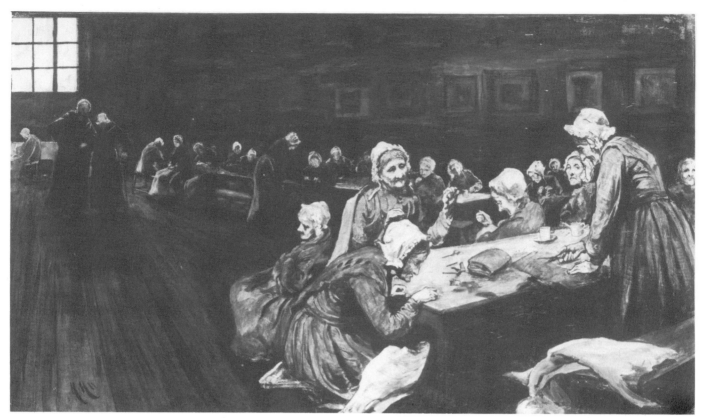

54. Hubert von Herkomer, *Old Age – a study at the Westminster Union*, 1877, Private Collection

55. Hubert von Herkomer, *Christmas in a Workhouse*, 1876, York City Art Gallery

propaganda), to set down the appearance of Dr Barnardo's orphans, or to record old housing before it was destroyed in slum clearance programmes.[21] But this was a very different thing from the *Graphic* engravings; though they were published in a journalistic context and though they incidentally recorded many aspects of working-class life, they were essentially works of art, not of record. They were conceived by artists to tell a story or to arouse the feelings and often the pity of readers. The same was true of the oil paintings they inspired. For the Victorian artist, truth was to be enhanced by sentiment and pathos.

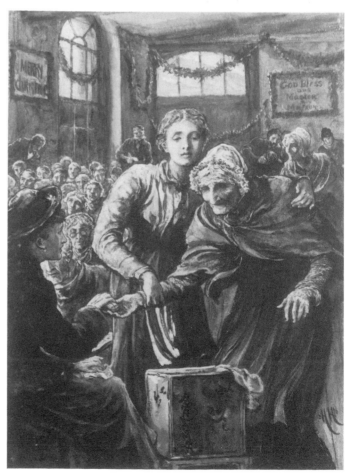

8 | Gustave Doré and Alphonse Legros

The two artists in this chapter were both Frenchmen who came to London, but there the resemblance ends. Doré spent a relatively short time in London, but made it the subject of the illustrated book, *London, A Pilgrimage*, published in 1872. This should be seen in the context of previous French views of London; Théodore Géricault had visited London in 1821 and made a series of prints which featured poverty in London, and in the late 1840s Gavarni published bitter caricatures of the London poor.[1] Doré's engravings, quite different, present a fantastic, theatrical view of the city. They make a significant contrast with the more sober documentary engravings published contemporaneously in the *Graphic*.

Legros came to London in 1863 and settled there for the rest of his life, anticipating the influx of French artists who came as political refugees from the Paris Commune in 1870, including Tissot, Dalou, Pissarro and Monet. Legros remained faithful to his French artistic upbringing: his work was entirely rural and French in subject-matter. But through his teaching he forms a link between the French realists of the mid-century and the younger British painters of the 1880s.

Gustave Doré

Gustave Doré was born in Strasbourg, made his reputation in Paris and first came to London in 1868 in connection with the English publication of his illustrated Bible. His books were already well-known in Britain, and in 1867 an exhibition of his paintings had been held in London. This led to the foundation of the Doré Gallery in New Bond Street where his sensational historical and religious fantasies were shown from 1869. On Doré's second visit, his friend the journalist Blanchard Jerrold suggested that they collaborate on a book about London. Doré signed a five-year contract with Grant & Co., the publishers. He was to come to London for two to three months each year, to make 250 designs and to be paid £10,000 per year. Doré travelled round the city with Jerrold making sketches and an album of finished drawings, probably including cat. 56, were shown at a party in Paris in summer 1869.[2] The work was interrupted by the Franco-Prussian War and by Doré's impatience with the need to re-draw his designs on wood-blocks for cutting by engravers. When he returned to England he brought an assistant, the engraver Bourdelin, who accompanied him on his ramblings. Doré did not make detailed drawings. 'I could seldom prevail upon him to make a sketch on the spot . . . notes of scenes . . . were the utmost he would take on the scene. He made his old answer: "J'ai beaucoup de collodion dans la tête"',[3] wrote his biographer. Doré's reliance on an allegedly photographic memory was supplemented by his assistant. Doré's notes, according to Bourdelin, were very summary. They 'served him for the composition of his blocks. I filled in backgrounds, houses or monuments, which he afterwards animated with his glowing, fanciful pencil'.[4] The project dragged on; Doré fell out with Jerrold and tried to be released from his contract, but eventually in 1872 *London, A Pilgrimage* appeared first in parts, then in one volume.

Though the book encompassed all aspects of London life – fashionable events, the City, Parliament, the river, working London and the underworld – its contents were not literal or documentary. Jerrold's text treated the city as a superficial spectacle, the reader being whisked from one novelty to the next without analysis or questioning. Jerrold and Doré relished not the everyday street scene, but the bizarre: the weird light of the opium den, the brewery where the men stood up to their necks in vats of malt, the dockland warehouses and railway viaducts transformed by exaggerated perspective into Piranesi-like stage sets, or the grotesque seller of second-hand clothes. The book is an imaginative creation; Doré's methods were not those of a literal observer and he saw the city in terms

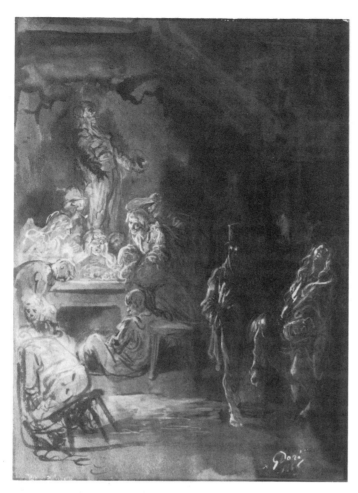

56. Gustave Doré, *Gray's Inn Lane – Robber's kitchen*, 1869, Private Collection

of contrasts, 'at the workhouse threshold or by the gates of a palace'. Like Doré's previous work, each scene either sparkles with the radiance of heaven or is seen in hell-like gloom.[5] The gloom is seen in a finished drawing, probably from the album of 1869, *Gray's Inn Lane – Robber's kitchen* (cat. 56). It shows a bravura of handling which was almost entirely destroyed in the mechanical engravings of the published work. *Gray's Inn Lane*, which appears in altered form in the book, as *Thieves Gambling*, shows a lurid thieves' kitchen with figures slumped over a card game, a drunk standing on the table and others performing a fantastic dance.

This was one of the places Doré visited under police escort. Two private detectives were placed at his disposal and went with him to the East End, to docks, night refuges and public houses.[6] *The Bull's Eye* (cat. 57) is one of a number of engravings of Whitechapel showing the dramatic circumstances in which Doré and his companions

visited these places. The poor are caught in the policeman's aggressive flash-light like a freak show. 'Low-browed ruffians and women who emphasise even their endearments with an oath, scowl at us in threatening groups as we pass, keeping carefully in the middle of the road. "Stick close together, gentlemen; this is a very rough part", our careful guides tell us.' The image emphasises the gulf between classes. 'We were to them as strange and amusing as Chinamen; and we were something more and worse. We were spies upon them; men of better luck whom they were bound to envy, and whose mere presence roused the rebel in them. A few of them, loitering about the Whitechapel Road, flung a parting sneer or oath at us, as we hailed a returning cab.'[7]

Another striking image of social separation is *Newgate, Exercise Yard* (cat. 58), the prisoners walking in a relentless circle in a bleak stone courtyard while the gentlemen warders stand nonchalantly in a corner. Jerrold described Doré's reliance on his memory during their visit to Newgate: 'He declined to make a sketch . . . he asked the turnkey who accompanied us, to leave him for a few minutes at an opening that commanded a view of the yard. When we returned to him he had not used his pencil, but his eye had taken in every detail of the scene . . . The next day we met he laid before me his circle of prisoners. It was a chain of portraits from the poor frightened little postman who had succumbed to temptation in his poverty, to the tall officer who had cheated a widow out of her last mite.'[8] But it is not individual portraits which give the image its power, for the figures are generalised in the engraving, but the inhumanity of the circle of prisoners, presented without comment or comforting moral or narrative clues as to past or future, a very different attitude to that behind other prison scenes of the period (cat. 73, 88).[9]

Van Gogh knew the *Newgate* engraving, for in 1890 while at the asylum in St Remy, he made a copy of it (Pushkin Museum, Moscow). He had written in 1882, 'the other day, I saw a complete set of Doré's pictures of London. I tell you it is superb, and noble in sentiment – for instance that room in the 'Night Shelter for Beggars.'[10] This must refer to Doré's *Scripture Reader in a Night Refuge* (cat. 59), a drawing of the Field Lane Night Refuge showing in Jerrold's words 'the dormitories set out like barracks, and warmed with a stove, which is always the centre of attraction. Here, when all are in bed, a Bible-reader reads, comforting, let us hope, many of the aching heads.'[11] In contrast with the pious description of Jerrold and the emotional reaction of Van Gogh, Doré, perhaps unconsciously, again illustrates a gulf between the needs

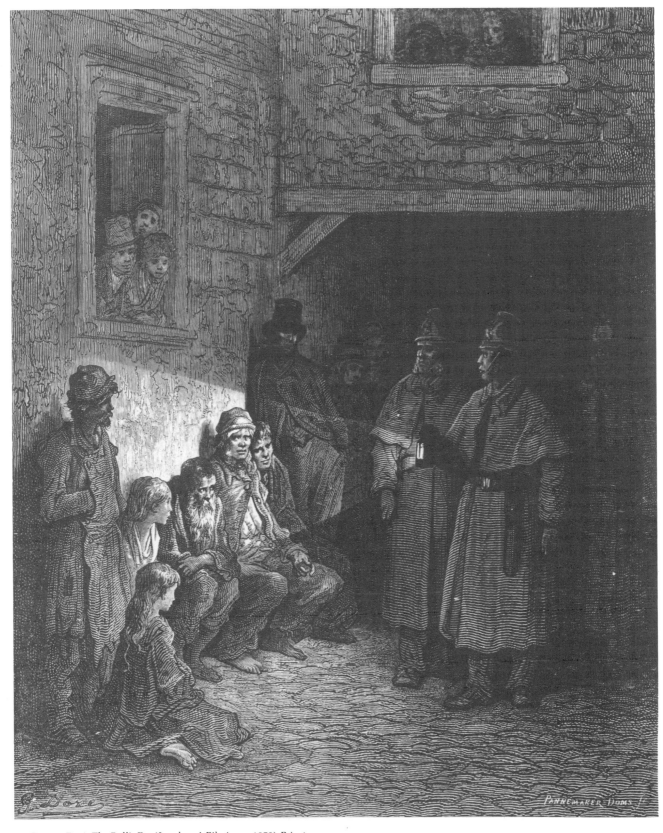

57. Gustave Doré, *The Bull's Eye* (*London, A Pilgrimage* 1872), Private
Collection

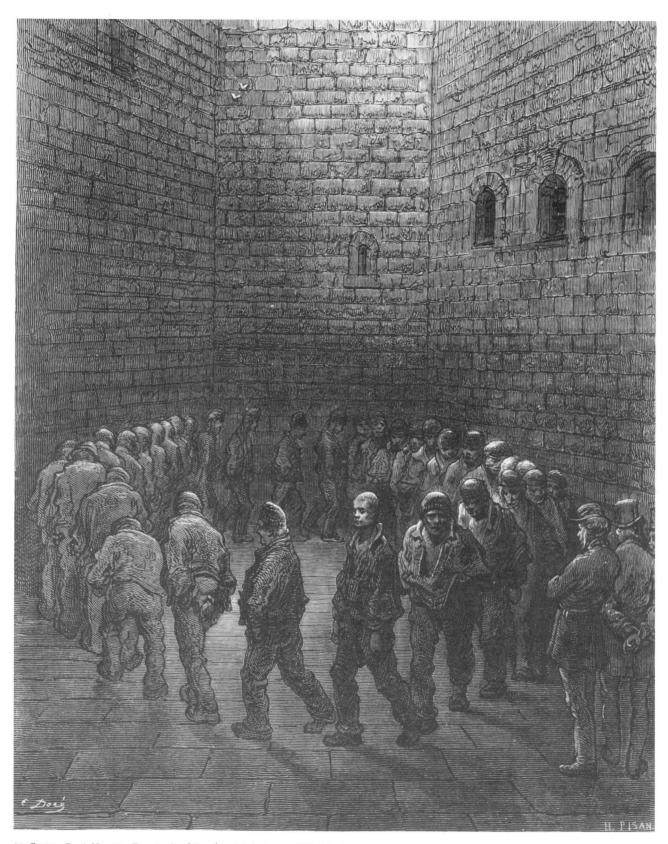

58. Gustave Doré, *Newgate, Exercise Yard* (*London, A Pilgrimage* 1872), Private
Collection

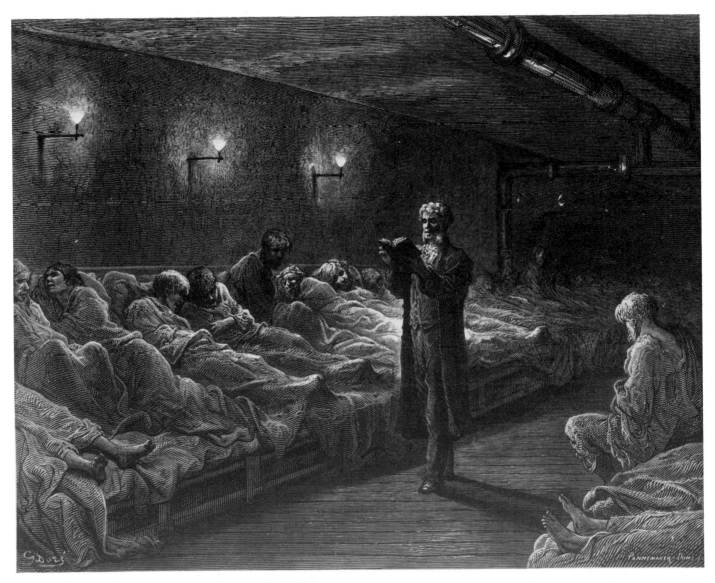

59. Gustave Doré, *Scripture Reader in a Night Refuge* (London, A Pilgrimage 1872), Private Collection

of the homeless and their treatment by the authorities. He has made the faces of the inmates desperately unhappy, and their bodies look restless. Few are listening to the reader. Charles Booth, writing a little later, condemned the official casual wards (admittedly not quite the same thing as the voluntary charitable refuge depicted by Doré) with the words 'there you are taken in and provided for on the principle of making it as disagreeable as possible for yourself, in order to deter you from again accepting the hospitality of the rates'.[12] Doré also drew a view of down-and-outs waiting outside a refuge, a scene inspired

by Fildes' *Houseless and Hungry* (cat. 38) which appeared in the *Graphic* whilst Doré was preparing his book.

Jerrold's last chapter, 'London Charity' is headed by an image of a stone seat on London Bridge, *Asleep under the Stars* (cat. 60). 'He had been deeply impressed with the groups of poor women and children we had seen upon the stone seats of the bridge one bright morning on our way to Shadwell. By night it appeared to his imagination the scene would have a mournful grandeur.'[13] The original sketch for this[14] has an angel seated on the parapet of the bridge but in the published illustration, the angel is shown

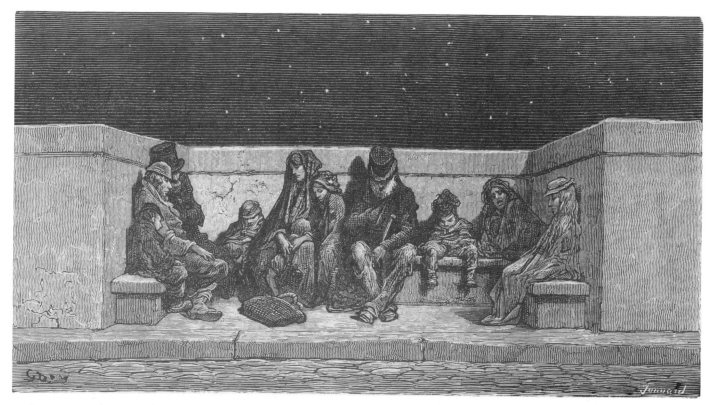

60. Gustave Doré, *Asleep under the Stars* (*London, A Pilgrimage* 1872),
Private Collection

in a separate vignette, knocking on a door, and carrying an
infant. The inclusion of the Angel of Charity shows that
even in an ostensibly realistic work, Doré could not resist
his penchant for allegory and fantasy.

In the design for a different book, the title-page to
Hood's *Poetical Works* (cat. 61), realism is abandoned
completely. The frontispiece shows the woman contem-
plating suicide from Hood's poem *The Bridge of Sighs*,
which had inspired Watts' painting of *c.* 1850 (cat. 14).
Doré places her on a parapet of impossibly exaggerated
scale, against a lurid backdrop of St Paul's, recalling the
heightened language of Hood's verse:

Glad to death's mystery, Swift to be hurl'd,
Anywhere, anywhere out of the World!

Alphonse Legros

Legros was born in Dijon. He studied art there and in Paris,
where his principal teacher was Lecoq de Boisbaudran,
who stressed the training of the visual memory, challeng-
ing official academic methods. Legros became close to
Fantin-Latour and Whistler, and though he exhibited at

61. Gustave Doré, *Glad to death's mystery, swift to be hurl'd, Anywhere,
anywhere out of the world*, 1871, Victoria & Albert Museum

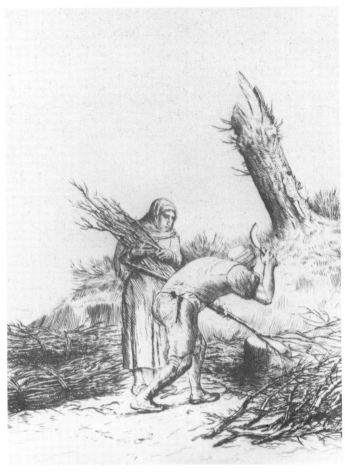

62. Alphonse Legros, *The Vagabond's Death*, Manchester City Art Galleries

63. Alphonse Legros, *The Faggot Makers*, Manchester City Art Galleries

the Salon, in 1863 he decided to settle in London, where
Whistler and Seymour Haden had helped sell his etchings.
He continued to show in Paris whilst also exhibiting at the
Royal Academy; his subjects were always French rural
and peasant themes, deeply affected by the monumental
and solid qualities of the Old Masters as well as by French
realism. 'To this former disciple of Courbet', wrote Charles
Ricketts, 'the harmony expressed by the divine Raphael,
Holbein and Poussin counted most. Discipline, balance,
design, a hatred of all exaggeration – such were the sober
virtues he valued and strove for . . . classed in dictionaries
as a realistic painter, he is in temper a classicist – an
unfrocked classicist if you will . . .'.[15]

His early work had the stark simplicity and interest in
commonplace subject-matter of Courbet and it is in this
sense that he was a realist. But he must have been totally
antipathetic to the minute surface realism of the Pre-
Raphaelites, or to the topical social realist set pieces of

Fildes and Holl. In the 1870s his work must have appeared
very out of touch in its austerity and refusal to be bound by
fashion.

Legros' chief importance was as a teacher. His oils were
bought by influential London patrons, such as George
Howard and Constantine Ionides, and his etchings were
widely admired, but through his teaching positions he
influenced the younger generation of artists, many of
whom were important in the formation of the New English
Art Club in 1887. These included H. H. La Thangue, Ernest
Sichel and Fred Brown (cat. 93, 94 and 96). From 1875,
Legros taught etching at the South Kensington Schools of
Design, and in 1876 was appointed Slade Professor of Fine
Art, University College London.

Tramps and wanderers were a frequent subject of
Legros; this is a continuation of the subject-matter of
French realism rather than a comment on current social
problems in England as painted by the English (see cat. 82).

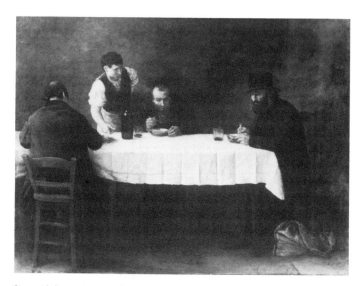

fig. 7. Alphonse Legros, *The Poor at Meat*, 1878, Tate Gallery

Legros showed a painting of a tramp sleeping under a tree, *The Close of Day* (Sunderland Art Gallery) at the Grosvenor Gallery in 1878. A more brutal and arresting version of this theme is *The Vagabond's Death (La Mort du Vagabond)* (cat. 62). Here the tramp lies not merely exhausted but in the stiff attitude of death, by a barren and equally angular windswept tree. This theme fascinated Legros and in several other etchings he includes the symbolic figure of Death with a scythe, beckoning to a peasant or labourer, as in the three versions of *Death and the Woodcutter*, probably influenced by Millet's etching of the same title.[16]

Millet's influence is also seen in Legros' etchings of field-workers, such as *The Faggot Makers (Les faiseurs de fagots)* (cat. 63) which, a later critic wrote, expressed 'the woman's attitude of dull submission, the daily monotony of labour by which she and her man manage to scrape a living, the open-air healthiness of it, promising an old age still toiling for a bare pittance'.[17] The relentless gloom recalls Cosmo Monkhouses's description of the etchings: 'His eight huge portfolios do not contain one scene of happiness or a face that smiles . . . It is to be doubted whether even his gloomy view of the life of the poor can be accounted for entirely by his experience. He gives us their labour in the fields, but never their laugh at the cabaret; he paints their fasts and death beds, but never their marriages and festivals. His bathers are depressed, his fishers out of spirits, his travellers either tired or caught in the rain. Millet was always grave, but his gravity was always sweet. The sadness of Legros is sometimes grim and terrible.'[18]

Even though Legros' work showed rural France, and was not intended as contemporary social comment, it was interpreted as such. His *The Poor at Meat* (*Le Repas des Pauvres*, Tate Gallery; fig. 7), shown at the Grosvenor Gallery in 1878, depicted, according to *The Times*, 'the hungry shabby diners in a café borgne, Communists or criminals . . . It is impossible to conceive anything more grim, sordid and even repulsive than the subject of this picture; but its strong, truthful direct knowledge lifts it into the region of art, and we find ourselves asking the question before it, is this the outcome of our civilization for hundreds of thousands in our great cities?'[19]

9 | Frank Holl: 'the graver, greyer aspect of life'

When Frank Holl died at the age of forty-three in 1888 he was painting portraits at the gruelling rate of twenty a year. He had become one of the most fashionable and successful portraitists, inundated with commissions to paint prominent people in his literal yet forceful manner. Success brought wealth: he commissioned Norman Shaw to build not just one, but two houses in the Queen Anne style, 'Three Gables', his studio house in Hampstead and 'Burrow's Cross', a country retreat near Gomshall, Surrey.[1] But success became a treadmill of intolerable pressure. 'It was simply the race for success, wealth and fame which brought poor Frank Holl to the grave', wrote Harry Quilter.[2] Described by his daughter as outwardly cold and reticent, Holl 'threw into his art all the passion and smouldering intensity which found so little outlet in his social relationships'. One of his obituarists wrote that the portraits 'were painted under stress of excitement, for the artist used to say that unless he put his whole force into a picture he could not work at all'. Incapable of letting go, even after a nervous breakdown about one year before he died, he defied doctor's orders by finishing two important portraits and commencing a third; he was killed by overwork at the height of his powers.[3]

Yet his success as a portraitist only dated from 1879. Until then, his reputation had been as a subject painter, with a preference for lugubrious themes, treated with sombre colouring and harsh chiaroscuro. Though critics carped, his tragic and emotional subjects found success with the public. Quilter summed up Holl's achievement in a passage prophetic of the kitchen sink school of the 1950s and hinting at his contribution to the modern sensibility in art. 'Here was a painter who deliberately set himself to harrow our feelings . . . Anything more dreary and depressing than the two pictures above mentioned [fig. 4 and cat. 64] is not to be found in the whole range of art ancient or modern . . . Yet these were genuine and in one sense, almost great pictures; they struck a note in modern art

which may possibly rise to be the dominant one. The traditions of the schools are dying away; the costume art is dying fast, and it is pictures like these which devote unsparing power to the facts of everyday life that are hastening the change.'[4]

Mourning subjects

Holl was born in 1845 in London. His great-grandfather, grandfather and father were all engravers of repute, and the boy showed early aptitude for art. At fifteen, he entered the RA Schools where he won a silver medal in 1862, a gold in 1863 and a travelling scholarship in 1868. Two things are significant about his early career. In the first place, though some of his early work was of conventional subject-matter (the gold medal was for a biblical scene) much of it was already in the sombre vein for which he first became famous, as in the picture of a miserable beggar-woman and child which was bought by a Rochdale cotton-merchant named Schofield.[5] The sad character of his subjects must be due to his upbringing which was marked by narrowness and frugality. He was a lonely child, delicate and often ailing.[6] Not permitted many toys, and shunning the society of boys of his own age, he worked tenaciously at his drawing: the over-conscientious and determined attitude to his work which finally killed him was present from the start.

Secondly, the travelling scholarship, which he won for *The Lord gave and the Lord hath taken away* (cat. 64) had a peculiar outcome. Holl had once been to Italy on a sketching tour with a fellow student, F. W. Topham, but it had been cut short because of a cholera epidemic in Naples and Capri.[7] After winning his scholarship Holl was able to travel again, this time taking with him his wife, Annie Davidson, a niece of F. W. Topham: they had married in 1867. By way of Paris, where they visited the Louvre, Basle, Lucerne and Milan, they arrived at Venice

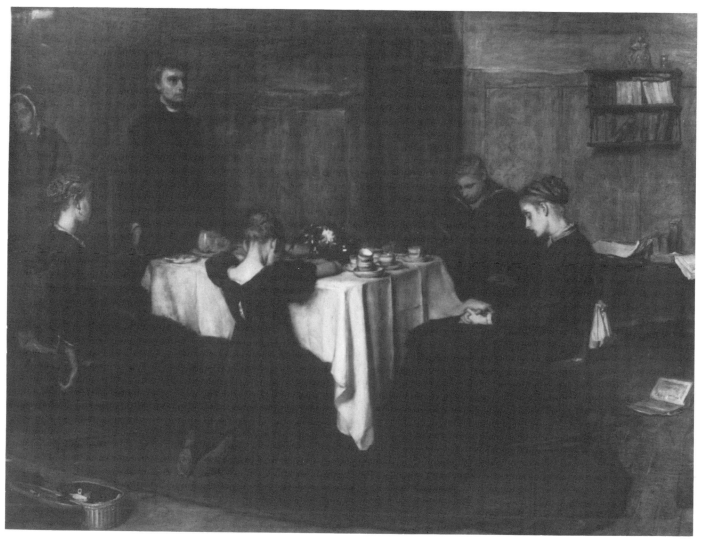

64. Frank Holl, *The Lord gave and the Lord hath taken away*, 1869, Guildhall Art Gallery, City of London

where they were greeted by Topham. There Holl admired and copied Tintoretto. He did not, according to his daughter, 'regard the Travelling Studentship as do most young artists – as an opportunity for studying the architecture and painting of the past – but that his first concern was always with the life of the present, either to like or dislike it'. After two months, he decided he did not like it: 'the southern picturesque was a little too obvious to his graver temperament'.[8] He cut short his scholarship, sent his resignation to the Academy and returned to England via Munich, Cologne and Antwerp. Of all the places and picture galleries visited, it was only Antwerp with which he felt any sympathy. In Italy he felt out of place: 'he knew Italy must be a closed book henceforth, so far as his own individual conception of Art was concerned.'[9] His wife wrote that 'all of Holland and the Netherlands have ever been most dear to us both, and in after years we were always ready on the first excuse to run over to our beloved 'boors', their wonderful pictures, their quaint scenery and picturesque towns, and lovable and unspoilt simplicity of way of life'.[10] His interest in Jozef Israels has already been noted. Holl was a Northener by temperament, and spent many holidays in North Wales, which he first visited in 1863. His daughter heard him say over and over again, 'give me a grey day', and she noted that though he was not a morose man he possessed 'a somewhat morbid strain, or, rather, an unconscious preference for the graver, greyer aspect of life'.[11]

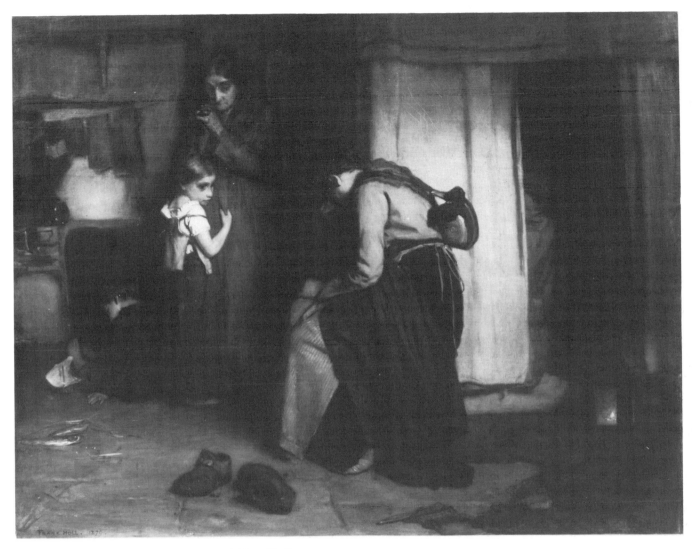

65. Frank Holl, *No Tidings from the Sea*, 1870, Her Majesty The Queen

This preference was in evidence in his first big success, *The Lord gave and the Lord hath taken away; blessed be the name of the Lord* (cat. 64), which not only earned him the travelling scholarship, but was very soon sold, before being exhibited; it was bought by Fred Pawle, a friend of Holl's wife's parents. Furthermore, at the Academy, it attracted favourable attention: 'its pathos is profound and genuine. How rarely are we able to write this!' was one of several approving notices.[12]

The title comes from Job, i, 21, but the subject is from Mrs Craik's novel of 1851, *The Head of the Family*, which opens with the reunion of a family after the death of the father. 'They gathered round the table – Lindsay sitting where she had presided for some years as mistress of her father's household. Opposite to her was that father's empty chair. Each glanced that way, and then all eyes were lowered. None looked up, and all kept silence as Ninian came in and took the vacant place. There was a pause – as if each waited for the ever-silenced voice; and then Ninian, in his low, quiet tones, said the grace: "Lord, we thank thee for these and all thy mercies; and forgive us our sins, for Christ's sake. Amen." And all felt this to be the token whereby their brother took upon himself the duties, responsibilities and rights of eldership, and became henceforth the Head of the Family.'[13] All are in mourning clothes, and despite some richness of colour in the flesh tints and in the details of still life and setting, the general impression is drab. *The Times* commented that

'everything indicates a long struggle of education and refinement with the most pinching poverty'.[14]

The subject might almost have been calculated to appeal to Queen Victoria, still in mourning for the head of her own family. Seeing Holl's painting at the 1869 Academy, she wished to buy it, but Pawle absolutely refused to give it up. The Queen therefore commissioned another picture from Holl, giving him a free choice of subject.[15] The result was *No Tidings from the Sea* (cat. 65), shown in 1871, another dark and mournful scene suggesting the nearness of death but this time moving down the social scale to depict the poor people of his mature work. It was painted after a two-month stay in the village of Cullercoats on the Northumberland coast and it is significant that Holl came here the year after his unsuccessful Italian journey. It is very likely that he was modelling himself on Jozef Israels who had also sought inspiration in the daily lives of primitive fisherfolk, living among them to observe their ways. One night, according to his daughter, the boats had been out after a terrible storm and some did not return. Working in one of the cottages, Holl witnessed a woman 'with hair dishevelled, and wild eyes . . . muttering and moaning distractedly, wandering from door to window, from window to door, half mad with suspense and misery . . .'. Holl 'was greatly moved and upset at the sight of her grief, terribly primitive in its intensity, which haunted him for days, finally resolving itself into a conception for a picture . . .'.[16]

In the little cottage, the teapot is on the hob and the bed is ready, but the husband will not return. The woman has come in from her lamplit vigil, her bonnet still hanging down her back, and she sits bent over the back of a chair weeping. There is a slight awkwardness in her pose and also those of the clinging child and the old woman shrinking into the background. Yet the image is still a poignant one.

Holl's subject was not particularly original. Long before Israels had depicted such scenes, Richard Redgrave's *Bad News from the Sea*, RA 1842, had shown a sailor's wife hesitating to open a letter with a black seal and *Break, Break, Break* by C. J. Lewis, RA 1862, had a fisherman's wife looking through a window at the sea. At the 1871 Academy there were besides the Holl five other scenes of Cullercoats fisherfolk by English painters.[17] Yet Holl gave the subject a new tragic and emotional force. His treatment anticipated a type of picture which became almost commonplace in England in the 1880s and 1890s, with the advent of the Newlyn School (cat. 92); and it is noteworthy that it was to Cullercoats, not Newlyn, that the American painter Winslow Homer came in 1881 to observe the notorious shipwrecks and the plight of the fishermen's wives.[18]

Holl's picture was completed on 31 October 1870, despatched to Windsor and approved by the Queen, who paid 100 guineas for it; Fred Pawle had paid £262 for *The Lord gave . . .* But in 1872, Holl was able to get 400 guineas from the Yorkshireman, James Akroyd, for the admittedly larger *I am the Resurrection and the Life*, another mourning subject[19] (fig. 4). His fame was growing.

London subjects

Holl began to work for the *Graphic* in December 1871 at the suggestion of J. D. Linton, and his first drawing *At a Railway Station* (cat. 44) appeared on 10 February 1862. In that Holl had already achieved success as a painter, he was different from the other principal *Graphic* artists: both Fildes and Herkomer made their names with illustration and only later turned to painting, but for Holl life as a painter was precarious, and the steady source of income afforded by working for the weekly paper was especially welcome to one who lacked self-confidence. He worked for the *Graphic* for over five years, and benefited from the discipline of working to a deadline. It concentrated his ideas, corrected his tendency to worry at a design and forced him to carry through what he had begun; 'the mere fact of having to have the block ready to the moment when the "Graphic" messenger presented himself at the studio door gave him the necessary impetus'.[20]

Holl was able to rework his more successful drawings into Royal Academy pictures. His first *Graphic* etching (cat. 44) became *A Seat in a Railway Station–Third Class* (Private Collection) shown at the RA in 1873. Another subject which began as a *Graphic* illustration and was later painted in oils was *Deserted–A Foundling*, of 1874. The exhibited painting is lost, but the oil sketch survives (cat. 66): it has a bravura of touch usually lacking in Holl's finished paintings and its rich colour reflects the finished work which is known to have been warmer in colour than usual. Of an early painting, Frith had prophetically remarked to Holl's father, 'Yes, Holl, it is clever but he will never be a colourist'. Much of his work has a sooty blackness in the shadows which was often seized upon by critics.[21] *Deserted* may well have been a self-conscious attempt to remedy this. If so, it was not a lasting change.

The scene is Bankside, in the London docks. Like Doré and Fildes, Holl used to prowl around the East End of

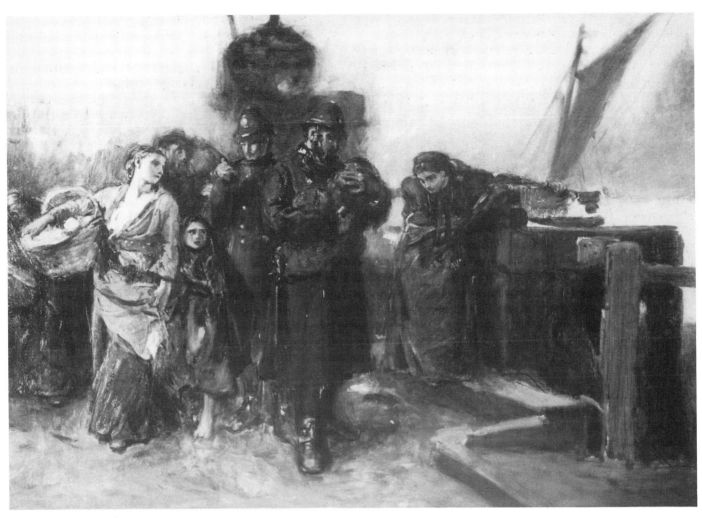

66. Frank Holl, *Study for 'Deserted – A Foundling'*, 1874, Private Collection

London in search of subjects. In company with C. E. Johnson, an artist friend, Holl saw a baby abandoned by its mother and discovered by a policeman. The *Graphic* commentary runs: 'The wretched mother, evidently the woman leaning on the post, had left it carefully wrapped up, hoping that someone would find it and cherish it. As for herself, she had intended to end her earthly woes in the dark, sullen river, but the sight of her baby in the arms of the policeman re-arouses her motherly instincts.'[22] Evidently the figure of the mother gave Holl some trouble: in the illustration and the oil sketch she is on the right, but in the exhibited oil she was moved to the left and further back. Nevertheless, the critics felt that the figure of the mother was too obvious: 'The real mother is apparent enough to the spectator in the poor creature sobbing . . .

who must have been "spotted" by any policeman less blind than a pantomime "Bobby".'[23]

On the other hand Van Gogh, who admired the engraving, did not comment on the mother. His description of the scene runs, 'It represents some policemen in their waterproof capes who have picked up a baby exposed among the beams and planks of the Thames embankment. Some inquisitive people are looking on, and in the background one sees the grey silhouette of the town through the mist.' The way he picked out details such as the waterproof capes and the misty silhouette suggest he saw the image as a nostalgic one: of this and other engravings he wrote: 'When I was looking them over, all my memories of London ten years ago came back to me – when I saw them for the first time; they moved me so deeply that I have been

thinking about them ever since, for instance Holl's "The Foundling" . . .'.[24]

This is a very different approach from that of the English commentators, who read the image in narrative and moral terms. The *Graphic* having described the story drew from it a conventional message. 'Those who from weakness, or passion, or a mistaken sense of what is due to an ardent lover, yield to such temptations, are sure to be visited with remorse, wretchedness, too often with utter ruin. The man, though generally the chief offender, frequently escapes, as far as his world is concerned, scot-free, while the burden of the sin falls on the feebler partner in his transgression.' Holl's policeman comes across as a father figure of beneficent authority, wrapping the infant in his cape and looking at his bundle, according to *The Times*, 'with the eye of a man who has babies of his own', while the woman with a basket looks on with sympathy. How different is Doré's policeman in the East End (see cat. 56), an aggressive and threatening presence in a sullen and hostile crowd.

The two exhibited oils, *A Seat in a Railway Station– Third Class* and *Deserted–a Foundling* were bought from Holl for 220 guineas and 800 guineas respectively by Holl's brother-in-law, Captain Henry Hill of Brighton. Hill also bought *The Song of the Shirt* (cat. 67 and colour plate III after p. 12). There is no record that this was exhibited and it may have been that he obtained it straight from the artist's studio in 1874. Hill owned works by Degas, who probably visited him in Brighton in the 1870s.[25] It is tempting to see a connection between Degas' paintings of weary laundresses and Holl's depiction of exhausted sempstresses. In a drab interior enlivened only by a bunch of flowers and a print on the wall, three girls are seated at their work. One threads a needle, the other stitches intently. The third is not working: with head downcast, hands resting lightly before her, one on the table, the other loosely holding a pair of scissors in her lap, she has sunk into an exhausted sleep – or is it death? Holl's depiction of the girl is ambiguous. Its gentle sadness should be contrasted with the earlier pictures of sempstresses, single figures, eyes enlarged and upraised in theatrical sorrow.

Further London ramblings with C. E. Johnson led to the discovery of a pawnbroker's shop in Camden Town, used as the setting for a lost painting of 1873, *Want–her poverty but not her will consents*, showing a woman hesitantly offering her wedding ring to the pawnbroker and his clerk, who look on with pity for her shame.[26] Nearby this shop was a humble chemist's, which provided the subject for another oil, *Doubtful Hope*, 1875 (cat. 68 and colour plate

IV after p. 12). A woman with a baby wrapped in a bundle of rags on her lap sits waiting for the chemist to mix up some medicine. The details of the interior, with its wooden fittings, its rows of jars, bottles and flasks, were painted from elaborate on-the-spot studies made after obtaining reluctant permission from the owners.[27] The focus is on the facial expressions: the pharmacist, intent on measuring out the prescription, the clerk routinely writing out the bill, and above all the anxious mother whose face expresses so pathetically concern for her child; will it live or die?

Gone (cat. 69) another work based on Holl's exploration of London, originally appeared as a *Graphic* illustration, *'Gone'–Euston Station* (19 February 1876), with text identifying the subject precisely as the departure of emigrants on the 9.15 pm train for Liverpool, 1875. A group of women and children stand on the platform as the train bearing their menfolk to Ireland steams out of the station. The *Graphic* published several scenes of emigrants leaving by ship, mostly crowded, lively pictures of the excitement as well as the pain of departure.[28] The scene at the railway station is one entirely of sadness. Typically, Holl

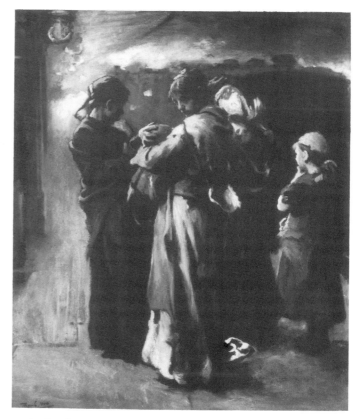

69. Frank Holl, *Gone*, 1877, Geffrye Museum

concentrates on the plight of the less fortunate: 'The comparatively well-to-do classes who go to India or the colonies generally hope and intend to return home again, but to the poor the parting is generally forever – as far as this life is concerned'. Holl's first *Graphic* subject (cat. 44) also showed figures on a station platform, but the individuality of the different characters and the precisely rendered setting have given way in the later work to a more atmospheric evocation of the grief of parting and the 'misty, steamy appearance which railway platforms present, particularly at night, when trains go out'. 'It is fraught with feeling' wrote *The Times* of the oil version exhibited at Tooths in 1877.[29] Van Gogh admired Holl's engraving and was struck by the woman with the baby, whose character he likened to that of Sien (see cat. 104).[30]

Maternal grief

Many of Holl's pictures deal with mothers and children, and several of these show the mother grieving over a child's death. In the Victorian period infant mortality was high and there was nothing unusual about such a sight. On the other hand, Holl's pictures on this theme are not meant to be specifically modern; he treated the subject of maternal grief as a universal one. Even so, critics questioned its suitability for art. Holl had painted a child's funeral in *I am the Resurrection and the Life*, RA 1872 (fig. 4), and returned to the subject in 1876 with *Her First Born* (Dundee Art Gallery) set in Shere churchyard, Surrey. It shows a procession of mourners led by four young girls bearing the tiny coffin in a white pall. Behind are the besmocked father and grandfather and in the centre the weeping mother, 'almost fainting under her grief'. 'Mr

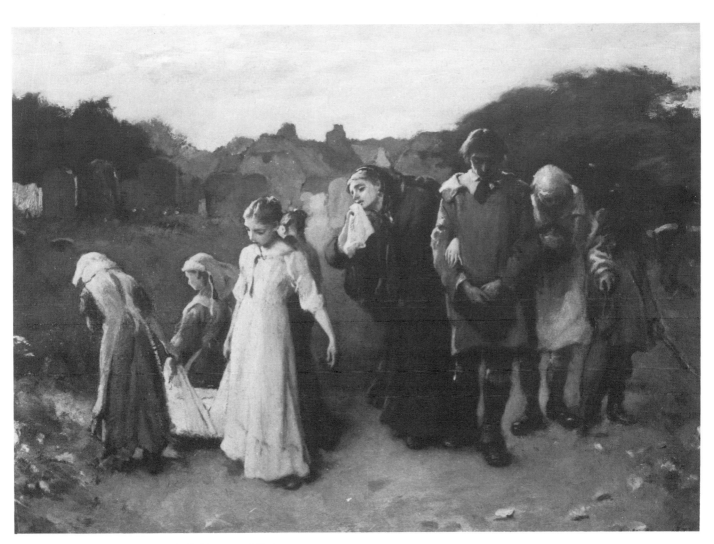

70. Frank Holl, *Her First Born*, 1877, Sheffield City Art Galleries

Holl, we are sure, never painted better or made the onlooker sadder', wrote the *Art Journal* of the exhibited picture.[31] The small replica (cat. 70) is beautifully and freely handled in dull, subdued colours, with touches of pink, yellow and blue, but the faces of the three main figures are more highly finished. By this date such subjects were not uncommon: other examples at the 1876 Academy were Fildes' *The Widower* (cat. 76), Herkomer's *At Death's Door* (Private Collection), J. Morgan's *Sown in dishonour, it shall be raised in glory*, F. D. Hardy's *Fatherless* and F. Morgan's *Whither?* (all unlocated). The *Graphic* critic wrote of the Holl: 'Who would choose to live in constant contemplation of such a domestic tragedy? The choice of such subjects is surely a mistake, and is one far too prevalent just now, to judge by the amount of "agony" piled up in this exhibition.'[32]

Holl's mournful subjects, however, continued. A group of cottage subjects of the late 1870s and early 1880s which, like *No Tidings from the Sea* (cat. 65) anticipate the more familiar fishermen's cabins of Newlyn, share the same setting, a cottage at Criccieth in North Wales. Holidaying there in 1876, Holl took shelter from the rain in a little hut owned by a young widow who lived there with two children, one still a baby. Holl's daughter recalled: 'The woman had scarcely any English, but her magnificent build and presence at once inspired my father with the idea of a large composition. She was of a massive and almost savage type, living quite alone with her children, and seeing no-one for weeks together.'[33] In the next few years, Holl painted several pictures of her in her cottage. The most moving, painted in 1877, is the small pair entitled *Hush!* and *Hushed* (cat. 71, 72). In the first of these the mother rocks her sick baby to sleep in its cradle whilst the elder child stands by. In the second the cradle is still; the mother, overcome with grief, has buried her head in her arms and the child stands close to its mother in touching bewilderment. The colours are drab, and Holl's handling of paint has an idiosyncratic softness which suits the muted tenderness of the subject.

Unconsciously or not, in these pictures of a mother grieving over a child in a dark cottage interior, Holl is recalling the work of Israels. Many of Holl's other pictures of this period re-use elements derived from the Dutch master: the cottage interior, the deep window sill, the cradle, the statuesque figure of the woman, the half-hidden weeping face.[34] At this time, Holl was experimenting with portrait painting; the likeness of the *Samuel Cousins* shown at the RA in 1879 was his first great public success in this field.[35] As fame and wealth beckoned and his energies were thrown more and more into portraiture, it is not surprising that a certain repetitiveness crept into his subject pictures, until inspiration dried up altogether.

Newgate

Holl's greatest social realist picture just pre-dates his switch to portraiture. It is a London subject, based on scenes witnessed by the artist and is the largest work he painted: its scale gives it an epic quality. *Newgate– Committed for Trial* (cat. 73) shown at the Academy of 1878, had its origin in the friendship between the artist and Sidney Smith, Governor of Newgate, who invited Holl to visit the prison, perhaps knowing of his humanitarian interests. The visit took place several years before the picture was painted. 'I shall never forget the impression it made upon me!', wrote Holl, 'Prisoners of all sorts of crime were there – the lowest brutal criminal – swindlers, forgers, and boy thieves – all caged together, awaiting the results of their separate trials, and in one or two cases, the misery of their friends in seeing them in this hopeless condition, fell but lightly on their brains dulled by incessant crime . . .'. The scene was 'the part of Newgate prison, called the cage – in which prisoners whilst on trial are permitted at certain hours, and on certain days, to see their friends – on the inner side the prisoners are placed, and in the passage – their friends are conducted to them when their relations or friends are at once brought out – A Warden walks between the 2 gratings, who can hear and see everything that takes place between the friend and prisoner – It is particularly impressive for scenes of such pathos and agony of mind on both sides take place.'[36]

On the right, visitors are admitted including a self-confident, expensively-dressed woman and two others weeping into their handkerchiefs. On the left, close to the spectator, Holl depicts an incident he saw at the prison: a young wife and children visiting her husband, a man of good family who, working for a bank, had embezzled large sums of money, for which he was sentenced to five years of penal servitude. This is the emaciated figure at the extreme left. The central space is taken up by a seated woman protectively hugging her child, while her husband, his face half-hidden, glares at her from behind the bars. He is 'the brute who had probably half killed her before doing the deed which took him to a safeguarded asylum between the walls of Newgate, and released his wife from a life of martyrdom at the hands of the big, burly bully'.[37] The visual device of the row of bars draws the eye across the picture to the central confrontation.

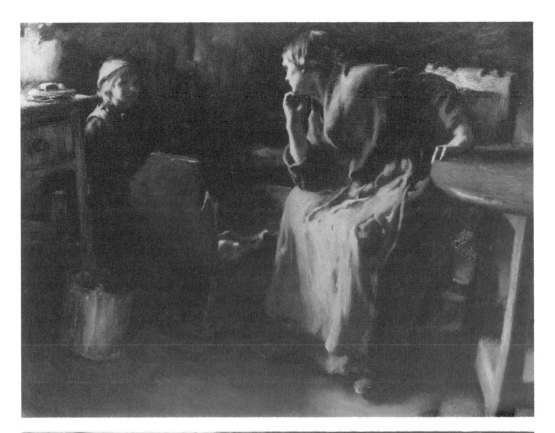

71. Frank Holl, *Hush!*, 1877, Tate Gallery

72. Frank Holl, *Hushed*, 1877, Tate Gallery

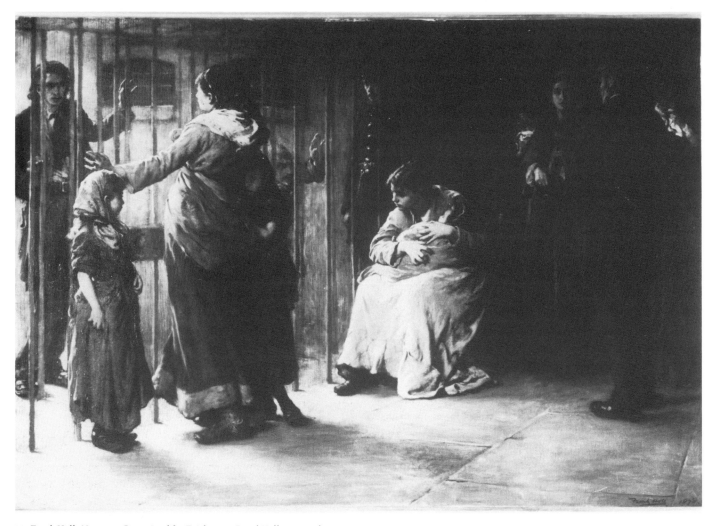

73. Frank Holl, *Newgate: Committed for Trial*, 1878, Royal Holloway and Bedford New College

Holl was awarded the ARA in 1878; this was allegedly not for *Newgate*, but for a portrait shown in the same exhibition.[38] Nevertheless, the impact of *Newgate* was great, praised by many even if condemned by some: 'how an artist personally so healthy, bright, and manly can year after year give way to this melancholy habit of mind and brush is beyond comprehension'.[39] But it is not a simple picture. Neither its use of pathos nor its anecdotal and descriptive qualities should blind the modern viewer to the ambiguities in the relationships between the wives and their criminal husbands. A wretched swindler, a battered wife and a punitive prison regime; these are not comforting subjects. It was a brave thing to paint, and even braver of Edward Hermon MP to buy it for 1000 guineas. The painting embodies the humanitarianism of the Victorian age.

10 | Luke Fildes: 'Dumb, wet, silent horrors'

In many ways it is puzzling that Luke Fildes became known as a social realist. Holl's anxious temperament inclined him towards the darker side of life, and Herkomer's independence of mind led to experimentation with the unconventional. But Fildes' personality was much more straightforward. Born in the provinces, after a career as a black and white illustrator, he successfully took up painting, soon stepping easily into an establishment position as a pillar of the Royal Academy and a quintessential eminent Victorian. If he had doubts, he did not record them. He strove for excellence, but it was not an intellectual struggle or a desire to challenge orthodoxy. His son recalls the occasion when his father was given a copy of Tolstoy's *What is Art?*. 'He glanced at the title and laid the book aside with the remark that practising artists had not time for speculations of that sort'.[1]

Much of his work is the very opposite of social realism. Besides the many portraits, on which he in common with Holl and Herkomer relied for a steady income in the latter part of his career, there were the fancy subjects. Fildes' earliest exhibited works were romantic pictures of flirtatious lovers in pretty historical costume. Later he painted a series of gorgeously coloured scenes of Venetian life which presented a very one-sided view of the inhabitants of that decadent, dirty and crumbling city. His pictures of contemporary English life were few in number and one of them, *The Village Wedding* (RA 1883, Private Collection) has the brightness and happy outlook of the Venetian scenes. There could not be a greater contrast with his other English subjects, dark, tragic and overwhelming in their emotional impact.

It is said that Fildes derived his sympathy with the working class from his grandmother Mary, a committed Radical from Manchester. She had appeared on the platform with Orator Hunt at Peterloo, where she had been wounded in the Massacre and had later joined the Chartists. She settled in Chester and Fildes, born in Liverpool

in 1843, soon moved there to be brought up by her. At seventeen he entered the Warrington School of Art where one of his fellow pupils was Henry Woods, his future brother-in-law. In 1862 he first visited London, to see the International Exhibition, and the following year he won a scholarship to South Kensington. Wishing to study fine art, he gained entry to the RA Schools in 1866, but in order to support himself became an illustrator. Making a fortunate contact with W. L. Thomas, he worked for many books and magazines, but it was not until *Houseless and Hungry* (cat. 38) appeared in the first issue of the *Graphic* that Fildes distinguished himself from all the others producing illustrations on wood. It was much admired; on the strength of it Millais recommended Fildes to Dickens who was looking for someone to illustrate *The Mystery of Edwin Drood*, and this and other commissions resulted.[2] Fildes continued as an illustrator until the mid-1870s but by then, irked by the restrictions of black and white work and by dependence on the engraver, he turned to the greater freedom and larger scale of oils.

The Casuals

The oil painting *Applicants for Admission to a Casual Ward* (cat. 74 and colour plate V after p. 12) was shown at the Royal Academy in 1874. Based on the engraving *Houseless and Hungry* which had appeared in the first issue of the *Graphic* (cat. 38), it showed the scene outside a police station with a queue of homeless paupers seeking overnight shelter. The Houseless Poor Act authorised them to be admitted to the casual wards of workhouses, provided they had obtained tickets by registering at a police station. On several occasions Fildes stated that he based his engravings on first-hand experience. 'Some few years before, when I first came to London, I was very fond of wandering about, and never shall I forget seeing somewhere near the Portland Road, one snowy winter's night

the applicants for admission to a casual ward.'[3] All the same, many elements of the scene are present in a passage from a novel of 1858, *Paved with Gold*, written by Augustus Mayhew, based on material gathered by his brother Henry for *London Labour and the London Poor*. It describes a crowd queuing up outside an Asylum for the Houseless Poor; 'they stand shivering in the snow, with their thin cobwebby garments hanging in tatters about them . . . The mob is of all ages, and women as well as men and boys are huddled there close together. There are old looking lads, shrinking within their clothes with the cold, and blowing their nails to warm their finger tips . . . Each man has his hands in his pockets . . .'.[4]

Unlike the previous generation of magazine illustrators, who did not make elaborate preparatory drawings, Fildes took great pains over his drawing. He used real models, finding down-and-outs in the street and inviting them to his studio. Several studies made for the engraving bear the names and addresses of models. The top-hatted drunk in the centre was a George Mills of 46 Bedfordbury, Chandos Street, Charing Cross, who when posing, 'had always to be put in quarantine by being made to stand on sheets of brown paper sprinkled with Keating's Powder'.[5] The woman with a shawl on the left seems to have been inspired by the similar figure in Fred Walker's *The Lost Path* (cat. 35), which W. L. Thomas himself engraved for the fourth issue of the *Graphic*.

Though *Houseless and Hungry* was carefully contrived in the studio, the *Graphic* published it with a journalistic description emphasising the documentary quality of the scene. 'All these people, with many others, received tickets and were admitted into the casual wards of one of our great workhouses, a few minutes after this sketch was taken.'[6] The text gave the principal figures histories and identitites as in the case of Ford Madox Brown's *Work* (cat. 19). These include, on the extreme left next to the policeman a respectable man come from the country to visit his criminal son to whom he has given all his money; next the woman with a baby and ragged children, evicted after her husband has been imprisoned for assaulting her; the crouching boy, 'bred in the gutter'; in the centre the drunkard who 'has sacrificed comfort and position to drink'; and the pathetic family group, the mechanic nursing a child and the sick wife with her clinging children. The engraving was much admired; Vincent van Gogh described how he bought a collection of magazines in 1882: 'There are things among them that are superb, for instance "The Houseless and Hungry" by Fildes (poor people waiting in front of a free overnight shelter).'[7]

Some years later, when starting up as a painter, Fildes asked the advice of Millais who suggested he should begin not with *Houseless and Hungry* but with the more marketable image, *Hours of Idleness*, a superficial fancy picture of prettily dressed figures in a punt, originally printed in *Once a Week*. The resulting painting, re-named *Fair Quiet and Sweet Rest* (Warrington Art Gallery), was shown at the Academy of 1872 and sold to a dealer. The following year he painted *Simpletons*, a similar subject. But already in 1872, Fildes began elaborating *Houseless and Hungry* into a large painting. He wrote of it in 1873 as his bid for fame. 'I am hard at work in London, and have been all summer, on my big picture for next year's Royal Academy. I am anxious about its success. I want it to be one very much, as so much depends on it.'[8]

Fildes returned to his original studies from models found in the streets, and also made new studies. The composition was changed to give more depth and space, the setting of the painting becoming more detailed. Fildes introduced the lamp, and the posters ironically offering £2 for a missing child, £20 for a missing dog, £50 for a murderer and £100 for a runaway. He moved some of the figures around, added more characters, and gave more space to the woman on the left and to the policeman reading out the names. Nearly all the figures are self-absorbed with downcast eyes, except for the man next to the policeman, the respectable man from the country; new to such a scene, he looks on with horror. His reaction is ours, the spectators'.

The livid colour, the huge scale and the extended frieze of tragic figures brought to Fildes' original small engraving a heightened emotionalism. Fildes for some reason abandoned the title *Houseless and Hungry* for the more factual *Applicants for Admission to a Casual Ward*. But a tear-jerking reaction was guaranteed by the addition of an extract from a letter written to Fildes by Dickens, describing a scene he saw in 1855 when a workhouse in Whitechapel was too full to admit any more people. 'Dumb, wet, silent horrors! Sphinxes set up against the dead wall, and none likely to be at the pains of solving them until the *general overthrow*'.[9]

The painting caused a tremendous stir at the Academy; it had to be protected from the crowds by a rail and a policeman, and was purchased for £1250 by the Wigan cotton-manufacturer, Thomas Taylor, for the gallery at his Oxfordshire country house, Aston Rowant. All the critics devoted lengthy notices to it, and its impact was remembered in later years. Even those who disliked it conceded its power. Some felt it to be lacking in finish or too much

like a scene in a theatre, but most of the criticism dwelt on the painful ugliness of its subject. Some could find no redeeming feature about it: the figures were 'repulsive in the extreme and quite belong to the chamber-of-horrors style of art . . . they simply appal and disgust without doing the slightest good to humanity or making it more merciful' (*Manchester Courier*). Others, though horrified, approved its truthfulness even if this conflicted with their view of art. 'This is the most notable piece of realism we have met with for a very long time. The painter has shirked nothing, he has set down the facts as he found them, and has, as a result, produced the most startling impression of all wayward and unlovely reality. These deformed and wretched creatures who wait for admission to a wretched resting-place, are only admissible into art that is indifferent to beauty . . . The arrangement of the different figures is as artistic as the subject permitted . . . that admission leaves unsettled the larger question of the subject's fitness for art at all' (*Art Journal*). But if it was artistically unacceptable, it had a different value; 'not a few of us will see the miseries of their fellow beings for the first time in these personations . . . Few men will turn away without long study of this mournful presentation of the *debris* of London life, and many will not fail to say "What can I do to better this state of things?" Morally and socially speaking, this is the picture of the year' (*Athenaeum*).[10]

Fildes must have anticipated this kind of humanitarian reaction as he planned his *mise-en-scène*, rearranging 'the facts as he found them', to heighten the guilt of his middle-class audience, made to see what it had tried to ignore. Fildes was not a cynic, yet there is something calculating about his alternating between social subjects and pictures of pretty girls such as *Betty*, shown in 1875; he knew his market.

The Widower

In *Houseless and Hungry* and the *Casuals*, one of the most striking figures is that of the man cradling his bare-legged child in his arms, whilst his little girls cling to their sick mother. The model for the man gave Fildes the idea for *The Widower*. 'I was painting in a rough-looking fellow with his child. He got tired of standing, so I suggested he should rest. He took a chair behind the screen. I went on with something else – no movement reached me, so I peeped behind the screen and there I saw the motive for 'The Widower'. The child had fallen asleep, and there was this great, rough fellow, possibly with only a copper in the

world, caressing his child, watching it lovingly and smoothing its curls with his hand.'[11]

In the oil, shown at the 1876 Academy, the motif has become one of sorrow, the burly labourer in his simple cottage, clutching the child, whose head, caught in the light, has fallen back limply in death. The eldest daughter, who has had to take the place of the mother of the family, bows her head, but three small children and a puppy play on the floor, indifferent to the tragedy. The exhibited oil was even larger than the *Casuals*, for which it was criticised.[12] It was bought by the owner of the *Casuals*, Thomas Taylor, and is now in Australia at the Art Gallery of New South Wales. The composition and colour were repeated in the replica painted in 1902 (cat. 76) and cat. 75 is an oil sketch for the principal figure.

On seeing *The Widower* at the Academy, Fildes' friend, the writer G. A. Sala wrote, 'it touched me very deeply indeed . . . You bold young geniuses lash in your colour so audaciously that we weak-eyed fogies are puzzled, sometimes, to know whether there is any drawing underneath the paint at all. Well, you may say, Rembrandt painted with his thumb and Goya . . . painted the Dos de Mayo with a fork'.[13] The replica, painted in 1902 for Agnew[14] is rather slick, but the dashingly handled sketch of the widower and baby demonstrate what Sala meant. All the studies show the artist experimenting with different positions; in this sketch, the baby's head does not fall back in the pathetic manner of the finished work, and in others the baby is on the father's other knee.[15]

The Widower, sombre as it is, lacks the bite of the *Casuals*: its social message was not at all challenging or topical, and it recalls very strongly some of Thomas Faed's cottage paintings of the 1860s, particularly *From Dawn to Sunset*, RA 1861 (formerly Steigal Fine Art, Edinburgh). This has a big man in boots seated in mourning, though not with a child on his lap, and small children play on the floor, ignoring the tragedy.

On the whole, *The Widower* was well received. It was, according to the *Art Journal* a genre subject lifted into the region of High Art. 'It may be said to stand at the head of that class of pictures in which the poetry of common life has been placed on canvas.' 'Note the powerful, yet subdued expression of the principal idea, viz. the rough helplessness and momentary tenderness of a rugged nature', wrote *Academy Notes*. But *The Times* after describing the 'squalid room crowded with ill-attended children and foul for lack of "cleaning up"', criticised the choice of subject: 'The painter, we submit, is under a mistake who brings big dirty boots, squalling and scrambling children,

parental and sisterly love, into such contact . . . intense painfulness, overstrained expression, and great vehemence of momentary action or short lived attitude are all qualities that make pictures unpleasant to live with.'[16]

Fildes did not receive the ARA as he had hoped in 1876 (he had to wait until 1879) but in the meantime, perhaps because of such criticisms, he modified the realism of his scenes of the life of the English poor. The social criticism in *The Widower* seems today less powerful than that of the *Casuals*; that in *The Return of the Penitent* (RA 1879, Cardiff City Hall) is weak, despite its kinship with Redgrave's *The Outcast* (cat. 12); and there is no social criticism at all in *The Village Wedding* (RA 1883, Private Collection), an example of rustic genre without tragedy or High Art.

76. Luke Fildes, *The Widower*, 1904, National Museums and Galleries on Merseyside (Walker Art Gallery)

The Doctor

By the mid 1880s, Fildes appeared to have quite given up English subjects but Henry Tate, realising where the artist's bent lay, asked Fildes to paint another English picture of importance (cat. 78). Fildes did not hasten to fulfil the commission and Tate corresponded with him about it in 1887, when Fildes hinted he had a subject in mind but had not yet advanced the design.[17] Still Fildes took his time, but in June 1890 prepared a first sketch, probably prompted by the knowledge that Tate was about to present to the nation his collection of pictures by all his contemporaries; Fildes could not afford to be left out. He wrote to his patron 'in coming to see the very slight sketch I will show you, you will not expect to find anything beyond what refers to the *idea* or *subject* of the picture . . . this sketch . . . has been done vaguely, purposely, to leave me as free-handed as possible in the artistic arrangement and treatment of the large picture, but I have no vagueness

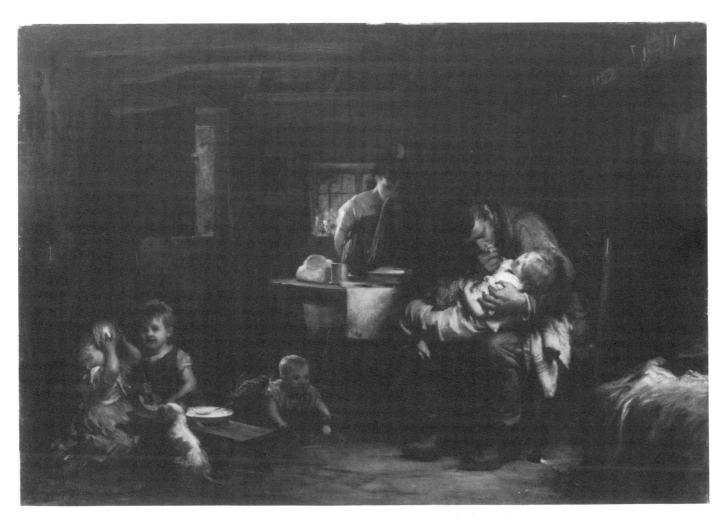

whatever about the subject. *That* you can see clearly enough, and *that* I understand, is what you first desire to be satisfied about.'[18]

The subject was a doctor watching over a sick child: it had been in Fildes' mind ever since 1877, when on Christmas morning his eldest boy Paul had died; the bearing of Dr Murray, the family physician, had deeply impressed the artist.[19] Tate approved the sketch. 'I fancy he was pleased with the idea and when I told him I should require £3,000 he assented and letters have passed to that effect. It is, of course, a very large sum to ask for a picture with so little work in it. Still, it will give me a great deal of trouble. It is a very difficult subject to paint by lamp and dawn effect and quite prevents me taking up anything else while it is in progress. I should probably make more money by portraits, which I have to entirely give up after making a success, to go on with his commission. So with one thing and another the price, from my point of view, is not excessive.'[20] In this letter, with its frankness about the

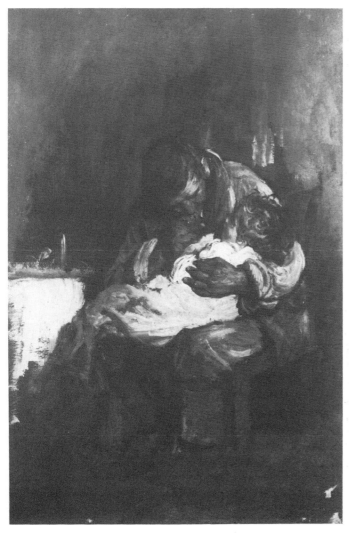

75. Luke Fildes, *Study for 'The Widower'*, 1875, Private Collection

high price and his reluctance to give up lucrative portrait commissions (he went on to say that he had had to turn down several applications for portraits already), the business side of being an artist appears. Painters had wives and establishments to keep up, children to be provided for, and income was not always predictable. Some years later Fildes was to write, 'It's all very well to talk of painting more "Doctors" but I don't see how I am to get at it unless I chuck all these things that are coming in, away from me – to do so, I think, would be the height of folly.'[21] The statement that the picture had 'so little work in it' must refer to the small number of figures, particularly as compared to the *Casuals* or *The Village Wedding*. Fildes' son wrote that 'the Doctor was the easiest and quickest painted of all his big pictures'.[22] Nevertheless, it was not painted without trouble and the image was carefully contrived and refined for maximum effect.

The first sketch, probably the one shown to Tate, is known only from reproductions[23]: though the elements of the finished picture are present, there are three obvious differences. Firstly the child lies on a distractingly light-coloured sofa instead of two mismatched chairs; secondly, the sketch is more evenly lit; and most important, the whole scene is the other way round, with the doctor on the right and the parents on the left. An intermediate stage is the oil sketch in the Robert Packer Hospital (cat. 77). Here the picture is still the opposite way round from the final version, but the more homely chairs and the more dramatic lighting have been introduced, and the doctor leans forward more intently towards the child. This is part of a general heightening of drama which is evident in the finished work.[24] Fildes set himself the artistic task of mingling lamplight with the natural light of dawn. By the window, the clasped hands of the mother and one side of the father's face are tinged with the greenish cast of dawn; in contrast the warmer light of the lamp picks out the medicine bottle and cup, the doctor's face and hands, and highlights the bedding and the restless child. Large black shadows are cast on the right-hand wall.

It is not clear why the whole image was reversed, but it may have something to do with the full-scale mock-up of the cottage interior which Fildes had built in his studio. This was freely based on various cottages seen by Fildes in Scotland and Devon. He visited Devon in May 1890. 'Last night I saw Prinsep who gave me a most rapturous description of a delightful fishing village called Hope near Salcombe on the Devonshire Coast which from what he says of the interiors quite fulfils my expectations for my picture.'[25] A drawing of Fildes in his studio painting from

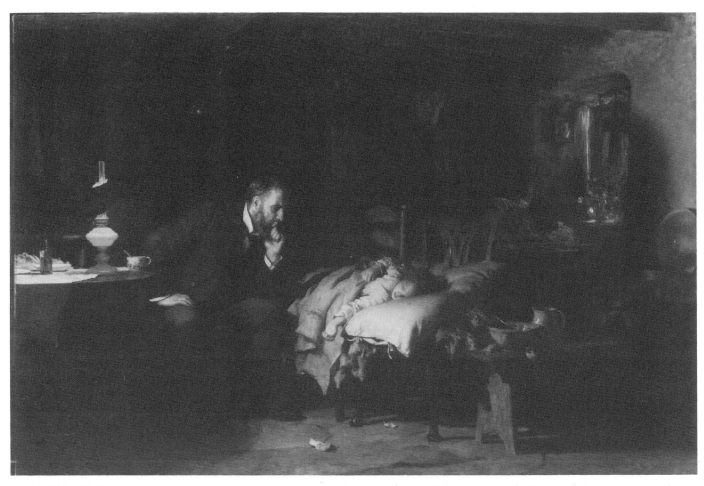

78. Luke Fildes, *The Doctor*, 1891,
Tate Gallery

77. Luke Fildes, *Study for 'The Doctor'*,
*c.*1891, Robert Packer Hospital and
Guthrie Medical Center

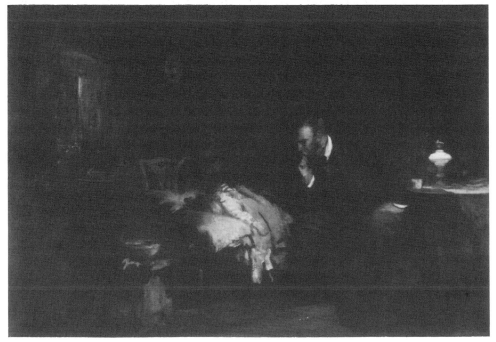

the reconstructed cottage shows it was the same way round as the finished picture; thus the two sketches were done before the 'set' was built. The transposition may have taken place because Fildes had to take into account the need to light the set in the studio, for in order to admit real daylight the cottage window was built in front of one of the studio windows. The English winter light had always been a problem for Fildes (his Venetian pictures had been one way to evade the difficulty). 'No-one will ever know the frightful difficulties I have had this winter with the darkness', wrote Fildes in March 1891 of *The Doctor*. 'Mr Tate saw it for the first time last week and I believe he likes it.'[26]

Just as the cottage was a composite, based on sketches of several places, so the doctor is not a portrait of an individual. A professional model was used, though Fildes had himself photographed in the correct pose and costume to help the model; the face of the doctor bears a certain resemblance to the artist.[27] The child was also studied from more than one person, both of them Fildes' own children: the head of his daughter Phyllis and the arm of his son Geoffrey. 'One day, I had just finished the picture with the child's hands tucked up close together at the neck, as children sleep, when I noticed my boy's hand fall over the side. I thought it exquisite – so pleading and pitiful. I altered the hands in the picture at once, and painted the left one as you see it now', he told a journalist.[28]

Fildes' idea for the picture was not altogether a new one. Pictures of sickbeds and lonely vigils were often seen at the Academy; *The Doctor* has much in common with Faed's *Worn Out* (cat. 30), and also with Holl's *Widowed* (National Gallery of Victoria). What was new was to combine the pathos of a sick child in a humbly furnished interior with the unsung heroism of the doctor. This went down well with the medical profession: a doctor lecturing to his students wrote, 'What do we not owe to Mr Fildes for showing to the world the typical doctor, as we would all like to be shown – an honest man and a gentleman, doing his best to relieve suffering? A library of books written in our honour would not do what this picture has done and will do for the medical profession in making the hearts of our fellow-men warm to us with confidence and affection.'[29]

It also went down well with the critics who were uniform in their high praise, for Fildes had hit on a realist theme which was neither too dirty or painful ('the sentiment is natural without being vulgar, intense without being forced'), nor too pretty: 'Among the tragedies of the exhibition, none surpasses *The Doctor* of this artist, who has, we hope, finally abandoned the Venetian flower-sellers.'[30]

It became one of the most popular pictures with the public. Even Mrs Fildes, visiting the Academy, could not get near it for the crowds. Agnew's photogravure of it became the most popular print the firm ever issued, adorning doctors' surgeries all over the world. It was reproduced on two postage stamps.[31] Though Fildes succeeded in creating a universal image of suffering and hope, he did it by purifying his art of the uncomfortable social truths of his first success.

11 | Hubert von Herkomer: 'Sympathy for the old and for suffering mankind'

Lee M. Edwards

'Supposing my position as cartoonist for a comic paper had continued – might not my mind have been diverted from its real bent, which, as my whole life can testify, has been towards the pathetic side of life, towards a sympathy for the old, and for suffering mankind?'[1]

When Hubert von Herkomer wrote those words towards the end of his life, the dominant focus of his career during the previous thirty years had been portraiture. After the death of Frank Holl, in 1888, Herkomer's reputation as the pre-eminent Victorian portraitist soared; in 1898, the French art critic Robert de la Sizeranne declared him 'the greatest portrait painter in the United Kingdom. . . . His portraits are unequalled'.[2] Yet Herkomer is best known today for a handful of provocative images of 'suffering mankind'. With their exaggerated perspective and forcefully applied paint, these pictures had a daring originality which propelled them beyond mere documentation. At a time when Great Britain was a supreme industrial and imperial power, works like *Eventide* (cat. 80) and *Hard Times* (cat. 82) became symbols of the deprived and neglected victims of materialistic Victorian society. Yet in the light of Herkomer's own astonishing rise from poverty to affluence as well as the sources that inspired the artist, these works can be interpreted through several layers of meaning.

Herkomer's sympathy for the poor was fostered in part by his own humble origins. He was born in Waal, Bavaria where his father Lorenz was a wood-carver.[3] In 1851, the family emigrated to America, but after six years in Cleveland, Ohio, they left the United States and settled in Southampton, England where their early life, like their experience in America was marked by harsh poverty.[4]

Young Hubert received his first art instruction from his father, and later took classes at the Southampton School of Art. While on a visit to Bavaria in 1865, he briefly attended the Munich Academy; and in 1866 and 1867 he spent two summer terms at the South Kensington Art Schools. It was while Herkomer was at Kensington that the art of Frederick Walker (see cat. 35–7) became important to him, an inspiration that he acknowledged throughout his career.[5] Such adulation of Walker was not an isolated phenomenon; many artists and critics during the late Victorian period admired the poetic realism of Walker's art in what amounted to a cult-like veneration.[6] At Kensington, Herkomer became friendly with Luke Fildes. Together with Frank Holl, they became the three most important artists working for the *Graphic* (see Chapter 7). Of the 'big three', Herkomer was the most prolific, his first illustration, *A Gypsy Encampment on Putney Common* (cat. 40), appearing on 18 June 1870. He worked up several of his *Graphic* engravings into exhibited paintings, among them *The Last Muster* (see cat. 79). The phenomenal success of this work, and its continued popularity into the early years of the twentieth century established Herkomer as a leading artist of his generation. His idiosyncratic and vigorous style, inspired by the bold realism of contemporary German painters like Wilhelm Leibl on the one hand, and tempered by the gentle idealism of Walker on the other, introduced to Victorian art an energetic visual language that anticipated the critical acceptance of 'foreign tendencies' in the next generation of French-trained English artists such as H. H. La Thangue (cat. 93) and Frank Bramley. Herkomer's *Graphic* illustrations were collected by Vincent van Gogh, who greatly admired them, and was influenced by the pathos of their subject-matter as well as their stylistic originality (see Chapter 14).

Herkomer also painted landscapes and Bavarian peasant scenes near his home in Landsberg am Lech where he spent a portion of almost every year after 1870. His international reputation was enhanced by his stature in Germany where his work was well known. An award of the Order of Merit from Kaiser Wilhelm II in 1899 entitled him to add the prefix 'von' to his name.

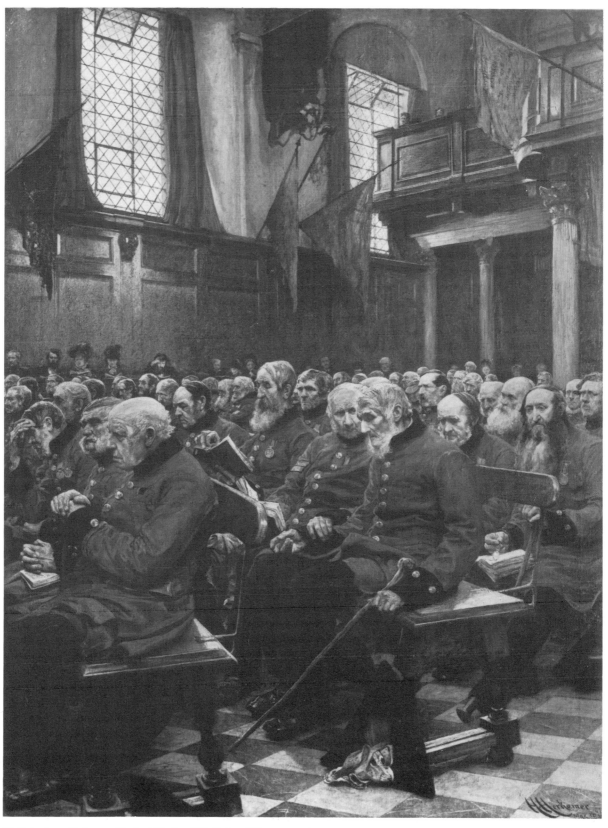

79. Hubert von Herkomer, *The Last Muster*, 1875, National Museums and
Galleries on Merseyside (Lady Lever Art Gallery, Port Sunlight)

The rewards of portrait painting resulted in an immense fortune for the artist, who built himself a neo-Gothic castle called Lululaund in Bushey, Hertfordshire, designed by his friend, the American architect Henry Hobson Richardson (it was demolished in 1939). Herkomer was a man of remarkable energy and outspoken enthusiasm, and his genius for self-promotion kept him in the public eye throughout his career. Always loyal towards his adopted homeland, he was particularly gratified by the knighthood he received in 1907.

Herkomer founded an art school at Bushey which flourished from 1883 to 1904. He was a frequent lecturer, wrote and performed in plays and musical diversions and was a pioneer of the British film industry. Passionately committed to bringing all forms of art to the attention of the public, his diverse activities outside the realm of painting ultimately dissipated his talent and energy. Nevertheless, his willingness to experiment, and the didactic impulse and social aims that fuelled his imagination, remained at the core of all his endeavours.

The Last Muster

With its heroic depiction of old age, *The Last Muster: Sunday in the Royal Hospital Chelsea* (1875, cat. 79) set the tone for several of Herkomer's subsequent social themes. However, the artist was initially overwhelmed by the huge popular and critical success of the painting. 'It is a rare thing to have such a fuss made over my *Pensioners*', he wrote to his friend and patron Mansel Lewis from Munich in 1877. 'Well, that is once – never to appear again in a painter's lifetime. It settles him.'[7] Exhibited at the Royal Academy in 1875, *The Last Muster* was awarded one of the two grand medals of honour (the other went to Millais) at the Paris International Exhibition in 1878. So great was the crush of visitors at the English Fine Art Court to view the painting at the Paris exhibition, that the *Graphic* published an illustration of the crowd. As Herkomer himself later recalled: 'My name stood at the top of the list; and standing with Millais, I gained an immediate position in the eyes of the world, which under ordinary circumstances, would have taken years to obtain.'[8]

The composition of *The Last Muster* was based on an earlier wood-engraving by Herkomer, *Sunday at Chelsea Hospital* (cat. 52) which had appeared in the *Graphic* on 18 February 1871. W. L. Thomas, the magazine's founder, was so taken with the image that he commissioned for himself a watercolour version (untraced), which Herkomer painted for him in December 1871. The subject was

suggested to the artist after he attended service in the Chelsea Hospital Chapel. 'The idea was to make every man tell some different story, to be told by his face, or by the selection of attitude', he wrote.[9] His group of old pensioners, their faces marked by age and hardship, included one who had answered the 'last muster'; the fingers of the pensioner seated next to him feel for a pulse that no longer beats. Although the inmates of the Chelsea Hospital were seasoned war veterans who qualified for residence because of their indigence, the artist's primary focus here is on the pathos of old age and death rather than a specific social condition.

Images of death were not uncommon in Victorian pictures: but with few exceptions (cat. 14, 23, 93), the focus generally lingered on the tortured emotions of those left behind (for example, see cat. 70). That *The Last Muster* was frequently interpreted as a military subject by its contemporary viewers is suggested in the articles that appeared after its exhibition. The incident of the death itself was rarely mentioned except in military phrases. 'An old soldier, placed at the end of one of the benches, has just answered the last call, and ceased to live rather than died, so softly and silently that his neighbour knew it not for a time', was F. G. Stephens' description of the work for the *Athenaeum*[10]. When the reporter for the *Graphic* wrote of the popularity of the picture in the Paris exhibition of 1878, he noted that 'the military taste of the French is proverbial, and that this picture, so essentially military in its tone, should be a general favourite, is hardly to be wondered at'.[11] On the other hand, Charles Pascoe, in the American edition of the *Art Journal*, connected the social circumstances of the old men to their soldiering. While noting that 'the crimson and blue ribbons of the war-torn veterans tell of the allotted threescore years that have passed since the hard days of the Peninsular War', he added that 'their faces and grizzly white beards speak of their . . . fourscore years of labour and sorrow'.[12]

Herkomer has left us a detailed account of how he executed the painting, planning it from the start to be a triumph.[13] He made no preliminary cartoon, working directly onto the canvas. Because he wanted to achieve a dry fresco-like finish for the picture's surface, it was improperly prepared, and the result almost immediately proved fragile. The painting has required periodic repair work ever since, a problem that has arisen in a number of the artist's other works. Although the two pensioners who had posed for the principal figures in the original *Graphic* illustration of 1871 were again pressed into service as models, Herkomer still had his preliminary sketches to

work from, one of the earliest known being *Study of a Chelsea Pensioner* (cat. 53) dated 1870. When Mansel Lewis visited Herkomer's Chelsea studio in March 1873, he noticed all four walls were covered with studies of Chelsea pensioners, which gives some indication of the artist's long-term involvement with the project.[14] Herkomer also included in the picture a portrait of his father Lorenz (the white-bearded figure, third row from the left, costumed as a Chelsea pensioner), who had himself led a life of poverty and hardship. In the background, lined up along the south wall of the chapel, are several tiny figures in civilian clothes reading from prayer-books. These have been identified as Clarence Fry (second from the left), a wealthy Watford businesman and Herkomer's first patron, who bought *The Last Muster* for £1,200 before it was exhibited; next to him, Herkomer's first wife Anna; Mrs Clarence Fry; the artist, his contemplative pose giving the appearance of a bearded mystic; and the Frys' small son with a nurse.[15] These personal elements reinforced Herkomer's assumed role as on-the-spot observer, and gave a deeper more personal meaning to a work of which he was so proud. Indeed, in 1909, some forty years later, he turned to his most celebrated painting again, reproducing it as a lithograph (cat. 79) and garnering fresh praise with its appearance in a new medium.

Eventide

While the subject of urban poverty is only tangential to the principal themes of old age, death and patriotism in *The Last Muster*, it is a central concern in *Eventide: A Scene in the Westminster Union* (1878, cat. 80a). A group of old women (some are seated at a table, others shuffle about in a gloomy interior) are portrayed in the day-room of the St James's workhouse, which was administered by the Westminster Union in Poland Street in Soho. This scene, like *The Last Muster*, was one the artist had witnessed while roaming London in search of a suitable subject. The exhibited painting was worked up by the artist from the double-page wood-engraving, *Old Age – A Study in Westminster Union*, which had appeared in the *Graphic* on 7 April 1877. An oil study (cat. 54) for the engraving survives, as does a watercolour version (cat. 80b) of the exhibited picture.

Eventide was regarded as a 'female' companion to *The Last Muster* in part because of its depiction of old women in a charitable institution, and because of the intimations of mortality in its descriptive title. That the artist's response to the plight of the women he observed in the workhouse issued from deeply-felt sympathy was corroborated by the writer J. W. Comyns Carr who, in his study

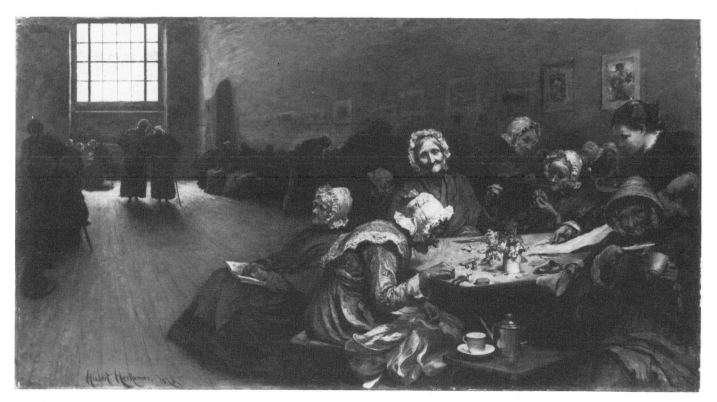

80. Hubert von Herkomer, *Eventide: A Scene in the Westminster Union*, 1878, National Museums and Galleries on Merseyside (Walker Art Gallery)

on Herkomer published in 1882, quotes from the artist's statement to him about the genesis of *Eventide*: 'I was struck by the scene in Nature. I felt that every one of these old crones had fought hard battles in their lives – harder battles by far than those old warriors I painted – for they had to fight single-handed and not in the battalions as the men did.' Upset that *Eventide* was less popular with the public than his earlier picture, Herkomer concluded that 'the world hates to be reminded of the sorrowful side of humanity'.[16]

The day-room of the workhouse depicted by Herkomer in the painting is typical of the dreary jail-like interiors of these establishments. Indeed the punitive nature of the English workhouse and the attitudes towards the poor that such incarceration implied, was the subject of scathing commentary by the French social historian Hippolyte Taine, who on a tour of England in 1873 wrote: 'The doctor put me into the hands of a clergyman who was one of his friends . . . [He] took me to St Luke's Workhouse. Everybody knows that a workhouse is an asylum a little like a prison.'[17]

The workhouse as a dreaded place of last resort was confronted in such novels as Charles Dickens's *Oliver Twist* (1838), Frances Trollope's *Jessie Phillips* (1844) and George Moore's *Esther Waters* (1894). Jack London's account in *The People of the Abyss* (1902) of a night spent in the Whitechapel workhouse casual ward is a portrayal of human degradation and maltreatment that echoes the documentary account of James Greenwood's *A Night in a Workhouse*, published forty years earlier. Henry James's working-class hero Hyacinthe Vivier in *The Princess Casamassima* (1886) employs the universal fear of the workhouse as an instrument for social change: 'He amused himself with an inquiry if she were satisfied with the condition of society and thought that nothing ought to be done for people who at the end of a lifetime of starvation-wages had only the reward of the hideous workhouse and a pauper's grave.'[18]

Herkomer had portrayed indigent women in grim institutional interiors in two earlier *Graphic* engravings – *Low Lodging House at St Giles* and *Christmas in a Workhouse* (cat. 55) – which were published on 3 August 1873 and 25 December 1876 respectively. In the latter engraving, a young and pretty workhouse volunteer is shown handing a Christmas package to an elderly inmate while another young woman offers assistance. A plaque on a background wall decorated with evergreens reads 'God Bless our Master and Matron', perhaps intended by the artist to be read ironically or, conversely, to emphasise the notion of

charity and 'good works' so soothing to Victorians largely isolated from the ghetto-like horror of London's slums.

While scenes of life in the workhouse are rare in Victorian painting, Herkomer was obviously indebted to such precedents as Frederick Walker's *The Harbour of Refuge* (see cat. 37) and Luke Fildes' *Applicants for Admission to a Casual Ward* (1874, cat 74). Indeed, Herkomer acknowledged his close friendship with Fildes by including in the background of *Eventide* a reproduction of *Betty*, a painting (now in the Forbes Magazine Collection) by Fildes of a pretty milkmaid, whose beauty and girlish vigour contrast with the bent and wizened aspect of the workhouse inmates. The other recognisable 'picture within a picture' on the workhouse walls of *Eventide* is the reduced version of *The Last Muster*, published in the *Graphic* on 15 May 1875.

Herkomer's broad handling of paint, already noticeable in *The Last Muster* is even more obvious in *Eventide*. The dark flat forms of two figures that seem to be shuffling forward, their heads outlined by an eerie light sifting into the room from the window above them, cast long symbolically-laden shadows. The more clearly defined figures in the immediate foreground loom into the viewer's space, while the artist's brilliant manipulation of the plunging perspective adds a spatial tension that accentuates the disquieting proximity of the figures and the larger message of the old women's deprivation and loneliness.

Spatial distortions were a pronounced ingredient in Herkomer's art from his earliest *Graphic* engravings, though Herkomer attempted to lessen them somewhat in his exhibited pictures with mechanical aids such as a *camera obscura* rigged up for him by his father. However, the perspective in *Eventide* is still 'off', a factor noted by critics at the time. With his strong sense of design, it seems logical that Herkomer should combine his idiosyncratic sense of space with the expressive component of his work. In *Eventide*, the deformed spatial context fuelled the spiritual intensity he wished to convey. As J. W. Comyns Carr noted in 1882, *The Last Muster* 'succeeds by the simple strength of its portraiture', whereas *Eventide* 'overpowers the elements of purely human interest by laying stress upon the cheerless spaces of bare wall and the expanse of boarded floor'.[19]

Eventide was exhibited at the Royal Academy in 1878 and at the Salon in Paris in 1879. While it was warmly received in Paris, its reception at the Royal Academy exhibition was less favourable, and the actual slum context was generally ignored. For example, Blackburn's *Academy Notes* thought that the artist had depicted 'hap-

py and comfortable old age . . . in short to give the sunny side of life in a workhouse'.[20] As to style, the *Illustrated London News* critic focused negatively on the broad technique of *Eventide*. To him, it was a manifestation of the artist's German origin, the picture's 'muscular and petulant ardour . . .' issuing from 'that most vigorous of the athletes of the Deutsche Turnverein. . . . Although replete with expression, it is bold and broad, well-nigh to the verge of coarseness'.[21] However, the art reviewer for the *Athenaeum*, F. G. Stephens, was genuinely touched by the scene. Here was a subject 'to reach all hearts . . . a home for our fellow beings beaten in the battle of life. . . . Should Mr Herkomer's beautiful work draw out more strongly our sympathies for our less fortunate fellow beings, [it] will in its more important object have fulfilled the intentions of its author.'[22]

This is not to say that Herkomer's *Eventide* was a militant drama of social protest. Yet the sometimes harsh images that Herkomer (and to a lesser extent the more sentimental Holl and Fildes) used to visualise the poor and the deprived denote an engagement that, while not necessarily making an overt statement for political and social change, *does* encourage reformist sympathies. Just the fact that Herkomer had, with *Eventide*, painted a subject that was so alien to the experience of the normal viewing public, assured either public compassion or censure. As with Courbet's and Millet's earlier paintings, heroic depictions of society's anonymous victims could be counted upon to draw a response that, in the end, was often more revealing of the viewer's political and social sensibility than of the artist's.

Pressing to the West: A Scene in Castle Garden, New York

Pressing to the West (1884, cat 81 and colour plate VI after p. 12) is Herkomer's most reformist and, at the same time, most personal work. The painting depicts a group of immigrants gathered in the immigrant station and employment centre at Castle Garden, a former concert hall (the Swedish singer Jennie Lind made her American debut there) that served as the port of entry for emigrants to America from 1855 to 1892. Those wishing to continue their journey for settlement in the Western states often remained at Castle Garden for many weeks, surviving in the most squalid conditions, until employment could be found for them. It is this state of affairs that Herkomer has depicted here, and in order to erase any puzzlement about the contents of the picture, he wrote an explanatory

paragraph for inclusion in the Royal Academy catalogue when it was shown in 1884.

Emigration scenes were a popular Victorian genre (cat. 4, 5, 28, 69), but Victorian paintings usually masked the real hardships experienced by the emigrants themselves. Victorian literature also tended to idealise the emigrant's experience, the idyllic scene of Mary Barton and Jim Wilson settled in their pioneer cottage in the Canadian wilds at the conclusion of Elizabeth Gaskell's *Mary Barton* (1848) being a case in point. By concentrating on the distress of the newly-arrived immigrants in *Pressing to the West*, Herkomer has taken an unusual aspect of a well-known theme and treated it with a fresh eye.

The picture was conceived by the artist during a triumphant American tour, which occurred between December 1882 and June 1883. His arrival in New York, to fulfil portrait commissions and lecture engagements, was greeted with considerable fanfare, for advance publicity had included lengthy interviews with the press.[23] Thus his return as a celebrity was vastly different from the experience thirty years previously when he and his parents had passed through New York as impoverished immigrants. On this return visit Herkomer was accompanied by his father Lorenz, as well as by his mistress Lulu Griffiths, who travelled with them as nurse-companion to the old man.

The artist's memory of his family's earlier suffering was revived when he observed the crowded and degrading conditions at New York's Castle Garden immigrant centre. He wrote: 'The extraordinary motley of nationalities interested me; but the subject touched me in another way that was more personal. Here I saw the emigrant's life and hardships – conditions in which my parents found themselves when they left the Fatherland for this Land of Promise.'[24]

By January 1883, the artist was well advanced with the painting, informing Edmund Gosse in a letter written from Boston: 'I am getting deeply interested in my picture Castle Garden – such a subject . . . but so immense that I fear I cannot do it further.'[25] The painting was finally completed over a year later, in March 1884.[26]

The composition of *Pressing to the West* is similar to that of *Eventide*, with its cavernous interior space, tilted perspective and looming figures in the foreground. As in the earlier painting, the distorted foreshortening of the floorboards is an expressionist device that accentuates the emotion-charged content. In the immediate foreground, a child with a simple toy between his fingers stares listlessly at the viewer, while another crawls along the floor littered

with old food scraps and blackened pots and pans. A young mother, her infant cradled in her arms, wearily pushes away a dish of food proffered by her husband, the dark circles around her eyes marking her illness and fatigue. Lulu Griffiths (she became Herkomer's second wife in 1884) posed as the figure for the mother, the artist modelled that of the husband, and Lorenz Herkomer, dressed as an old Jew supporting a younger female, is recognisable as the white-bearded figure in the middleground. The foreground family group doubtless symbolised for the artist the suffering his parents endured much earlier, and probably accounts for his use of Lulu and himself as models for such a personal image.

Herkomer's technique here is even looser, with rough passages of paint which amplify the harsh reality of the scene, a 'slash and dash' style (as it was characterised by one critic), that had been growing progressively more extreme. *Pressing to the West* was shown first in a special exhibition at the firm of Goupil and Company in London in late March 1884 when it was reported by the *The Times* that 'this splendid work will add to the renown of the famous painter of *The Last Muster*'.[27] However, after its exhibition in the Royal Academy of 1884, the art critics were more ambivalent. 'Technically speaking', wrote F. G. Stephens in the *Athenaeum*, 'the work is coarse, vigorous, unlike nature in the ordering of light and shade, unpicturesque through the neglect of opportunities for a happy disposition of colour, devoid of learned modelling, and crudely and roughly drawn. Nevertheless, every one of these defects, great and obvious as they are, is redeemed by the power of its conception.'[28]

Another writer, echoing the critical derision that greeted Luke Fildes' *Applicants for Admission to a Casual Ward* (cat. 74) when it was exhibited ten years earlier (the portrayal of 'grovelling misery' was objected to), denounced *Pressing to the West* without mincing words: 'What pictorial or moral purpose can be served in depicting this unsavoury mass of squalid discomfort or misery, in however appropriately dull, ugly colouring, and although there is a touch of pathos in the foreground?'[29] The most negative comment was offered by that some-time advocate of the working classes, John Ruskin, whose portrait by Herkomer painted in 1879 (National Portrait Gallery) remains one of the artist's most compelling images. In a lecture delivered at Oxford in 1884, Ruskin offered the following comments on *Pressing to the West*: 'Some artists are apt to become satirists and reformers instead of painters; to use the indignant passion of their freedom no less vainly than if they had sold themselves into slavery. Thus Mr Herkomer, whose true function is to show us the dancing of Tyrolese peasants to the fife and zither, spends his best strength in painting a heap of promiscuous emigrants in the agonies of starvation.'[30]

In 1894, Herkomer exhibited *Pressing to the West* at the Munich Secession with nine other works, including a group portrait of businessmen titled *A Board of Directors* (1892, destroyed). Symbolist abstractions such as *Feinde* (*Hateful*, untraced), and Bavarian peasant 'heads'. His immigration picture was purchased from the Secession exhibition by the Leipzig Museum. That Herkomer should have included both *Pressing to the West* and a work that was its opposite ideologically and thematically, *A Board of Directors*, in the same exhibition, underlines his belief by this time that his portraits and subject pictures were documents of contemporary history that encompassed all classes of society. *Pressing to the West* is also a work that synthesises both realist and symbolist elements. The painting goes beyond realism with its literal attention to detail and sets up inward-turning or subjective tensions, visualised by the disorienting space and disturbing human message, to function as a metaphor for the artist's own humble beginnings.

Hard Times 1885

According to Herkomer, the subject of *Hard Times 1885* (cat. 82 and colour detail on front cover) was suggested by a group he saw resting at the roadside in Coldharbour Lane (his students thereafter called it 'Hard Times Lane') near his Bushey home.[31] The economic depression which began in 1873, worsened during the 1880s, and hundreds of workers 'on-the-tramp' for the too few jobs available were a common sight. The painting depicts an unemployed country labourer leaning on a farm gate, his wife seated wearily on the ground at his feet with one child at her breast and another resting against her.

Although Herkomer did not begin to paint *Hard Times* until January 1885, the subject seems to have percolated in his mind as early as March 1884 after he saw a work in progress with a 'tramp' theme by a student at his school in Bushey. The student, a young Welsh woman named Mary Godsal, who kept a voluminous diary of her experiences at the art school,[32] was told by Herkomer to keep working on her picture and 'to get real tramps and pose them under a hedge, and a sick child, and put them in several positions'.[33] In addition, Miss Godsal seems to have been the first to use Annie Quarry, described as 'a very pretty woman', as a model.[34] It was the Quarry family of Merry

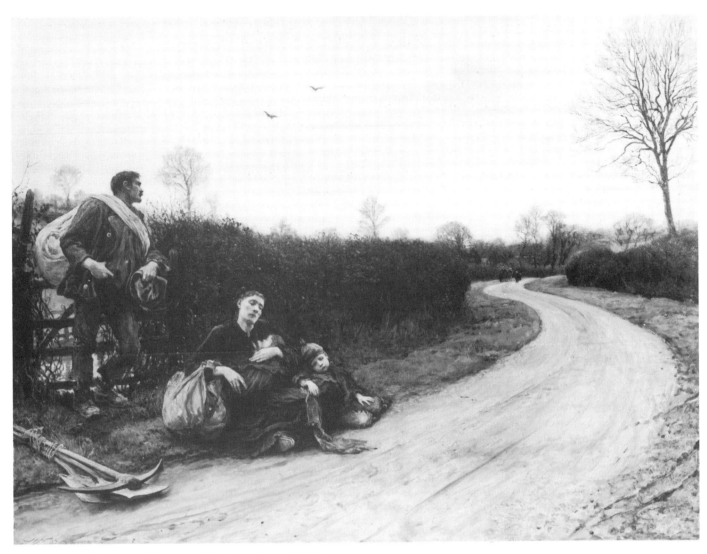

82. Hubert von Herkomer, *Hard Times 1885*, Manchester City Art Galleries

Hill Lane, Bushey, that Herkomer portrayed in *Hard Times*. James Quarry, who posed as the out-of-work navvy, was himself a fully-employed labourer. His wife Annie posed with their two young sons, Frederick George, the infant at her breast in the picture, and James Joseph, who leans against her knee.[35] Thus Herkomer's scene of roadside destitution described so graphically in his memoirs,[36] was ultimately contrived, and possibly initially inspired by a student's groping example.

In contrast to the background which was painted from nature, the figures were posed and painted indoors, in 'the angle room' of the Herkomer art school.[37] The figures are finely detailed, though broad brush-strokes are used for the browns of the sweeping road, and large expanse of sky;

and thick encrustations of paint build up the folds and furrows of the woman's black dress. In order to depict accurately the background, the artist worked in a glassed-in hut built for him in Coldharbour Lane,[38] capturing on his canvas the natural effects of light and the low, cheerless tones of the wintry landscape. The red roofs of the Atkins farm buildings, now demolished, appear in the distance.

Hard Times was the first of several rural images painted by Herkomer in the 1880s and 1890s that reveal the impact of his rekindled interest in the art of Frederick Walker. With the large-scale realism of paintings like *The Last Muster* (cat. 71), and *Eventide* (cat. 80), Herkomer felt he was emancipated, at least stylistically, from his youthful

dependence on Walker.[39] Yet, after a period of painting scenes of Bavarian peasant life and social subjects like *Pressing to the West* (cat. 81) which seem more closely related to the work of his German contemporaries, Herkomer returned to the sources which inspired the themes of his subject pictures. Although Walker died tragically young in 1875, his influence was still very much felt by his followers. His work was frequently on view in salerooms and galleries, most particularly at Thomas Agnew and Sons, for Walker had been a favourite of that enterprising dealer William Agnew. Indeed, Herkomer's student, Mary Godsal, mentioned in a diary entry of 1884 that she went up to London, probably at Herkomer's suggestion, to see Walker's *The Harbour of Refuge* (see cat. 37), then on view at Agnew's. She also recorded almost verbatim a lecture on Walker's *The Old Gate* (1869, Tate Gallery) given by Herkomer that year to the Bushey art school students, in which the painting's stylistic originality and soulful realism were glowingly praised. During that time, Walker's watercolour *Philip in Church* (1863, Tate Gallery), after an illustration he had done for William Thackeray's last novel, *The Adventures of Philip* (1862), was placed on view in the picture gallery at the Herkomer school so that the students could see for themselves the art their master held in such high esteem.[40] Clearly Herkomer was again in the thrall of Walker, and in 1885 his etchings after Walker's *Philip in Church* and *The Old Gate* were shown along with *Hard Times 1885* at the Royal Academy exhibition. The major exhibition of Walker's work at the Dunthorne Gallery in the same year seemed to confirm Herkomer's rekindled enthusiasm and the wide appeal of Walker's art on a national scale.

The arrangement of the figures in *Hard Times* bears comparison with Walker's composition of the gypsy group in *The Vagrants* (1868, cat 36), a work whose theme had earlier inspired Herkomer's first engraving for the *Graphic* magazine in 1870 (see cat. 40). And the description of the husband in Herkomer's painting as, 'an Apollo or Hermes incarnated in the shape of an English "out of work",'[41] recalls a similar perception of Walker's heroic figures (Ruskin called them 'galvanised Elgin').

Seeing the worker in these symbolic terms – a strong individual who, in a sense, embodied the values of a pre-industrial past – brings to mind earlier depictions of this type: for instance, the shirt-sleeved navvies in Ford Madox Brown's *Work* (1857, cat. 19), in George Elgar Hicks' *The Sinews of Old England* (1857, Private Collection); and in G. H. Boughton's *The Miners* (1878, Walker Art Gallery, Liverpool). A similar ideology also prevailed

in heroic depictions of workers in European examples such as in Adolph von Menzel's *The Ironworks* (1876, Staatliche Museen, Berlin), Jean-François Rafaelli's *At the Foundry* (1886, Musée de Lyon), and Jules Dalou's *Monument to Labour* (1889–91, Petit Palais, Paris). While the motive behind such dignified portrayals of the worker was doubtless well-intentioned, they ultimately distanced him, and reduced to myth the meaning of his struggle in the real world. In *Hard Times*, the intimation of better days ahead, underlined by the idealised male figure, is further suggested by the prominent placement of his work tools, implying that his physical strength will eventually overcome adversity.

In addition, the tilted perspective of the roadway, so different from the thrusting space of *Eventide* (cat. 80) and *Pressing to the West* (cat. 81), which heightens the forbidding enclosure, seems here expansive and flexible, its arc reaching into an illusory depth. Standing upright against a wooden fence a few feet behind his wife, the husband in *Hard Times* looks steadily into the distance, a gesture that suggests the hope of future employment at the end of the winding road pictured before him. While Herkomer used abrupt changes of perspective as an expressionist device throughout his career nowhere is it more brilliantly employed than in *Hard Times*, where the tightly grouped figures of the mother and her children at the left of the picture are offset by the daring composition of the road to their right. The arbitrary structure of the roadway in *Hard Times* also shares affinities with the symbolist language of Vincent van Gogh, who often used a road motif for both decorative and thematic purposes.

When *Hard Times* was exhibited at the Royal Academy in 1885, it was universally viewed as reformist – the more conservative condemning its 'modern sociology' and 'mawkish sentiment', the more liberal hailing it as 'a cry for humanity in these hard times'. In 1905, it was still being written of as 'art on the way to make socialists of us'.[42] Frequently reproduced (a detail currently appears on a paperback edition of Elizabeth Gaskell's *Mary Barton*), the painting has become a symbol of the suffering and deprivation of the Victorian working class. However, despite its descriptive Dickensian title, and its obviously sympathetic portrayal of the plight of an unemployed labourer and his family, *Hard Times* is less polemic than allegory, and concerned more with hope than with destitution.

With their allusion to the timeless and the heroic, the figures in *Hard Times* contrast with the tattered, grimy appearance of the displaced family depicted by Joseph

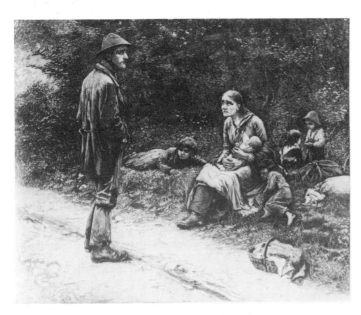

fig. 8. Joseph Farquarson, *Where Next?*, 1883 (unlocated)

Farquharson in *Where Next?* (fig. 8), which was exhibited at the Royal Academy in 1883. Yet the proximity of the dates and the coincidence of the subject-matter suggest that Herkomer must have known the picture.[43] With his very different approach to the theme, Herkomer may ultimately have wished to respond to Farquharson's example by showing him how such a subject should be painted. Ironically, Farquharson's depiction of a contemporary social problem, with its suggestion of the potentially threatening behaviour of the victims of poverty, looks back to the harsh documentation explored in the early pages of the *Graphic* magazine. In comparison with Farquharson's tattered and sickly drifters, Herkomer's family suggests survival and hope.

Though sympathetic to the sufferings of the poor and toil-worn, Herkomer showed little patience for what he termed the 'unemployable' and those who openly protested against the system.[44] He and his family had gone through grim periods of poverty, but by 1885 Herkomer was reaping the rewards that success within the system had brought him. While he informed his readers and lecture audiences of the hardships he himself had suffered, he was equally adept at reminding them that he had become successful through extremely hard work and ambition. While the Victorians acknowledged the sufferings of the poor with charity, sympathy and religious exhortation, actual social change to alleviate their deprivation was still essentially a thing of the future. *Hard Times*,

in a larger sense, reflects these predominant social values.

Depictions of the rural wayfarer have a long tradition in English painting.[45] Herkomer no doubt knew Frederick Walker's *The Wayfarers*, a large and currently untraced oil picture of 1860 which depicts an old, blind rustic leaning on a boy's shoulder as they tramp along a country lane.[46] Earlier examples of displaced families on-the-tramp include John Joseph Barker's *The Irish Emigrants* (c. 1845, Victoria Art Gallery, Bath); Walter Deverell's *Irish Vagrants* (1853, Johannesburg); and George Frederick Watts' *The Irish Famine* (cat. 13) of 1848, all of which document the appalling suffering of the Irish rural poor during the potato famine. Despite the explicit landscape in *Hard Times*, the universal imagery of Watts' *Irish Famine* with its evocation of a modern *Holy Family* or *Rest on the Flight into Egypt*, seems applicable to Herkomer's conception as well.[47] Additionally, the intimation of suffering endured, embodied in the haggard face of the wife in *Hard Times*, shares the timeless vision of enduring womanhood portrayed by Watts in another of his early social themes, *The Sempstress* (1850, Trustees of the Watts Gallery). Herkomer made a special trip to London in March 1882, accompanied by his cousin the painter Herman G. Herkomer, to view the huge exhibition of Watts' paintings then at the Grosvenor Gallery, where these early social-subject pictures were seen in public.[48]

Although images of female melancholia date from classical times, the depiction of the wife as 'the bearer of the burden' in *Hard Times* can also be viewed not only as a symbol of dutiful suffering, but as an example of the wide gap between male and female attitudes and expectations in the Victorian era. When contrasted with the upright composure of the husband in *Hard Times*, who directs a steady gaze down the winding road before him, his wife's exhausted demeanour and downcast face is a picture of hopeless dejection. The undertone of male/female separateness added a dimension of tension to many later Victorian domestic genre scenes, perhaps in a subconscious reaction to the growing movement towards greater female independence. An example is the carefree navvy followed at a distance by three female relatives burdened with babies and heavy bundles in George Henry Boughton's *Bearers of the Burden* (1875, untraced). Louise Jopling's *Saturday Night: Searching for the Breadwinner: 'Pay night, drink night, crime night'* (1883, untraced), which shows a woman with a baby in her arms and a child at her side about to enter a pub in search of an errant husband, documents the problem of abandonment and drunkenness. Herkomer also made the undercurrent of

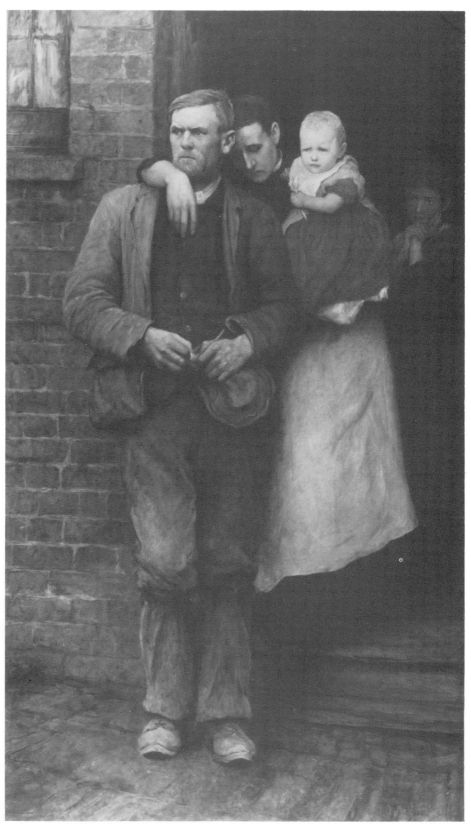

83. Hubert von Herkomer, *On Strike*, 1891, Royal Academy of Arts

male/female friction a sub-theme in *On Strike* (cat. 83), which will be discussed below. The conflict between male and female was also explored in such late nineteenth-century novels as George Gissing's *New Grub Street* (1894), in which the idealistic motives of the writer-protagonist George Reardon contrast with the more materialistic concerns of his wife Amy; and in *Esther Waters* (1891) by George Moore, which graphically describes the brutal treatment of Mrs Waters by her husband.

On Strike

By the end of the nineteenth century, labour disputes and strikes became far more frequent and violent as workers demanded improved wages and working conditions. There was a vast difference between the non-violent and reasonable striking workers described in Elizabeth Gaskell's mid-century novel *North and South* (1854–5), and Paul Muniment's angry mob that would 'lift a tremendous hungry voice and awaken the gorged indifference to a terror that would bring them down' in Henry James's *The Princess Casamassima* (1886). These late-century social changes are what Herkomer reflects in *On Strike* (cat. 83), his diploma picture painted on election to full membership in the Royal Academy in 1891. In the painting, the striking worker is a monumental figure who dominates the canvas; his tensed fingers which grip a crumpled hat and pipe compound his disquieting facial expression. Unlike the idealised toiler tied to old-world tradition in *Hard Times*, the worker in *On Strike* is portrayed with objective forcefulness. His sorrowful wife, who leans against his shoulder, carries their infant in one arm, while an older child looks out from the dark doorway of their dwelling.

It is significant that Herkomer chose a serious social subject for his diploma picture. It was as if, at a time when portraiture was the dominant focus of his career and his subject pictures had reverted to a Walkerian vision, he wished to reassert his earlier status as an innovative and socially-aware artist whose genesis had been through 'the eye-witness school' of the *Graphic*'s demanding requirements. That he had consciously sought to be 'modern' for his diploma work is revealed in another, probably aborted attempt, an unfinished study titled *In the Black Country* (cat. 84), also painted in 1891. With its plunging space, slashing brush-strokes and looming foreground figures, this image of a coal miner and his family shares affinities with the grim expressionist vision of *Eventide*.

Paintings with strike themes proliferated as dissenting

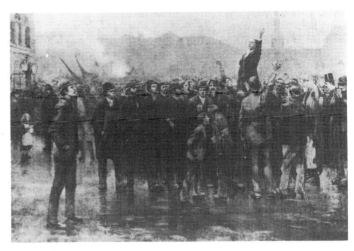

fig. 9. Dudley Hardy, *The Dock Strike, London, 1889*, 1890 (unlocated)

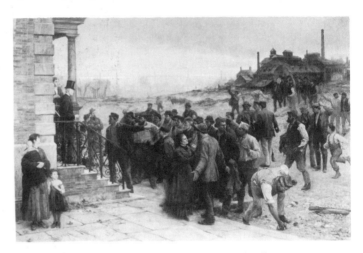

fig. 10. Robert Koehler, *The Strike*, 1886, Lee Baxendall Collection

workers became more visibly militant. Crowded gatherings which celebrated social protest and the power of change, were generally what was depicted.[49] For example, Dudley Hardy's *The Dock Strike, London, 1889* (fig. 9), exhibited at the Royal Academy in 1890, is a typically animated and crowded documentation of an actual strike: the strikers' leader John Burns is shown inciting his fellow workers to rally to the cause, which *did* eventually result in wage improvements.[50]

A similarly crowded scene is Robert Koehler's *The Strike* (fig. 10), which was exhibited in New York in May 1886 and reproduced that month as a double-page engraving in *Harper's Weekly*. Herkomer, who was in America fulfilling portrait commissions from December 1885 to May 1886, most certainly knew the picture for it created a sensation at its exhibition.[51] In Koehler's painting, which

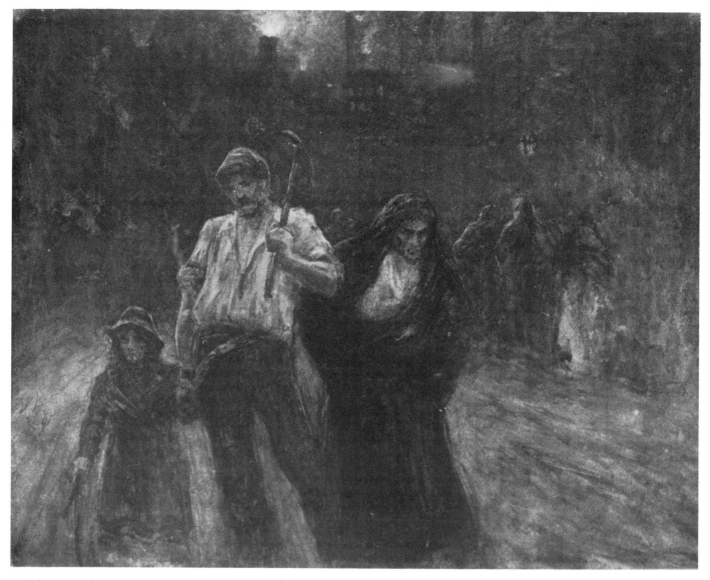

84. Hubert von Herkomer, *In the Black Country*, 1891, Mr & Mrs R. W. Sumner

depicts an actual strike incident at a Pittsburgh mill, the hostility of the workers is explicitly depicted as they bring their protest (one reaches down to pick up a rock) to a gaunt mill-owner, who, elegantly dressed, stands on the steps of his office. Koehler was a well-known socialist, and his sympathy for the workers in this painting is obvious in the pointed contrast between the poor and the privileged.

Rather than a crowded or violent scene of social protest, Herkomer in *On Strike* chose to portray a lone worker living with the consequences of his act of defiance. 'Nobody will deny', wrote one Academy critic, 'that in these days of labour disputes and acute social questions such a subject is appropriate to art; and in his figure of the gaunt,

dogged and surly labourer, of his unhappy wife and half-famished children, Mr. Herkomer has given us a summary of one side, and a very important side, of modern civilisation.'[52]

The size and obvious coarseness of the main figure reflect the influence of contemporary French painting, in particular that of Jules Bastien-Lepage, whose art Herkomer admired. Tom ('Money') Birch, one of the artist's favourite models and a gardener on his Bushey estate, posed again for him here. It is difficult to tell from the context of the painting, whether the worker is supposed to represent an urban or agricultural labourer. Given the publicity about the London dock strike in 1889 and

Dudley Hardy's 1890 Academy picture of the subject (see fig. 9), it might be assumed that Herkomer's picture was inspired by the same incident. Indeed, one contemporary critic called the painting 'Herkomer's Dockers' Strike'.[53] However, given the number and frequency of strikes among many segments of the working population in 1891, the worker portrayed could just as well be lingering outside a village cottage in Bushey as a tenement in London's East End.

The painting's critical reception was decidely mixed, and it was hung too high at the Royal Academy exhibition. One London critic, appalled that such a mean-looking creature as Herkomer's striking worker could exist in English painting, compared the painting to one then on view at the French Gallery titled *The Malcontent* (currently untraced) by the popular German genre painter Ludwig Knaus.[54] The allusion to a work by a German artist is significant, for the prototype for the family in *On Strike* comes from one of Herkomer's earlier Bavarian peasant scenes, a watercolour, titled *The Arrest of a Poacher in the Bavarian Alps* (Private Collection) painted in 1874.[55] Its composition emphasised the domestic drama of the scene: a sorrowful wife, her two bewildered children by her side, clings to her defiant husband, who is about to be taken away by the police. Interestingly, only one critic took notice of the domestic conflict in the artist's much later painting. '*On Strike*, a really strong study of a working man halting between two views of life – his duty to his comrades and his duty to his family. Of the former motive we only see the trace in the sullen obstinacy of the man's face as he leans against the doorpost of his lodgings. His wife with a baby in her arms, followed by an elder child, is urging the breadwinner to think of their hapless lot.'[56]

Portrayed as a surly dissident, the worker in *On Strike* may have supported his fellow strikers in their desire for better working conditions, but at the same time he has involved his wife and children in the chaos of unemployment and economic sacrifice: the sorrowful wife (another 'bearer of the burden' like the woman in *Hard Times* [cat. 82]) and her crying children are visual opposites to the figure of the determined husband – as unyielding as the rigid doorframe against which he stands.

It is difficult to assess the artist's own attitudes here. In that sense, the painting is much like the so-called problem pictures of the 1890s, in which the interpretation of the content, or the outcome of the narrative set up by the picture, is left to the imagination of the viewer. A negative image on the one hand – after all the striking worker threatens the security of his family, a sacred Victorian

entity – his monumental size nevertheless evokes heroic parallels. Additionally, his expressive face emphasises the harsh realitities of his existence. On another level, the artist's depiction of the 'modern' worker reaches out to a much larger issue, the disturbing human effect of industrialisation. Uprooted from cottage industries and a rural way of life, the working class was now tied to long hours in factories and dispiriting jobs in overcrowded cities. The old Victorian platitudes would no longer suffice as militant workers became instrumental in bringing about social change.

Though the sentiments expressed in *On Strike* suggest an engagement or commitment which we interpret from twentieth-century expectations, Herkomer's view of his role as an artist, at least in his late years, was as a recorder of history rather than a reformer or polemicist. Precisely because the message or sentiment in *On Strike* is not overt, it remains Herkomer's most intriguing painting, its degree of ambiguity a challenge that demands more from the viewer than the emotive imagery of his earlier works. In attempting to give visual expression to all levels of society – the oppressed or victimised in his subject pictures, the eminent and glamorous in his portraits – Herkomer's ultimate goal was to document all aspects of modern life. 'Truly, art that brings a living individual before our eyes is *great* art', were his words to a group of Royal Academy students in a lecture series given in 1900. 'Be it remembered that we paint and write for future generations to dream over and wonder.'[57]

12 | Late Victorian social subjects

Though Holl, Fildes and Herkomer received most critical attention, other artists painted pictures showing poverty and social evils. Some important social subjects were produced early in their careers by artists who later became famous for work in quite a different mood, such as R. W. Macbeth, Joseph Farquharson, Dudley Hardy and James Guthrie (see cat. 47; figs 8, 10, 13). A good example is *The End of her Journey* by Alice Havers (Rochdale Art Gallery, 1877; fig. 11). This picture of death in the fields has a muted sadness, but her later work is idyllic in feeling. There was an element of social realism in the work of the 'idyllic' school of landscape painters who often depicted peasants at work in the fields, but as the name suggests these artists expressed an idealised view, softening the pain of rural life and labour. In contrast, some regular Royal Academy exhibitors attempted social subjects, but the results were often unadventurous and lacking in commitment. The most successful are those such as the works of Eyre Crowe which are descriptive rather than anecdotal.

Eyre Crowe

The Dinner Hour, Wigan by Eyre Crowe (cat. 85 and colour plate VII after p. 12) was shown at the Academy of 1874, the same exhibition as Fildes' *Casuals* (cat. 74) and Holl's *Deserted – A Foundling* (see cat. 66). Crowe's painting of working-class life did not ask for sympathy, yet it too must be counted as a piece of social realism simply by virtue of addressing a subject which no artist had ever painted before. Here is the earliest painting of an urban industrial landscape which is not romantic, topographical or narra-tive: it is the ancestor of the Northern townscapes of L. S. Lowry. *The Times* thought it a 'praiseworthy attempt to find paintable material in the rude life of some of the most unlovely areas of Lancashire'. It was perhaps the lack of a story which caused the *Athenaeum* to complain that 'a

photographer could have contrived as much', though the writer continued in the usual vein that 'notwithstanding the local interest of the subject, we think it was a pity Mr. Crowe wasted his time on such unattractive materials'[1]. Even so, to modern eyes, the girls look clean, well-nourished and neatly-dressed as they relax between shifts – only one is barefoot. The orderliness of their life is em-phasised by the presence of a policeman.

Crowe is an intriguing figure. His father was a journalist and his brother, J. A. Crowe, a diplomat and art historian whose *History of Painting in Italy* (1903), written with the Italian, G. B. Cavalcaselle, laid the foundations for the modern study of Renaissance art. Eyre Crowe studied in Paris with the historical painter Delaroche and then in London at the Academy schools. He became a regular RA exhibitor, showing conventional costume pictures such as *Pope's Introduction to Dryden at Will's Coffee House*, *De Foe in the Pillory* and *Charles II knighting the loin of beef*. But his work has another side which shows an eye for the unusual and a sympathy for the underdog. In 1853, while touring America as secretary to the novelist W. M. Thack-eray, he sketched an auction of negro slaves at Richmond,

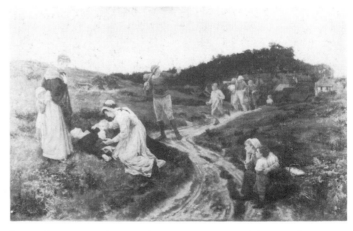

fig. 11. Alice Havers, *The End of her Journey*, 1877, Rochdale Art Gallery

Virginia; in 1861 he showed at the Academy *Slaves waiting for sale at Richmond, Virginia* (Heinz Collection, Washington).[2] In 1869 he exhibited *Shinglers* (Forbes Magazine Collection), a remarkable scene of workers in an iron foundry, with an eerie lighting effect derived from Joseph Wright of Derby. In 1874, besides *The Dinner Hour, Wigan*, he showed another Wigan subject, *A Spoil Bank*, now lost, but described as 'kerchiefed Wigan lasses and women groping for lumps of coal among the slack under the shoots, and the tall black colliers, davy in hand, looking down on them'.[3]

By the 1870s, Lancashire factory and colliery girls were well known, to newspaper readers at least, as types of the industrial North and Wigan was attracting 'tourists' curious to see them. A. J. Munby, whose fascination with working girls is recorded in his diary, saw cotton-factory girls in 1862 at the International Exhibition in London, and frequently visited Wigan, where photographs of pit-brow girls in working costume were on sale to visitors. Articles on the conditions of Wigan colliery life appeared in various newspapers in the early 1870s and the *Graphic*

had published an engraving of dinner time at a Lancashire cotton-factory. But Crowe was the first person to attempt to transmute these materials into art fit to be shown at the Academy. Curiously, Munby visited the 1874 exhibition but did not comment on Crowe's pictures in his diary.[4]

There may have been a more specific reason for Crowe's coming to Wigan. The large factory buildings on the left of the street running back into the centre of the picture were the Victoria Mills, owned by Thomas Taylor, the art collector, who was to purchase the *Casuals* and *The Widower*.[5] It is possible that Crowe was hoping to sell his painting to Taylor, but if so (and there is no evidence connecting Crowe and Taylor) he failed, for the picture was not sold and remained on the artist's hands.

This did not deter him from painting further off-beat subjects from time to time. The punningly titled *Sandwiches*, RA 1881 (cat. 86) shows a group of sandwich-board men in Trafalgar Square. Like the Wigan factory girls, the men are having a lunch-break; also as in the Wigan picture, Crowe may have had a collector in mind as a possible purchaser, as one of the placards features

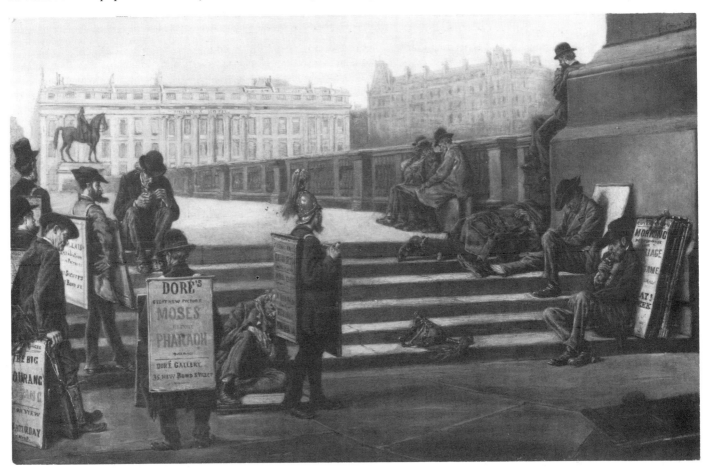

86. Eyre Crowe, *Sandwiches*, 1881, Private Collection

'Doré's Great New Picture, Moses before Pharaoh' at the Doré Gallery, and another advertises the Millais exhibition at the Fine Art Society. But the figures tell a story of poverty and failure. Sandwich-board men were the lowest of the low among casual labourers; the job was the last refuge of the aged, the unskilled and the otherwise unemployable. The helmets in the picture show that many ex-soldiers, a group who found it difficult to find employment, took work carrying sandwich-boards. Many would have been otherwise destitute. 'To the reflecting mind . . . the announcements which these poor heralds bear upon their wooden tabards are often suggestive of painful thoughts. The sunken cheek and hungry eye of the bearer of a placard concerning a "Food Exhibition", or intimating where a sumptuous dinner may be obtained; the fluttering rags and broken shoes of the old man who battles with the searching wind that he may keep the subject of warm clothing before the public eye; the rueful countenances of the long line of poverty-stricken creatures who shuffle in the gutter to call attention to a roaring farce, or a gay burlesque, may sometimes make us pause to ask: 'Where do these itinerants come from, and how do they live?'[6]

One of the sandwich-board men is sleeping on the pavement, and several have the air of down-and-outs. Trafalgar Square seems to have been a haunt of such unfortunates. Another painting, now lost, commemorates the period in 1887 when, according to accounts in *The Times*, large numbers of homeless poor congregated there and 'turned Trafalgar Square into a public dormitory', sleeping out overnight.[7] Dudley Hardy's large and dramatic *Sans Asile* (*Without Shelter*) was shown in Paris in 1888 and then in Munich, Dusseldorf and Berlin before coming to London in 1893 (fig. 12).[8]

Another small picture of this type is Crowe's *Convicts at*

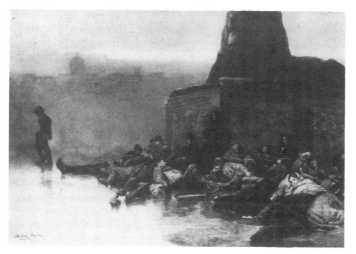

fig. 12. Dudley Hardy, *Sans Asile*, 1888 (unlocated)

Work, Portsmouth, RA 1887 (cat. 87) which would count simply as a piece of lively genre were it not for the oddity of the subject. The convicts are excavating the area below the bridge, under the supervision of uniformed officers, one standing by a sentry box on a scaffolding platform; the whole scene is watched by a woman peeping through the fence. This unposed picture of convicts, painted with a fresh eye, is very far from the contrived prison scenes of Doré or Holl. In all his social pictures Crowe accepts his subjects as facts rather than as vehicles for pathos or moralising: he was criticised for 'prosaic literalness . . . He has not attempted to appeal to the imagination or the slightest reference to sentiment'.[9] From a twentieth-century standpoint, that is why his work is so intriguing.

Other academic artists

Many other painters took up social themes in the 1870s and 1880s, but few did so with power or originality. Frith, for instance, painted a prison scene, *Retribution* (cat. 88) as the final episode of *The Road to Ruin*, a Hogarthian moral fable about a fraudulent promoter of bubble companies who ruined a gullible clergyman and his family, but was finally brought to justice. The series of five was shown in London in 1880[10] and is now at the Baroda Museum, India; cat. 88 is a reduced replica. There was a real-life parallel to Frith's story in the career of Baron Albert Grant and a fictional one in Trollope's *The way we live now* (1875), but whereas Trollope's swindler committed suicide, Frith shows him in gaol: 'In prison-garb, the luckless adventurer takes his dismal exercise with his fellow convicts in the great quandrangle of Millbank Gaol' wrote Frith,[11] who related in detail how he obtained permission from the Governor to see the yard, take a photograph of it and to borrow a prison uniform, but only on condition that he avoided any facial resemblance to the prisoners he had seen. Otherwise his painting is accurately observed showing the prisoners walking in a circle, spaced out, as he was told, to prevent their speaking to each other. For all his efforts at authenticity, he has followed the essentials of Doré's more terrifying if less literal image (cat. 57). Frith's painting was meant as an awful warning of the consequences of criminal behaviour. The *Art Journal*, missing the point entirely, wrote 'the taste is questionable not altogether morbid which would be gratified by such a sight as a set of hideously attired, hideously visaged convicts walking round in a single file . . .'.[12]

Doré's London engravings were also very influential on the work of Augustus E. Mulready, a painter of children

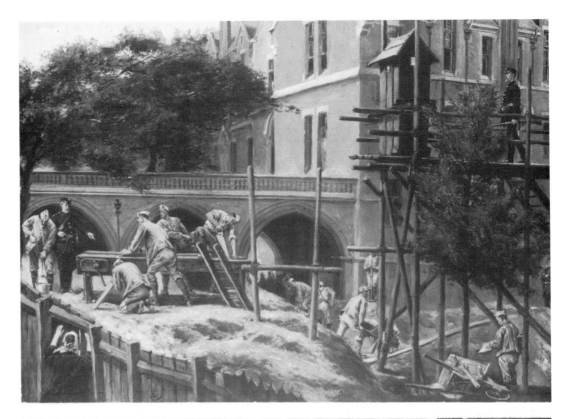

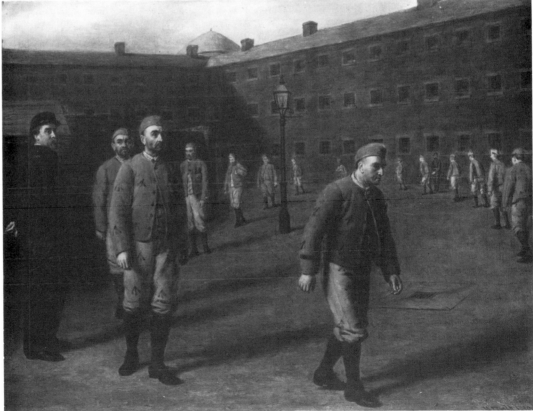

87. Eyre Crowe, *Convicts at Work, Portsmouth*, 1887, Trafalgar Galleries,
London

88. William Powell Frith, *Retribution*, 1880, Birmingham Museum
and Art Gallery

originally associated with the charming Dutch-style genre scenes of the Cranbrook colony. In the 1880s and 1890s, he painted many small pictures of starving waifs, street beggars and flower girls. He idealised his subjects giving them stage rags and winsome expressions without a hint of dirt or malnutrition, and as a result most of his pictures have a mawkish kind of charm rather than a sense of tragedy. *A Recess on a London Bridge*, RA 1880 (cat. 89), is a development of Doré's engraving *Asleep under the Stars* (cat. 60) and re-uses the same stone seat and the clear starry sky.

Homelessness was also a theme of Arthur H. Marsh, who was known for his pictures of the Cullercoats fisherfolk. His rustic wanderers are versions of Legros' desperate peasants without Legros' bitter sense of tragedy. *Wayfarers*, 1881 (cat. 90), was justly described in the *Magazine of Art* as 'two young women of the class and type that this artist invariably paints (and paints from imagination, for though not maudlin, pretty or sentimental, they are entirely idealised)'.[13] This picture of homeless wanderers compares unfavourably with those by Herkomer or Farquharson for instance (cat. 82, fig. 8).

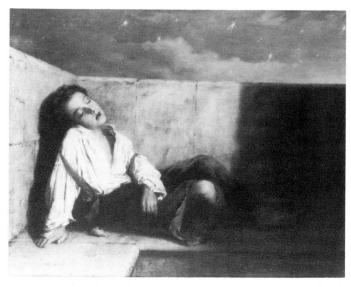

89. A. E. Mulready, *A Recess on a London Bridge*, 1879, Laing Art Gallery, Newcastle upon Tyne (Tyne and Wear Museums Service)

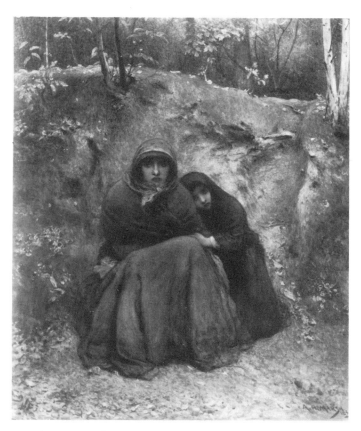

90. Arthur H. Marsh, *Wayfarers*, 1879, Laing Art Gallery, Newcastle upon Tyne (Tyne and Wear Museums Service)

13 | New styles in social realism

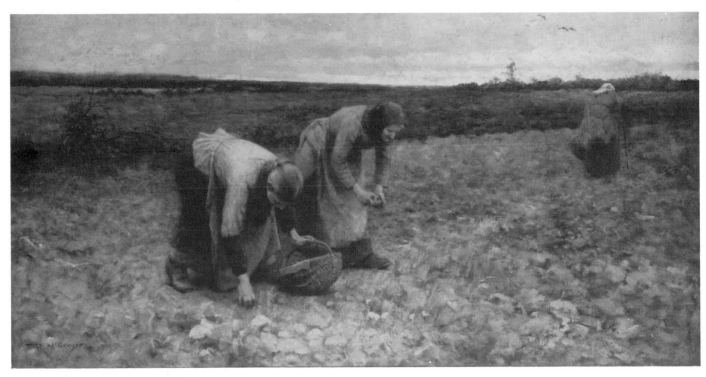

91. Robert McGregor, *Gathering Stones*, City of Edinburgh Museums and Art Galleries

In the 1880s and 1890s, a new younger generation of painters was coming to the fore. Impatient of conventional academic technique and studio subjects, they looked to French art for inspiration. In the 1870s it was possible to see the work of Millet, Corot, Degas and Manet at the Deschamps Gallery in London; Henry Hill lent French pictures from his collection for exhibition in Brighton and the teaching of Legros encouraged a more cosmopolitan interest in French art. Many artists visited France and admired particularly the work of Bastien-Lepage. Plein-air painting; moving from London to the country where the light was better and there were peasants and field-workers to paint; an interest in tonal values rather than colour, resulting in a greyer, softer appearance; a careful observation of modelling and the fall of light; all these came to England from France in the late 1870s and 1880s.[1]

Studio subjects were now despised, but narrative painting was still very much a part of the new style. Whistler's arrangements of colour and tone, and the Impressionists' setting down the optical sensations of light and colour were still too advanced for most English painters. Though the artificially arranged subjects of social realism were rejected by the younger artists, they retained a deep interest in the observation of the humble and common-

place, stemming from French realism. Though this meant for the most part scenes of peasant and village life, the urban realism of English academic painters was also absorbed into the new art movement. There began to be enthusiasm not just for Bastien-Lepage, but, at least among a small coterie of artists, dealers and collectors, for Manet, Degas and the Impressionists, artists whose celebration of *la vie moderne* led them to paint the life of the city. Thus, pictures of the poor and oppressed became part of the repertoire of progressive painters and eventually of the modern art of our own century.

Social realism and the rural naturalists

The work of Robert McGregor is a harbinger of the new interest in French painting. His father, a Scottish manufacturer, had settled in Yorkshire where Robert was born. He trained as a textile designer, returned to Scotland and also took up book illustration. After studying at the Royal Scottish Academy Schools, he began to exhibit in the 1870s, travelling the country districts to record peasants in the fields, pedlars and vagrants and scenes of village life. He is said to have received early instruction in art from a Frenchman, and this may have led to his adoption of a tonal style of painting before any of the younger Scottish artists, such as Guthrie or Walton.[2] *Gathering Stones* (cat. 91) shows three women collecting stones, to clear a field for ploughing and planting potatoes. Like Millet's *Gleaners* (Louvre), two of the women are bent double and a third carries a heavy basket. Though not a work of overt social realism, the painting expresses a feeling for the hardship of the women. Their carefully observed thick clothing, the heavy atmosphere and the flat, featureless landscape reinforce the sense of tedium. Subjects like this became commonplace in the 1880s and 1890s in the work of English naturalists such as Clausen and La Thangue.

One consequence of the admiration of French art was the escape of painters from London and the foundation of artists' colonies such as that in the Cornish fishing village of Newlyn where in the 1880s a group of artists settled to live among the fisherfolk and record their lives. To some extent, this idea had been anticipated by Frank Holl's visits to Cullercoats and Criccieth, but Holl only summered in these places and worked his subjects up in the artificial surroundings and controlled light of a London studio. Walter Langley, a Birmingham painter, was the first artist to settle in Newlyn.[3] He had visited it in 1880 and in 1881 made a short visit to Brittany, another popular haunt of artists. He was settled at Newlyn by January 1882 and his watercolour *But men must work and women must weep* (cat. 92) dates from that year. The title is an extract from *The Three Fishers*, a poem of 1851 by Charles Kingsley, a memory in the art of the 1880s of the social idealists of the 1850s (Kingsley was originally to have been one of the 'brain workers' in *Work*, cat. 19, by Ford Madox Brown.):

Three fishers went sailing away to the West,
Away to the West as the sun went down;
Each thought on the woman who loved him the best,
And the children stood watching them out of the town;
For men must work and women must weep,
And there's little to earn, and many to keep,
Though the harbour bar be moaning.

Three wives sat up in the lighthouse tower,
And they trimmed the lamps as the sun went down;
They looked at the squall, and they looked at the shower,
And the night-rack came rolling up ragged and brown.
But men must work and women must weep,
Though storms be sudden, and waters deep,
And the harbour bar be moaning.

Three corpses lay out on the shining sands
In the morning gleam as the tide went down,
And the women are weeping and wringing their hands
For those who will never come home to the town;
For men must work, and women must weep,
And the sooner it's over, the sooner to sleep;
And good-bye to the bar and its moaning.

While reading Kingsley's poem, Langley heard a signal gun. 'He went out into the black night – an awful storm was howling – and he saw the blue rockets being fired from Penzance as a signal to those who were at sea. The scene was in the last degree impressive – a fearful constraint on his cosy fireside – and the idea at once suggested itself'.[4] The subject re-states Frank Holl's picture of twelve years before (cat. 65). Langley painted many variations on the theme of weeping fishermen's wives and widows but the subject was made famous by another Newlyn artist, Frank Bramley in *A Hopeless Dawn* (1888, Tate Gallery). This is an oil painting and technically much more characteristic of the French-influenced tonal manner of the Newlyn school than Langley's watercolour. Langley shows a firm control of tone but his brilliant rendering of light and texture is a result of his training and practice as a designer of jewellery.

In the 1880s and 1890s paintings of agricultural workers toiling in the fields, similar to McGregor's *Gathering Stones* (cat. 91), became commonplace in English art, though by the mid-1890s, the tonal handling of Bastien-

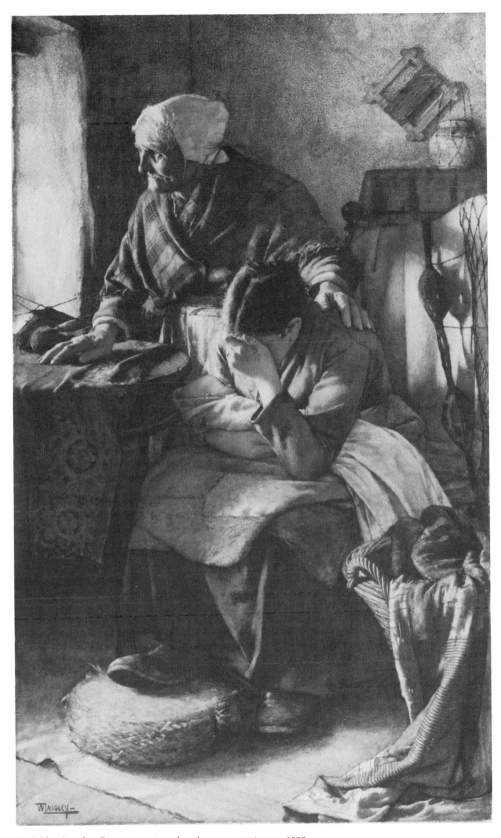

92. Walter Langley, *But men must work and women must weep*, 1882,
Birmingham City Museum and Art Gallery

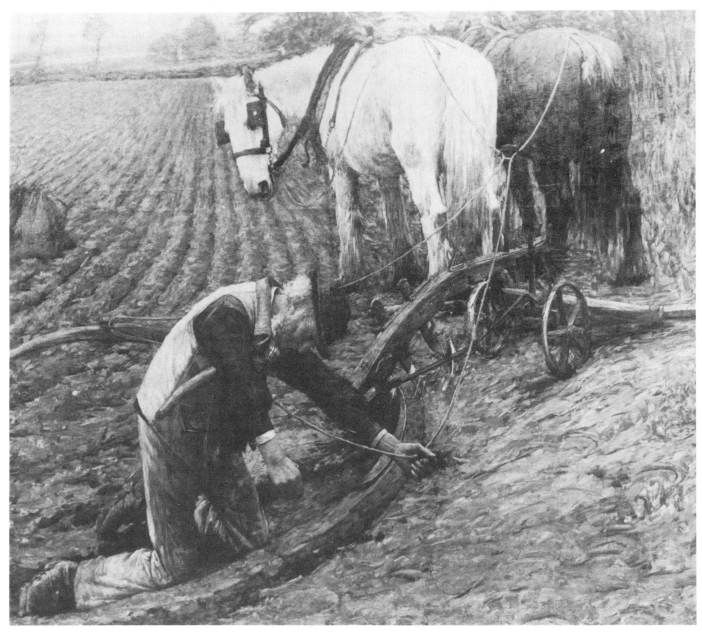

93. H. H. La Thangue, *The Last Furrow*, 1895, Oldham Art Gallery

Lepage was giving way to a rougher, more broken touch akin to Impressionism. The most notable exponents of this kind of rural naturalism were George Clausen and Henry La Thangue. Clausen's declared concern was with the beauty of effect through rendering light and atmosphere. He does not seem to have been much interested in expressing the hardship of the peasant's life, though in his more wintry subjects, the misery of outdoor toil does come across.[5] However, in La Thangue's *The Last Furrow* (cat. 93) the spectator is forced to confront not just hardship, but death, and the picture implies the social injustice of a life of unremitting toil. La Thangue had trained in London and Paris, and had worked in Brittany, Norfolk and Rye before he settled at Bosham near Chichester in 1890. Not

all of his work is as dramatic as *The Last Furrow*, but in the 1890s much of it had a melancholic strain. In 1891 he painted *A Mission to Seamen* (Nottingham Art Gallery) a sombre quayside scene in the Newlyn manner, with a small crowd of humble villagers listening to a wandering preacher; and in 1894 he painted *Some Poor People* (Dunfermline Museum), two peasant women sitting sadly in a cottage. *The Last Furrow* is an out-of-doors scene in a drab landscape. *The Times*, commenting on the artist's 'true feeling for the country with its profound unspoken tragedies' described it: 'An old labourer has broken down over his ploughing; as he turns the last furrow he falls swooning over the plough-handle; his horses have stopped; we see one of them looking around and understand-

94. Ernest L. Sichel, *A Child's Funeral in the Highlands*, 1896, Bradford Art Galleries and Museums

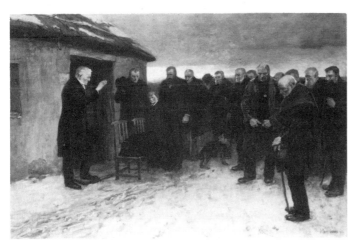

fig. 13. James Guthrie, *A Funeral Service in the Highlands*, 1881, Glasgow Art Gallery and Museum

ing . . . J. F. Millet would have rendered such a subject on a canvas two feet square and would have moved us infinitely more.' This last somewhat unjust comment may also be a criticism of the broad handling which went with the large scale. This was still unacceptable to many. It is noteworthy that the *Art Journal* contrasted what it saw as La Thangue's harsh and grotesque realism with the 'poetic idealisation' of Clausen;[6] social realism even in the 1890s was still regarded as too painful. Various paintings have been cited as influencing La Thangue, and there are similarities with a watercolour of a horse collapsed at the plough by J. C. Dollman and with Clausen's picture of a plough-boy of 1894; La Thangue may have seen Courbet's *Stonebreakers* which was shown in the Paris Exposition of

113

1889.[7] He knew Legros' etchings (see cat. 62). But the stiffly collapsed body of the dead man also recalls Henry Wallis's *The Stonebreaker* (cat. 23) which La Thangue could have seen at the Whitechapel Art Gallery in 1887; and it is similar in spirit to the dead veteran of Herkomer's *The Last Muster* (see cat. 79) shown at the Academy while La Thangue was a student. The year after he showed *The Last Furrow*, he painted *The Man with the Scythe* (Tate Gallery), in which the death of a sick child is indicated by an old reaper passing by in the background; but in *The Last Furrow* the symbolic device is not necessary to indicate the presence of death.

Ernest Sichel, a Bradford artist, painted *A Child's Funeral in the Highlands* in 1896 (cat. 94). Here the beauty of the twilight heightens the poignancy of the sight of a boat bearing a tiny coffin and a band of five mourners. Sichel probably knew the funeral subjects of Frank Holl; *I am the Resurrection and the Life* (fig. 4) was purchased in 1894 by Leeds City Art Gallery. He must also have known *A Funeral Service in the Highlands* (Glasgow Art Gallery) by the Scottish painter, James Guthrie, which dates from 1881 (fig. 13). But Sichel has absorbed other influences. He was taught at the Slade School of Fine Art by Legros, from whom he learned to express the humility of peasant life, and on a visit to Paris he was much impressed with the work of Puvis de Chavannes.[8] There is more than an echo here of Puvis' *The Poor Fisherman* (Louvre) in the mute figure standing in the boat with bowed head, reading from a prayer-book.

Later social realism and the urban scene

J. H. Henshall's *Behind the Bar* (cat. 95 and colour plate VIII after p. 12) was exhibited at the Dudley Gallery in November 1882. It does not appear to have attracted critical attention, but of the exhibition as a whole, the *Athenaeum* wrote that 'the influence of Paris, either direct or indirect, is even more obvious than before'.[9] In 1882, Manet had shown at the Paris Salon his *Bar at the Folies Bergère* (Courtauld Institute). Henshall's picture is a witty attempt to paint an English equivalent, turning the whole scene round literally and figuratively.[10] There is an unmistakable general resemblance between the two works and a direct quotation in Henshall's barmaid and her top-hatted admirer. Manet's viewpoint has literally been reversed so that instead of the sparkling array of bottles, fruit and flowers, the bar is seen from behind with its shelves, drawers and sinks, and with the barman drawing a cork; Henshall paints the customers not as a glittering blur

reflected in a mirror, but as a detailed line-up of types, old and young, lonely and convivial. Socially, Henshall transforms the scene from the fashionable Parisian *demimonde*, to a working-class district of London, and philosophically, the cool detachment of Manet's barmaid surveying the pleasure-loving crowd, is replaced by an understated warning of the effects of drink. Prominent in the line of drinkers are a mother spoon-feeding a baby with gin, an old woman drinking, and a young child, barely tall enough to see over the bar, waiting for a bottle to be filled. The man with a beard is a street-violinist, spending the money he has received on drink. Leaning by the snob-screen is an unhappy old man being consoled by the man in the bowler hat. On the right is a man with an unpleasant-looking bandage over one eye, perhaps a result of a wound in a tavern brawl. The loose morals of the barmaid are suggested by her receiving a present of earrings from her admirer. Most telling of all, across the street, the three golden balls of a pawnbroker's shop point out the connection between poverty and drink. Henshall's composition is slightly awkward as the barmaid and the central figure do not quite balance the barmen on the left. Nevertheless, his painting is remarkable. Much influenced by the vivid gin-shop scenes and contrasting types of the *Graphic* engravers (see cat. 49), he has merged the matter-of-fact observation of working-class life with the realistic light of French tonal painting. To these he has added the social consciousness of English narrative painting to produce something unique in British art.

Frederick Brown's *Hard Times* (cat. 96) was exhibited in 1886, a French-style response to Herkomer's painting of the previous year (cat. 82). Here the out-of-work vagrant has stopped for a drink in a bar or inn, the bundle of tools at his feet, as in the Herkomer, showing he is on the tramp in search of work. The little girl warming her hands by the fire may be his companion. Unemployment was high at this period, and Charles Booth's *In Darkest England* reprints a particularly pathetic account of the fruitless and lengthy search for work by one of the unemployed.[11] The man in the painting was modelled by a friend of Brown's, Thomas Smith.[12]

Brown was one of a group of young artists who, trained at South Kensington, travelled often to Holland, France and Belgium to paint and in London frequented the Deschamps Gallery where French art was exhibited regularly.[13] Brown's despairing vagrant seated at a table meditating over his drink recalls Degas' painting *L'Absinthe* (Louvre). It is not too fanciful to suppose that Brown knew it at first hand, for it had entered the collection of

96. Frederick Brown, *Hard Times*, 1886, National Museum and Galleries on Merseyside (Walker Art Gallery)

Captain Henry Hill of Brighton in 1875 or 1876 either through Deschamps or even directly from Degas in Paris; and it was exhibited in Brighton in 1876 in an exhibition of Modern French Pictures. It was then called 'A sketch at a French café' and though described by the *Brighton Gazette* as 'the perfection of ugliness', the association with absinthe had not given it the stigma it later attracted.[14]

Brown's *Hard Times* was included in the first exhibition of the New English Art Club, an organisation set up by younger artists to counter the exclusiveness and traditionalism of the Academy. The first secretary of the Club was Thomas H. Kennington who had trained in Liverpool, London and Paris. His work employs the French-style square brush-stroke and muted tonal palette. Though not a great artist, he was one of the few who in the 1880s and 1890s painted a series of overtly social realist works (as opposed to those who only occasionally or incidentally represented the poor and dispossessed). He painted a number of Murillo-like urchins whose poverty was presented with a sweet sadness. *Widowed and Fatherless* (cat. 97) of 1888 is more ambitious. It shows a sparsely furnished garret with a broken chair and patched coverlet. A sick child lies in bed, comforted by her sister while her mother sits sewing. Despite a pinkish cast, the colouring is drab. The subject is similar to Octave Tassaert's *The Unfortunate Family* of 1851, then in the Musée du Luxembourg, Paris, which by the 1880s must have come to look somewhat melodramatic.

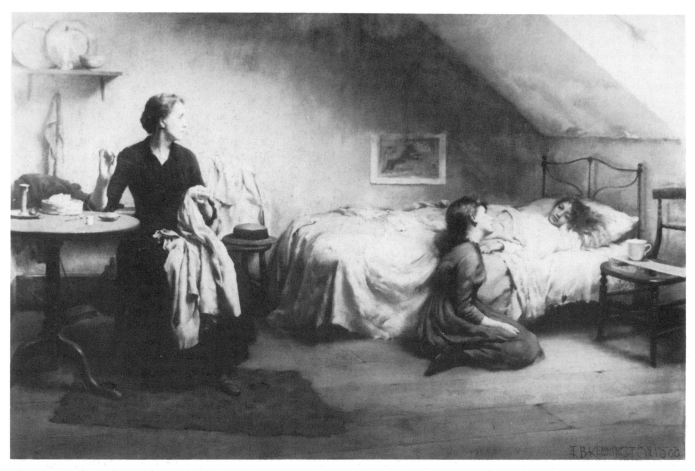

97. Thomas B. Kennington, *Widowed and Fatherless*, 1888,
Private Collection

98. Thomas B. Kennington, *The Pinch of Poverty*, 1891,
Thomas Coram Foundation for Children

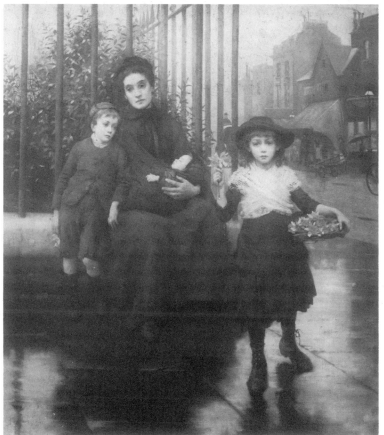

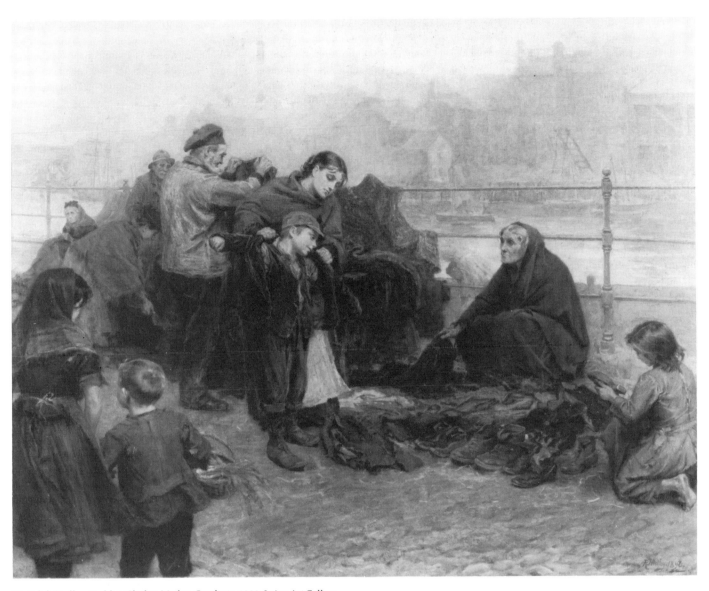

99. Ralph Hedley, *Paddy's Clothes Market, Sandgate*, 1898, Laing Art Gallery, Newcastle upon Tyne (Tyne and Wear Museums Service)

In 1891 Kennington followed with *The Pinch of Poverty* (cat. 98, a replica of the original in the Art Gallery of South Australia). In a drab London street, a family is reduced to begging: the little girl offers daffodils for sale. The figures are set against the railings of a London square: this too may have a French source in Manet's *The Railway* (National Gallery of Art, Washington) exhibited in Paris in 1884, and showing a woman seated in front of railings. The refined face of Kennington's model hints at a respectable background, reduced by circumstances. *The Times* remarked of his painting: 'There are few faces in the whole Academy so pathetic as that of his poor woman'.[15] Working-class

street types, such as the cockney characters of Phil May's contemporary *Punch* cartoons, were coarser and therefore less appealing as objects of sympathy to a middle-class audience.

The painter Ralph Hedley, born in Yorkshire, became an apprentice wood-carver in Newcastle upon Tyne, where he attended evening classes at the School of Design. One of his teachers was the Pre-Raphaelite painter William Bell Scott. Hedley later founded a firm of wood and stone carvers, but he also became a prominent local artist and exhibited regularly. Isolated from the cult of French painting and less concerned to make an impression on the

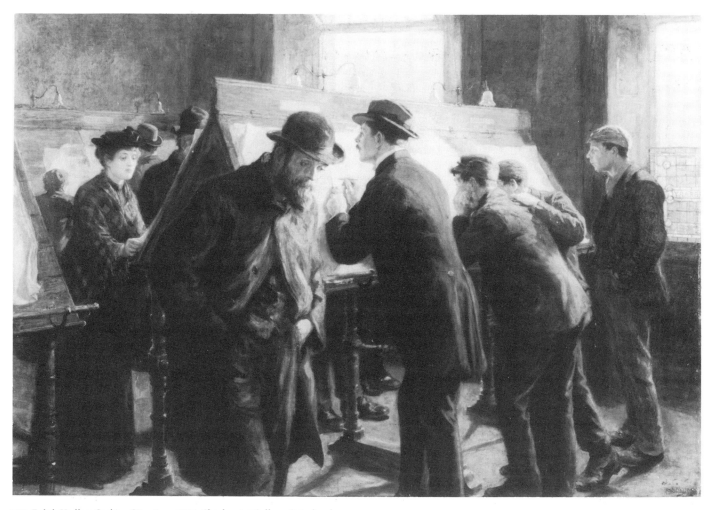

100. Ralph Hedley, *Seeking Situations*, 1904, Shipley Art Gallery, Gateshead
(Tyne and Wear Museums Service)

fashionable art scene, his work pursued its own quiet
course in the provinces. A Newcastle newspaper de-
scribed his views on art: 'He thinks that there are plenty of
good subjects to be found in the North, and that it is
unnecessary to go further afield. Moreover he contends
that an artist should give special study to events of our
own day in preference to those which took place say a
couple of centuries ago. This, he thinks is the true ideal of
the historical painter.'[16] His painting *Paddy's Clothes
Market* 1898 (cat. 99), showing a second-hand clothes
seller in Sandgate recalls Shields' picture of mill-girls
trying on old clothes (cat. 48). There is an attractive view
of Tyneside industrial buildings behind and nicely
painted still-life detail in the rows of boots and shoes, and

the basket of vegetables. In the centre, the mother helps
her son try on his coat. Hedley has achieved an unforced
air of melancholy and a genuine rapport with his subjects;
the characters do not appear to be studio models, their
clothes and surroundings are dirty and authentic and the
artist's evident affection for such a commonplace scene is
something peculiarly modern.

Hedley's *Seeking Situations* of 1904 (cat. 100) has more
of the character of an illustration, yet it also has an
affecting, weary air of melancholy. In the reading room of a
public library, young people look for jobs in the news-
papers, but the shabby middle-aged man in the fore-
ground, head bared, has no hope of employment. The
message of rejection is still with us today.

14 | Vincent van Gogh and English social realism: 'And the truth is that there is more drudgery than rest in life'

Louis van Tilborgh

It is now well known that Van Gogh's fascination with social subjects during his Dutch period owed much to his study of English models.[1] He got great pleasure from George Eliot's *Adam Bede* and *Felix Holt*, read all of Dickens, and was deeply moved by the illustrations of everyday life in the *Graphic* and the *Illustrated London News*.

He had first come across these popular magazines during his three-year stay in England from 1873–6, but it was not until he was living in The Hague that he became really enthusiastic about these British scenes 'from the people, for the people'.[2] He immediately set about expanding his collection of wood-engravings with illustrations of this kind by scouring second-hand bookshops, and making exchanges with his equally enthusiastic friend, Anthon van Rappard. He was overjoyed when he managed to acquire a set of *Graphic* volumes covering the years 1870–80. 'Just what I have been wanting for years', he had written a year earlier after another, more modest coup, 'drawings by Herkomer, Frank Holl, Walker, and others'.[3]

These and the other wood-engravings in his collection, more than 1,500 of which are now preserved in the Vincent van Gogh Museum, were of the greatest importance to Van Gogh during his Hague period (1882–3), for he was teaching himself his craft largely unaided (see Chapter 7). They sharpened his competitive instincts, confronted him with a wide range of styles, showed him how other artists tackled technical problems, and broadened his own still limited vocabulary. He rapidly came to the conclusion that his collection was really a kind of Bible. 'Seen together', he said in 1883 of his artistic Bible, 'one wonders at the firmness of drawing, that personal character, that serious conception and that penetration and artistic elevation of the most ordinary figures and subjects on the street, in the market place, in a hospital or an almshouse.'[4]

Inspired by these and other subjects, which were still fairly uncommon in Holland, Van Gogh went looking for similar themes in the residential areas of The Hague, and this led to studies of the Potato Market, the Pawnshop, the State Lottery Office, and navvies repairing streets. He undoubtedly made these sketches in the hope that he might one day work as an illustrator for English periodicals, and even ran ahead of himself slightly by giving them English titles ranging from the prosaic *The Dustman* to the more romantic *Shadows Passing*.

Typical of his ambition to document the life of the poor and the working man is *The Public Soup Kitchen* of 1883 (cat. 101). This drawing, which is done in black mountain chalk, shows the kitchen run by the Society of St Vincent de Paul in The Hague, where people down on their luck (Van Gogh even used it himself) could get a hot meal for 11 cents or in exchange for a coupon. His forceful study, which he associated with the work of George Eliot, was not actually made on the spot but back in his studio, where he re-created the scene fairly closely, using some women friends to pose for the figures. It is a very thoughtfully composed scene. The placing of the four figures in the setting shows Van Gogh's feeling for spatial organisation. The figures are seen from the front, the rear and the side and are perhaps a little stiff, but the lack of movement actually reinforces the solemn, almost ceremonious mood of the silent figures, who are all staring at the floor.

In 1882, following in the footsteps of the illustrators he so admired, Van Gogh took up lithography in an attempt to bring his own art directly to the people. After learning about the new technique of transfer lithography from his brother Theo, he began carrying out his own experiments with advice from a friendly printer. Using specially prepared paper, he transferred some of his drawings to the lithographic stone, which he left only lightly worked. Although he had intended to produce a series of thirty lithographs, he got no further than eight, for in the end he found the technique too troublesome.

His first lithograph was *The Orphan Man* of 1882 (cat. 102), who has been identified fairly certainly as Adrianus Jacobus Zuyderland, a resident of the Dutch Reformed Home for Old Men and Women in The Hague. This and the Roman Catholic Orphanage and Old People's Home were useful sources of models for Van Gogh, and it was not entirely coincidental that he chose figures who resembled the careworn types in his print of Herkomer's *Sunday at Chelsea Hospital* (cat. 52). This is also true of the *Orphan Man Drinking Coffee* of 1882 (cat. 103), which is probably a portrait of the same man wearing a different hat. Pinned to his lapel is the Cross for Meritorious Service, which was awarded to members of the Hague militia who had served in the 1830 war against Belgium.

More ambitious than these two figure studies is the lithograph to which Van Gogh gave the English title *Sorrow*, which also dates from 1882 (cat. 104). Earlier that year Van Gogh made three drawings of the subject, in which he set out to capture 'not sentimental melancholy, but serious sorrow'.[5] Two of the drawings still survive.

Sorrow is a disguised portrait of Sien, the prostitute whom he began living with in 1882, much to the dismay of his brother and friends. In an attempt to justify the relationship he inscribed the second drawing, which was intended for his brother, with the words: 'Comment se fait-il qu'il y ait sur la terre une femme seule, délaissée!' ('How can it be that there is on earth a woman alone, forsaken!'). This rather melodramatic quotation is from

101. Vincent van Gogh, *The Public Soup Kitchen*, 1883, Rijksmuseum Vincent van Gogh, Amsterdam

102. Vincent van Gogh, *The Orphan Man*, 1882, Rijksmuseum Vincent van Gogh, Amsterdam

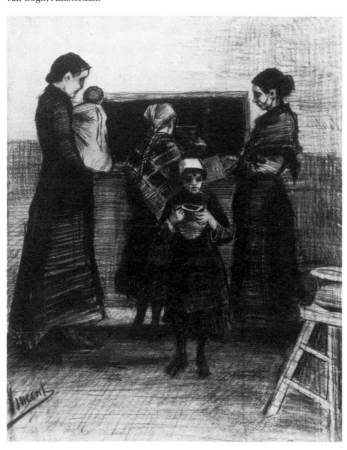

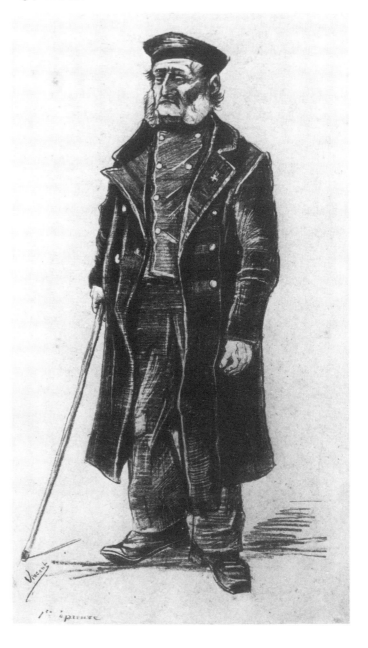

Michelet's *La Femme*, in which the author urges men to save abandoned women from certain downfall – women who are 'still young, but in the decay of their bloom, grown a little thin and pale – with ennui and anxiety – with bad and unhealthy food perhaps'.[6]

The pose of the figure and the linear draughtsmanship can be traced back to the models which Van Gogh had copied time and again from the well-known manual by Charles Bargue. However, he himself compared *Sorrow* to 'the English drawings done in this style', by which he was undoubtedly referring to his obvious attempt to capture the coarser, more powerful effect of the English wood-engraving by his handling of line.[7] In his next letter he agreed with Theo's observation that it could best be

compared to an 'unburnished etching'.[8]

A work as serious in its intent as *Sorrow* is *At Eternity's Gate*, a lithograph of 1882 of an old man hunched over in a chair resting his bald head on clenched fists (cat. 105). Van Gogh had earlier used this motif of a pensive man by a hearth in a small watercolour of 1881, which he titled *Worn Out* after an engraving of Facd's painting (cat. 30). When he repeated the subject in The Hague he improved the expressiveness of the figure by giving it the pose of the old man in an illustration by Arthur Boyd Houghton for Dickens's *Hard Times* (fig. 14). He made two drawn versions, one of which he transferred to the lithographic stone. The prints, which he had hoped to sell for 15 cents each, survive in several versions, and one of them bears

103. Vincent van Gogh, *Orphan Man Drinking Coffee*, 1882, Rijksmuseum Vincent van Gogh, Amsterdam

104. Vincent van Gogh, *Sorrow*, 1882, Rijksmuseum Vincent van Gogh, Amsterdam

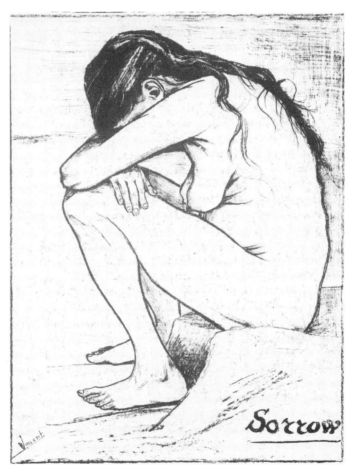

the English title *At Eternity's Gate*. In 1890 he used the lithograph as the model for a virtually identical painting which is now in the Rijksmuseum Kröller-Müller in Otterlo.

The subject of an old man sunk deep in thought should be related to Van Gogh's desire to combine Jozef Israels' *Old Comrades* (Philadelphia Museum of Art) with Jean-François Millet's *Death and the Woodcutter* (Copenhagen, Ny Carlsberg Glyptothek).[9] Israels' painting is a peaceful, slightly sentimental scene of an old man and his dog by a crackling fire. Millet's is an allegory in which Death firmly but kindly grasps the shoulder of an aged woodcutter, heedless of his protests.

At Eternity's Gate, in other words, was Van Gogh's attempt to unite the conflicting moods of these two works in order to evoke the crucial moment of an old man's uneasy resignation in the face of approaching death. For Van Gogh such a moment had a religious dimension, and he wrote to his brother that the 'infinitely touching ex-pression' of the man with his patched, bombazine clothes was 'one of the strongest proofs of . . . the existence of God and eternity'.[10]

He also described the old workman's feelings as 'great and noble', and not 'destined for the worms',[11] which was completely in accord with the aims of both English and French humanitarian realism, in which Van Gogh's art must be included. Following the example of Michelet's *Le Peuple* of 1846, Van Gogh idealised the working man, and elevated the nobility of work to an article of faith. He disliked industrialisation, for to him, 'the so-called civil-ised world of progress' was a delusion – a view which was reinforced by his reading of Thomas Carlyle.[12] Genuinely humanitarian values survived only in the countryside, and in 1883 Van Gogh decided to go in search of them. He went first to the north-eastern province of Drenthe, where he echoed Michelet by declaring that 'a simple farmer, *who works, and works intelligently*, is *the* civilized man'.[13] After a stay of only a few months he was forced to

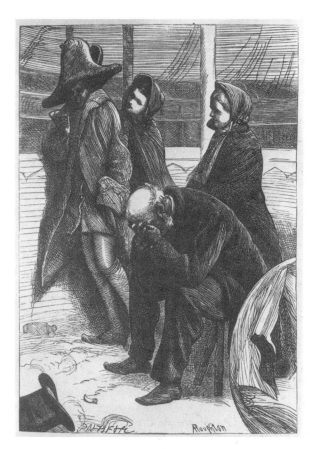

fig. 14. Arthur Boyd Houghton, *Father and Son* (*Hard Times*, 1854 edn)

105. Vincent van Gogh, *At Eternity's Gate*, 1882, Rijksmuseum Vincent van Gogh, Amsterdam

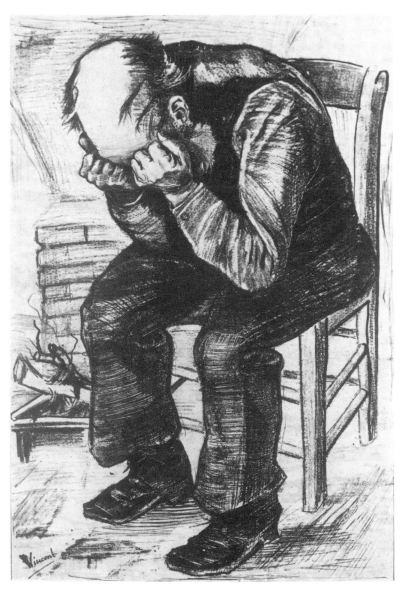

return to his parental home at Nuenen in the southern province of Brabant.

He lived at Nuenen from late 1883 to November 1885, and at first he tried out his talent on a subject which he had come across in his favourite books by George Eliot: weavers. In Nuenen the weavers worked in the winter months, when there was nothing to do on the land. To Van Gogh the charm of this form of cottage industry was that it had managed to survive in the face of increasing mechanisation. True to his preference for the old values, he depicted only the old looms, and substituted traditional lamps for the more modern lighting in the weavers' cottages.[14]

The drawing of a weaver in this exhibition, which was based on a painting now on loan to the Hague Gemeentemuseum, was one of a series of four (cat. 106). Van Gogh had only one or two illustrations of weavers in his collection, and he believed (wrongly, as it happened) that he had come across a virtually untouched subject. Despite the rather stiff and awkward look of some of his drawings he was evidently pleased with the results, and asked Theo to mount the series in grey passe-partouts.

Van Gogh's most ambitious portrait of peasant life in Nuenen was of course *The Potato Eaters* of 1885 (Amsterdam, Rijksmuseum Vincent Van Gogh), which he intended as a work to rival the history paintings of the old masters. There are three versions: a small study, an initial essay, and the final painting. The lithograph in this exhibition (cat. 107) was executed from memory after the initial version (Otterlo, Rijksmuseum Kröller-Müller). It was his ninth, and last, lithograph, and he was not very happy with it, feeling that incorrect instructions on the part of the printer had robbed it of much of its power.

In a letter he told Theo what he had set out to portray in this document of hard times on the land: 'I have tried to emphasise that those people, eating their potatoes in the lamplight, have dug the earth with those very hands they put in the dish, and so it speaks of *manual labour*, and

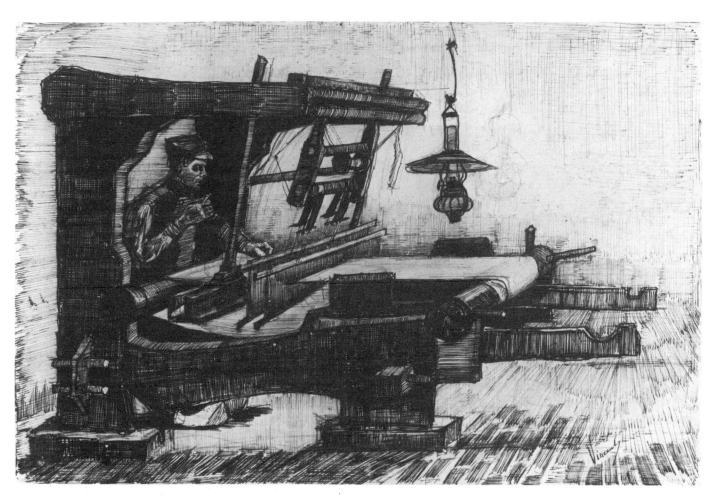

106. Vincent van Gogh, *The Weaver*, 1885, Rijksmuseum Vincent van Gogh, Amsterdam

123

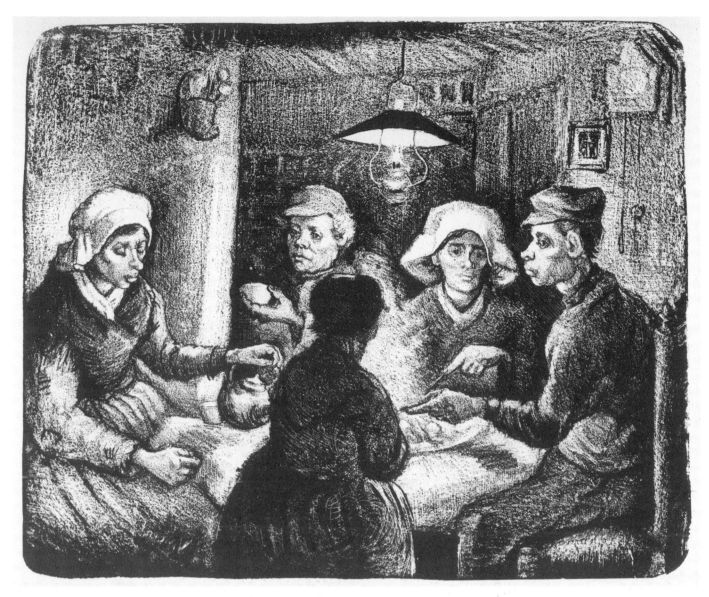

107. Vincent van Gogh, *The Potato Eaters*, 1885, Rijksmuseum Vincent van Gogh, Amsterdam

how they have honestly earned their food. I have wanted to give the impression of a way of life quite different from that of us civilised people.'[15]

So *The Potato Eaters* is not a social protest, but an unadorned glorification of the harmony of a peasant household, in which a higher premium was put on work than in 'the so-called civilised world'. This kind of simple, hard-working life was his own goal as an artist, and he eagerly followed the example of his idol, Jean-François Millet. According to Sensier, Millet's biographer, the French painter of peasant life lived only for his work, and

cared nothing for financial reward or the approval of the bourgeoisie. This struck a very responsive chord in Van Gogh. '[It] would be bad enough for me if I wanted fine shoes and the life of a gentleman, but – "*puisque j'y vais en sabots, je m'en tirerai . . .*" What I hope I shall not forget is that "one should go about in clogs", which means to be content with the food, drink, clothes and board which the peasants content themselves with.'[16]

Van Gogh's touching still lifes of workmen's boots must be seen in the light of this hymn of praise to those who work hard and scorn pretension. There are seven of them

in all, and their number alone shows how closely he identified with the honest life of the working man, which he saw symbolised in the boots. The group is represented in this exhibition by the battered pair of boots (cat. 108) from Van Gogh's Paris period (1886–7).

With hindsight it is perhaps not so surprising that Van Gogh's sympathy for the worker should have been seized on and blown up out of all proportion by twentieth-century socialists. Conservative it may have been, but it was sympathy nonetheless, which is why Julius Meier-Graefe could write in 1906 that Van Gogh's ideas 'were from the beginning determined by a thoroughgoing socialism'.[17] Another person who was struck by this 'political outlook' was the Dutch socialist politician Pieter Jelles Troelstra, who visited the famous Van Gogh exhibition in Amsterdam in 1905. According to his son, 'the sombre, cheerless *Potato Eaters* and the gloomy, desperate-ly miserable Brabant cottages . . . struck straight and deep to Pieter Jelles' socialist heart. . . . The deep compassion and the protest that spoke from these works convinced him of the burning seriousness of the revolutionary who, in order to be true to his calling, could not follow in the paths trodden by others, but had to break new ground like a true pioneer.'[18]

Van Gogh, though, did not regard his work as a protest against the social conditions of the workers, nor for that matter did he identify with them as closely as many people think. It is true that at the start of his career he liked to dress as a simple workman, but the income he needed, and received from Theo, was four times that of the average weaver.[19] Certainly, he admired peasants for being so much more refined than civilised gentlemen, but not in every respect, 'for what', he asked, 'do they know of art, and many other things?'[20]

108. Vincent van Gogh, *A pair of boots*, 1886, Rijksmuseum Vincent van Gogh, Amsterdam

15 | Words and pictures: Changing images of the poor in Victorian Britain

Peter Keating

'Descend where you will into the lower class', Carlyle announced in *Past and Present* (1843), 'in Town or Country, by what avenue you will, by Factory Inquiries, Agricultural Inquiries, by Revenue Returns, by Mining-Labourer Committees, by opening your own eyes and looking, the same sorrowful result discloses itself.' As these words suggest, Victorian attitudes to the poor (and, to a slightly lesser extent, the working classes as well) were built upon a series of apparently unresolvable paradoxes. The poor were everywhere, in town and country, as even the most casual observer could determine simply by opening his 'own eyes and looking', yet throughout the period their way of life was described repeatedly as hidden, distant, alien, unknown. In the early years of Victoria's reign they were often not regarded as constituting an integral part of society at all. Instead, they were seen collectively as making up a kind of colonial dependency, from which total loyalty was demanded and for which token responsibility was assumed: alternatively, they were inhabitants of a 'nether world' into which intrepid adventurers occasionally 'descended'.

Whether this near-yet-distant imagery served to express genuine ignorance or functioned as a rhetorical device, it contained within it a still more surprising paradox. From about 1830 the poor were endlessly studied, analysed, classified and categorised, written up and legislated for. Much of this activity came from official Government investigations, as Carlyle indicates: it was supplemented by the work of journalists, reformers, philanthropists, slum priests and doctors, statisticians, sociologists and Socialists. The poor were not only *not* unknown, they were, arguably, one of the most known sections of Victorian society. Little of this, however, could be realised from art and literature where, until quite late in the century, the poor were generally treated – albeit sympathetically – as members of an alien race.

Concern at their relative absence from literature was frequently expressed. When the radical Scotsman Sandy Mackaye, in Charles Kingsley's novel *Alton Locke: Tailor and Poet* (1850), discovers that Alton Locke has been writing a poem about the South Seas, he tells him angrily: 'True poetry, like true charity, my laddie, begins at hame. If ye'll be a poet at a', ye maun be a cockney poet.' However sensible that advice, it was followed by few of the real-life Alton Lockes who hoped to make successful careers in literature. Tradition was largely against them. The great poets they mostly admired – Milton, Byron, and Shelley – had lived radical lives, but their poetry was not concerned with the everyday reality of poverty, and many of the young working-class poets of the 1830s and 1840s would have echoed Alton Locke's timid rejoinder to Sandy Mackaye's demand that he write about the slums: 'But all this is so – so unpoetical.' Burns certainly had succeeded in making everyday life 'poetical', and Sandy Mackaye recommends Alton Locke to read him daily, but times were changing and in some respects Burns could seem more removed than Milton from the social and political crises of the time: after 1848, even Chartism, which had provided many working-class poets with a political theme for their poetry, lost its immediate literary appeal.[1]

The situation in fiction was hardly more encouraging. With the important exception of Dickens, whose astonishing career as an author began in the mid-1830s, the most popular fiction of the day dealt with High Society or historical themes. The vast amount of cheap fiction directed at a working-class audience followed these trends: little of it portrayed a world that its readers would have recognised from their own experience of life, though it did sometimes embody a melodramatic radical element.[2] Even when a significant number of novelists did begin to attempt to portray the lives of the poor, they were not usually motivated by personal interest in, or knowledge of, that way of life, as *Alton Locke* can once again demonstrate. The kind of 'cockney poet' that Sandy

Mackaye wants Alton Locke to become is one who will be able to write 'like Jeremiah of old, o' lamentation and mourning and woe, for the sins o' your people'. The poor were a social problem, and, in literature and art, a social problem they remained.

It was Dickens more than any other novelist who challenged early Victorian perceptions of the poor with *Sketches by Boz* (1836), *Pickwick Papers* (1837) and *Oliver Twist* (1838). The nature of Dickens's impact was well described by Mary Russell Mitford, herself a popular novelist, who in 1837 wrote to a friend in Ireland urging her to read *Pickwick Papers*. It is, she enthused, 'fun – London life – but without anything unpleasant: a lady might read it all *aloud*'. Its character sketches she described as 'so graphic, so individual, and so true,' and she warned her friend that not having heard of Dickens was like 'not having heard of Hogarth, whom he resembles greatly, except that he takes a far more cheerful view, a Shakespearian view, of humanity'.[3] It would be difficult to better Mitford's immediate understanding of Dickens's distinctive qualities as a novelist: his 'fun', strikingly visual characterisation, uncanny inside knowledge of London, the close connections with his eighteenth-century predecessors – Hogarth notably, but novelists like Fielding and Smollett as well – and the way he had managed to refine away the coarser aspects of the eighteenth century while retaining an emotional sympathy for the deprived that placed him nearer to the 'humanity' of Shakespeare than the bitter satire of Hogarth.

Dickens's own view of British society was to become darker, his 'fun' sharper, and the themes of his novels more aggressively contemporary, as his career developed, but he never entirely shed the characteristics defined by Mitford, and they were largely responsible for his highly selective portrayal of the poor and working classes. The impact of the railways on London he described brilliantly in *Dombey and Son* (1848), yet gave no central prominence in his novels to the massive expansion of London's dockland that was taking place at the same time. Nor did he allow any but the most cursory acknowledgement of farm-workers and agricultural labourers: a reader of, say, Hardy's or George Eliot's novels would often be hard put to understand that the social world they wrote of was exactly contemporary with that of Dickens. He frequently depicted the growth of suburbs in London, but not its modern factories: odd characters and corners of the great metropolis – both ancient and contemporary – abound, but its rapidly organising, and often radical, working class is largely absent from the novels.

Dickens's obsession with London also led him to give relatively little attention to the new industrial areas of Britain. In *The Old Curiosity Shop* (1841) and *Bleak House* (1853) the reader is offered glimpses of burnt, blackened Northern industrial landscapes, while in *Hard Times* (1854) – the only one of Dickens's novels to focus on industrialisation – the dull, monotonous, mechanised environment is symbolic of the dull, monotonous, mechanised lives of the factory-workers. The alleviating quaintness of London, the eccentric vitality of many of its inhabitants, even the sympathetically-presented poverty of Dickens's London novels, have no place in *Hard Times*. In most respects it belongs with the comparable work of novelists such as Harriet Martineau, Frances Trollope, 'Charlotte Elizabeth', and most notably Disraeli, with *Sybil* (1845), and Elizabeth Gaskell, with *Mary Barton* (1848) and *North and South* (1855), who portrayed industrial life as one of stark contrasts between wealth and poverty, of harsh unregulated work conditions, devastatingly unmanageable trade fluctuations, and disruptive trade-union leaders. This interest in industrialism as a subject for fiction did not, however, survive beyond the mid-1850s, and when, towards the end of the century, a substantial number of novelists once again turned to working-class themes, the mood of their work, and indeed the nature of the society they were writing about, had changed markedly.[4] Only with the emergence of D. H. Lawrence in the few years prior to the First World War did British fiction find a novelist of genius who could write of industrial life from first-hand experience.

Whatever the limitations and omissions of the 'industrial' or 'condition of England' novels of the early Victorian period, Dickens, Kingsley, Gaskell, and Disraeli, had played genuinely pioneering roles in the fictional portrayal of working-class life, and, partly because of this, they had also helped confirm fiction as a leading form of social commentary. Painters of the same time were, in comparison, slow to respond to the changing, increasingly serious mood of Victorianism, and indeed, slow to pick up the earlier examples open to them – Hogarth again, but also the industrial landscapes of painters such as Joseph Wright of Derby and J. S. Cotman, and the detailed Scottish village realism of Alexander Carse and David Wilkie. Of course, painters did not entirely ignore the destitute and the distressed in either country or town, but poverty in paint was, as Susan Casteras points out (see Chapter 16), most acceptable if it dealt with well-defined character types – street urchins, crossing-sweepers, emigrants, flower-sellers, sempstresses, prostitutes and bet-

rayed women – who were capable of evoking an equally well-defined moral or philanthropic sentiment.

There was a double irony built into the greater willingness of novelists to attempt to convey the contemporary reality of poverty in their work. Firstly, the fashion for narrative painting owed a great deal to the growing sophistication and popularity of the novel as it developed from Defoe, Fielding, and Richardson in the eighteenth century, through Scott and Austen, to Dickens and Thackeray. Secondly, early Victorian visual artists achieved their greatest successes in their portrayal of lower-class life by linking themselves closely to the written word, and that meant engraving rather than painting. Just as one side of Dickens's genius looked back to Hogarth, so the same can be said of his main illustrators Cruikshank and 'Phiz'. They belonged to a very strong and unbroken tradition which numbered Rowlandson and Gillray among its greatest exponents, and, like Dickens, Cruikshank and Phiz were capable of adapting their art to the moral and social sensitivity of the early Victorians without sacrificing the vitality they had inherited from the eighteenth century and the Regency. The alliance between writer and engraver, manifested either directly (through the illustration of Dickens's novels and other works of strong social commentary, like Thomas Hood's poems) or indirectly (on topics inspired by fiction), produced visual images of poverty far more vivid and memorable than anything achieved by early Victorian painters. The trend was enhanced by the development of new-style illustrated periodicals, notably *Punch* and the *Illustrated London News*, which were founded respectively in 1841 and 1842, with *Punch*, especially in its first few years, favouring a high degree of social concern that found visual expression in the drawings of John Leech (cat. 1, figs 2, 3).

By the early 1850s there was observable a drastic change of political mood throughout Europe, though the form this took in Britain was quite different from that of other countries. Linda Nochlin has noted of France: 'After the 1848 Revolution, the worker becomes the dominant image in Realist art, partaking of both the grandeur of myth and the concreteness of reality.'[5] Britain, however, celebrated the fact that the revolution had *not* taken place, and Victorian painters and novelists allowed little of the 'grandeur of myth' and not much more 'concreteness of reality' to the worker: there was to be in Britain no very close equivalent of, say, Millet's *Sower*, Degas' *Ironers*, or Zola's *Germinal*, at least until Hardy's *Tess of the d'Urbervilles* (1891). Victorian Britain's political revolution took place in 1867 with the passing of the Reform Act which enfranchised the urban working man and established the principle (though not, for some time, the practice) of universal manhood suffrage. It is not inconceivable that the ballot-box might have been invested with something of the heroic status usually granted to the street-barricade, but the extension of the franchise was carried through with little enthusiasm or confidence: it was, in the much-quoted phrase of the day, 'a leap in the dark'. Amid the uncertainty about what kind of society was likely to emerge out of the darkness, there was a widespread conviction that political power was being shifted from the responsible few to an irresponsible and ill-informed mass, a danger that Forster's great Education Bill of 1870 was intended to combat. In the 1840s class fear had focused on an image of a violent revolutionary mob: in the 1870s that dominant image was transformed into what Walter Bagehot described, in his introduction to the second edition of *The English Constitution* (1867), as 'the ignorant multitude of the new constituencies'.

Organised working-class pressure played only a relatively small part in the passing of the Reform Bill, though for one moment in 1866 when a meeting of the Reform League in Hyde Park developed into a rowdy demonstration that was quickly (and unfairly) dubbed 'a riot', there was a revival of the old-style class panic. There were, however, several other events of 1866 that carried rather more significance for the changing national mood. For the fourth, and last, time in the nineteenth century there was a major cholera outbreak which killed more than fifteen thousand people: it was followed by a particularly harsh winter which drove the poor, the destitute and the unemployed, visibly and vocally onto city streets. Matthew Arnold was one of the many commentators who expressed their horror at the depth of suffering the terrible winter revealed. In the topsy-turvy satire of *Friendship's Garland*, Arnold himself becomes the bland Englishman who is forced to listen to the scathing criticisms of his Prussian friend Arminius: 'About the state of the streets [Arminius] was bad enough, but about the poor frozen-out working men who went singing without let or hindrance before our houses, he quite made my blood creep. "The dirge of a society *qui s'en va*," he used to call their pathetic songs. It is true I had always an answer for him.'[6]

Nobody had an answer for James Greenwood when early in 1866 he dressed himself in shabby clothes and set out to spend a night in the casual ward of a London workhouse. His dramatised experiences were first published in the recently-founded *Pall Mall Gazette* which was edited by Greenwood's brother Frederick. They were also reprinted

in *The Times*; published as a pamphlet, *A Night in a Workhouse* (1866); turned into broadside ballads; commented upon endlessly by other journalists; and became the inspirational impetus for a long tradition of similar works of social exploration, the most famous of which are Jack London's *The People of the Abyss* (1903) and George Orwell's *Down and Out in Paris and London* (1933).[7]

The growing concern in the 1860s with the poor, destitute, vagrants and homeless, needs to be set against several other trends which can appear separate but are in fact closely related to changing images of poverty. 1861 saw the publication, after many years of part-issue, of Henry Mayhew's four volume study *London Labour and the London Poor*. Primarily a massive compendium of working-class and street types, Mayhew's methods of gathering information and his attempt at quantification anticipate in certain important respects the objective developments in empirical sociology later in the century. Contemporaneously, there was a marked shift in styles of book illustration: *Punch* had rapidly shed its early radical reputation, and the Hogarth tradition that had played such an important part in the early Victorian visualisation of poverty did not carry easily into the mid-Victorian period. In a very broad sense it was Pre-Raphaelitism that now became the main influence, though not exclusively so, as the illustrations to Dickens's later works demonstrate. With Fred Walker's illustrations for *Reprinted Pieces* (1858), Marcus Stone's for *Great Expectations* (1861) and *Our Mutual Friend* (1865), and Luke Fildes' for the uncompleted *Edwin Drood* (1870), the Hogarth-Cruikshank-Phiz line of satirical grotesque came effectively to an end. In its place there were simpler, clearer line drawings of characters, set within contrasting planes of light and dark. These illustrations were more distanced, more 'realistic' than those by Cruikshank and Phiz, and they were also less in harmony with Dickens's exuberant imagination: they looked forward rather than backward. It was to this school of engravers that W. L. Thomas turned when he founded the *Graphic* in December 1869.

In terms of the news it carried, its political stance, and its general format, there was nothing remarkably new about the *Graphic*: even the engravings of destitution and poverty that were to become its most celebrated feature had their equivalents in other periodicals, notably the *Illustrated London News*, the *Graphic*'s greatest rival. The *Illustrated London News* was, however, very much an Establishment paper: its coverage of social issues could be powerful and effective, but it gave pride of place to the visual representation of great national and public events.

The *Graphic* made the single full-scale engraving its focal point, and with Fildes' *Houseless and Hungry* (cat. 38) in the first number it captured the complex social and artistic mood of the late 1860s with stunning accuracy. Like Greenwood in *A Night in a Workhouse*, Fildes concentrates on the 'casuals' who were either unwilling or not eligible to enter a workhouse on a permanent basis. The policeman, giving directions in what is shown as a friendly and helpful manner, would be acting under the Houseless Poor Act of 1864 which was an attempt by the London authorities to prevent people from sleeping in the open by providing them with temporary accommodation in workhouses.[8] The term 'casual' quickly became applied to both the types of accommodation and the 'applicants' who were a socially heterogeneous group, ranging from beggars and alcoholics, through men and women temporarily down-on-their-luck, to tramping artisans and the unemployed. In his picture Fildes hints at the presence of some of the less deserving types of casual, but concentrates overwhelmingly on the blameless victims – the widow (or, perhaps, deserted woman) with her two young children, the complete family group, the crippled soldier. These anguished, shivering, ragged figures are also portrayed as depressingly passive: only the dog is given any vivacity, and he presumably embodies an ironic social comment. They are also – as the air of lost respectability typifying many of them proclaims – the potential voters of the new democracy.

There is, then, a very specific context – social, political, and artistic – for the emergence of a school of realistic artists at precisely this time. The change was not, of course, abruptly sudden: as this exhibition demonstrates, the new mood was anticipated by British painters like Thomas Faed, Frederic Shields, Fred Walker, and Henry Wallis, and influenced by the more adventurous examples of French, Dutch and German realists. Even so, the changes effected by the *Graphic* engravers, as the 1860s turned into the 1870s, were highly significant: they were also – in spite of the European influences – variations on a distinctive British tradition.

The new visualisation of poverty did not, for example, involve any substantial expansion of the artists' social range. With notable exceptions, such as Eyre Crowe's *The Dinner Hour, Wigan* (cat. 85) and Herkomer's *On Strike* (cat. 83), industrial working-class life remained relatively neglected, and until late in the century the unsensational, everyday experiences of the poor and working classes were still largely unrecorded, though painters like Frank Bramley, Stanhope Alexander Forbes, Henry Scott Tuke,

and Frank Brangwyn, were bringing a new kind of realistic attention to the lives of fishermen and sailors. In comparison, the last thirty years of the century saw a massive expansion of narrative painting which portrayed in intimate detail the social life of upper-class, and increasingly middle-class, Britain. Artistic interest in working-class life continued mainly to stress poverty and destitution – the casual ward, workhouse, prison cell, emigrants, sempstresses, the unemployed and the dispossessed. It is not surprising that 'Hard Times' recurred as a title for paintings, drawings and novels: it described perfectly the only kind of social context within which the vast majority of Victorian painters and novelists could understand or represent working-class life.

If the subject-matter of the *Graphic* engravers did not mark a striking break with the past, the tone of their work most certainly, and dramatically, did. Quite suddenly the philanthropically-appealing character types have gone, leaving, as it were, groups of figures in isolation. The poor are now distanced, objectified, on their way to becoming sociological statistics in the new democracy. When the ruling classes are represented at all, it is by the policeman, whether directing the 'applicants for admission to the casual ward', maintaining prison order in Holl's *Newgate: Committed for Trial* (cat. 73), or fixing a group of the homeless poor in a beam of light in Doré's *The Bull's Eye* (cat. 57). As already noted, the police are not generally presented as threatening or oppressive – in Holl's *Deserted* (cat. 66) a policeman is even shown tenderly carrying the woman's deserted child: rather, they are the new professional agents of order and control, related more to other professionals serving the fragile democracy – like Fildes' *The Doctor* (cat. 78) – than the philanthropic lady visitors and sympathetic observers of most earlier paintings.

However, even this kind of class intervention is often dispensed with, creating instead a solidarity between the poor themselves which heightens the distancing effect and either enforces the sense of an unrevealed mass of the dispossessed or hints at a new kind of class consciousness. This technique is particularly observable in Herkomer – the old soldier dying among his comrades in *The Last Muster* (cat. 79); the roadside family group in *Hard Times 1885* (cat. 82); the crowded lower deck of *Pressing to the West* (cat. 81); the seemingly unconnected groups of

figures in *Our Village* (Aberdeen Art Gallery); the man, woman and child framed in the doorway in *On Strike* (cat. 83). A similar tendency is present in many other paintings of the time, in Frederick Brown's *Hard Times* (cat. 96), for example, and Holl's *Song of the Shirt* (cat. 67).

There were other ways as well in which the *Graphic* engravers broke decisively with the immediate past. Like their early Victorian counterparts, their work was at first linked with book illustration and periodical publication, but unlike their predecessors they were extremely successful in translating their engravings into full-scale paintings. In achieving this, at a time when novelists were showing little interest in the poor, they temporarily took over from fiction its hitherto predominant role as the nation's artistic conscience on such matters: that position they held throughout the 1870s, and beyond. When, in the last two decades of the century, there was a resurgence of fiction about working-class life, its social context was created by publicity over 'outcast' London; the agricultural depression and the depopulation of the countryside; the growth of organised trade unionism; the first attempts to establish a parliamentary party that would speak on behalf of the working classes; and by the professionalisation of empirical sociology, the 'science' of humanity that would objectively quantify the precise nature and extent of poverty in Britain.

The immediate source of all of these concerns and trends can be traced back to the late 1860s, and they can be seen to have their visual correlatives in the engravings and paintings of Fildes, Herkomer and Holl. Their work was not only of its time but proleptic as well, in that it was already intuitively expressing the kinds of social concern to be found in such characteristic late Victorian books as Andrew Mearn's *The Bitter Cry of Outcast London* (1883), George R. Sims' *How the Poor Live* (1883), George Gissing's *The Nether World* (1889), and Charles Booth's *Life and Labour of the People in London* (1889). When the *Graphic* began publication in 1869 it announced that its aim was to provide 'a faithful literary and pictorial chronicle' of its times. On the pictorial side at least, the *Graphic* went some way beyond that reasonably humble ambition. What it captured was not simply the surface reality of poverty, but a formative mood of the late Victorian age, and therefore of twentieth-century Britain as well.

16 | 'The gulf of destitution on whose brink they hang': Images of life on the streets in Victorian art

Susan P. Casteras

The idea of a 'gulf of destitution', a term used in Charles Booth's book *Life and Labour of the People of London*, published in 1889, suggests both the class differences and the moral assumptions about urban poverty which many Victorians shared. These attitudes are seen in many Victorian paintings, but this essay will examine three of the most common types of image: the broken family, the child waif and the prostitute in the city. The way all three are depicted underlines how Victorian artists reinforced the attitudes of viewers towards charity and the poor, inducing spectators to feel sorry for characters in a painting but not – at least until the 1870s – stressing the need for guilt or reform in order to lessen the burden of the homeless.

Am important element in Victorian attitudes involved the mixture of apprehensiveness and antagonism that the middle and upper classes felt towards the poor. Modern historians have documented the factors affecting the growing awareness of poverty after about the 1850s and have pointed out how city slums were initially perceived as a source of contagion as well as a moral and social threat to the well-being of society.[1] Furthermore, beneath this increasing awareness of urban blight loomed a latent fear of pauperism, and an anxiety about one's social station. There was concern too about the city as a potential breeding ground for rebellion, and the poor were often classified either as undeserving or deserving, idle and depraved or self-reliant and worthy of their charitable endeavours.[2] The middle-class cult of cleanliness also coloured contemporary reaction to the poor, whose situation was equated with the dark forces of ignorance, illness, and suffering in opposition to the bourgeois values of health, sanitation, and happiness.[3] The shadowy places where the poor were often placed in paintings reflected not only the reality of the dank world of disease and defeat which they inhabited but also the way the poor were perceived as sinister and threatening.

In art, typically benign confrontations between the two classes prevailed, with women often playing the role of philanthropic missionaries, for example, in Rebecca Solomon's lost canvas of 1859 *The Friend in Need* (fig. 15). Solomon depicts an officious beadle trying to move along a needy mother and infant, and as the *Illustrated London News* commented about this figure of authority, 'the poor and homeless tremble at his approach; the widow and orphan flee before his scowl . . . and poverty is a sin which, in his opinion, nothing can palliate'.[4] However, a benevolent middle-class lady intercedes between the tyrant and his anguished victims, who have decamped on the pavement under a poster advertising London missionary society activities. In spite of the existence of such pictures, to modern eyes there seems to be a surfeit of Victorian images in which the 'haves' appear supremely indifferent to the less fortunate, as if the latter were merely refuse to be avoided. Augustus Mulready's *From Country to Town* (unlocated) and W. P. Frith's *For Better, For Worse* (1881, Forbes Magazine Collection) for example, convey pathos about the dispossessed without any indictment of the people who could but would not help them.

One of the salient features of portrayals of urban vagrant families like the one in *The Friend in Need* is the general absence of adult males or husbands, their presence presumably being less picturesque and sympathetic than that of women and children. Eliminating or minimising the presence of lower-class men in such contexts also served to make more remote the issues of whether or not these individuals were sober, criminal, or hostile, and especially whether they were able-bodied and thus should be working and not begging for alms. Pictures showing lower-class males in confrontation with authority are rare (an exception is cat. 24), and male aggression (aside from the unusual mood of the man in Herkomer's *On Strike*, cat. 83) is often played down in favour of comic effect. Images of brutish, idle, or ruined men in despair might have

offended or dismayed Victorian viewers, and rebellious or menacing urban males were generally held to be unsuitable subjects in art.

Broken families headed by destitute women with children were statistically common and this is reflected in Victorian images of the poor. The sight of a woman without work was presumably less disturbing than that of an unemployed man, and the issue of whether or not such women and children were worthy of help was obfuscated by making them appear weak and deferential – passive victims rather than angry breadwinners. Such images pointedly aroused compassion in viewers, who ironically seemed to play the role of passers-by being solicited for money or an act of charity. An example is Thomas Kennington's 1891 *The Pinch of Poverty* (cat. 98), where the artist invokes several social problems – displaced families, beggary, and unemployment – in a setting that is pitiful but not threatening.

Scores of paintings shown at the Royal Academy between roughly 1840 and 1900 dealt with the subject of neglected, orphaned, and destitute urban children.[5] Bands of impoverished youngsters flooded the streets of London and other cities struggling to survive, and exhibiting few child-like characteristics as they rapidly became toughened to the realities of hard times.[6] But painters who chose this theme produced attractive images of deferential crossing-sweepers, vendors of fruit and matchboxes, and beggars. One of the most frequently depicted figures of this type was the little girl street-vendor, especially the flower-seller or watercress girl. This creature appeared in numerous works of varying quality, ranging from J. C. Horsley's saccharine interpretations to Frith's flower-girl paintings of 1865 which depict suspiciously healthy, demure, and tidy adolescents, as fair and fresh a 'flower of feminity' as the blossoms they sell. A. E. Mulready's *London Flower Girl*, 1877 (unlocated), is a nocturnal scene in which a lone girl on a bridge is contrasted with the warmth and safety enjoyed by others. There is nothing sordid or frightening in this conception, and while the viewer may have wondered about the girl's plight, she is shown as unrealistically well-fed and clean, unlike the filthy, lice-ridden children of the streets.

A curious passivity permeates images where the poverty of the flower-girl is compared with the affluence of others. In George Clausen's *Schoolgirls* of 1880 (Yale Center for British Art) the promenading middle-class students totally ignore the member of the 'lower nation' selling flowers on the same street. Similarly, in Edward C. Wilkinson's *Spring: Piccadilly* of 1887 (Laing Art Gallery, Newcastle

upon Tyne; fig. 16) flower-sellers near Hyde Park attempt to interest a lady and child in buying a bouquet. Yet there is an almost invisible wall between the two social classes; rich and poor women occupy separate zones of the pavement and instinctively keep a distance from one another. Another variant is William Logsdail's poignant *St Martin-in-the-Fields* of 1888 (Tate Gallery), in which no one – not the policemen, the carriage drivers, or the well-heeled

fig. 15. Rebecca Solomon, *The Friend in Need* (*Illustrated London News*, 1859)

fig. 16. E. C. Wilkinson, *Spring, Piccadilly*, 1887, Laing Art Gallery, Newcastle upon Tyne

passers-by – takes any notice of the ragged little girl, whose seeming invisibility and anonymity make her just one more overlooked element of the urban landscape. Furthermore, the conduct of such pitiable types is never threatening to viewers, for the girls are typically shown as smiling wanly or wistfully appealing to pedestrians, and do not actively confront or annoy them. Like some of the more prosperous characters placed in their paintings, artists who produced such images frequently chose to disregard, or more likely, to manipulate to their own pictorial ends the patent social injustice, which placed the poor out on the cold pavement and transformed them into hardly visible shadowy beings.

In contrast with the passivity of the girls, boys were usually shown as carefree and impudent urchins with pleasant temperaments far removed from the thieving artful dodger described by Dickens. This is true of Frith's *Crossing-Sweeper* of 1863, for example, a type whom the *Art Journal* characterised as rough but not criminal, 'bright and intelligent, showing material which would work well in the hands of the schoolmaster, and which, properly employed, would turn out advantageous'.[7] To modern spectators this shoeless lad appears remarkably polite and healthy, although in real life he would have been very different. Ironically, Frith himself mentioned in his autobiography that the boy model was really a 'dangerous sitter' who tried to steal the artist's gold chain and key.[8] Yet, in this and similar paintings, such negative implications are conveniently absent.

Similarly, in *Punch*, many of John Leech's cartoons reinforced the public notion of the sweeper, the page, and the errand boy as cheeky and funny. These Cockney lads were ragged and impudent, but charming, seemingly untouched by their poverty and content with life. Even when they are mischievous, the *Punch* boys exhibit few signs of villainy or ferocity; their antics are entertainingly uncouth. Shifting emphasis from the boys' penury to the humorous aspects of their character, Leech and others made fun of both the lads themselves and of bourgeois attitudes towards them. Leech was, however, capable of depicting the poor with a chilling eye for truth (cat. 1).

Other artists could also be more serious and sympathetic. Thomas Armstrong shows ragged children realistically, but without comment (cat. 21); their plight speaks for itself. In contrast, Thomas Faed brings out the pathos of his subjects. His *Homeless* (cat. 31) of 1869, as its title makes clear, addresses the unsettling issue of a child without shelter or family to protect him. In William Daniels's *Children Selling Matches by Night* of 1851

(Private Collection), and A. E. Mulready's *A Recess on a London Bridge* (cat. 89) the physical surroundings of darkness and cold stone heighten the melodrama of the plight of innocent children adrift in the city. In the cult of the orphan, more often shown as female rather than male, the combination of abandonment and wistfulness could prove quite potent and calculated. Portrayed as improbably clean, handsome and resigned to their fate, orphans tugged at the heartstrings of viewers but, coping nobly with life's hardships, did not seriously disturb their consciences. Philip Calderon's *Orphans* (Private Collection) of 1870 verges on the ludicrous; a beautiful older girl plays a harp in a snowy street whilst her little brother stands shivering by her.

A final type in this series of urban images is the prostitute; the city environment was an integral factor in her downfall. One of the preferred formulae showed a solitary female on a bridge or near the water's edge, as in George Cruikshank's illustration 'The Meeting' for *Oliver Twist*, and Phiz's portrayal of the 'soiled dove' in *David Copperfield* (see p. 1), 1849. The prostitute Martha Endell recalls the innocence of her country youth as she stands on the brink of the Thames, whose dark, fetid surface beckons her to leap. Behind her are the silhouettes of the shot tower and St Paul's.

An earlier literary source was the poem 'The Bridge of Sighs' by Thomas Hood which first appeared in 1844. It created a prototype for the representation of the prostitute and led to a host of illustrations on the theme of a distraught female jumping from a bridge or drowning herself in a polluted river. Cruikshank's image of a catapulting 'unfortunate' in *The Drunkard's Children* of 1848, (cat. 10) and the etchings by J. E. Millais for the 1858 edition of Hood's poems both contributed to this pictorial tradition. Over a decade later Gustave Doré depicted another female contemplating suicide, and in this the familiar London skyline assumes emblematic proportions (cat. 61). The frequency of this literary and artistic type mirrored the real incidence of women who took their lives, for by the 1860s scores of females were believed to have perished in this manner in the Thames.

The Thames, the sewer of London, an image of corruption and vice, was a potent symbol of prostitution in the city. Among the many literary and journalistic responses to the prostitute in the 1850s was W. R. Greg's article in the *Westminster Review*. To him such women were modern Magdalens, injured martyrs who were shunned and inordinately punished by society: 'instead of helping her up, we thrust her down when endeavouring to rise; we

choose to regard her, not as frail but as depraved. . . . She is driven to prostitution by the weight of all society pressing upon her.'[9] Greg's remarks were paralleled in the visual arts by many representations of the fallen women from the late 1840s onwards.

The most ambitious subject of this type was Dante Gabriel Rossetti's *Found* (Delaware Art Museum) of *c*. 1853. Like her counterpart Esther in Mrs Gaskell's novel *Mary Barton*, the fallen woman in *Found* is shown confronted by a man from her past; she and Esther also wear clothing that communicates their woeful history: 'faded finery . . . all draggled . . . [and a] gay-coloured shawl . . .'.[10] The story of a country innocent gone astray in the city and rejected by society was not new, having been made famous by Hogarth's *The Harlot's Progress* in which the cowering posture of Rossetti's streetwalker was foreshadowed. She seems to suffer from what an 1843 author termed 'the tendency downward', which culminated 'down, down, rapidly down . . . in some scene of wretched squalidness'.[11] Slumped in a posture of shame near a cemetery wall, she too presumably 'drags on for a few years, and then sinks down to her grave'. The setting of the lone female on the bridge possibly alludes to suicide and the detail of her bouquet in the gutter is perhaps emblematic of her sullied purity.

The defiled woman in *Found* is echoed in many other works. Rossetti returned to the theme in his watercolour of 1857, *The Gate of Memory* (Private Collection). Inspired by lines from William Bell Scott's poem 'Rosabell', about the downfall of a country lass in the city, Rossetti depicts her hovering in the darkness against a brick wall. Among the figures in Simeon Solomon's *'I am starving'* (cat. 17) is a mournful prostitute who fingers a drooping flower, probably symbolic of her wilted virtue, while her top-hatted escort smokes a cigar. Perhaps she is another potential suicide victim, for she stares over the bridge at the city and the water below. While Abraham Solomon's *Drowned! Drowned!* (1860, unlocated) focuses on a dead woman and her guilty male seducer, the earlier *Found Drowned* (cat. 14) by Watts also shows the corpse of a suicide by the river. Augustus Egg shows the adulteress still alive. In the last scene of his trilogy *Past and Present* (1858, Tate Gallery) she is huddled beneath the arches of the Adelphi, a place the *Athenaeum* called 'the last refuge of the homeless, sin, vice, and beggary of London'.[12] But she too may consider the possibility of escape in the tainted river.

A scene beneath the arches of a Thames bridge also appears in Doré's *London: A Pilgrimage* which explored the inhabitants of the streets and alleyways of the London slums, and Luke Fildes' *Applicants for Admission to a Casual Ward* (cat. 74) of 1874 includes several of the types discussed – the urchin, the destitute female, and the unemployed – utilising a dreary brick wall as a setting for the parade of human misery. Accompanied by Dickens's lines 'Dumb, wet, silent horrors! Sphinxes set up against the dead wall . . .' the painting offered viewers a relentless vision of urban poverty. More than any previously exhibited painting it forced the public to confront the execrable conditions endured by the poor; the *Athenaeum* claimed as a result that 'not a few will see the miseries of their fellow-beings for the first time in these personations . . . There is not a figure that is not . . . faithful and true in sentiment'.[13]

While images of the urban poor remained a constant feature of Victorian art, perceptions of the 'Great Unwashed' shifted in the art of the 1870s and 1880s. Mid-Victorian images could be touching, but the majority of Royal Academy pictures in this category avoided disturbing subjects, sanitised their characters, and projected the poor as suffering but surviving. The patronising, complacent attitudes conveyed by such emphasis on less threatening types, such as the winsome flower-girl, the stoic widow or mother, the carefree chimney-sweep, and the martyred harlot, were in contrast to late Victorian images of the urban homeless as real people with dirty clothes, wretched types who stirred reactions of shock as much as pity. For Holl, Fildes and Herkomer, the streets of London were foul places of stench and disease, which they had explored at first hand and the people they painted were based on what they had seen, real portraits of genuine distress. Moral and social assumptions about the causes of poverty might vary, but in the last quarter of the century the work of at least a few artists constituted a visual crusade acknowledging what Booth called the 'unending struggle' of the poor. Yet ultimately Booth's own remarks about the public perception of urban ills suggest the deeper realities which remained unresolved during the Victorian era, for 'the lives of the poor lay hidden from view behind a curtain on which were painted terrible pictures: starving children, suffering women, overworked men; horrors of drunkenness and vice, monsters and demons of humanity; giants of disease and despair. Did these pictures truly represent what lay behind, or did they bear to the facts a relation similar to that which the pictures outside a booth at some country fair bear to the performance or show within?'[14]

Notes

Introduction

1. Nochlin 1971; Edward Lucie Smith and Celestine Dars, *Work and Struggle, the painter as witness*, 1977
2. Rodee 1975
3. R. Muther, *A History of Modern Painting*, vol.3, 1896, p.114
4. *Our Mutual Friend*, ch.11
5. *Middlemarch*, 1872, ch.39; *Half-hour lectures on the history and practice of the fine and ornamental arts*, 1874, p.328
6. *AJ*, 1858, p.170; 1869, p.198; 1874, p.201
7. *Ath*, 9 May 1874, p.637; *Times*, 11 May 1878, p.201
8. *Times*, 1 December 1877; *Ath*, 4 May 1878, p.577
9. *Ath*, 9 May 1866, p.6; *Times*, 18 June 1869, p.4
10. J. Bronkhurst, 'Fruits of a Connoisseur's Friendship . . .', *Burl Mag*, vol.125, 1983, p.588; *AJ*, 1860, pp.171, 306
11. *AJ*, 1855, pp.177–8; 1874, p.201; *Times*, 8 May 1876, p.9
12. Letter to Henry Woods, 6 July 1890, V&A
13. C. W. Cope, *Reminiscences*, 1891, p.142
14. Reynolds, pp.25, 37–9, 87–8; information on Pawle from Local Studies Library, Guildford; Christie's sale, 20 March 1925
15. *MofA*, 1882, pp.1, 80, 116; Christie's sale, 25 May 1889 and Feb 1892; R. Pickvance, 'Henry Hill, an untypical Victorian collector', *Apollo*, Dec 1962, p.789
16. *MofA*, 1882, p.309; Christie's sale, 28 April 1883; obit. *Wigan Examiner*, 19 May 1892.
17. Obit. *Preston Guardian*, 7 May 1881; Christie's sale, 13 May 1882
18. *Victorian Social Conscience*, exh. cat. by R. Free, Art Gallery of New South Wales, 1976
19. Clive Bell, *Art*, 1949 edn, p.32
20. L. V. Fildes, p.73
21. Owen, pp.164–8, 181
22. Christie's sale, 4 May 1922
23. *ILN*, 12 Sept. 1863; cat. 66 was used in charity advertising in the 1970s
24. Owen, p.211
25. Edelstein, pp.184, 210; J. Hichberger, *The mythology of the Old-Soldier in Patriotic Art*, 1984, forthcoming
26. *Ath*, 2 May 1874, p.602

1 | The hungry forties

1. G. Himmelfarb, 'The Culture of Poverty', *Victorian City*, vol.2, p.707
2. T. S. R. Boase, 'The decoration of the New Palace of Westminster', *Journal of the Warburg and Courtauld Institutes*, vol.17, 1954, pp.319–58; W. Vaughan, *German Romanticism and English Art*, 1979, pp.178, 202–18
3. M. H. Spielmann, *The History of Punch*, 1895, p.187
4. Errington, pp.397–400
5. *Tribute to Wilkie*, exh. cat. by L. Errington, National Gallery of Scotland, 1985
6. *e.g.* Gainsborough, *Charity relieving distress* (1784, coll. Sir F. Cassel, Bt); Wheatley, *Rustic Benevolence* (mezzotint by G. Keating 1797); Wheatley, *Night* (1799, Mr & Mrs Paul Mellon)
7. Anne Digby, 'The Rural Poor', *Victorian Countryside*, vol.2, pp.594–5; Owen pp.135–8; G. Himmelfarb, *The Idea of Poverty*, 1984, pp.147–76
8. Owen, pp.137–8, 165–8
9. *Blackwood's Magazine*, vol.63, 1848, p.184
10. Errington, fig.4, pp.57–68
11. Casteras, Emigration, pp.1–19
12. *Art Union*, 1839, p.33
13. *The PRB Journal* (ed. W. E. Fredeman) 1975, p.18 (8 October 1848)
14. *AJ*, 1850, p.173
15. *Punch*, vol.15, 1848, p.27
16. M. W. Jones, *George Cruikshank, His Life and London*, 1978, pp.87–91

2 | Richard Redgrave and G. F. Watts

1. *AJ*, 1850, p.48
2. M. S. Watts, vol.2, p.126
3. *Victorian High Renaissance*, exh. cat. Manchester, Minneapolis and Brooklyn, 1978, cat.no.7; P. Mathews, 'The Minotaur of London', *Apollo*, May 1986, p.338
4. M. H. Spielmann, *The History of Punch*, 1895, p.333; Christina Walkley, *The Ghost in the Looking Glass, the Victorian Sempstress*, 1981
5. Edelstein, pp.188–90; *The Poor Teacher, a painting and its public*, exh. cat. Newcastle upon Tyne Polytechnic, 1981
6. *Fraser's Magazine*, June 1844, pp.704–5; *Ath*, 18 May 1844, p.459
7. F. M. Redgrave, p.45

8. Wood, p.136
9. Errington, p.124
10. *Victorian High Renaissance* (see note 3 above), cat.no.8
11. W. Ward, *Aubrey de Vere, a Memoir*, 1904, pp.120–1
12. Blunt, p.42; *Romantic Art in Britain*, exh. cat. by A. Staley and F. Cummings, Detroit Institute of Arts, 1968, cat.no.204
13. M. S. Watts, pp.108–9
14. A. Whitley, 'Thomas Hood and "The Times"', *Times Literary Supplement*, 17 May 1957, p.309
15. Nochlin 1978, p.143

3 | The street folk

1. *The Germ*, no.4, May 1850, ed. A. Rose, 1979, p.170
2. 'Blind Charity', *Punch*, 1853, p.217; see Errington, p.400 and Mayhew, vol.1, pp.395–9; vol.2, p.560
3. Mary Bennett's tentative attribution ('Footnotes to the Millais Exhibition', *Liverpool Bulletin*, vol.10, 1967, p.41) was confirmed to the writer by Malcolm Warner
4. Mayhew, vol.1, pp.153–5; vol.2, pp.58, 62; E. D. H. Johnson, 'Victorian artists and the urban milieu' in *Victorian City*, vol.2, 1973, p.458
5. *Sublime and Instructive, Letters from John Ruskin to Louisa, Marchioness of Waterford, Anna Blunden and Ellen Heaton*, ed. V. Surtees, 1972, pp.80–1
6. Hueffer, pp.189–95
7. Grieve, p.44; *Punch*, 1850, p.30; E. D. H. Johnson, 'The Making of Ford Madox Brown's "Work"', in *Victorian Artists and the City*, ed. I. B. Nadel and F. S. Schwarzenbach, 1980, p.149
8. *The Diary of Ford Madox Brown*, ed. V. Surtees, 1981, p.194
9. D. Robertson, *Sir Charles Eastlake and the Victorian Art World*, 1978, p.413, n.221
10. *Ragged School Union Magazine*, vol.15, 1863, pp.109–12; E. Hodder, *The Life and Work of the 7th Earl of Shaftesbury, K.G.*, 1886, vol.2, p.341; G. Finlayson, *The 7th Earl of Shaftesbury*, 1981, pp.124, 251, 350, 408
11. Fox, p.227; *Passages from Modern English*

Poets, illustrated by the Junior Etching Club, 1861, pl.33; The Realist Tradition, exh. cat. Cleveland, 1981, no.170
12. Hodder (see note 10 above), vol.3, p.110; repr. G. Battiscombe, Shaftesbury, 1974, f.p.307
13. AJ, 1873, p.101
14. They are (left to right, top to bottom) W. H. Simmonds, after J. L. Dyckmans, The Blind Beggar; T. L. Atkinson after Landseer, The Shepherd's Prayer; next two unidentified; Henry Le Jeune after James Faed, Christ Blessing Little Children; S. Cousins after Millais, The Order of Release; W. J. Edwards after F. Sandys, Lord Shaftesbury; W. J. Davey after W. C. T. Dobson, The Alms Deeds of Dorcas; H. Cousins after Thomas Faed, Home and the Homeless; J. J. Chant after W. C. T. Dobson, The Plough; S. Cousins after Thomas Faed, The Mitherless Bairn; S. Cousins after Landseer, Saved
15. AJ, 1861, p.368; The Young George du Maurier, ed. Daphne du Maurier, 1951, p.242

4 | The rural poor in the 1850s and 1860s

1. AJ, 1856, p.121
2. G. E. Mingay, 'Rural England in the Industrial Age' and D. Jones, 'Rural Crime and Protest', Victorian Countryside, vol.1, p.6, vol.2, p.566
3. Hueffer, p.189
4. Times, 9 May 1866, p.6
5. Morning Star quoted in The Pre-Raphaelites, exh. cat., Tate Gallery, 1984, p.167
6. ILN, 15 May 1858, p.498; Ath, 1 May 1958, p.567; AJ, 1858, p.170; Ruskin, Works, vol.14, pp.170, 153
7. Times, 11 June 1869, p.12
8. AJ, 1859, p.169
9. MofA, 1880, p.84
10. E. Mills, pp.108–9
11. Times, 9 May 1866, p.6

5 | Thomas Faed

1. Van Gogh Letters, no.242
2. McKerrow, p.xvi
3. Times, 7 May 1855, p.10
4. Ruskin, Works, vol.14, p.15
5. McKerrow, p.98; Burdett-Coutts sale, Christie's, 4 May 1922 (184); DNB
6. See Casteras, Emigration, pp.10–12
7. Nochlin 1971, p.127; Hilary Guise, Great Victorian Engravings, 1980, p.164
8. McKerrow, p.115
9. Times, 2 May 1868, p.14
10. AJ, 1863, p.112
11. Times, 1 May 1869, p.12; Mayhew, vol.ii, p.563
12. McKerrow, pp.120–1
13. J. Hichberger, The mythology of the old-soldier in Academic Art, forthcoming, 1984

6 | Jozef Israels and Frederick Walker

1. The Hague School, exh. cat. Royal Academy, 1983, p.187
2. W. M. Rossetti, Fine Art, Chiefly Contemporary, 1867, p.144

3. Times, 27 August 1862, p.10
4. Charles Dumas, 'Art Dealers and Collectors', The Hague School, exh. cat. Royal Academy, 1983, pp.126–7
5. Graphic, 1888, p.169
6. Christie's sale, 20 March 1925 (74, 75)
7. Reynolds, p.313
8. 'J. W. North ARA, RWS, Painter and Poet', MofA, 1893, p.342
9. Good Words, 1862, p.184
10. Times, 7 and 9 May 1863
11. The Late Frederick Walker ARA, exh. cat., Deschamps Gallery, London, 1876, pp.3–4
12. Once a Week, 27 January 1866, p.103
13. Marks, p.108
14. Times, 2 May 1868, p.14; AJ, 1868, p.107
15. A. G. Temple, Painting in the Queen's Reign, 1896, pp.251–2
16. C. Black, Frederick Walker, 1902, p.161
17. Marks, pp.238, 240

7 | The Graphic

1. L. V. Fildes, pp.12–13; letter of 6 Sept 1869, V&A
2. C. N. Williamson, 'Illustrated Journalism in England: Its Development', MofA, 1890, pp.297–301, 334–40, 391–6
3. Charles Knight, Passages of Working Life during Half a Century, 1864–5, vol. 3, pp.246–7
4. C. Fox, 'Social Reportage in English Periodical Illustration', Past and Present, vol.74, 1977, pp.90–111; Fox, pp.196–7
5. Wolff and Fox, 'Pictures from the Magazines', Victorian City, vol.2, p.563
6. W. L. Thomas, 'The Making of the Graphic', Universal Review, vol.2, 1888, p.81
7. DNB; R. Engen, Dictionary of Victorian Wood-Engravers, 1985, pp.258–9
8. L. V. Fildes, p.23
9. W. L. Thomas (see note 6 above), p.87
10. Graphic, 18 June 1870, pp.679–80
11. Graphic, 26 June 1875, p.616; 9 Oct 1875, p.360; 15 April 1876, p.376; 20 Sept 1879
12. Reynolds, pp.97, 105
13. Van Gogh Letters, nos. R.24, 262
14. Graphic, 27 May 1871, p.493; 3 June 1871, p.516; 10 June 1871, p.533; 26 Oct 1872. p.389
15. Van Gogh Letters, nos. R.23, R.24
16. Graphic, 13 April 1872, p.333; 2 Nov 1872, p.424; 1 Feb 1873
17. Graphic, 17 Dec 1870, pp.586–7; E. Mills, pp.78, 84, 90
18. Chesneau, p.286; Graphic, 6 Jan 1872, pp.1, 3; a drawing is reproduced in Henry Blackburn, Illustrated catalogue of pictures and sculpture in The British Fine Art Section, Universal Exhibition Paris, 1878, p.12
19. Graphic, 19 April 1873, pp.368–9
20. H. Quilter 'Some Graphic Artists', Universal Review, vol.2, 1888, p.104
21. G. H. Martin and David Francis, 'The Camera's Eye', Victorian City, p.237; Arts Council, The Real Thing, exh. cat. 1975, p.18; National Portrait Gallery, The Camera and Dr. Barnardo, exh. cat. 1974

8 | Gustave Doré and Alphonse Legros

1. Fox, pp.189, 195
2. AJ, 1870, p.195; Jerrold, p.155–6
3. Jerrold, pp.153–4
4. Roosevelt, p.368
5. A. Woods, 'Doré's London; Art and Evidence', Art History, vol.1, no.3, 1978, pp.345, 350
6. Roosevelt, p.349; Jerrold, p.151
7. London, A Pilgrimage, pp.145, 149–50
8. Jerrold, p.196
9. Woods (see note 5 above), pp.351, 356
10. Van Gogh Letters, R.13; Arts Council 1974, pp.45, 54
11. London, A Pilgrimage, p.143
12. Charles Booth, In Darkest England and The Way Out, 1890, p.68
13. London, A Pilgrimage, p.6
14. Jerrold, p.149; exh. Hazlitt Gallery, 1983, cat. no. 19
15. Alphonse Legros, Paintings, Drawings and Prints from the collection of Frank E. Bliss, exh. cat. Grosvenor Gallery, London, 1922
16. Peasantries, exh. cat. Newcastle upon Tyne Polytechnic 1981, cat. no.30
17. Salaman, p.9
18. MofA, 1882, p.331
19. Times, 2 May 1878, p.7

9 | Frank Holl

1. A. Saint, Richard Norman Shaw, 1976, pp.425, 429
2. Universal Review, 1888, p.488
3. Reynolds, pp.302–10, 318; Graphic, 11 Aug 1888, p.144
4. Quilter, p.307
5. Reynolds, pp.20–1
6. Reynolds, pp.10–15
7. Reynolds, pp.31–4
8. Reynolds, p.59
9. Reynolds, p.62
10. Reynolds, p.71
11. Reynolds, pp.59–60
12. Ath, 15 May 1869, p.675
13. Mrs Craik, The Head of the Family, 1855 edn, p.2
14. Times, 18 June 1869, p.4
15. Reynolds, p.49
16. Reynolds, pp.83–7
17. Art Union, 1842, p.126; AJ, 1862, p.133; Times, 22 May 1871, p.6; RA 1871, nos.166, 281, 383, 434, 781, by A. H. Marsh, T. J. and J. D. Watson
18. D. Hoopes, Winslow Homer Watercolours, 1976, pp.17, 24, 26
19. Reynolds, p.96
20. Reynolds, p.98
21. Reynolds, pp.24, 123
22. Graphic, 26 April 1873, p.368
23. Times, 26 May 1876, p.6
24. Van Gogh Letters, nos. R.23, R.24
25. C. Musgrave, Life in Brighton, 1981, p.353
26. Reynolds, p.110; AJ, 1876, p.10
27. Reynolds, p.127
28. Graphic, 18 December 1869, p.60; 5 March 1870, p.324; 24 Aug 1872, pp.172–3; cf Goodbye by C. J. Staniland, Bradford Art Gallery

29. *Graphic*, 19 Feb 1876, p.176; *Times*, 1 Dec 1877
30. *Van Gogh Letters*, no. R.25
31. *Times*, 18 May 1876, p.8; *AJ*, 1876, p.261
32. *Graphic*, 20 May 1876, p.338
33. Reynolds, p.133
34. *e.g. Widowed*, 1879, National Gallery of Victoria; *No Tidings*, 1872, Sotheby's, 18 March 1985 (132); *Hope*, 1881 and *Despair*, 1883, Southampton Art Gallery
35. Reynolds, pp.144–5
36. Letter of 1 Sept 1887, Royal Holloway College, see J. Chapel, *Victorian Taste*, Royal Holloway College, 1982, p.96
37. Reynolds, pp.144–5
38. *DNB*
39. *AJ*, 1878, p.168

10 | Luke Fildes

1. L. V. Fildes, p.93.
2. L. V. Fildes, pp.1–13; *Strand Mag*, vol.6, 1893, p.111
3. *Strand Mag*, vol.6, 1893, pp.119–20
4. B. Myers, 'Studies for "Houseless and Hungry" and the "Casual Ward" by Luke Fildes R.A.', *Apollo*, July 1982, pp.39–40
5. L. V. Fildes, p.25; drawings published by Myers (see note 4 above)
6. *Graphic*, 4 December 1869, p.9
7. Arts Council 1974, p.37
8. *Graphic*, 4 December 1869, p.10
9. John Forster, *The Life of Dickens*, vol.3, pp.53–4
10. *Manchester Courier*, 27 May 1874, p.6; *AJ*, 1874, p.201; *Ath*, 2 May 1874, p.602
11. *Strand Mag*, vol.6, 1893, p.124
12. *Ath*, 13 May 1876, p.672
13. L. V. Fildes, pp.41–2
14. Letter to Henry Woods, 10/12 October 1902, V&A
15. Thomson, repr. pp.4, 5
16. *AJ*, 1876, p.189; *Academy Notes*, 1876, pp.42–3; *Times*, 8 May 1876, p.9
17. Letter to Henry Tate, 5 May 1877, draft in V&A, repr. L. V. Fildes, pp.108–9; see also *ibid.* pp.117–18
18. Letter to Sir Henry Tate, 22 June 1890, Tate Gallery Archive
19. L. V. Fildes, pp.46, 118
20. Letter to Henry Woods, 6 July 1890, V&A
21. Letter to Henry Woods, 8 November 1895, V&A
22. L. V. Fildes, p.118
23. Thomson, repr. p.13
24. A. Meyer, '"The Doctor" by Sir Luke Fildes', *Guthrie Bulletin*, April 1974, pp.163–4
25. Thomson, p.12; L. V. Fildes, p.118; Letter to Henry Woods, 19 May 1890, V&A
26. Letter to Henry Woods, 23 March 1891, V&A
27. *Strand Mag*, vol.6, 1893, p.127; L. V. Fildes, p.118
28. *Strand Mag*, vol.5, 1893, pp.114–5
29. *British Medical Journal*, 8 Oct 1892, pp.787–8
30. *Times*, 2 May 1891, p.14; *Ath*, 1891, p.574.
31. L. V. Fildes, p.123; A. Meyer (see note 24 above), p.169; G. Agnew, *Agnews 1817–1967*, p.66

11 | Hubert von Herkomer

1. *Herkomers*, vol. 1, p.72
2. Robert de la Sizeranne, *English Contemporary Art*, trans. H. M. Poynter, 1898, pp.187, 191
3. Lorenz Herkomer's most important commission, a neo-Gothic altar completed in 1850 for the church in Waal, has recently been restored and regilded
4. Biographical material can be found in several contemporary monographs, and in Herkomer's memoirs. Herkomer also maintained a lengthy correspondence, a great deal of which survives. Family correspondence can be found in the Herkomer Archive, Yale Center for British Art, New Haven, Connecticut. For a complete bibliography, see Edwards, and the author's forthcoming book on the artist, *Hubert von Herkomer: A Life in Art*
5. Although Herkomer was accused at early points in his career of being Walker's 'imitator', he never met Walker and 'only saw him at a distance on two occasions'. *Herkomers*, vol. 1, pp.83, 88
6. See Rosemary Treble, 'Herkomer and Fred Walker' in Watford 1982, pp.19–34
7. Herkomer to Mansel Lewis, written from Munich, 12 October 1877, Private Collection, Wales
8. *Herkomers*, vol. 1, p.112; *Graphic*, 29 June 1868, p.618
9. Hubert Herkomer, 'Drawing and Engraving on Wood', *AJ* 1882, p.166
10. F. G. Stephens, 'The Royal Academy', *Ath*, 1 June 1875, p.755
11. *Graphic*, 29 June 1878, p.648
12. Charles E. Pascoe, 'The Royal Academy', *AJ* (American edition), 1875, p.188
13. *Herkomers*, vol.1, pp.80–112; J. Saxon Mills, pp.77–87; Louis Engel, *From Handel to Halle with Autobiographies of Professor Huxley and Professor Herkomer*, 1890, pp.188–93
14. C. W. Mansel Lewis, handwritten manuscript, Private Collection, Wales
15. Inventory File, Lady Lever Art Gallery, Port Sunlight
16. J. W. Comyns Carr, 'Hubert Herkomer A.R.A.' in *Modern Artists*, ed. F. G. Dumas 1882–4, pp.67–8
17. Hippolyte Taine, *Notes on England*, trans. W. F. Rowe, New York 1873, p.214
18. Henry James, *The Princess Casamassima*, 1886, 1976 edn, p.344
19. Carr (see note 16 above), p.69
20. H. Blackburn, *Academy Notes*, 1878, p.67
21. *ILN*, 11 May 1878, p.435
22. *Ath*, 4 May 1878, p.577
23. 'Hubert Herkomer: A Talk with him on Leaving England', *New York Tribune*, 29 October 1882, p.19; 'Herkomer in New York', *AJ*, 1882, p.379
24. *Herkomers*, vol.1, p.133
25. Herkomer to Gosse, 16 January, 1883, Brotherton Collection, University of Leeds
26. Herkomer to C. W. Mansel Lewis, 29 February 1884, Private Collection
27. 'The Herkomer Exhibition at Goupil's', *Times*, 30 March 1884

28. *Ath*, 21 June 1884, p.799
29. *ILN*, 17 May 1884, p.490; on Fildes, see 'The Royal Academy', *AJ*, July 1874, p.201
30. John Ruskin, *Works*, vol.33, p.338. It should be noted that Ruskin was extremely fond of Herkomer's zither playing, which he heard on a number of occasions. Herkomer to C. W. Mansel Lewis, 8 November 1878, Private Collection
31. *Herkomers*, vol.1, p.136
32. I am most grateful to Bushey historian, Mr Grant Longman, for bringing the eighteen-volume diary of Mary Godsal to my attention and to Major P. Godsal for permission to read them. The diaries are now deposited in the Clwyd County Council Library, Wales
33. Godsal Diary, 26 March, 1884
34. Godsal Diary, 3 May, 1884
35. Information by courtesy of Mrs Topping of Bushey, great-grandaughter of the Quarrys. Author's interview, February 1981
36. See *Herkomers*, vol.1, p.136
37. Godsal Diary, 19 January, 1885
38. Godsal Diary, 6 February, 1885
39. *Herkomers*, vol.1, p.110
40. See Godsal Diary, vol.4, 1884
41. J. Saxon Mills, p.153
42. *AJ*, 1885, p.226; *Ath*, 20 June 1885, p.796; *Blackwood's*, vol.138, July 1885, p.21; J. E. Phythian, *Handbook to the Manchester City Art Gallery*, 1905, p.21
43. Rodee 1977, p.311
44. Hubert von Herkomer, *My School and My Gospel*, 1908
45. Rodee 1975, p.40
46. Marks, p.81; *Great Victorian Pictures*, exh. cat. by Rosemary Treble, Arts Council, 1978, p.44
47. *Romantic Art in Britain*, exh cat. by Allen Staley and Frederick Cummings, Detroit Institute of Arts, 1968, p.288
48. Herman Herkomer to John Herkomer, 1 March 1882, Herkomer Archive, Yale Center for British Art
49. Among European examples are works by Theophile Steinlen, Eugene Laermans, Mihaly Munkacsy, and Giuseppe Pellizza
50. For a sympathetic contemporary view of the celebrated London dock strike of 1889, see H. H. Champion, 'The Great Dock Strike', *Universal Review*, vol.6, September–December 1889, pp.157–79
51. See Patricia Hills, *The Working American*, Smithsonian Institution, 1979, pp.9–10
52. *Times*, 11 May 1891, p.8
53. *ILN*, 2 May 1891, p.573
54. *AJ*, 1891, p.197
55. The watercolour was a variation of the engraving published in the *Graphic*, 17 May 1873, p.465
56. *ILN*, 16 May 1891, p.648
57. Hubert von Herkomer, *Five Lectures Delivered to the Students of the Royal Academy* (privately printed), London, pp.43, 25

12 | Late Victorian social subjects

1. *Times*, 26 May 1874, p.6; *Ath*, 9 May 1864, p.637
2. J. G. Wilson, *Thackeray in the United States*, 1904, p.131; *ILN*, 1856, pp.555–6
3. *Times*, 26 May 1874, p.6
4. D. Hudson, *Munby, Man of two worlds*, 1972, pp.75–7, 129, 328, 342–3, 366–7; *Manchester Guardian*, 17–18 April 1873; *Pictorial World*, 11–18 April 1874; *Graphic*, 26 Oct 1872, p.391
5. Information and maps kindly supplied by the Local History Library, Wigan
6. G. S. Jones, *Outcast London*, 1976, p.77; *Graphic*, 27 December 1884, p.669
7. *Times*, 10 Nov 1887, p.7
8. A. E. Johnson, *Dudley Hardy*, 1909, pp.20–3
9. *ILN*, 6 June 1874, p.543
10. Shown at the King Street Galleries; *Ath*, 20 March 1880, p.383
11. W. P. Frith, *My Autobiography and Reminiscences*, vol.2, 1887, pp.143–9
12. *AJ*, 1880, p.207
13. *MofA*, 1880, p.160

13 | New styles in social realism

1. K. McConkey, 'The Bouguereau of the Naturalists and British Art,' *Art History*, vol.1, no.3, 1978, pp.378–89
2. J. L. Caw, *Scottish Painting Past and Present*, 1908, p.283; R. Billcliffe, *The Glasgow Boys*, 1985, p.50
3. *Painting in Newlyn 1880–1930*, exh. cat. by C. Fox and F. Greenacre, Barbican Art Gallery, London, 1985, p.8
4. *Edgbastonia*, July 1890, vol.10, p.101
5. *Sir George Clausen R.A.*, exh. cat., by K. McConkey, Cartwright Hall, Bradford, 1980, p.11
6. *Times*, 18 May 1895, p.17; *AJ*, 1896, p.26
7. *A Painter's Harvest, H. H. La Thangue*, exh. cat. by K. McConkey, Oldham Art Gallery, 1978, p.30
8. *Yorkshire Evening Post*, 21 November 1932
9. *Ath*, 4 November 1882, p.602
10. I am grateful to Celina Fox for drawing my attention to this parallel
11. C. Booth, *In Darkest England and the Way Out*, 1890, p.33
12. This information was kindly given to me by Edward Morris
13. G. Clausen, 'Autobiographical Notes,' *Artwork*, no.25, spring 1931, p.18
14. R. Pickvance, '"L'Absinthe" in England', *Apollo*, 1963, pp.395–6
15. *Times*, 1 June 1889, p.17
16. *Newcastle Weekly Chronicle Supplement*, 23 February 1889, p.5. I am grateful to John Millard for this reference

14 | Vincent van Gogh and English social realism

The quotation in the title of the chapter is from letter 251 from Van Gogh to his brother Theo. For further reading on the works mentioned in this article see the literature references in the main catalogue. I am grateful to Sjraar van Heugten for drawing my attention to the print by Houghton in Dickens's *Hard Times*. The article was translated from the Dutch by Michael Hoyle.

1. See Ronald Pickvance's thought-provoking exh. cat. *English Influences on Vincent van Gogh*, Arts Council, 1974, on which I have based some of my observations. See also V. W. van Gogh, *Vincent van Gogh on England, Compiled from His Letters*, Amsterdam, 1968
2. *Van Gogh Letters*, no.251
3. *Van Gogh Letters*, no.169
4. *Van Gogh Letters*, no.297
5. *Van Gogh Letters*, no.218
6. Quoted in Hope Benedict Werness, *Essays on Van Gogh's Symbolism*, Santa Barbara, 1972 (unpublished dissertation), pp.37–8
7. *Van Gogh Letters*, no.186
8. *Van Gogh Letters*, no.187
9. *Van Gogh Letters*, no.181
10. *Van Gogh Letters*, no.248
11. *Van Gogh Letters*, no.248
12. *Van Gogh Letters*, no.408. For Carlyle's influence on Van Gogh see Griselda Pollock, exh. cat. *Vincent van Gogh in zijn Hollandse jaren*, Rijksmuseum Vincent van Gogh, Amsterdam, 1980–1, pp.89–91
13. *Van Gogh Letters*, no.334
14. On the subject of weavers in Van Gogh's art see Carol Zemel, 'The "Spook" in the Machine: van Gogh's Pictures of Weavers in Brabant', *Art Bulletin*, vol.67, 1985, pp.123–37, esp. pp.131–2
15. *Van Gogh Letters*, no.404
16. *Van Gogh Letters*, no.400
17. From Meier-Graefe's essay for the *Sozialistischen Monatshefte*, 1906, given in Bogomila Welsh-Ovcharov, *Van Gogh in Perspective*, Englewood Cliffs (New Jersey), 1974, p.74
18. Jelle Troelstra, *Mijn vader Pieter Jelles*, Leeuwarden, 1980, p.82, with thanks to Evert van Uitert for bringing this book to my notice
19. Zemel (see note 14 above), p.131
20. *Van Gogh Letters*, no.404

15 | Words and pictures

1. For examples of Chartist poetry and fiction, see *An Anthology of Chartist Literature*, ed. Y. V. Kovalev, Moscow, 1956
2. See Louis James, *Fiction for the Working Man 1830–1850*, 1963
3. Quoted in *Dickens: The Critical Heritage*, ed. Philip Collins, 1971, p.35
4. See P. J. Keating, *The Working Classes in Victorian Fiction*, 1971
5. Nochlin 1971, p.113
6. *Friendship's Garland*, 1871, Letter VI. First published in the *Pall Mall Gazette*, 20 April 1867
7. See *Into Unknown England 1866–1913: Selections from the Social Explorers*, ed. Peter Keating, 1976
8. M. A. Crowther, *The Workhouse System 1834–1929*, 1981, p.251

16 | Gulf of destitution

1. Anthony S. Wohl, *The Eternal Slum. Housing and Social Policy in Victorian London*, Montreal, 1977, p.249 and *passim*
2. See, *e.g.*, Michael E. Rose, *The Relief of Poverty 1834–1914*, 1972, pp.7–8 and *passim*; also Derek Fraser, *The Evolution of the British Welfare State, A History of Social Policy since the Industrial Revolution*, 1973, pp.115–28
3. Anthony S. Wohl, *Endangered Lives: Public Health in Victorian Britain*, Cambridge, Mass., 1983, pp.72–3 and *passim*
4. 'The Friend in Need', *ILN*, 23 April 1859, p.400
5. I am grateful to Jane E. Veron, for sharing her research with me and her list of over 500 paintings of rural and urban poverty which were exhibited at the RA and the British Institution, primarily during Victoria's reign
6. See Mayhew
7. 'Selected Pictures: The Crossing-Sweeper', *AJ*, 1864, p.64
8. W. P. Frith, *My Autobiography*, 1887, vol.1, p.216
9. W. R. Greg, 'Prostitution', *The Westminster Review*, vol.53, 1850, p.471
10. Elizabeth Gaskell, *Mary Barton*, 1911 edn, p.116
11. R. Wardlaw, *Lectures on Female Prostitution: Its Nature, Extent, Effects, Guilt, Causes and Remedy*, Glasgow, 1843, p.58
12. *Ath*, 1 May 1858, p.566
13. *Ath*, 2 May 1874, p.602
14. C. Booth, *Life and Labour of the People in London, First Series: Poverty*, vol.1, p.172

List of Abbreviations

AJ	*Art Journal*
Ath	*Athenaeum*
Arts Council 1974	*English Influences on Vincent van Gogh*, exh. cat. by R. Pickvance, Nottingham Art Gallery, Arts Council 1974
Baldry	A. L. Baldry, *Hubert von Herkomer, RA*, 1901
Blunt	W. Blunt, *England's Michaelangelo*, 1975
Burl Mag	*Burlington Magazine*
Cartwright	J. Cartwright, 'G. F. Watts RA', *Art Journal Easter Annual*, 1896
Casteras, Emigration	S. P. Casteras, ' "Oh! Emigration thou'rt the curse . . .", Victorian images of emigration themes', *Journal of Pre-Raphaelite Studies*, 1985, pp.1–19
Casteras, English Art	S. P. Casteras, 'The 1857–58 Exhibition of English Art in America', *The New Path, Ruskin and the American Pre-Raphaelites*, exh. cat. Brooklyn Museum 1985, pp.109–33
Chesneau	E. Chesneau, *The English School of Painting*, 1887
DNB	*Dictionary of National Biography*
Edelstein	Teri J. Edelstein, 'They sang "The Song of the Shirt": The visual iconology of the Seamstress', *Victorian Studies*, vol.23, 2, Winter 1980, pp.183–210
Edwards	Lee M. Edwards, *Hubert von Herkomer and the Modern Life Subject*, PhD Dissertation, Columbia University, 1984
Errington	Lindsay Errington, *Social and Religious Themes in English Art 1840–60*, PhD Thesis, Courtauld Institute of Art, London University 1973 (published 1984)
Faille	J.-B. de la Faille, *The works of Vincent van Gogh: His paintings and drawings*, Amsterdam, 1970
L. V. Fildes	L. V. Fildes, *Luke Fildes, RA, A Victorian Painter*, 1968
Fox	Celina Fox, *Londoners* (Museum of London), 1987
Grieve	Alastair Grieve, *The Art of Dante Gabriel Rossetti, 1. Found, 2. The Pre-Raphaelite Modern Subject*, 1976
Herkomers	Hubert von Herkomer, *The Herkomers*, 2 vols, 1910
Hueffer	F. M. Hueffer, *Ford Madox Brown*, 1896
Hulsker	Jan Hulsker, *The complete van Gogh: Paintings, drawings, sketches*, New York, 1980
ILN	*Illustrated London News*
Jerrold	Blanchard Jerrold, *Life of Gustave Doré*, 1891
MofA	*Magazine of Art*
Manchester 1968	Manchester City Art Gallery, *Art and the Industrial Revolution*, 1968
Marks	J. G. Marks, *The Life and Letters of Frederick Walker, ARA*, 1896
Mayhew	Henry Mayhew, *London Labour and the London Poor*, 2 vols, 1851–2
McKerrow	Mary McKerrow, *The Faeds*, 1982
E. Mills	Ernestine Mills, *The Life and Letters of Frederick J. Shields*, 1912
J. Saxon Mills	J. Saxon Mills, *The Life and Letters of Sir Hubert Herkomer, CVO, RA, A study in Struggle and Success*, 1923
New York and Princeton 1975	Metropolitan Museum, New York and Princeton University Art Museum, *The Royal Academy Revisited, Victorian Paintings from the Forbes Magazine Collection*, 1975
Nochlin 1971	L. Nochlin, *Realism*, 1971
Nochlin 1978	L. Nochlin, 'Lost and *Found*: Once more the Fallen Woman', *Art Bulletin*, vol.60, March 1978
Owen	D. Owen, *English Philanthrophy 1660–1960*, 1965
Phillips	Claude Phillips, *Frederick Walker and his Works*, 1894
Pietsch	Ludwig Pietsch, *Herkomer*, Leipzig, 1901
Quilter	Harry Quilter, *Preferences in Art, Life and Literature*, 1892
RA	Royal Academy
RMI	Royal Manchester Institution
F. M. Redgrave	F. M. Redgrave, *Richard Redgrave, CB, RA, A Memoir*, 1891
Reynolds	A. M. Reynolds, *The Life and Work of Frank Holl*, 1912
Rodee 1975	Howard Rodee, *Scenes of Rural and Urban Poverty in Victorian Painting and their development 1850–90*, PhD Dissertation, Columbia University, 1975
Rodee 1977	'The Dreary Landscape as a background for scenes of Rural Poverty in Victorian Paintings', *Art Journal* (USA), vol.37, 1977, pp.305–13
Roosevelt	Blanche Roosevelt, *Life and Reminiscences of Gustave Doré*, 1885
Ruskin, *Works*	*The Compete Works of John Ruskin*, ed. E. T. Cook and A. Wedderburn, 39 vols, 1904
Salaman	M. Salaman, *Modern Masters of Etching, Alphonse Legros*, 1926
Spielmann	M. H. Spielmann, 'The Works of Mr G. F. Watts, RA', *Pall Mall Gazette Extra Number*, 22, 1886
Thomson	D. Croal Thomson, 'The Life and Work of Luke Fildes, RA', *Art Annual*, 1895
Van Gogh Letters	*Complete Letters of Vincent van Gogh*, New York, 1958
V&A	Victoria & Albert Museum
Victorian City	*The Victorian City*, ed. H. J. Dyos and M. Wolff, 2 vols, 1973
Victorian Countryside	*The Victorian Countryside*, ed. G. E. Mingay, 2 vols, 1981
Watford 1982	*A Passion for Work, Sir Hubert von Herkomer*, exh. cat. by Lee M. Edwards, David Setford and Rosemary Treble, Watford Museum 1982
M. S. Watts	M. S. Watts, *G. F. Watts: The Annals of an Artist's Life*, 1912
Wood	Christopher Wood, *Victorian Panorama, Paintings of Victorian Life*, 1976
Yale 1982	*The Substance or the Shadow*, exh. cat. by Susan P. Casteras, Yale Center for British Art, 1982

Catalogue

Entries compiled by Julian Treuherz except nos 79–84 by Lee M. Edwards and nos 101–8 by Louis van Tilborgh.

For books, place of publication is London unless otherwise indicated.

Sizes are given first in inches, then centimetres, height before width.

Abbreviations

s	signed
inscr	inscribed
blc	bottom left corner
tr	top right etc
mon	monogram
Prov	Provenance
Exh	Exhibited
Lit	Literature
Engr	Engraved

John Leech (1817–64)

1. *Substance and Shadow* (from *Punch*, vol.v, 1843, p.23)
Wood engraving, 7 × 9¾ (17.8 × 24.8)
s (bl) within image: Leech
Lent by Manchester City Art Galleries
PROV: Platt Hall, Gallery of English Costume
LIT: *Victorian City*, vol.2, p.569, fig.379; Errington, pp.89–90; Fox, p.192

Attributed to Frank Stone (1800–59)

2. *Charity*
Watercolour, 21¼ × 17½ (54 × 44.5)
s (brc): Frank Stone
Lent by Warrington Museum and Art Gallery
PROV: Walker's Galleries; J. H. Booth, from whom purchased 1969
EXH: Walker's Galleries, London, *27th Annual Exhibition*, 1931 (129)
ENGR: by H. W. Egelton, published 2 March 1844, by S. Hollyer.
The lettering on the engraving (copy at Geffrye Museum) states the original was painted by William Drummond (active 1800–50) which suggests that the Stone signature may be spurious. Drummond's father Samuel showed similar subjects RA 1817 (223) and British Institution 1820 (215)

C. W. Cope (1811–90)

3. *The Wanderer*
(from *Etch'd Thoughts* by the Etching Club, 1844, p.24)
Etching, 4¾ × 3¾ (12.1 × 9.5)
s (brc within image): C. W. Cope
Lent by the Trustees of the Victoria & Albert Museum
PROV: Purchased from Richard Redgrave 1866
LIT: Errington, p.72, fig.8

P. F. Poole (1807–79)

4. *The Emigrant's Departure*
Oil on panel, 26 × 36 (66 × 91.4)
s (bl): P. F. Poole
Lent by the Forbes Magazine Collection, New York
PROV: Anon. sale, Sotheby's Chester, 17 Jan 1986 (3177); bt. Fine Art Society, from whom acquired 1986
EXH: RA 1838 (266); Liverpool Academy 1838 (249)
LIT: *Art Union*, 1839, p.33

James Collinson (1825–81)

5. *Answering the Emigrant's Letter*
Oil on panel, 27⅝ × 35⅞ (70.1 × 91.2)
s (brc): J. Collinson 1850
Lent by Manchester City Art Galleries
PROV: Anon. sale, Sotheby's, 13 July 1966 (103); bt. Colnaghi for Manchester
EXH: RA 1850 (448); Manchester 1968 (15); Agnew's, London, *Pre-Raphaelites from Manchester*, 1974; National Gallery of Scotland, *Tribute to Wilkie*, 1985 (39)
LIT: *AJ*, 1850, p.173; *PRB Journal*, ed. W. E. Fredeman, 1975, pp.8, 18, 25–6, 30, 35–7, 50, 53, 55, 59–60, 65–6, 69, 70; Wood, p.169, fig.185; Grieve, pp.21–2, fig.1; J. Treuherz, *Pre-Raphaelite Paintings from the Manchester City Art Gallery*, 1980, p.35, pl.14

George Cruikshank (1792–1878)

6. *Cold, misery and want destroy their youngest child*
Watercolour, 10 × 14⅛ (25.5 × 36)
after *The Bottle*, 1847, pl.5
7. *The husband, in a state of furious drunkenness, kills his wife with the instrument of all their misery*
Watercolour, 10 × 14 (25.5 × 35.5)
after *The Bottle*, 1847, pl.7

8. *Neglected by their parents . . . they are led to the gin shop*
Tinted glyphograph, 8⅝ × 13 (22 × 33)
The Drunkard's Children, 1848, pl.1

9. *He is taken by the police at a threepenny lodging house*
Tinted glyphograph, 8⅝ × 13 (22 × 33)
The Drunkard's Children, 1848, pl.4

10. *The poor girl, homeless, friendless, deserted, and gin mad, commits self-murder*
Tinted glyphograph, 8⅝ × 13 (22 × 33)
The Drunkard's Children, 1848, pl.8
6–10 Lent by the Trustees of the Victoria & Albert Museum
PROV: Given by Mrs George Cruikshank, 1884
EXH: Victoria & Albert Museum (Arts Council), *George Cruikshank*, 1974 (317, 319, 330, 333, 335)
LIT: G. W. Reid, *A descriptive catalogue of the works of George Cruikshank*, vol.2, 1871, nos 2713, 2715, 2717, 2720, 2724; B. Jerrold, *Life of George Cruikshank*, 1880, vol.3, pp.89–100; A. M. Cohn, *George Cruikshank, a catalogue raisonné*, 1924, 194–5; M. Wynn Jones, *George Cruikshank, His Life and London*, 1978, pp.87–91; Fox, p.194; Yale 1982, p.68

Richard Redgrave (1804–88)

11. *The Sempstress*
Oil on canvas, 25 × 30 (63.5 × 76.2)
s (bl): R. Redgrave, 1846
Replica of RA 1844 (227), unlocated
Lent by the Forbes Magazine Collection, New York
PROV: P. Horthewick; Sotheby's Belgravia, 27 March 1973 (49), bt. Fine Art Society, from whom acquired 1973
EXH: New York and Princeton 1975 (57); Delaware Art Museum, *The Pre-Raphaelite Era*, 1976 (1.14); Arts Council, *Great Victorian Pictures*, 1978 (47); Brown University, Providence, Rhode Island, *Ladies of Shalott*, 1985 (37); Museum of London, *Londoners*, 1987, p.193
LIT: (1844 version) *Art Union*, 1 June 1844, p.158; *Ath*, 18 May 1844, p.459; *Fraser's Magazine*, June 1844, pp.704–5; *ILN*, 11 May 1844, p.227; *Times*, 8 May 1844, p.7, 6 May 1845, p.6; *AJ* 1850, p.49; Redgrave, pp.43–5; Errington, pp.91–4, 116–18; Wood, p.127, fig.127; Edelstein, pp.185–95, fig.1; C. Walkley, *The Ghost in the Looking Glass, the Victorian Sempstress*, 1981, p.11

12. *The Outcast*
Oil, 31 × 41 (78.8 × 104.2)
s: Rich. Redgrave 1851
Lent by the Royal Academy of Arts
PROV: Presented by the artist as his diploma work 1851
EXH: RA Winter 1951 (337a); National Gallery of Scotland, *Tribute to Wilkie*, 1985 (40)
LIT: Errington, pp.123–4, fig.22; Nochlin 1978, p. 143, fig.8; D. Robertson, *Sir Charles Eastlake and the Victorian Art World*, 1978, p.349, fig.167: S. Casteras, *The McCormick Collection*, exh. cat., Yale Center for British Art, 1984, p.72

G. F. Watts (1817–1904)

13. *The Irish Famine*
Oil on canvas, 71 × 78 (180.4 × 198.1)
Lent by the Trustees of the Watts Gallery, Compton
PROV: Artist's collection
EXH: Grosvenor Gallery, *Watts*, Winter 1881–2 (15); Detroit Institute of Arts and Philadelphia Museum of Art, *Romantic Art in Britain*, 1968 (204)
LIT: Spielmann, p.30; Cartwright, p.16; H. Macmillan, *The Life-Work of G. F. Watts RA*, 1903, p.218; M. S. Watts, vol.1, pp.108–9; R. Chapman, *The Laurel and the Thorn*, 1945, p.42; Errington, pp.180–9, fig.40; Blunt, pp.45, 55, 211; Rodee 1977, p.310, fig.5

MANCHESTER SHOWING ONLY:
14. *Found Drowned*
Oil on canvas, 57 × 84 (144.7 × 213.4)
Lent by the Trustees of the Watts Gallery, Compton
PROV: Artist's collection
EXH: Liverpool Academy 1862 (377); Grosvenor Gallery, *Watts*, Winter 1881–2 (90); Metropolitan Museum, New York, *Watts*, 1884–5 (118); Whitechapel Art Gallery, *G. F. Watts*, 1974 (12)
LIT: Spielmann, p.30; Cartwright, p.16; H. Macmillan, *The Life-Work of G. F. Watts RA*, 1903, p.217; Mrs R. Barrington, *G. F. Watts*, 1905, p.135; M. S. Watts, vol.1, p.126; R. Chapman, *The Laurel and the Thorn*, 1945, pp.46–7; Errington, pp.180–206, fig.55; Blunt, p.55; Wood, pp.137–8, fig.142; Nochlin 1978, p.143, fig.10

J. E. Millais (1829–96)

15. *The Blind Man*
Ink, 8 × 11 (20.3 × 28)
s (brc): 18 JEM 53 (monogram)
Lent by the Yale Center for British Art (Paul Mellon Fund)
PROV: Lady Millais; Lady Stuart of Wortley (née Millais); George Gray and by descent, bt. by Davis & Long, New York, from whom purchased 1980
EXH: Fine Art Society, London, *J. E. Millais*, 1901 (79); Yale Center for British Art, *Recent Acquisitions*, 1981; Tate Gallery, *The Pre-Raphaelites*, 1984 (191); Davis & Langdale, New York, *British Drawings*, 1985 (53); Yale Center for British Art, *The First Decade*, 1986 (108)
LIT: J. G. Millais, *The Life and Letters of Sir J. E. Millais*, 1899, vol.1, p.193; vol.2, p.490; Errington, pp.399–400, fig.103; Grieve, p.28, fig.12

Charles Allston Collins (1828–73)

16. *Drink*
Ink, 10½ × 16¾ (26.7 × 42.5)
Mount inscribed, probably incorrectly, 'Drawn by J. E. Millais when a lad'
Lent by Dundee Art Galleries and Museums
PROV: Probably B. G. Windus; sold Christie's, 14 Feb 1868 (19); bt. Hogarth; T. H. Smith who presented it to Dundee 1926
EXH: RA, *Millais*, 1967 (337)
LIT: M. Bennett, 'Footnotes to the Millais Exhibition', *Liverpool Bulletin*, vol.12, 1967, pp.40–2, 52, fig.19; Errington, p.401, fig.100; Grieve, p.26, fig.8

Simeon Solomon (1840–1905)

17. *'I am starving'*
Ink, 6⅞ × 3¾ (17.5 × 9.5)
s (brc): SS 57
Lent by Roy and Cecily Langdale Davis
PROV: Christie's, 14 May 1968 (13); Anthony d'Offay, from whom purchased
EXH: Davis Galleries, New York, *Turn of the Century English Watercolours and Drawings*, 1969 (48); Delaware Art Museum, *The Pre-Raphaelite Era*, 1976, (3.16)

LIT: E. D. H. Johnson, 'Victorian artists and the urban milieu', *The Victorian City*, vol.2, p.458; S. Reynolds, *The Vision of Simeon Solomon*, 1984, pl.12

Anna Blunden (1830–1915)

18. *For only one short hour . . .*
Oil on canvas, 18½ × 15 (47 × 38.1)
s (bl): 1854/Anna Blunden
Lent by Christopher Wood
PROV: Stone Gallery, Newcastle upon Tyne
EXH: Society of British Artists, 1854 (133); USA, *British and Pre-Raphaelite Art*, 1857–8; Newcastle Polytechnic, *The Poor Teacher*, 1981 (26)
LIT: *ILN*, 15 July 1854, p.37; *Penny Illustrated Paper*, 1862, p.428; *Sublime and Instructive*, ed. V. Surtees, 1972, p.80; Wood, p.127, fig.129; Edelstein, pp.190–1; C. Walkley, *The Ghost in the Looking Glass, The Victorian Sempstress*, 1981, pp.44–5; Casteras, *English Art*, p.116, fig.34

MANCHESTER AND AMSTERDAM SHOWINGS:
Ford Madox Brown (1821–93)

19a. *Work*
Oil on canvas, 53¹⁵/₁₆ × 77¹¹/₁₆ (137 × 197.3)
s (brc): F. MADOX BROWN 1852-/65
Lent by Manchester City Art Galleries
PROV: Commissioned by Thomas Plint, November 1856; repudiated by Plint's executors and purchased by Ernest Gambart, 1863; reacquired by Plint's executors, sold by them, Christie's, 17 June 1865 (118), bt. in; J. C. Knight by 1883; Benjamin Armitage, 1884; purchased from a Mr Plint 1884
EXH: (selective; for full lit. see Liverpool 1964 cat.) 191 Piccadilly, *Madox Brown*, 1865 (99); Leeds, *National Exhibition*, 1868 (1483); Queen's Park Art Museum, Manchester, *Opening Exhibition*, 1884 (6); Manchester, *Royal Jubilee Exhibition*, 1887 (47); Grafton Galleries, London, *Ford Madox Brown*, 1897 (54); Walker Art Gallery, Liverpool, *Ford Madox Brown*, 1964 (25); Manchester 1968 (10); Tate Gallery, *The Pre-Raphaelites*, 1984 (88)
LIT:(selective; for full lit. see Liverpool 1964 cat.) *Ath*, 28 April 1860, 11 March 1865; *AJ*, 1865, p.156; F. T. Palgrave, *Essays on Art*, 1866, pp.172–5; Hueffer, pp.189–97 and *passim*; Grieve, 1976, pp.38–45, pl.24; E. D. H. Johnson, 'The Making of Ford Madox Brown's Work', *Victorian Artists and the City*, ed. I. B. Nadel and F. S. Schwarzbach, 1980, pp.142–151; *Diary of Ford Madox Brown*, ed. V. Surtees, 1981, pp.78, 106, 113–5, 118–9, 134–6, 153, 159, 192–4, 196–201, 204, 206–7, 215; M. Bennett, 'The Price of "Work": the background to its first exhibition 1865', *Pre-Raphaelite Papers*, 1984, pp.143–52

NEW HAVEN SHOWING ONLY:
19b. *Sketch for 'Work'*
Watercolour and pencil, arched top, 7¾ × 11 (19.7 × 28)
inscr (brc): FMB (monogram)
Lent by Manchester City Art Galleries
For details, see Liverpool cat. 1964 (70) and Tate cat. 1984 (181)

William Macduff (active 1844–76)

20. *Shaftesbury, or Lost and Found*
Oil on canvas, 18½ × 16 (47 × 40.6)
s (blc): W. Macduff 1862
Private Collection
PROV: Mrs Viva King; Christopher Wood, from whom purchased

EXH: RA 1863 (547); Leicester Galleries, London, *Victorian and 19th Century Pictures*, 1941 (39); RA, *First Hundred Years of the RA*, 1951 (328); Arts Council, *British Life* 1953 (74); Agnew, *Victorian Painting*, 1961 (119); Arts Council, *Victorian Paintings*, 1962 (42); Manchester 1968 (37); Mappin Art Gallery, Sheffield, *Victorian Paintings*, 1968 (95)
LIT: *Times*, 27 May 1863, p.6; G. Reynolds, *Painters of the Victorian Scene*, 1953, p.84, fig.63; G. Battiscombe, *Shaftesbury*, 1974, repr. f.p.307; Wood, fig.67; Fox, pp.216, 227
ENGR: By James Scott, publ. by Henry Graves 1864

Thomas Armstrong (1832–1911)

21. *A street scene in Manchester*
Oil on canvas, 29⅞ × 24¼ (76 × 61.6)
s (blc): T./Armstrong/1861
Lent by Manchester City Art Galleries
PROV: T. Greg Dowson; Sotheby's, 14 July 1983 (224), bt. Fine Art Society; purchased by Manchester 1985
EXH: RMI 1861 (316)
LIT: *AJ*, 1861, p.368; J. Boyles, 'The Chiefs of our National Museums, no.5, Mr Thomas Armstrong', *AJ*, 1891, p.271

T. R. Lamont (1826–98)

22. *Hard Times*
Oil on canvas, 31 × 25 (78.7 × 63.4)
Lent by Christopher Wood
PROV: Christie's, 14 March 1969 (28); bt. Wood
EXH: RA 1861 (737)
LIT: *Times*, 21 May 1861, p.11; Wood, p.112, fig.113

Henry Wallis (1830–1916)

23. *The Stonebreaker*
Oil on canvas, 25¾ × 31 (65.4 × 78.7)
s: HW 1857–8 (monogram)
Lent by Birmingham City Museum and Art Gallery
PROV: Temple Soames; Joseph Dixon 1887; presented by Charles Aitken, 1936
EXH: RA 1858 (562); Hogarth Club, London, 1859; Liverpool Academy 1860 (54); Whitechapel Art Gallery 1887 (197); Birmingham, *The Pre-Raphaelite Brotherhood*, 1947 (77); Tate Gallery, *The Pre-Raphaelite Brotherhood*, 1948 (23); Leicester Galleries, London, *The Victorian Romantics*, 1941 (91); Tate Gallery, *The Pre-Raphaelites*, 1984 (92)
LIT: *Ath*, 1 May 1858, p.567; *ILN*, 15 May 1858, p.498; *AJ*, 1858, p.170; Ruskin, *Works*, vol.14, pp.153, 170; Birmingham Art Gallery, *Catalogue*, 1960, p.149; Grieve, p.47, fig.28; A. Staley, *The Pre-Raphaelite Landscape*, 1973, p.88, pl.5, fig.43a; Wood, pp.118–20, fig.119; D. Cherry, 'The Hogarth Club 1858–61', *Burl Mag*, vol.122, 1980, pp.241, 3, 4, fig.20

Marcus Stone (1840–1921)

24. *Silent Pleading*
Oil on canvas, 36¼ × 28⅜ (92.1 × 72.1)
Lent by Calderdale Museums
PROV: Smith Art Gallery, Halifax
EXH: RA 1859 (456)
LIT: *AJ* 1859, p.169; *MofA*, 1880, p.84; A. L. Baldry, 'Marcus Stone', *Art Annual*, 1896, p.17

Frederic J. Shields (1833–1911)

25. *One of our Breadwatchers*
Watercolour, 15½ × 22¾ (39.2 × 57.6)
Lent by Manchester City Art Galleries
PROV: T. H. McConnel of Manchester by 1868; his sale, Capes & Dunn, Manchester, 30 July 1872 (261); dc Murietta, his sale, Christie's, 23 Feb 1894 (131); bt. Agnew and sold to Manchester 1894
EXH: London, Society of Painters in Watercolour, 1866 (259); Leeds, *National Exhibition*, 1868 (2192); RMI 1875 (39); Glasgow, *International Exhibition*, 1901 (1018); Manchester City Art Gallery, *F. J. Shields*, 1907 (82); Alpine Club, London, *Shields Memorial Exhibition*, 1911 (87); Gray Art Gallery, Hartlepool, *Shields*, 1922 (59)
LIT: *Illustrated Times*, 18 March 1866, p.90, engr. p.89; *Times*, 9 May 1866, p.6; *Ath*, 19 May 1866, p.676; E. Mills, pp.108–9, repr. f.p.110; Rodee 1977, p.309, fig.4
A watercolour replica is also in the Manchester City Art Gallery

Thomas Wade (1828–91)

26. *Carting Turf from the Moss*
Oil on canvas, 30 × 36½ (76.2 × 92.7)
s: WADE 1866–8
Lent by the Harris Museum and Art Gallery, Preston
PROV: By descent to Dr and Mrs Richardson from whom purchased 1935
EXH: RA 1867 (515); RMI 1868 (668); Harris Art Gallery, Preston, *Lancashire Art*, 1935 (22); Towneley Hall, Burnley, *Life in the Country*, 1983
LIT: Wood, p.118, fig.118

MANCHESTER AND AMSTERDAM SHOWINGS:
Thomas Faed (1826–1900)

27. *The Mitherless Bairn*
Oil on panel, 13⅞ × 24¼ (35.2 × 61.6)
s (brc): Thomas Faed
Replica of RA 1855 (141) now in the National Gallery of Melbourne, Australia
Lent by the Royal Pavilion, Art Gallery and Museums, Brighton
PROV: J. W. Leather of Leeds by 1866; his sale, Christie's, 9 Feb 1867 (59), bt. Johnson; James Fallows of Manchester; his sale, Christie's, 23 May 1868 (114), bt. Mouncey; H. G. Simkins bequest to Brighton 1916
EXH: Wembley, 1925 (W.48)
LIT: (principal version) *Times*, 7 May 1855, p.10; *Ath*, 2 June 1855, p.648; *AJ*, 1855, p.172; *MofA*, 1878, p.95; *Ath*, 3 July 1886, p.25; *MofA*; 1893, pp.272–3; Ruskin, *Works*, vol.14, p.15; D. & F. Irwin, *Scottish Painters at home and abroad*, 1975, pp.301–2; *Great Victorian Pictures*, exh. cat. by R. Treble, Arts Council 1978, no.11; McKerrow, pp.95–8
ENGR: S. Cousins, publ. by Henry Graves, 1860

MANCHESTER SHOWING ONLY:
28a. *The Last of the Clan*
Oil on canvas, 57 × 72 (144.8 × 182.9)
s (bl): Thomas Faed 1865
Lent by Glasgow Art Gallery and Museum
PROV: Purchased from the artist by L. V. Flatou; Richard Sutton of Penham Park by 1871; Sir S. V. Sutton; Christie's, 5 March 1971 (123); Fine Art Society; private collection Hamburg; Fine Art Society, from whom purchased 1980
EXH: RA 1865 (150); London, *International Exhibition*, 1871 (527); Fine Art Society, Edinburgh, *Art in Scotland 1800–1920*, 1980; Glasgow Art Gallery and Museum, *N.A.–C.F. 80th Birthday*, 1983

LIT: *Ath*, 29 April 1865, p.592; *AJ*, 1865, p.169; D. & F. Irwin, *Scottish Painters at Home and Abroad*, 1975, p.302, pl.146; Wood, p.224, fig.235; McKerrow, pp.110–11; *Burl Mag* supplement April 1983, fig.88; Casteras, Emigration, p.11
ENGR: W. H. Simmons, publ. by Henry Graves, 1868

AMSTERDAM AND NEW HAVEN SHOWINGS:
28b. *The Last of the Clan*
Oil on canvas, 34 × 44 (86.3 × 111.7)
s (bl): Thomas Faed 1865
Lent by Robert Fleming Holdings Ltd
PROV: Mrs Henry J. Mason

29. *The Poor: the Poor Man's Friend*
Oil on canvas, 16½ × 24 (42 × 61)
s (bl): Thomas Faed 1867, formerly collection Marquis of Montrose
Replica of RA 1867 (107)
Lent by the Trustees of the Victoria & Albert Museum
PROV: ? sold to estate of L. V. Flatou for £600; Jones bequest 1871
EXH: National Gallery of Scotland, *Tribute to Wilkie*, 1985 (27); (Principal version) RA 1867 (107); London, *International Exhibition*, 1871 (63); Manchester, *Royal Jubilee Exhibition*, 1887 (395); Glasgow, *International Exhibition*, 1901 (272)
LIT: (Principal version) *Times*, 4 May 1867, p.12; *Ath*, 4 May 1867, p.593; *AJ*, 1867, p.142; Nochlin, 1971, p.127; Wood, p.49, fig.43; McKerrow, p.107
ENGR: W. H. Simmons, publ. by Henry Graves, 1868

30. *Worn Out*
Oil on canvas, 41¾ × 57 (106 × 144.8)
s (bl): Thomas Faed 1868
Lent by the Forbes Magazine Collection, New York
PROV: Sold to Gambart for £1200; Daniel Thwaites by 1887; Associated Galleries, 15 June 1951; Sterling Hotel, Wilkes Barre, PA; purchased from E. J. Landrigan, New York, 1985
EXH: RA 1868 (172); Manchester *Royal Jubilee Exhibition*, 1887 (394); Guildhall, London, 1890 (9); Blackburn 1894 (89); Guildhall, London, 1900 (69); Denver, Colorado, *Childhood in Victorian England*, 1985 (16); Forbes Magazine Galleries, New York, *Victorian Childhood*, 1986 (5)
LIT: *Times*, 2 May 1868, p.14; *Ath*, 2 May 1868, p.632; *MofA*, 1893, p.272; A. G. Temple, *Painting in the Queen's Reign*, 1897, p.298; McKerrow, pp.112, 115

31. *Homeless*
Oil on canvas, 25⅝ × 19¼ (65.1 × 48.9)
s (br): Thomas Faed
Lent by the Beaverbrook Art Gallery, Fredericton, New Brunswick, Canada
PROV: Sold to Agnew; Anthony Wood 1869; H. F. Bolckow, Marton Hall, Middlesbrough by 1872; F. C. R. & R. C. Britten, sale, 8 March 1946 (58), bt. Sir Max Aitken; Lord Beaverbrook 1954; Second Beaverbrook Foundation; given to Beaverbrook Art Gallery 1960
EXH: RA 1869 (73); RSA 1872 (246); Mendel Art Gallery, Saskatoon, Canada, *Victorian England in Canada*, 1976 (p.2); Art Gallery of Greater Victoria, Canada, *Victorian Milieu–Narrative Painting in England*, 1979 (5)
LIT: *Times*, 1 May 1869, p.12; *Ath*, 1 May 1869, p.610; *AJ*, 1869, p.164; Beaverbrook Art Gallery, *Paintings*, 1959, p.41; McKerrow, pp.104, 152

32. *From Hand to Mouth*
Oil on canvas, 59 × 83 (149 × 210)
s (r, on counter): Thomas Faed 1879
Lent by the Wadsworth Atheneum (Ella Gallup Sumner and Mary Catlin Sumner Collection)

PROV: Angus Holden, afterwards Lord Holden; R. B. Dobell of Rowley Hall Staffs; Anon. sale Christie's and Edmiston's, Glasgow, 7 July 1983 (105), bt. Fine Art Society, from whom purchased 1985
EXH: RA 1880 (316)
LIT: *Ath*, 1 May 1880, p.573; *Times*, 6 May 1880, p.10; *Graphic*, 8 May 1880, p.478; *AJ*, 1880, p.186; *MofA*, 1893, p.269, engr.

MANCHESTER SHOWING ONLY:
Jozef Israels (1824–1911)

33. *Fishermen carrying a Drowned Man*
Oil on canvas, 50¾ × 96 (128.9 × 243.8)
s (bl): Jozef Israels
Lent by the Trustees of the National Gallery, London
PROV: Purchased 1862 by E. Gambart; sold to Arthur J. Lewis, London; Alexander Young, Aberdeen; his sale Christie's, 30th June–4th July 1910 (362); bt. Mrs Alexander Young who presented it to the National Gallery in accordance with his wishes
EXH: Paris Salon 1861 (1596); London, *International Exhibition*, 1862 (1253); Glasgow, *International Exhibition*, 1888 (742); Dowdeswell Galleries, London, 1889 (124); Hanover Gallery, London, *Israels*, 1890 (18); Grafton Galleries, London, Winter 1896 (15); Guildhall, London, 1903 (11); French Gallery, London 1909 (18); Ben Uri Art Gallery, London, 1949 (2); RA, *The Hague School*, 1983 (29)
LIT: (Selective; for full lit. see RA exh. cat. 1983) *Ath*, 14 June 1862, p.791; *AJ*, 1862, p.197; *ILN*, 12 Sept 1863; W. M. Rossetti, *Fine Art, Chiefly Contemporary*, 1867, p.144; *Burl Mag*, vol.2, 1903, p.177; *Studio*, 1912, pp.294–9; *AJ*, 1910, p.310; N. McLaren, *National Gallery Catalogue*, The Dutch School, 1960, pp.200–1; J. de Gruyter, *De Haagse School*, vol.1, Rotterdam 1968, pp.56, 58

MANCHESTER SHOWING ONLY:
34. *Grief*
Oil on canvas, 18⅛ × 22⅞ (46 × 58)
s: Jozef Israels
Replica of *The Day before Parting* now in the Boston Museum of Fine Arts
Lent by Glasgow Art Gallery and Museum
PROV: Sanford sale, Brussels, 15 Feb 1875 (37); Alexander Young by 1903; his sale Christie's, 30 June–4 July 1910 (206), bt. Lefevre; Sir Charles Wakefield sale, Christie's 30 June 1911 (55), bt. Agnew; E. Ruffer and others sale, Christie's, London, 9 May 1924 (36), bt. Thomas; Miss M. D. Wylie, by whom presented 1951
EXH: Goupil Gallery, London 1897 (27); Guildhall, London 1903 (9); French Gallery, London, 1909 (20)
LIT: *Studio*, 1912, p.94; *Museum of Fine Arts Bulletin*, Boston, vol.16, 1918, p.82; *The Hague School*, exh. cat. RA 1983, p.190

NEW HAVEN SHOWING ONLY:
Frederick Walker (1840–75)

35a. *The Lost Path*
Oil on canvas, 36 × 28 (91.5 × 71.1)
s (brc): F W 1863
Makins Collection
PROV: A. W. Lyon, Rocester, by 1868; his sale, Christie's, 19 May 1883 (3), bt. Ashe; Agnew; H. F. Makins 1887, thence by descent
EXH: RA 1863 (712); Leeds, *National Exhibition*, 1868 (1473); Derby, 1870 (2); Deschamps Gallery, London, *The Late Frederick Walker*, 1876 (74); Manchester, *Royal Jubilee Exhibition*, 1887 (686); Guildhall, London, 1897 (108); RA Winter, 1901 (109); RA, *The First Hundred Years of the RA*, 1951 (306); National Gallery of Canada,

Victorian artists in England, 1965 (152); RA, *This Brilliant Year, Queen Victoria's Jubilee 1887*, 1976 (156)
LIT: *Times*, 9 May 1863, p.11; *Ath*, 16 May 1863, p.655; *Graphic*, 25 Dec 1869, p.85; Phillips, pp.27, 34–6, 41, 48, 223, 319, repr. p.35; C. Black, *Frederick Walker*, 1902, p.85; J. Maas, *Victorian Painters*, 1969, p.235, repr. p.236

MANCHESTER AND AMSTERDAM SHOWINGS:
35b. *The Lost Path*
Engraving, 9 × 6 (22.9 × 15.2) from *Good Words*, 1862, p.185
Lent by Manchester Public Libraries

MANCHESTER SHOWING ONLY:
36. *The Vagrants*
Oil on canvas, 32¾ × 49¾ (83.2 × 126.4)
Lent by the Trustees of the Tate Gallery
PROV: Bought by Agnew, July 1867 and sold to William Graham; his sale, 2 April 1886 (86), bt. 1770 gns for the National Gallery; transferred to the Tate 1897
EXH: RA 1868 (477) under erroneous title, *In the Glen, Rathfarnham Park*; RMI 1868 (15); Deschamps Gallery, London, *The Late Frederick Walker*, 1876 (74)
LIT: *Once a Week*, 27 Jan 1866, f.p.112; *Times*, 2 May 1868, p.14; *Ath*, 16 May 1868, p.701; Phillips, pp.47–8, repr. f.p.48; Marks, pp.99–103, 108–12, 117, 120, 126–8, 158–9, 319, repr. f.p.110; C. Black, *Frederick Walker*, 1902, pp.107–8, repr. p.105; Wood, pp.51–2, pl.44; Rodee 1977, pp.310–11; Edwards, pp.58–9

37. *Study for 'The Harbour of Refuge'*
Watercolour, 9¾ × 17⅞ (24.8 × 45.4)
Study for the oil exh. RA 1872 (227) and now in the Tate Gallery
Lent by the Trustees of the Tate Gallery
PROV: Walker studio sale, Christie's, 17 July 1875 (102), bt. Agnew; John Heugh 1876; Sir William Agnew 1887; his bequest to the Tate 1911
EXH: Deschamps Gallery, London, *The Late Frederick Walker*, 1876 (149); Manchester, *Royal Jubilee Exhibition*, 1887 (1784); Whitworth Art Gallery, Manchester 1889; Glasgow, *International Exhibition*, 1901 (1100); Plymouth Art Gallery, *British Artists, 1750–1850*, 1939 (4)
LIT: Phillips, p.59; Marks, pp.240, 315, repr. p.239

Luke Fildes (1847–1927)

38. *Houseless and Hungry* (from the *Graphic*, 4 December 1869, p.9)
Wood engraving, 11½ × 16 (29.2 × 40.7)
Lent by the Rijksmuseum Vincent van Gogh, Amsterdam (Vincent van Gogh Foundation)
PROV: Vincent van Gogh
EXH: Arts Council 1974 (10)
LIT: *Strand Mag*, vol.6, 1893, pp.119–20; Thomson, p.26; Van Gogh *Letters*, nos.169, 205, 240, 252, R.20, R.24; L. V. Fildes, pp.12–13; *Victorian City*, vol.2, p.573, fig.385; *Apollo*, July 1982, pp.36–43

William Small (1843–1929)

39. *A queue in Paris* (from the *Graphic*, 11 March 1871, p.217)
Wood engraving, 11½ × 16 (29.2 × 40.7)
Lent by the Rijksmuseum Vincent van Gogh, Amsterdam (Vincent van Gogh Foundation)
PROV: Vincent van Gogh
EXH: Arts Council 1974 (70)
LIT: *Van Gogh Letters*, no. R.24

Hubert von Herkomer (1849–1914)

40. *A Gypsy Encampment on Putney Common*
(from the *Graphic*, 18 June 1870, p.680)
Wood engraving, 11½ × 16 (29.2 × 40.7)
Lent by Manchester City Art Galleries
PROV: Platt Hall, Gallery of English Costume
LIT: *Herkomers*, vol.1, p.80; Edwards pp.56–9

41. *A sketch at a concert given to the poor Italians in London*
(from the *Graphic*, 18 March 1871, p.253)
Wood engraving, 16 × 11½ (40.7 × 29.2)
Lent by the Rijksmuseum Vincent van Gogh, Amsterdam (Vincent van Gogh Foundation)
PROV: Vincent van Gogh
EXH: Arts Council 1974 (24)
LIT: Edwards, pp.61–2

Arthur Boyd Houghton (1836–75)

42. *Night Charges on their way to Court*
(from the *Graphic*, 11 December 1869, p.33)
Wood engraving, 11½ × 16 (29.2 × 40.7)
Lent by Manchester City Art Galleries
PROV: Platt Hall, Gallery of English Costume
LIT: P. Hogarth, *Arthur Boyd Houghton*, V&A, 1975, p.46

William Small (1843–1929)

43. *Heads of the People drawn from life–'The British Rough'*
(from the *Graphic*, 16 June 1875, p.616)
Wood engraving, 16 × 11½ (40.7 × 29.2)
Lent by the Rijksmuseum Vincent van Gogh, Amsterdam (Vincent van Gogh Foundation)
PROV: Vincent van Gogh
EXH: Arts Council 1974 (75)
LIT: *Van Gogh Letters*, no.252

Frank Holl (1845–88)

44. *At a Railway Station–a study*
(from the *Graphic*, 10 February 1872, pp.128–9)
Wood engraving 16 × 23 (40.7 × 58.4)
Lent by Manchester City Art Galleries
PROV: Platt Hall, Gallery of English Costume
LIT: Reynolds, pp.97, 105; *Van Gogh Letters*, nos R.23, R.24

G. J. Pinwell (1842–75)

45. *The Sisters* (from the *Graphic*, 6 May 1871, p.416)
Wood engraving, 16 × 11½ (40.7 × 29.2)
Lent by the Rijksmuseum Vincent van Gogh, Amsterdam (Vincent van Gogh Foundation)
PROV: Vincent van Gogh
EXH: Arts Council 1974 (62)
LIT: *Universal Review*, vol.2, 1888, p.96; *Van Gogh Letters*, nos 262, R.24

M. W. Ridley (1836–88)

46. *Pitmen heaving the Coal*
(from the *Graphic*, 28 January 1871, p.77)
Wood engraving, 11½ × 16 (29.2 × 40.7)

Lent by the Rijksmuseum Vincent van Gogh, Amsterdam (Vincent van Gogh Foundation)
PROV: Vincent van Gogh
EXH: Arts Council 1974 (63)
LIT: *Van Gogh Letters*, nos R.17, R.23, R.24

Robert Walker Macbeth (1848–1910)

47. *A Lincolnshire Gang* (from the *Graphic*, 15 July 1876, pp.60–1)
Wood engraving, 16 × 23 (40.7 × 58.4)
After the oil RA 1876 (46)
Lent by Manchester City Art Galleries
PROV: Platt Hall, Gallery of English Costume
LIT: *Victorian Countryside*, vol.1, p.170

Frederic J. Shields (1833–1911)

48. *Factory Girls at the Old Clothes Fair, Knott Mill, Manchester*
(after the engraving in the *Graphic*, 17 December 1870, p.583)
Watercolour, 9⅜ × 12⅝ (23.8 × 32.1)
s (brc): 1875 FS (monogram)
Lent by Manchester City Art Galleries
PROV: Charles Rowley, Manchester 1875; James Gresham, Manchester by 1907; his bequest 1917
EXH: RMI Autumn 1875 (464); New Islington Public Rooms, Manchester, 1880 (30); Manchester City Art Gallery, *F. J. Shields*, 1907 (99); Manchester City Art Gallery, *Manchester in 19th century Pictures and Records*, 1938 (163); Manchester 1968 (258)
LIT: E. Mills, pp.78, 84, 90, 145, 164, 322; Edwards p.63

Charles Green (1840–98)

49. *A Sunday afternoon in a Gin Palace*
(from the *Graphic*, 8 February 1879)
Wood engraving, 11½ × 16 (29.2 × 40.7)
Lent by the Rijksmuseum Vincent van Gogh, Amsterdam (Vincent van Gogh Foundation)
PROV: Vincent van Gogh
EXH: Arts Council, 1974 (21)
LIT: *Van Gogh Letters*, no. R.29

Frank Holl (1845–88)

50. *Shoemaking at the Philanthropic Society's Farm School at Redhill* (from the *Graphic*, 18 May 1872, p.468)
Wood engraving, 11½ × 16 (29.2 × 40.7)
Lent by the Rijksmuseum Vincent van Gogh, Amsterdam (Vincent van Gogh Foundation)
PROV: Vincent van Gogh
EXH: Arts Council 1974 (33)
LIT: Reynolds, p.99; *Van Gogh Letters*, nos. R.20, R.31

Francis S. Walker (1848–1916)

51. *'The Young Ravens'–A Friday Dinner at Great Queen Street*
(from the *Graphic*, 21 December 1872, p.585)
Wood engraving, 11½ × 16 (29.2 × 40.7)
Lent by the Rijksmuseum Vincent van Gogh, Amsterdam (Vincent van Gogh Foundation)
PROV: Vincent van Gogh
LIT: *Victorian City*, vol.2, p.573, fig.388

Hubert von Herkomer (1849–1914)

52. *Sunday at Chelsea Hospital*
(from the *Graphic*, 18 February 1871, p.160)
Wood engraving, 16 × 11½ (40.7 × 29.2)
Lent by the Rijksmuseum Vincent van Gogh, Amsterdam (Vincent
van Gogh Foundation)
PROV: Vincent van Gogh
EXH: Arts Council 1974 (25)
LIT: *Autobiography of Hubert Herkomer*, 1890, p.35; Baldry, p.21; H.
von Herkomer, *My school and my gospel*, 1908, pp.26–7; *Herkomers*,
vol.1, p.150; J. Saxon Mills, pp.58–9; *Van Gogh Letters*, nos.169, 263,
280, R.20, R.23, R.24; Edwards, pp.151–2

53. *Study of a Chelsea Pensioner for 'Sunday at Chelsea Hospital'*
Charcoal, 10 × 6⅞ (25.4 × 17.5)
Private Collection, on loan to Watford Museum
PROV: Egerton Collection
EXH: Watford 1982 (B.2)
LIT: Edwards, p.155, fig.99

54. *Old Age–a study at the Westminster Union*
(engraved in the *Graphic*, 7 April 1877, pp.324–5)
Oil on paper, 20 × 35½ (50.8 × 90.2)
s (blc): HH 77
Private Collection
PROV: Charles J. Galloway, Manchester; Christie's, 27 June 1905 (298);
Christie's, 10 July 1970 (23)
EXH: Dudley Gallery, *Black and White Exhibition*, 1877 (353)
LIT: *A Catalogue of Paintings and Drawings at Thorneyholme,
Cheshire collected by Charles J. Galloway* (privately printed), 1892,
no.278; *Van Gogh Letters*, nos. R.20, R.23, R.24, R.29; Edwards,
pp.227–8

55. *Christmas in a Workhouse*
(engraved in the *Graphic*, 25 December 1876, p.30)
Gouache, 14⅞ × 10¹³⁄₁₆ (37.8 × 27.4)
s (br): 18 HH 76
Lent by York City Art Gallery
PROV: J. Tillotson Hyde, by whom presented 1962
EXH: Watford 1982
LIT: *Van Gogh Letters*, no.240; Edwards, pp.232–3

Gustave Doré (1832–83)

56. *Gray's Inn Lane–Robber's kitchen*
(study for the engraving in *London, A Pilgrimage*, p.45)
Watercolour and white heightening, 14⅛ × 10¼ (36 × 26)
s (brc): G. Doré/1869; verso inscr. with title
Private Collection
EXH: Paris, Salons du Cercle, 1885 (362); Hazlitt, Gooden & Fox,
London, *Gustave Doré*, 1983 (18); Musée de Strasbourg, *Gustave
Doré*, 1983 (74); Museum of London, *Londoners*, 1987, p.184;
Barbican Art Gallery, London, *The Image of London*, 1987 (187)

57. *The Bull's Eye* (from *London, A Pilgrimage*, p.144)
Wood engraving, 15¾ × 12 (40 × 30.5)
Private Collection
LIT: *Art History*, vol.1, 1978, p.352

58. *Newgate, Exercise Yard* (from *London, A Pilgrimage*, p.136)
Wood engraving, 15¾ × 12 (40 × 30.5)
Private Collection
LIT: Arts Council 1974, p.45, cat. no.88; *Art History*, vol.1, 1978,
p.351; Fox, p.215

59. *Scripture Reader in a Night Refuge*
(from *London, A Pilgrimage*, p.142)

Wood engraving, 15¾ × 12 (40 × 30.5)
Private Collection
LIT: *Van Gogh Letters*, no. R.13; Arts Council 1974, no.86

60. *Asleep under the Stars* (from *London, A Pilgrimage*, p.179)
Wood engraving, 15¾ × 12 (40 × 30.5)
Private Collection
LIT: Jerrold, p.153; *Art History*, vol.1, 1978, p.356

**61. *Glad to death's mystery, swift to be hurl'd,
Anywhere, anywhere out of the world***
Drawing for the title page to *Hood's Poetical Works*, 1871
Indian ink heightened with white, 9¾ × 7¼ (24.8 × 18.4)
s (brc): GD
Lent by the Trustees of the Victoria & Albert Museum
PROV: Bequeathed by H. H. Harrod, 1948
EXH: V&A, *Charles Dickens*, 1970 (I.55)

Alphonse Legros (1837–1911)

62. *The Vagabond's Death*
Etching, 21½ × 15¼ (54.6 × 38.7)
Lent by Manchester City Art Galleries
PROV: Presented by the artist 1881
EXH: Manchester City Art Gallery, *Legros*, 1912 (155)
LIT: *MofA*, 1882, p.332; *AJ*, 1897, p.214; *Burl Mag*, vol.20, p.275;
Salaman, p.9, pl.v; *Peasantries*, exh. cat. Newcastle upon Tyne, 1981,
no.20

63. *The Faggot Makers*
Etching, 15 × 10¾ (38.1 × 27.4)
Printed signature (blc): A. L.
Lent by Manchester City Art Galleries
PROV: Presented by the artist 1881
EXH: Manchester City Art Gallery, *Legros*, 1912 (170)
LIT: H. Béraldi *Les graveurs du XIX siècle*, 1885–92, no.182 iii;
Salaman, p.9; *Peasantries*, exh. cat. Newcastle upon Tyne, 1981, no.21

Frank Holl (1845–88)

64. *The Lord gave and the Lord hath taken away*
Oil on canvas, 36 × 49 (91.5 × 124.5)
s: Frank Holl 1868
Lent by the Guildhall Art Gallery, City of London
PROV: Sold by the artist 1869 to F. C. Pawle of Reigate; his bequest
1915
EXH: RA 1869 (210); Paris, *Exposition Universelle*, 1878 (112); RA
Winter 1889 (185); Barbican Art Gallery, London, *The City's Pictures*,
1984 (29)
LIT: *Ath*, 15 May 1869, p.675; *Times*, 18 June 1869, p.694; *AJ*, 1869,
p.169, 1876, p.11, 1889, pp.54–5; Quilter, p.307; A. G. Temple,
Painting in the Queen's Reign, 1896, pp.339–40; Reynolds, pp.44–9,
315

65. *No Tidings from the Sea*
Oil on canvas, 27½ × 35½ (69.9 × 90.2)
s: Frank Holl, 1870
Lent by gracious permission of Her Majesty The Queen
PROV: Commissioned from the artist by Queen Victoria and purchased
1870
EXH: RA 1871 (595); RA Winter 1889 (211); RA Winter 1901 (61); RA
Bicentenary 1968 (312)
LIT: *Times*, 22 May 1871, p.6; *Ath*, 10 June 1871, p.726; *AJ*, 1871,
p.177; *Catalogue of the Paintings . . . at Osborne*, 1876, p.328; *AJ*,
1876, pp.10–11, 1889, pp.55–6; Reynolds, pp.83–7; Wood, p.56,
fig.50

66. *Study for 'Deserted–A Foundling'*
Oil on canvas, 21¾ × 30 (55.2 × 76.2)
Study for the oil RA 1874 (487), unlocated
Private Collection
PROV: Mrs Frank Holl; Anon. sale Christie's, 20 December 1963 (122)
bt. by present owner
LIT: Reynolds, p.123; (engraving) *Graphic*, 26 April 1873, pp.392–3;
Van Gogh Letters, R.23, R.24; (principal version) *Times*, 26 May 1874,
p.6; *Ath*, 30 May 1874, p.740; *Graphic*, 6 June 1874, p.543; *AJ*, 1876,
pp.9, 11; Reynolds, pp.107–8

67. *The Song of the Shirt*
Oil on canvas, 19 × 26⅛ (48.3 × 66.2)
s (br): Frank Holl
Lent by the Royal Albert Memorial Museum, Exeter
PROV: Probably commissioned by Captain Henry Hill of Brighton
1874; Hill sale, Christie's, 25 May 1889 (135); bt. Agnew; Sir Charles
Tennant and by descent to Hon. Colin Tennant; Sotheby's Belgravia,
10 July 1973 (85), bt. Agnew; sold to Exeter 1975
EXH: Glasgow, *International Exhibition*, 1901 (181A)
LIT: Wood, p.128, fig.131; Exeter, *Catalogue*, 1978, p.78

68. *Doubtful Hope*
Oil on canvas, 37½ × 53½ (95.2 × 136)
s (br): Frank Holl 1875
Lent by the Forbes Magazine Collection, New York
PROV: Sold by the artist to Wallis (French Gallery); L. H. Lefevre,
5 October 1905: Anon. sale Christie's, 6 March 1981 (44), bt. Fine Art
Society by whom sold to present owner, 1981
EXH: French Gallery, Winter 1875–6 (163); Yale 1982 (41); Denver
Colorado, *Childhood in Victorian England*, 1985 (20); Forbes Maga-
zine Galleries, New York, *Victorian Childhood*, 1985 (7)
LIT: *Graphic*, 6 November 1875, p.454; *AJ*, 1876, p.26; Reynolds,
pp.110, 127

69. *Gone*
Oil on canvas, 30¾ × 22 (78.1 × 56)
s (blc): Frank Holl
Small version of the oil exh. Tooth's Winter 1877
Lent by the Geffrye Museum
PROV: Sold to Tooth's 1877; Pym's Gallery, 1983 from whom pur-
chased 1984
EXH: ? Tooth's, London, Winter 1877; Pym's Gallery, London, *Autumn
Anthology*, 1983 (1); Nottingham Art Gallery, *Train Spotting*, 1985
LIT: Reynolds, p.148; (engraving) *Graphic*, 19 February 1876, pp.180–
1; *Van Gogh Letters* nos.218, 214, R.12, R.24, R.25; (large oil) *Times*,
29 October 1877, p.11, 1 December 1877, p.4; *AJ*, 1878, p.16, 1889,
p.57; *MofA*, 1880, p.188; Reynolds, pp.147–8

70. *Her First Born*
Oil on board, 13¾ × 19¾ (35 × 50.2)
s (br): Frank Holl 1877
Small version of the oil RA 1876 (286), now in Dundee City Art
Gallery
Lent by Sheffield City Art Galleries
PROV: Mrs E. M. Dartford, grand-daughter of the artist; Fine Art
Society; Anon. sale, Sotheby's Belgravia, 12 June 1973 (138); bt. Fine
Art Society; Forbes Magazine Collection, New York; sold Sotheby's,
15 March 1983 (67); bt. Sheffield
EXH: Fine Art Society, *Recent Acquisitions*, 1969 (50); Minneapolis
University Gallery, *The Art and Mind of Victorian England*, 1974
(21); New York and Princeton, 1975 (27)
LIT: (large version) *ILN*, 13 May 1876, p.475; *Times*, 18 May 1876, p.8;
AJ, 1876, p.261, 1889, p.56; Reynolds, pp.128–9; *Dundee City Art
Gallery Catalogue*, 1973, p.63

71. *Hush!*
72. *Hushed*
Both oil on canvas, 13½ × 17½ (343 × 445)
Both s: Frank Holl /77
Lent by the Trustees of the Tate Gallery
PROV: Bought by F. C. Pawle of Reigate; Henry Tate by 1888; Sir Henry
Tate gift 1094
EXH: Dudley Gallery, Winter 1877–8 (68, 100); RA Winter 1889 (200,
203)
LIT: *Ath*, 1 December 1877; *Times*, 1 December 1877; *AJ*, 1878, p.54,
1893, p.197; Reynolds, pp.146–7

73. *Newgate: Committed for Trial*
Oil on canvas, 60 × 83 (152.3 × 210.7)
Lent by Royal Holloway and Bedford New College
PROV: Bought from the artist by Edward Hermon MP, Wyfold Court,
Henley-on-Thames; his sale, Christie's, 13 May 1882 (60), bt. Martin
for Thomas Holloway
EXH: RA 1878 (423); RA Winter, 1889 (221): RA *Bicentenary*, 1968
(317); Agnew, *Thomas Holloway, The Benevolent Millionaire*, 1981
(17)
LIT: (Selective; for full lit. see J. Chapel below) *Academy*, 25 May
1878, p.470; *AJ*, 1878, p.168; *ILN*, 1878, p.459; *MofA*, 1878, p.100;
Times, 11 May 1878, p.6; *MofA*, 1880, p.189; A. G. Temple, *Painting
in the Queen's Reign*, 1897, p.339; Reynolds, pp.144–6; G. Reynolds,
Painters of the Victorian Scene, 1953, pp.28, 93, fig.83; J. Maas,
Victorian Painting, 1969, p.237; Wood, 1976, p.58, fig.51; J. Chapel,
Victorian Taste, Royal Holloway College, 1982, cat. no.29

Luke Fildes (1844–1927)

74. *Applicants for Admission to a Casual Ward*
Oil on canvas, 54 × 96 (137.1 × 243.7)
s (brc): Luke Fildes 1874
Lent by Royal Holloway and Bedford New College
PROV: Bought from the artist by Thomas Taylor, Aston Rowant,
Oxfordshire; his sale, Christie's, 28 April 1883 (71), bt. Martin for
Thomas Holloway
EXH: RA 1874 (504); Liverpool, Autumn, 1874 (187); Philadelphia,
International Exhibition, 1876 (45); Paris, *Exposition Universelle*,
1878 (73); Guildhall 1892 (8); RA Winter, 1928 (280); County Hall,
London, *Jubilee*, 1939; National Gallery, Ottawa, *Victorian Artists in
England*, 1965 (38); RA, *Bicentenary*, 1968 (311); V&A, *Charles
Dickens*, 1970 (I.67); Riverside Studios, London, *Victorian Paintings*,
1981 (23); Agnew, *Thomas Holloway, The Benevolent Millionaire*,
1981 (11)
LIT: (selective; for full lit. see J. Chapel below) *Academy*, 2 May 1874,
p.500, 23 May 1874, p.585; *AJ*, 1874, p.201; *Ath*, 2 May 1874, p.602,
30 May 1874, p.740; *Graphic*, 8 May 1874, p.455; *ILN*, 9 May 1874,
p.446; *Manchester Courier* 21 May 1874, p.6; *Times*, 26 May 1874,
p.6; *MofA*, 1880, p.51, 1882, p.310; *Strand Mag.*, vol.6, 1893, pp.122–
4; Thomson, pp.2–6; A. G. Temple, *Painting in the Queen's Reign*,
1896, p.341; G. Reynolds, *Painters of the Victorian Scene*, 1953,
pp.28–9, 94, pl.84; L. V. Fildes, pp.24–7, 51; J. Maas, *Victorian
Painting*, 1969, pp.235, 238–9; Nochlin 1971, p.154, pl.89; *Connois-
seur*, 1974, pp.34–5; Wood, pp.52–3, fig.45; *Apollo*, July 1982,
pp.36–43; J. Chapel, *Victorian Taste*, Royal Holloway College, 1982,
cat. no.22

75. *Study for 'The Widower'*
Oil on canvas, 21 × 14½ (53.3 × 36.8)
Private Collection
PROV: Fildes Studio sale, Christie's, 24 June 1927 (22), bt. Gooden and
Fox; F. W. Wignall, Rookery House, Tattenhall, Cheshire; Wignall

sale 1958, bt. Sir Leonard Stone by whom given to father of present owner
LIT: Thomson, repr. p.4

76. *The Widower*
Oil on canvas, 26⅛ × 37 (66.3 × 94)
s: Luke Fildes
Replica of RA 1876 (476), now in the National Gallery of New South Wales, Sydney
Lent by the Trustees of the National Museums and Galleries on Merseyside (Walker Art Gallery)
PROV: Purchased from the artist by Agnew 1903; sold to the Walker 1904
EXH: Liverpool, Autumn 1904 (1217); RA, *Bicentenary*, 1968 (315)
LIT: (1876 version) *Times*, 29 April 1876, p.14; *Ath*, 29 April 1876, p.603, 13 May 1876, p.672; *Strand Mag*, vol.6, 1893, p.124; Thomson, pp.4, 8; L. V. Fildes, pp.25, 38–43; *Victorian Social Conscience*, exh. cat. by R. Free, Art Gallery of New South Wales, 1976, cat. no.20

77. *Study for 'The Doctor'*
Oil on canvas, 23 × 36 (58.4 × 91.4)
Lent by the Robert Packer Hospital and Guthrie Medical Center, Sayre, Pennsylvania
PROV: Fildes' studio sale, Christie's, 26 June 1927 (4); bt. Sampson; presented to Robert Packer Hospital by Allen P. Kirby 1944 in memory of Dr Donald Guthrie
LIT: Alice A. Meyer, ' "The Doctor" by Sir Luke Fildes, The Robert Packer Hospital Oil Sketch Original', *Guthrie Bulletin*, April 1974, pp.155–161

MANCHESTER SHOWING ONLY:
78. *The Doctor*
Oil on canvas, 65½ × 95¼ (166.4 × 241.9)
Lent by the Trustees of the Tate Gallery
PROV: Commissioned by Henry Tate and purchased 1891; Sir Henry Tate gift 1894
EXH: RA 1891 (199); Liverpool, Autumn 1891 (853); Walker Art Gallery, Liverpool, *Historical Exhibition of Liverpool Art*, 1908 (630); RA Winter 1928 (262); Toronto, *Canadian National Exhibition*, 1936; Royal Glasgow Institute 1938
LIT: *Times*, 2 May 1891, p.14; *Ath*, 2 May 1891, p.574; *Graphic*, 2 May 1891, p.486; *Academy*, 9 May 1891, p.448; *MofA*, 1891, pp.220, 253; *AJ*, 1891, pp.153–6, 195, 1893, pp.11–12; *British Medical Journal*, 8 October 1892, pp.787–8; *Strand Mag*, vol.6, 1893, pp.110, 114–5, 117, 126; Thomson, pp.12–13; C. Bell, *Art*, 1949 edn, p.32; G. Reynolds, *Painters of the Victorian Scene*, 1953, pp.29–30, 94–5, fig.85; L. V. Fildes, pp.108–9, 116–123; Wood, pp.100–102, fig.102; *Great Victorian Pictures*, exh. cat. by R. Treble, Arts Council, 1978, cat. no.14

Hubert von Herkomer (1849–1914)

79. *The Last Muster*
Lithograph, 24 × 18 (61 × 45.7)
inscr: H.V.H. 1909
After the oil RA 1875, now at the Lady Lever Art Gallery, Port Sunlight
Lent by the Trustees of the Victoria & Albert Museum
PROV: Presented by the artist 1910
EXH: Arts Council, *Great Victorian Pictures*, 1978 (20); (oil painting) RA 1875 (898); Paris, *Exposition Universelle*, 1878 (107); Whitechapel, *Fine Art Exhibition*, 1885 (10); Manchester, *Royal Jubilee Exhibition*, 1887 (465); Birmingham 1887 (166); Chicago, *World's Columbian Exposition*, 1893 (213); Blackburn, *Opening of the New Art Gallery*, 1894 (106); Guildhall, London 1894 (7); West

Ham, 1897 (132); Dublin *International Exhibition*, 1907; London, *Franco–British Exhibition*, 1908 (135); Rome, *International Exhibition*, 1911 (704); RA Winter 1922 (9); Liverpool, Walker Art Gallery, 1923; Wembley 1925; Blackburn Art Gallery 1934
LIT: (selected) *Ath*, 1 May 1875, p.591, 5 June, p.755; *Times*, 1 May 1875, p.12; *Graphic*, January–June, 1875, pp.415, 447, 474, 482, 498, 518; *ILN*, 8 May 1875, p.446; Ruskin, *Works*, vol.14, p.291 (1875); *AJ*, 1875, pp.188, 252; *Graphic*, 29 June 1878, p.648; *Gazette des Beaux-Arts*, 1878, p.304; *AJ*, 1878, p.174; *Les Chefs-d'Œuvre d'Art à l'Exposition Universelle*, vol.2, 1878, pp.14–16; *L'Art*, 1879, p.179; *MofA*, 1880, p.262; Chesneau, 1885, pp.295–96; *MofA*, 1890, frontispiece; *Autobiography of Hubert Herkomer*, 1890, pp.43–7; Quilter, 1892, p.317; *Art Annual*, 1892, pp.9–10; *The Artist*, February, 1898, pp.81–83; Baldry, 1901, pp.24–28; Pietsch, 1901, pp.8–9; *Herkomers*, vol.1, 1910, pp.196–209; J. Saxon Mills, pp.77–93; G. Reynolds, *Painters of the Victorian Scene*, 1953, pp.96–7, fig.91; Nochlin 1971, p.87; Watford 1982, pp.23–25, 37–39; Edwards, pp.150–190

MANCHESTER SHOWING ONLY:
80a. *Eventide: A Scene in the Westminster Union*
Oil on canvas, 43½ × 78¼ (110.5 × 198.7)
s (br): Hubert Herkomer 1878
Lent by the Trustees of the National Museums and Galleries on Merseyside (Walker Art Gallery)
PROV: Purchased from the Liverpool Autumn Exhibition, 1878
EXH: RA 1878 (1002); Liverpool, Autumn 1878 (110); Paris Salon 1879 (1547)
LIT: *Ath*, 4 May 1878, p.577; *Times*, 11 May 1878, p.6; *ILN*, 11 May 1878, p.577; *AJ*, 1878, p.179; *MofA*, 1878, p.104; *Portfolio*, vol.10, 1878, p.12; *L'Art*, vol.15, 1878; H. Blackburn, *Academy Notes*, 1878, p.67; J-K. Huysmans, *L'Art Moderne: Paris Salons 1879–81*, Paris, 1883, pp.46–7; *AJ*, 1879, p.16, 1880, p.111; Baldry, p.117; J. Saxon Mills, pp.96–7; *Country Life*, 25 January 1973, p.223; Wood, p.54, fig.47; Watford 1982, pp.40–1; Yale 1982, p.36; Edwards, pp.226–242

AMSTERDAM AND NEW HAVEN SHOWINGS:
80b. *Eventide: A Scene in the Westminster Union*
Watercolour, 16¼ × 29½ (41.3 × 74.9)
inscr (blc): Hubert Herkomer
Lent by the Trustees of the National Museums and Galleries on Merseyside (Walker Art Gallery)
PROV: Thomas Bartlett; his sale, Christie's 29 November 1912 (7), where purchased
LIT: Edwards p.236

81. *Pressing to the West: A Scene in Castle Garden, New York*
Oil on canvas, 57 × 84½ (144.7 × 214.6)
s (br): Hubert Herkomer 1884
Lent by the Leipzig Museum
PROV: Purchased from the Munich Secession Exhibition 1894
EXH: Goupil's, London 1884; RA 1884 (1546); Munich Secession 1894; Landsberg am Lech 1931
LIT: *AJ*, 1883, p.62; *New York Times*, 29 April 1883, p.12; *Times*, 30 March 1884; *ILN*, 17 May 1884, p.490; *Graphic*, 7 June 1884, p.562; *Ath*, 21 June 1884, p.798; Ruskin, *Works*, vol.33, p.339 (1884); Pietsch, p.41; J. Saxon Mills, pp.141–2; Wood, pp.222–3, fig.234; Edwards, pp.250–8

82. *Hard Times 1885*
Oil on canvas, 34¹/₁₆ × 44⅛ (86.5 × 112)
s (blc): HH 85
Lent by Manchester City Art Galleries
PROV: Purchased from the artist at the Manchester Autumn Exhibition 1885

EXH: RA 1885 (1142); Manchester City Art Gallery, Autumn 1885 (252); Manchester, *Royal Jubilee Exhibition*, 1887 (74); Glasgow, *International Exhibition*, 1888; Blackburn, *Opening of the New Art Gallery*, 1894 (80); RA 1922 (175); Russell-Cotes Art Gallery, Bournemouth, 1930 (10); Manchester City Art Gallery, *Victorian Favourites*, 1956; Manchester 1968 (24); RA, *This Brilliant Year, Queen Victoria's Jubilee 1887*, 1976 (145); Watford 1982

LIT: *Times*, 20 May 1885, p.6; *ILN*, 30 May 1885, p.564; *Ath*, 20 June 1885, p.796; *AJ*, 1885, p.226; *Blackwood's*, July 1885, p.125; *MofA*, 1888, p.216; R. Muther, *History of Modern Painting*, vol.3, 1896, p.182; Pietsch, pp.56–8; Baldry, p.52; J. E. Phythian, *Manchester City Art Gallery Handbook*, 1905, p.21; *Herkomers*, vol.1, p.136; J. Saxon Mills, pp.152–3; *Country Life*, 25 January 1973, p.222; G. Longman, *Bushey Then and Now, Our Village*, Bushey, 1976, p.20; Wood p.54, fig.48; Rodee 1977, p.311, fig.7; Watford 1982, pp.41–3; Edwards, pp.258–82

83. *On Strike*
Oil on canvas, 89¾ × 49¾ (228 × 126.4)
s (brc): Hubert Herkomer 91
Lent by the Royal Academy of Arts
PROV: Presented by the artist as his diploma work 1891
EXH: RA 1891 (77); Turin, *International Labour Exhibition*, 1961; RA *Bicentenary*, 1968 (314); Watford 1982
LIT: *Times*, 2 May 1891, p.14, 11 May, p.8; *ILN*, 2 May 1891, p.573, 16 May, p.648, 23 May, p.683; *Ath*, 16 May 1891, p.641; Baldry, p.54; Pietsch, p.62; *Herkomers*, vol.2, p.171; J. Saxon Mills, p.192; *Apollo*, 1969, p.58; J. Maas, *Victorian Painters*, 1969, p.239; Nochlin 1971, p.123; Wood, p.122, fig.123; Watford 1982, pp.43–5; Edwards, pp.272–82

84. *In the Black Country*
Watercolour with bodycolour, 15 × 19 (38.1 × 48.2)
s (l): HH 91
Lent by Mr & Mrs R. W. Sumner
PROV: Sotheby's, 13 May 1980 (191)
EXH: Watford 1982
LIT: Edwards, pp.273–4

Eyre Crowe (1824–1910)

85. *The Dinner Hour, Wigan*
Oil on canvas, 30¹/₁₆ × 42⅛ (76.3 × 107)
s (blc): E. CROWE/1874
Lent by Manchester City Art Galleries
PROV: The artist at least until 1898 (label on stretcher); Anon. sale, Christie's, 21 November 1921 (98), bt. Misell; purchased from A. E. Knight, London, 1922
EXH: RA 1874 (676); Manchester City Art Gallery, *Manchester in 19th Century Pictures and Records*, 1938 (174); Storey Institute Lancaster, *Festival of Britain*, 1951 (65); Geneva, *Art et Travail*, 1957; Manchester 1968 (17); Welsh Arts Council, Cardiff, *Work*, 1970 (116)
LIT: *Times*, 26 May 1874, p.6; *Ath*, 9 May 1874, p.637; *ILN*, 6 June 1874, p.543; *AJ*, 1874, p.227; G. Reynolds, *Painters of the Victorian Scene*, 1953, p.92, fig.80; F. D. Klingender, *Art and the Industrial Revolution*, 1968, fig.113; *Victorian City*, vol.2, p.457; *Connoisseur*, 1974, pp.32, 39; Wood, pp.125–7, fig.30

86. *Sandwiches*
Oil on canvas, 15½ × 24 (39.4 × 61)
s (trc): E. Crowe 1881
Private Collection
PROV: Anon. sale Sotheby's, 16 October 1968 (86), bt. Fine Art Society; sold to present owner 1972
EXH: RA 1881 (503)
LIT: *Ath*, May 1881, p.660; Wood, p.151, fig.158

87. *Convicts at Work, Portsmouth*
Oil on panel, 16 × 21 (40.7 × 53.3)
s (on fence): CROWE
Lent by Trafalgar Galleries, London
PROV: Purchased at Bonham's, 1969
EXH: RA 1887 (807)

William Powell Frith (1819–1909)

88. *Retribution*
Oil on panel, 12⅛ × 15½ (30.8 × 39.4)
s (brc): W. P. Frith 1880
Replica of oil from the *Race for Wealth* series at the Baroda Museum, India
Lent by Birmingham Museum and Art Gallery
PROV: ? Coll. Ellis sale, Christie's, 20 May 1882 (137), bt. Mendoza; S. E. Lucas sale, Christie's, 17 March 1961 (120), bt. Agnew; purchased by Friends of Birmingham Museum and Art Gallery, by whom presented 1962
EXH: Agnew, *Victorian Painting*, 1961; Musée des Beaux-Arts, Lyon, *Peintures et Aquarelles Anglaises 1700–1900 du Musée de Birmingham*, 1966 (47); Mappin Art Gallery, Sheffield, *Victorian Paintings*, 1968 (101)
LIT: (large version) *Ath*, 20 March 1880, p.384; *AJ*, 1880, p.207; W. P. Frith, *My autobiography and reminiscences*, vol.2, 1887, pp.143–52; Wood, pp.39–40, fig.30

A. E. Mulready (1843–1904)

89. *A Recess on a London Bridge*
Oil on canvas, 17⅛ × 21⅛ (43.6 × 53.5)
s (br): A. E. Mulready/'79
Lent by the Laing Art Gallery, Newcastle upon Tyne (Tyne and Wear Museums Service)
PROV: Given by Ralph Atkinson 1908
EXH: RA 1880 (479); Laing Art Gallery, *Inaugural Exhibition*, 1904 (106); South Shields, *Victorian Paintings from the Laing Art Gallery*, 1979
LIT: H. Blackburn, *Academy Notes*, 1880, p.45

Arthur H. Marsh (1842–1909)

90. *Wayfarers*
Watercolour, 25⅝ × 21½ (65 × 54.5)
s (br): A. H. MARSH/1879
Lent by the Laing Art Gallery, Newcastle upon Tyne (Tyne and Wear Museums Service)
PROV: Purchased from Mrs Mitchell, 1907
EXH: Newcastle Arts Association, Autumn 1881 (143); Newcastle upon Tyne Polytechnic, *Peasantries*, 1981 (42)
LIT: *MofA*, 1888, p.160

Robert McGregor (1847–1922)

91. *Gathering Stones*
Oil on canvas, 27 × 50 (68.6 × 127)
s (br): R. McGregor
Lent by the City of Edinburgh Museums and Art Galleries
PROV: Presented by the Scottish Modern Artists Association 1964
EXH: Royal Scottish Watercolour Society, *Pictures from the Scottish Modern Artists Association*, 1944 (40); Newcastle upon Tyne Polytechnic, *Peasantries*, 1981 (43)

LIT: R. Billcliffe, *The Glasgow Boys*, 1985, pp.49–50
This was formerly incorrectly identified with *Clearing Potato Field*, exh. RSA (319), sold Sotheby's Glasgow, 4 Feb 1987 (197)

Walter Langley (1852–1922)

92. *But men must work and women must weep*
Watercolour, 35⅝ × 20⅞ (90.5 × 53)
s (blc): W. LANGLEY
Lent by Birmingham City Museum and Art Gallery
PROV: Bequeathed by H. C. Brunning 1908
EXH: Royal Institution of Painters in Watercolours, 1882 (507); Liverpool, Autumn 1882 (665); Whitechapel, 1885 (90); Penzance Art Museum 1887; Royal Birmingham Society of Art, 1908 (324); Royal Birmingham Society of Artists, *Langley Memorial Exhibition*, 1923 (27); Leamington Art Gallery, 1928 (111); Newlyn, Plymouth and Bristol, *Artists of the Newlyn School*, 1979 (19); Exeter and Birmingham, *Walter Langley*, 1984 (7); Barbican Art Gallery, London, *Painting in Newlyn*, 1985 (20)
LIT: *Graphic*, 29 December 1883; *The Cornishman*, 2 April 1887; *Edgbastonia*, July 1890, vol.10, p.101; *Moseley and King's Heath Journal*, July 1897, vol.6, p.67

H. H. La Thangue (1859–1929)

93. *The Last Furrow*
Oil on canvas, 83 × 80 (211 × 203)
s (br): H. H. La Thangue
Lent by Oldham Art Gallery
PROV: Purchased from the artist at the Bradford exhibition 1896
EXH: RA 1895 (98); Bradford Art Gallery, Spring 1896 (4); Oldham Art Gallery, *A Painter's Harvest*, 1978 (13); Sainsbury Centre, Norwich, *Life and Landscape: P. H. Emerson, Art and Photography in East Anglia 1885–1900*, 1987 (45)
LIT: *Times*, 18 May 1895, p.17; *Ath*, 18 May 1895, p.647; *ILN*, 18 May 1895, p.620; *Graphic*, 1 June 1895, p.649; *AJ*, 1896, p.26; *MofA*, 1896, p.383

Ernest L. Sichel (1862–1941)

94. *A Child's Funeral in the Highlands*
Oil on canvas, 30⅝ × 51 (78.5 × 129.5)
s (bl): E. Sichel 1896
Lent by Bradford Art Galleries and Museums
PROV: Purchased from the artist at the Bradford exhibition 1896
EXH: Bradford Art Gallery, Spring 1896 (13); Cartwright Hall, Bradford, *Sichel Memorial Exhibition*, 1941 (41); Cartwright Hall, Bradford, *English Impressions*, 1978 (42)

John Henry Henshall (1856–1928)

95. *Behind the Bar*
Oil on canvas, 24½ × 43¾ (62.2 × 111.1)
Private Collection
PROV: M. Newman Limited; Christopher Wood Gallery
EXH: Dudley Gallery, Winter 1882–3
LIT: *AJ*, 1883, p.166; Wood, p.18, fig.6; Fox, pl.XVIII
A watercolour version is in the Museum of London

MANCHESTER SHOWING ONLY:
Frederick Brown (1851–1941)

96. *Hard Times*
Oil on canvas, 23⅜ × 36⅝ (72 × 93)
s (brc): F. Brown 1886
Lent by the Trustees of the National Museum and Galleries on Merseyside (Walker Art Gallery)
PROV: Purchased from the artist 1886
EXH: New English Art Club, 1886 (51); Liverpool, Autumn 1886 (241); Paris, *Exposition Universelle*, 1889 (13); Brussels, 1897; London, *Franco–British Exhibition*, 1908 (274); Spring Gardens Gallery, London, *NEAC Retrospective*, 1925 (107) and Manchester 1925 (265); Birmingham, *The Early Years of the N.E.A.C.*, 1952 (4); Manchester 1968 (12); Columbus Gallery of Fine Arts, Ohio, *British Art 1890–1918*, 1971 (13); Christie's, *N.E.A.C. Centenary*, 1986 (5)
LIT: *Times*, 12 April 1886; P. H. Rathbone in *University College Magazine*, Liverpool, 1886, p.292; W. J. Laidlay, *The Origin and First Two Years of the N.E.A.C.*, 1907, pp.204–5; F. Brown in *Artwork*, vol.6, no.24, May 1930, pp.269–78; A. Thornton, *50 Years of the N.E.A.C.*, 1935, p.4; Bruce Laughton, *Philip Wilson Steer*, 1971, p.23; Wood, fig.49; *Apollo*, vol.122, 1985, p.405.

Thomas B. Kennington (1856–1916)

97. *Widowed and Fatherless*
Oil on canvas, 48 × 71½ (121.9 × 181.6)
s (brc): T. B. KENNINGTON 1888
Private Collection
PROV: Christie's, 4 June 1982 (78); bt. David Messum, from whom purchased
EXH: RA 1888 (1126)
LIT: *Times*, 25 May 1888, p.4; *Ath*, 30 June 1888, p.832

MANCHESTER SHOWING ONLY:
98. *The Pinch of Poverty*
Oil on canvas, 45 × 40 (114.3 × 101.6)
s: T. B. KENNINGTON 1891
Replica of oil RA 1889 (734) in the Art Gallery of South Australia
Lent by the Thomas Coram Foundation for Children, London
PROV: Presented under the terms of the will of W. J. H. Le Fanu, 1926
EXH: Christie's, *N.E.A.C. Centenary*, 1985 (20)
LIT: *Thomas Coram Foundation*, cat., 1965, no.5; Benedict Nicolson, *The Treasures of the Foundling Hospital*, 1972, pp.51, 72, no.50, pl.98; (principal version) *Times*, 1 June 1889, p.17; *Ath*, 8 June 1889, p.734; *AJ*, 1889, p.220, 1894, p.344; *Victorian Social Conscience*, exh. cat. Art Gallery of New South Wales, 1976, cat. no.39

Ralph Hedley (1848–1913)

99. *Paddy's Clothes Market, Sandgate*
Oil on canvas, 38⅜ × 47⅜ (97.4 × 120.5)
s (br): R. Hedley 1898
Lent by the Laing Art Gallery, Newcastle upon Tyne (Tyne and Wear Museums Service)
PROV: Purchased from the artist 1911
EXH: Laing Art Gallery, *Ralph Hedley*, 1938 (69)

100. *Seeking Situations*
Oil on canvas, 37⅝ × 52¼ (95.6 × 132.7)
s (br): R. Hedley 1904
Lent by the Shipley Art Gallery, Gateshead (Tyne and Wear Museums Service)

Vincent van Gogh (1853–90)

101. *The Public Soup Kitchen*
Black mountain chalk, 22½ × 17½ (57 × 44.5)
s (bl): Vincent
Lent by the Rijksmuseum Vincent van Gogh, Amsterdam (Vincent van Gogh Foundation)
LIT: Faille 1020a; Hulsker 330; Jan Hulsker, 'Van Gogh's Family and the Public Soup Kitchen', *Vincent*, vol.2, 1973, no.2, pp.12–15

102. *The Orphan Man*
Lithograph, 24 × 14½ (61 × 39.5)
Printed signature (bl): Vincent
Inscribed by Vincent: épreuve d'essai
Lent by the Rijksmuseum Vincent van Gogh, Amsterdam (Vincent van Gogh Foundation)
LIT: Faille 1658; Hulsker 256; W. J. A. Visser, 'Vincent van Gogh en 's Gravenhage', *Die Haghe*, 1973, pp.58–65

103. *Orphan Man Drinking Coffee*
Lithograph, worked up with ink, 22½ × 14¾ (57 × 37.5)
Printed signature (bl): Vincent
Inscribed by Vincent: 1re épreuve
Lent by the Rijksmuseum Vincent van Gogh, Amsterdam (Vincent van Gogh Foundation)
LIT: Faille 1657; Hulsker 266; W. J. A. Visser, 'Vincent van Gogh en 's Gravenhage', *Die Haghe*, 1973, pp.58–65

104. *Sorrow*
Lithograph, 15¼ × 11½ (38.5 × 29)
Printed signature (bl): Vincent
Printed inscription (br): Sorrow
Inscribed by Vincent: épreuve d'essai
Lent by the Rijksmuseum Vincent van Gogh, Amsterdam (Vincent van Gogh Foundation)
LIT: Faille 1655; Hulsker 259; Hope Benedict Werness, *Essays on Van Gogh's Symbolism*, Santa Barbara, 1972 (unpublished dissertation), pp.34–62

105. *At Eternity's Gate*
Lithograph, 22 × 14½ (55.5 × 36.5)
Printed signature (bl): Vincent
Lent by the Rijksmuseum Vincent van Gogh, Amsterdam (Vincent van Gogh Foundation)
LIT: Faille 1662; Hulsker 268

106. *The Weaver*
Pencil, pen and brown ink, 10½ × 15¾ (27 × 40)
s (bl): Vincent
Lent by the Rijksmuseum Vincent van Gogh, Amsterdam (Vincent van Gogh Foundation)
LIT: Faille 1121; Hulsker 453; Linda Nochlin, 'Van Gogh, Renouard, and the Weavers' Crisis in Lyon: The Status of a Social Issue in the Art of the later Nineteenth Century', *Art, the Ape of Nature: Studies in the Honor of H. W. Janson*, New York, 1981, pp.669–88; Carol Zemel, 'The "Spook" in the Machine: Van Gogh's Pictures of Weavers in Brabant', *Art Bulletin*, vol.67, 1985, pp.123–37

107. *The Potato Eaters*
Lithograph, 10½ × 12 (26.5 × 30.5)
Printed signature (bl), in reverse: Vincent
Lent by the Rijksmuseum Vincent van Gogh, Amsterdam (Vincent van Gogh Foundation)
EXH: National Museum of Western Art, Tokyo, *Vincent van Gogh*, 1985 (30)
LIT: Faille 1661, Hulsker 737; J. G. van Gelder, *De aardappeleters van Vincent van Gogh*, Amsterdam and Antwerp, 1949; Albert Boime, 'A Source for Van Gogh's Potato-eaters', *Gazette des Beaux-Arts*, vol.67, 1966, pp.249–53

108. *A pair of boots*
Oil on canvas, 14¾ × 18 (37.5 × 45)
s (tl): Vincent
Lent by the Rijksmuseum Vincent van Gogh, Amsterdam (Vincent van Gogh Foundation)
LIT: Faille 255; Hulsker 1124; John A. Walker, 'Art History versus Philosophy. The Enigma of the "Old Shoes"', *Van Gogh Studies. Five critical Essays*, London, 1981, pp.61–71; Claus Korte, 'Van Gogh und das Schuh-Stilleben der Bataille du Réalisme, exh. cat. *Schuhwerke. Aspekte zum Menschenbild*, Kunsthalle, Nuremberg, 1976, pp.8–16

List of Lenders

Index of artists in the exhibition

Page numbers in bold type indicate main reference.